Informatics of Domination

Informatics of Domination

Edited by Zach Blas,
Melody Jue, and Jennifer Rhee

With an afterword by Donna J. Haraway

Duke University Press
Durham and London

2025

© 2025 Duke University Press
All rights reserved

Project Editor: Ihsan Taylor
Designed by A. Mattson Gallagher

Typeset in Garamond Premier
by Westchester Publishing Services

Library of Congress Cataloging-in-Publication Data
Names: Blas, Zach, editor. | Jue, Melody, [date] editor. | Rhee, Jennifer, editor.
Title: Informatics of domination / edited by Zach Blas, Melody Jue, and Jennifer Rhee.
Description: Durham : Duke University Press, 2025. | Includes bibliographical references and index.
Identifiers: LCCN 2024041533 (print) LCCN 2024041534 (ebook)
ISBN 9781478031000 (paperback) ISBN 9781478028383 (hardcover)
ISBN 9781478060581 (ebook) Subjects: LCSH: Haraway, Donna Jeanne. | Mass media—Political aspects. | Technology—Political aspects. | Technology and the arts. | Power (Social sciences) | Feminist theory. | Patriarchy. | Dominance (Psychology) Classification: LCC P95.8 .I54 2025
(print) | LCC P95.8 (ebook) |
DDC 302.23/082—dc23/eng/20241231 LC record available at https://lccn.loc.gov/2024041533
LC ebook record available at https://lccn.loc.gov/2024041534

Contents

xi Acknowledgments

1 **Introduction: Chart of Transitions**
Zach Blas, Melody Jue, and Jennifer Rhee

33 **1. Representation —— Simulation —— Generation**
Rita Raley

41 **2. Bourgeois Novel, Realism —— Science Fiction, Post-modernism —— Visionary Fiction, Cataclysm**
Alexis Lothian

48 **3. White Capitalist Patriarchy —— Informatics of Domination**
Radha May (Elisa Giardina-Papa, Nupur Mathur, and Bathsheba Okwenje)

52 **4. Organism —— Biotic Component**
Leon J. Hilton

57 5. Depth, Integrity —— Surface, Boundary —— Circulation, Residence Time
 Eva Hayward and Stefan Helmreich

65 6. Heat —— Noise
 Ollie Zhang

71 7. White Capitalist Patriarchy —— Informatics of Domination
 Hi'ilei Julia Kawehipuaakahaopulani Hobart

77 8. Biology as Clinical Practice —— Biology as Inscription —— Biological Transmutation-Adaptation
 Kathy High

83 9. Physiology —— Communications Engineering
 Esther Leslie

90 10. Small Group —— Subsystem
 Lawrence Lek

99 11. Perfection —— Optimization —— Absolution
 Alexander R. Galloway

103 12. Eugenics —— Population Control
 Ama Josephine Budge Johnstone

110 **13.** Decadence, *Magic Mountain* —— Obsolescence, *Future Shock* —— Speculation, *Cosmopolis*
 Bahar Noorizadeh and Bassem Saad

118 **14.** Hygiene —— Stress Management —— Procrastination
 Mahan Moalemi

124 **15.** White Capitalist Patriarchy —— Informatics of Domination
 Larissa Lai

130 **16.** Microbiology, Tuberculosis —— Immunology, AIDS —— Epigenetics, Body Burdens
 Isadora Neves Marques

136 **17.** Organic Division of Labor —— Ergonomics/Cybernetics of Labor —— Inorganic Division of Labor
 Ranjodh Singh Dhaliwal

146 **18.** Functional Specialization —— Modular Construction —— Object Orientation
 Jacob Gaboury

152 **19.** Reproduction —— Replication
 Luciana Parisi

159 20. White Capitalist Patriarchy —— Informatics of Domination
Ashkan Sepahvand

168 21. Organic Sex Role Specialization —— Optimal Genetic Strategies
Heather Dewey-Hagborg and Luiza Prado de O. Martins

176 22. Biological Determinism —— Evolutionary Inertia, Constraints —— Future Folklore
Ashley Ferro-Murray and Justin Talplacido Shoulder

182 23. Community Ecology —— Ecosystem —— Automated Environments
Jennifer Gabrys

189 24. Racial Chain of Being —— Neo-imperialism, United Nations Humanism —— the More Things Change-the More Things Change
Shaka McGlotten

196 25. White Capitalist Patriarchy —— Informatics of Domination
Jian Neo Chen

203 26. Scientific Management in Home/Factory —— Global Factory/Electronic Cottage
Ho Rui An

211 27. Family/Market/Factory —— Women in the Integrated Circuit —— Feminist Corpus of Organismic Art
Caroline A. Jones

218 28. Family Wage —— Comparable Worth
Dalida María Benfield

226 29. Public/Private —— Cyborg Citizenship
Amy Sara Carroll and Ricardo Dominguez, with contributions from micha cárdenas on behalf of Electronic Disturbance Theater 2.0

232 30. Nature/Culture —— Fields of Difference —— Composting
Jennifer Mae Hamilton and Astrida Neimanis

241 31. Cooperation —— Communications Enhancement —— Algorithmic Care
Stephanie Dinkins

249 32. White Capitalist Patriarchy —— Informatics of Domination
madison moore

257 33. Freud —— Lacan —— Bergson
Homay King

264 34. Sex —— Genetic Engineering
Shu Lea Cheang and Matthew Fuller

270	35.	Labor —— Robotics
		Lucy Suchman
276	36.	Mind —— Artificial Intelligence
		Ana Teixeira Pinto
282	37.	World War II —— Star Wars —— War as Big Data
		Tung-Hui Hu
288	38.	White Capitalist Patriarchy —— Informatics of Domination
		Thao Phan
295		Afterword: Pandemics of Transformation for Livable Worlds
		Donna J. Haraway
297		Epilogue: Interpreting Information
		Patricia Reed
305		Bibliography
335		Contributors
349		Index

Acknowledgments

The idea for this collection originated from a 2017 lecture series titled Informatics of Domination that Zach Blas organized for the Department of Visual Cultures public program at Goldsmiths, University of London. We are grateful and indebted to all speakers and respondents, as well as their lively audiences, for adventurous discussion and debate, and for inspiring us to expand this project into a book: Ramon Amaro, Erika Balsom, Rizvana Bradley, Simone Browne, Shu Lea Cheang, Heather Dewey-Hagborg, Ricardo Dominguez, Kodwo Eshun, Seb Franklin, Matthew Fuller, Metahaven, Nadja Millner-Larsen, Stefan Nowotny, Luciana Parisi, Irit Rogoff, Mohammad Salemy, Susan Schuppli, Nina Wakeford, and Joanna Zylinska. A special thanks to e-flux for publishing proceedings from the series on their *Conversations* platform.

At Duke University Press, we express heartfelt thanks to our editor Ken Wissoker, for his remarkable generosity, unwavering commitment to the collection, and for championing the diagrammatic experimentation that structures this book. To editorial associate Kate Mullen, senior project editor Ihsan Taylor, copyeditor Karen Fisher, designer A. Mattson Gallagher, marketing assistant Chad Royal, and Joshua Gutterman Tranen, who was assistant editor during the early stages of the project, thank you for your care and scrupulous work in guiding the book through various stages of editing and production. We are also appreciative of Talia Golland, for editorial assistance, and our anonymous reviewers, who provided valuable and encouraging feedback on the book proposal and manuscript.

This collection would not exist without its fifty contributors. We extend our deepest gratitude to you all. It has taken several years to complete this publication, and we are touched and humbled by your

trust and patience, your intellectual curiosity and artistic unruliness, your willingness to experiment, and your enduring commitment to the project.

Finally, we wish to acknowledge N. Katherine Hayles, whose extraordinary mentorship has marked each of our intellectual journeys.

Introduction: Chart of Transitions

Zach Blas, Melody Jue, and Jennifer Rhee

Nano Power, gray goo syndrome, wetware, rhizomatics: such concepts populate artist Ricardo Dominguez's *Virtual Timeline* (1997), a conceptual artwork cum hyperlinked chart that periodizes capitalism and its relations to science, technology, and power (figure I.1).[1] Headlined with directing arrows, ">>>>>," the four columns embed a temporal and spatial argument. When read horizontally, the chart maps a multitude of transitions across four stages of capitalism (Entrepreneurial, Monopoly, Multinational, and Virtual), while its vertical dimension provides a nonexhaustive list of capitalism's conditions at each particular stage. For example, *conquest of nature* shifts to *3rd world conquest* to *conquest of intelligence* to *conquest of existence*. Vertically, *Multinational Capitalism* includes *Micro Power*, *AIDS*, *computer*, *postmodernism*, *plagiarism*, and *simulacra*. Dominguez created the timeline as a website hyperlinking many of the catalogued terms. Now, some decades later, most of the links are broken.

Virtual Timeline responds to technological specificities of the 1990s: namely, the rise of the personal computer and the World Wide Web.[2] Indeed, the "virtual" of the title recalls a then-popular catchall term for describing conditions and experiences enabled by digital, networked computers. The artwork persists in this sense of the virtual, not only diagramming the qualities of four capitalisms but also materializing as a mode of experimental thought made possible through computers and the internet. Philosophically, the virtual signals potentiality—that which is real but not yet actualized.[3] Some of Dominguez's terms are virtual in this sense, like *gray goo syndrome*, a science fictional scenario in which nanomachines consume all biomass on Earth.[4] The virtual as potentiality also manifests in the chart's reading instructions: ">>>>>."

>>>>>			
VIRTUAL TIMELINE	VIRTUAL TIMELINE	VIRTUAL TIMELINE	VIRTUAL TIMELINE
Entreprenurial Capitalism	Monopoly Capitalism	Multinational Capitalism	Virtual Capitalism
Steam Power	Electric Power	Micro Power	Nano Power
Property Rights	Corporate Rights	Copy Rights	DNA Rights
Nature as Other	Alien as Others	Knowledge as Other	Biology as Other
conquest of nature	3rd world conquest	conquest of intelligence	conquest of existence
nationalism	imperialism	multinationalism	globalization
tuberculosis	cancer	AIDS	GGS (gray goo syndrome)
film	television	computer	wetware
Mechanical	Instantaneous	Logico-iconic	Fractal
realism	modernism	postmodernism	rhizomatics
high art	art as commodity	plagiarism	hypermedia
frame	screen	chip	bio-chip
possession	mediation	interface	introjection
image	collage	simulacra	chaotics
worker vanguard	consumer	affinity	virtual

1.1. Ricardo Dominguez, screenshot of *Virtual Timeline*, 1997, https://www.thing.net/~rdom/VRtime.html.

While these directions contain five ">"s, Dominguez only provides four stages of capitalism. What is the reader to make of the remaining ">"? Implicitly asking, "What stage might be next?" or "What aspects of capitalism remain unaccounted for?," *Virtual Timeline* engages in a practice of charting that is inherently unfinished, incomplete, and partial, even at its inception.

Virtual Timeline was inspired by an earlier experimental chart. Dominguez explains that the timeline creatively builds upon the diagrammatic work begun in a previous chart that also maps capitalism and power: feminist science and technology studies scholar Donna Haraway's "chart of transitions," which was published in her classic essay "A Manifesto for Cyborgs: Science, Technology, and Socialist Feminism in the 1980s" (1985). Dominguez describes the influence of Haraway's chart on *Virtual Timeline* thusly: "I was responding to [Haraway's chart] and adding my own drift."[5] In this collection, we, the editors, also return to Haraway's chart of transitions as a diagrammatic structure for thinking about power that invites modification and the addition of new drifts. We look for openings and borders in the chart, as well as latent possibilities to add, divert, and start anew.

The informatics of domination, our title and organizing concept, emerges from Haraway's "Manifesto for Cyborgs," which defines

informatics of domination as "a world system of production/reproduction and communication."⁶ In an eponymous section that includes her chart of transitions, Haraway narrates a wide-ranging shift in the operations of power, marking a move from social relations predominantly structured by industrial capitalism to those structured by information capitalism in the second half of the twentieth century. Here, Haraway also describes the informatics of domination in prose that teasingly evokes its meaning:

> In this attempt at an epistemological and political position, I would like to sketch a picture of a possible unity, a picture indebted to socialist and feminist principles of design. The frame for my sketch is set by the extent and importance of rearrangements in world-wide social relations tied to science and technology. I argue for a politics rooted in claims about fundamental changes in the nature of class, race, and gender in an emerging system of world order analogous in its novelty and scope to that created by industrial capitalism; we are living through a movement from an organic, industrial society to a polymorphous, information system—from all work to all play, a deadly game. Simultaneously material and ideological, the dichotomies may be expressed in the following chart of transitions from the comfortable old hierarchical dominations to the scary new networks I have called the informatics of domination:⁷

Haraway's conception of the informatics of domination comes into focus from this description rooted in visual language: sketches, pictures, frames, design. Haraway's particular interest in sketching a picture primes the reader for what follows this passage (which notably ends in the typographic graft of a colon): a two-column, thirty-two-row diagram that maps two modes of domination—the chart of transitions (figure I.2). As an ordering of late twentieth-century scientific, technological, cultural, social, and political worlds, Haraway's informatics of domination begins as a technical image, theorized through visual description and the chart of transitions.

The chart of transitions is inextricable from a genealogy of authoritative diagrams that comprises actuarial tables, slave ledgers, train times, mortality bills, and other bureaucratic, capitalist, and mercantile forms.⁸ In reference to charts that appear in her other writings, Haraway

Representation	Simulation
Bourgeois novel, realism	Science fiction, post-modernism
Organism	Biotic component
Depth, integrity	Surface, boundary
Heat	Noise
Biology as clinical practice	Biology as inscription
Physiology	Communications engineering
Small group	Subsystem
Perfection	Optimization
Eugenics	Population control
Decadence, *Magic Mountain*	Obsolescence, *Future Shock*
Hygiene	Stress Management
Microbiology, tuberculosis	Immunology, AIDS
Organic division of labor	Ergonomics/cybernetics of labor
Functional specialization	Modular construction
Reproduction	Replication
Organic sex role specialization	Optimal genetic strategies
Biological determinism	Evolutionary inertia, constraints
Community ecology	Ecosystem
Racial chain of being	Neo-imperialism, United Nations humanism
Scientific management in home/factory	Global factory/Electronic cottage
Family/Market/Factory	Women in the Integrated Circuit
Family wage	Comparable worth
Public/Private	Cyborg citizenship
Nature/Culture	Fields of difference
Cooperation	Communications enhancement
Freud	Lacan
Sex	Genetic engineering
Labor	Robotics
Mind	Artificial Intelligence
World War II	Star Wars
White Capitalist Patriarchy	Informatics of Domination

I.2. Donna J. Haraway, informatics of domination chart of transitions, "A Manifesto for Cyborgs: Science, Technology, and Socialist Feminism in the 1980s," *Socialist Review*, no. 80 (1985): 80.

states, "I like the idea of using a truly monological object like a chart, and not some timely fractal design, to figure nonlinear, dynamic relationships."[9] Yet Haraway is also critical of charts, writing, "The chart itself is a traditional little machine for making particular meanings. Not a description, it must be read as an argument, and one which relies on a suspect technology for the production of meanings—binary dichotomization."[10] In this passage, she alludes to the kind of logic one is conditioned to expect from a chart, and to the varied statistical, economic, capitalist, and medical contexts in which such forms are typically encountered. Undeniably, charts, tables, and diagrams have too easily supported and strengthened oppressive power structures and colonial epistemologies of classification and ordering. This noninnocent history makes it tempting to read Haraway's chart of transitions as a fixed snapshot of a period in time, a grid that locks down a set of characteristics, an unredeemable artifact of dominant power structures. Drawing attention to the chart's history as a compromised form, Haraway uses the chart to express a feminist position that simultaneously refuses any simplistic separation from the informatics of domination while also opening up the chart's organizing borders and potential meanings.[11] To use another of Haraway's terms, the chart of transitions could also be deemed a "compound eye," enclosing, yet multiple.[12]

Informatics of Domination embodies Haraway's critical positioning of the chart. In this collection, we take Haraway's chart of transitions as an organizing structure and experimental form for examining the informatics of domination and its mutations into the twenty-first century.[13] Situating the chart within scholarly and artistic genealogies of domination, informatics, white capitalist patriarchy, and the diagrammatic, we ask, how does this chart of transitions offer particular structures for thinking about power in the twenty-first century? And how does the reader's orientation in the chart determine what modes and enactments of power can be thought?

Like all charts, the chart of transitions requires the reader to decide how they will orient themselves and what vectors of reading they will follow.[14] Artist and writer Patricia Reed describes such diagrammatic reading practices as "a labour of navigation."[15] The chart, as a spatiotemporal material apparatus, requires the reader to do this orienting work—to make interpretations about shifts, directionalities, movements, and embodiments. What kinds of relations exist between the left column and the right column, from a term like *representation*

to *simulation*, from *labor* to *robotics*, from *perfection* to *optimization*? Is it a shift from one mode to another, as in a change in epistemes? Or is the relation between terms additive? Where one formerly talked about labor, must one also now consider robotics?[16] Responding to these questions involves apprehending how the chart diagrams multidirectional flows of power—through its terms and also the orientational relations of the reader. How does domination constrict and homogenize subjects? How do subjects act to reinforce or interrupt systems of power? Upon accepting the chart's invitation to orient, the reader ultimately generates meaning with, against, and beyond its contours as they navigate. In this way, the chart is a formal apparatus for generating and asking questions about relations of domination.[17]

While the cyborg—a feminist figure imbricated in networks of techno-scientific patriarchy—has been, and continues to be, considered the major theoretical contribution of "A Manifesto for Cyborgs," we assert that the surprisingly overlooked informatics of domination concept is a remarkably capacious, generative, and vital theoretical tool for our historical present. After all, the cyborg is but one figure—one myth—enduring in the world system that is the informatics of domination. What other figures, myths, stories, and concepts exist in its networks today? To begin answering this question, we define the informatics of domination as a concept that names and situates domination; as a form of power shaped by (but not totalized by) white capitalist patriarchy that manifests through information systems, networks, and computers in the twenty-first century; as a medium-specific analysis of domination's modalities; and as a diagrammatic form that is at once unfinished and inviting.[18]

Domination

Haraway's use of the term *domination* focuses attention on the inflection and influence of patriarchal power on information technologies. Throughout the 1980s and into the 1990s, feminist theory frequently named patriarchal power as "domination." Across a variety of social, political, legal, and philosophical approaches, feminist theorists utilized domination to broadly critique patriarchal power relations, which spanned gender-based oppression, class exploitation, and other aspects of women's lived experiences.[19] Concurrently, feminist science and technology scholars in the 1980s also invoked domination in their

critiques. In her 1982 essay "Feminism and Science," Evelyn Fox Keller linked a "masculinist" impulse in science with the drive to dominate nature: domination mobilized through "male consciousness" not only extended to the subordination of women's participation in research, but to the feminization of nature.[20] Sandra Harding, another key interlocutor of Haraway (whose formulations of feminist standpoint theory and strong objectivity influenced Haraway's theory of situated knowledges), refers to similar problems of "masculine dominance" in science, in *The Science Question in Feminism* (1986).[21] Domination, in the context of feminist science and technology studies at this time, crucially demonstrated that patriarchal power is not only located in the male subject but also embedded in the techno-scientific and nonhuman. In this sense, domination can be considered an antecedent to contemporary discussions of algorithmic bias, extraction, and other computational means of enacting oppression.

Throughout the sex wars of the 1970s and 1980s, feminists debated another kind of domination, namely, that which is practiced in BDSM, including sexual acts of bondage, discipline, dominance, submission, and sadism. Feminists were deeply polarized regarding the ways in which sex impacted women's emancipation. Luminaries in feminist theory, including Andrea Dworkin, viewed BDSM as a form of gender-based violence against women, akin to pornography and rape, that eroticized the unequal power structure between men and women.[22] Gayle Rubin, active in lesbian BDSM groups, argued against such criticisms and insisted that sadomasochism is not inherently patriarchal, cannot be reduced to gender oppression, and can be enjoyed by feminists.[23] Rubin's proto-queer theory of sex demonstrates that desire and pleasure complicate feminist understandings of domination as purely oppressive. We include feminist theoretical engagements with BDSM in our genealogy of domination, not because we seek to answer, once and for all, whether the submissive and dominatrix are oppressed or liberated. Rather, we take a different conclusion: desire and pleasure can be found and enjoyed while being dominated, in sex and in other aspects of life. Consider the pleasurable rush of dopamine someone may experience when posting and interacting on a corporate social media platform, all the while aware that information generated submits them to dynamics of domination, including surveillance, extraction, and commodification.[24]

Many frameworks for naming patriarchal power as domination during the sex wars relied on essentialist, cisgender interpretations

of men and women, as well as the invisibility of whiteness. One notable exception is social theorist Patricia Hill Collins, whose 1990 book *Black Feminist Thought* expanded feminist theorizations of domination through the concept "matrix of domination."[25] Writing to account for the specificity of American Black women's experiences, Collins argues that oppression converges across structural, disciplinary, hegemonic, and interpersonal domains. Fastidious in its analysis of domination as working across not only gender but also race, class, nation, and sexuality, Collins reframes domination through interlocking structures of oppression. We bring Collins's matrix of domination to our engagement with the informatics of domination to more thoroughly account for overlapping forms of domination extending through informatic technologies.

Informatics

Informatics is a concept that, when left to its own devices, likes to give the impression that domination is not part of the picture. The word emerged in the mid-twentieth century from three European terms (*Informatik* [German], *informatique* [French], and *informatika* [Russian]) that name the study of information processing.[26] In the twenty-first century, informatics overlaps with the field of computer science in Europe, while in the United States, the discipline encompasses a range of theoretical and applied approaches to the study, design, and use of information technologies, including—but not limited to—bio-, health, climate, and museum informatics. Across its varied contexts, informatics names the tendency to see the world as data and information: in the medicalized body, the weather, and in the large-scale surveillance of people's movements and interactions with technologies.[27] For example, the School of Informatics at the University of Edinburgh defines informatics as the "study of the structure, behaviour, and interactions of natural and engineered computational systems [where] information is carried at many levels, ranging, for example, from biological molecules and electronic devices through nervous systems and computers and on to societies and large-scale distributed systems."[28] The University of Edinburgh asks whether it will remain "helpful to maintain the distinction between natural and engineered systems," suggesting a world redefined as information.[29] Institutions often present informatics as a "solutionist" technology, in which the informationalization of the world

will inherently make it a better place.[30] The Information School at the University of Washington exemplifies this attitude with their mission statement that informatics is "for the good of people, organizations, and society."[31] Yet, for all their promise, such understandings of informatics fall short in considering the ways in which culture, politics, materiality, and relationality mark and shape information technologies.

Departing from such conceptions, media theorist N. Katherine Hayles describes informatics as the co-shaping process of information technologies and those who use them—which, in later work, she calls *technogenesis*.[32] Drawing on Haraway's informatics of domination, Hayles defines informatics as "the technologies of information as well as the biological, social, linguistic, and cultural changes that initiate, accompany, and complicate their development."[33] Here, Hayles emphasizes informatics as a set of conditions that comprises:

> the material, technological, economic, and social structures that make the information age possible. Informatics includes the following: the late capitalist mode of flexible accumulation; the hardware and software that have merged telecommunications with computer technology; the patterns of living that emerge from and depend on access to large data banks and instantaneous transmission of messages; and the physical habits of posture, eye focus, hand motions, and neural connections that are reconfiguring the human body in conjunction with information technologies.[34]

Each of Hayles's examples shares an understanding of informatics as a term that capaciously and insistently asserts the inextricability of information technologies from their political, material, cultural, and social contexts, that is, a co-shaping connection between embodiment and information. Her sense of informatics as focused on relations between technologies and humans differs from those offered by informatics departments that center information as a universal ontology in the service of social progress. Informatics, for Hayles and Haraway, also brings political questions of address, access, privacy, and consent. Together, they argue that the study of informatics must also ask: To whom is information intelligible, whom and what does it capture and render/represent as information, and who determines the contours of its legibility? These are political questions about distributions of power,

questions that bring us back to the power relations—of humans, world systems, and information technologies—that enact domination.

White Capitalist Patriarchy —— Informatics of Domination

In the final row of Haraway's chart of transitions, *informatics of domination* appears to the right of *white capitalist patriarchy*. Given that informatics of domination also names the section of the essay in which the chart first appears, these two terms can be understood as structuring the entire chart. The positioning of *white capitalist patriarchy* and *informatics of domination* together in this final row upends expected modes of reading charts, in which organizing concepts typically appear in the first row or as superintending titles. The chart's final row, by contrast, presents an exercise in back-reading. The two terms simultaneously have the final word while inviting a reencounter with the previous rows in the chart, which can be considered anew in light of the structuring role of the dyad white capitalist patriarchy —— informatics of domination. We read Haraway's placement of white capitalist patriarchy next to informatics of domination as marking the intimacy between these two terms, rather than indicating an epistemic shift or a conceptual separation.[35] White capitalist patriarchy is not rendered obsolete or replaced, but is instead reproduced in informatic forms of domination. This diagrammatic pairing, then, conveys that white capitalist patriarchy is no less technical or scientific than the informatics of domination (indeed, race and racial capitalism have long been understood as technologies of domination).[36] Likewise, the informatics of domination is no less political than white capitalist patriarchy, given that the informatics of domination emerges from and enacts white capitalist patriarchal power.

Yet white capitalist patriarchy alone does not encompass the full range of modes of power extended by the informatics of domination. Black feminist theorist bell hooks characterized the dominant system of oppression within the United States as "imperialist white-supremacist capitalist patriarchy."[37] hooks's important expansion of white capitalist patriarchy to include imperialism and white supremacy further enumerates interconnected power structures in a way that resonates with the theory of intersectionality; this theory was first conceptualized by critical race and legal scholar Kimberlé Crenshaw to name the multiple

forms of oppression experienced by Black women.³⁸ Intersectional analysis also corresponds with the matrix of domination, which Collins describes as systems of "heteropatriarchy, neocolonialism, capitalism, racism, and imperialism [that] constitute forms of oppression that characterize global geopolitics [and that] take different forms across nation-states, and catalyze social inequality."³⁹ Indeed, Collins has subsequently framed the matrix of domination through intersectionality: "Intersectionality's emphasis on intersecting systems of power suggests that distinctive forms of oppression will each have its own power grid, a distinctive 'matrix' of intersecting power dynamics."⁴⁰ *Informatics of Domination* takes seriously the limits of white capitalist patriarchy as an organizing concept, attending to the ways in which informatic technologies, while structured and bound to white capitalist patriarchy, produce novel modes of domination.⁴¹

Consider code, in all of its informatic as well as noncomputational manifestations. Haraway connects the informatics of domination to the authority given to code: "communications sciences and modern biologies are constructed by a common move—*the translation of the world into a problem of coding*, a search for a common language in which all resistance to instrumental control disappears and all heterogeneity can be submitted to disassembly, reassembly, investment, and exchange."⁴² Counter to many interpretations of this passage as a periodizing diagnosis (the world is now code!), the full context of the original passage is, by our interpretation, satirical. It parrots the perspective of those who, in a "common move," celebrate reductive fantasies of "the world" as singular and homogenous, and who desire a mode of control that is absolute and totalizing. The "common move" manifests in the imagination of a "common language" that would eradicate all resistance and difference—code as a means of total control.⁴³ However, despite this desire for total control and absolute translatability, there is not a singular world, but multiple worlds with much therein that is untranslatable by computer code.⁴⁴

Coding's history reflects this dynamic between a desire for totalizing control and the impossibility of totalization. Coding has been a prevalent mode of ordering worlds long before the emergence of contemporary informatic technologies. This history illuminates that code has functioned as a tool for both control and domination, as well as for resistance, subversion, and dissent. For example, scholars Safiya Noble, Jessica Marie Johnson, and Mark Anthony Neal link computer code to

Black codes, highlighting connections between racist Google algorithms and slave codes.[45] Johnson writes,

> Slave codes were once used to subjugate and control movement, identities, expressions, and access to resources. Placing Black codes in historical context, opens us up to an interrogation of the notion of "codes" as a means of control that apply in multiple material contexts—from the use of public facilities, to unequal education and healthcare, to digital life on the internet. How Black codes, in existence from the eighteenth-century and earlier, re-emerge in everything from slave trade databases to Google algorithms to the appearance of the color black on computer screens impacts what kind of programs, operating systems, and work is created.[46]

In her work on contemporary technologies' reproduction of historic racial discrimination and inequalities through processes of coding, sociologist Ruha Benjamin describes codes as "operat[ing] within powerful systems of meaning that render some things visible, others invisible, and create a vast array of distortions and dangers."[47] Highlighting these dangers, her concept of the New Jim Code describes how contemporary technologies reproduce older forms of racial discrimination under the guise of objectivity. These considerations of code and its Black histories also underscore that code takes on different material instantiations. For instance, code can be a series of embodied gestures, such as the look a face gives to say "'Don't walk all over me,'" or it can materialize as a complex craft practice, as in the case of Hawaiian flag quilts as coded political symbols of sovereignty.[48] Code depends mutually on processes of writing and reading code, as well as interpreting context. Take code-switching, in which minoritized people shift their modes of sociality in different situations. For example, Black people may speak differently in Black spaces than in predominantly white spaces, and queer, trans, and nonbinary persons may alter their voice, gender presentation, and mannerisms as survival strategies to pass in airports, classrooms, and hospitals.

Code can also grant agency and aid in struggles for the liberation of oppressed peoples. For example, handkerchief codes, popularized in the 1970s, were predominantly used by gay and queer men to signal sexual preferences and fetishes, enabling the existence of sexual subcultures. In artist and theorist micha cárdenas's work, "algorithmic

analysis" is a practice-based theoretical tool that includes "the creation of new algorithms, in functional computer programming languages, pseudocode, or code poetry" in art and poetics, with the aim to empower as well as protect queer and trans people of color.[49] In this spirit, artist Zach Blas created *transCoder: Queer Programming Anti-Language* (2008), an artwork that crosses a software development kit with code poetry and queer theory, in order to conjure a computational queerness that can be used to construct new worlds.[50] Together, these examples evidence that the stakes of attending to code are enmeshed with profound considerations of power. Geographer Sarah Elwood's intersectional feminist engagement with code makes this clear: "Much Black, queer/trans, and feminist code studies starts from the proposition that in spite of structural conditions aligned to ensure exclusion and death, these subjects are always also surviving and creatively intervening to catalyze possibilities for life and liberation."[51] Indeed, problems and potentialities of coding abound. For whom is the world a problem to be solved through coding?[52] Whose worlds are construed as a problem to be solved through the eradication of resistance and difference? Whose worlds, by their mere existence, attest to the impossibility of computer code as "a common language in which all resistance to instrumental control disappears and all heterogeneity can be submitted to disassembly, reassembly, investment, and exchange"? These questions animate our engagement with Haraway's chart and its diagrammatic form.

Situating the Diagram

We connect the chart of transitions to a genealogy of practices that use diagrams to understand power relations.[53] In this genealogy, we find particular promise in diagrams that hold openness—of thought, of the future, and of the potential for different configurations of power—as a guiding principle. Here, the diagram is not a mode of capture or containment, but always a starting point for something beyond itself.[54] Reed, for example, imagines diagramming as

> the navigation of what *could be* in the face of *what is*, for *what is* demarcates a zone of epistemic certainty that supports a particular logic of the world, foreclosing on alternative structural possibilities. Navigating the *could be* requires the creation of a diagramme for the inexistent, it is the articulation of a new

territory of logic unbound to the actual imperatives of the current landscape whose coordinates seem to have calcified our very imaginations, to the exception of cataclysmic narratives.[55]

The chart of transitions evokes Reed's sense of the *could be*. Even though the chart may appear to focus only on the *what is*, the chart's attentiveness to transitions accentuates the forces of change that are inherent to each of its terms, within and beyond the informatics of domination. Thus, the chart finds common cause with other diagrammatic engagements steeped in resistant histories, struggling for the inexistent and the yet-to-be. For example, sociologist and civil rights leader W. E. B. Du Bois's data visualizations from the turn of the twentieth century use bold contrasting colors and unusual bends or swirls of lines to animate a body of African American socioeconomic data, to expose racial inequality but also to spur equal rights and end racial segregation.[56] In 2020, the organization Stop LAPD Spying Coalition and the Free Radicals collective introduced their Algorithmic Ecology, an abolitionist tool for diagrammatically analyzing contemporary algorithms' broader ecologies of power. They used this tool to analyze the Los Angeles Police Department's use of predictive policing software, which disproportionately targeted Black and Indigenous communities, and to envision a world without police surveillance.[57]

We consider the chart of transitions to be a "feminist diagram," as defined by queer and feminist studies scholar Sam McBean. McBean's concept articulates charts and diagrams as theorizations of patriarchal power relations that simultaneously hold open the potentiality of reconfiguration:

> Diagrams seem to attempt to bridge these two temporalities—on the one hand they seem to be about explaining things as they are. Yet, on the other hand, feminist theory's diagrams and diagrammatic imaginaries are not just about observing the state of things. Feminist theory's diagrams aim to shift and challenge power relations; they straddle "the way things are" and a future that might be different.[58]

This work of observing, explaining, and worlding as straddling, rather than contradicting, echoes throughout the genealogy of diagrams in feminist theory McBean traces: feminist activist and writer Ti-Grace

Atkinson's charts map patriarchal power relations while also strategizing a feminist revolution that would radically overthrow these relations; queer Chicana feminist Gloria Anzaldúa's pedagogical drawings explain, for example, the relation between colonized peoples and colonizers; and feminist writer and activist Shulamith Firestone's diagram plots avenues toward cultural, economic, and sexual revolutions.[59] Across these instances, McBean frequently uses "mapping" to describe the work of feminist diagrams. Given that maps are intimately tied to colonial conquest, McBean aligns here with Haraway's feminist insistence on using noninnocent tools to chart toward the *could be*.

McBean also includes in this feminist genealogy a "diagrammatic imaginary," which includes visual metaphors and imagery that conceptually invoke diagrams, as in the work of Crenshaw (intersectionality), feminist writer and poet Adrienne Rich (lesbian continuum), and gender studies scholar Judith Butler (heterosexual matrix).[60] The informatics of domination can also be understood as a diagrammatic imaginary in this sense, through Haraway's use of diagrammatic language to describe the concept as "scary new networks."[61] While the diagrams and imaginaries in McBean's genealogy of feminist theory vary widely in form and style, they share with the chart of transitions a commitment to mapping power and to affirming openness.

The varied publication history of the chart of transitions exhibits principles of diagrammatic practices we have considered throughout this introduction: navigation, orientation, and openness. Different versions of the chart have been published since its first printing in 1985: its reprinting as "A Cyborg Manifesto: Science, Technology, and Socialist-Feminism in the Late Twentieth Century," as well as a modified presentation with different entries in its rows in the chapter "The Biopolitics of Postmodern Bodies: Constitutions of Self in Immune System Discourse," both in *Simians, Cyborgs, and Women: The Reinvention of Nature* (1991); to an altered diagrammatic display in the 2016 republication of "A Cyborg Manifesto" in *Manifestly Haraway*.[62] There are minute but significant formal differences across these versions.[63] In the original 1985 printing, two columns and thirty-two lines separated by negative, white space are displayed on one page (figure I.2). In the 2016 edition of "A Cyborg Manifesto," the overall spacing changes, where the chart sprawls across three pages instead of two (figures I.3–I.5). This publication also introduces two column headings, "Organics of Domination" and "Informatics of Domination," which are separated

by arrows (>) that move the reader from a term in the left column to its corresponding term in the right column—perhaps an unintentional echo of Dominguez's use of ">" in *Virtual Timeline*. Such variations to the chart of transitions demonstrate its openness to modification, that it was never sedimented in a fixed form.

Haraway's and Dominguez's charts employ ">" to articulate relationality, but in this collection, we have created the symbol: "———." Not to be confused with the em dash, the "———" can be understood as an edge in graph theory, which is a mathematical approach used in network science to diagram networks. Here, an edge is a link or connection between two points. (Points are also referred to as nodes or vertices.) Given Haraway's description of the informatics of domination as "scary new networks," we approach the chart of transitions as a diagram of networks. Like the monological chart, diagrams of networks based on graph theory are another "suspect technology for the production of meanings" and can exclude agency, diachronicity, complexity, and materiality in the formation and functioning of networks.[64] Aware of these limitations, we employ edges, represented by "———," to think with and add to the chart of transitions. From our point of view, "———" is a symbol that holds diagrammatic space for openness, navigation, and orientation, not only for the authors in the collection but also for its readers. "———" indicates that terms have relationality, but it does not overdetermine the nature of relation.

Organics of Domination		Informatics of Domination
representation	>	simulation
bourgeois novel, realism	>	science fiction, postmodernism
organism	>	biotic component
depth, integrity	>	surface, boundary
heat	>	noise
biology as clinical practice	>	biology as inscription

physiology	>	communications engineering
small group	>	subsystem
perfection	>	optimization
eugenics	>	population control
decadence, *Magic Mountain*	>	obsolescence, *Future Shock*
hygiene	>	stress management
microbiology, tuberculosis	>	immunology, AIDS
organic division of labor	>	ergonomics, cybernetics of labor
functional specialization	>	modular construction
reproduction	>	replication
organic sex role specialization	>	optimal genetic strategies
biological determinism	>	evolutionary inertia, constraints
community ecology	>	ecosystem
racial chain of being	>	neoimperialism, United Nations humanism
scientific management in home/factory	>	global factory/electronic cottage industry
family/market/factory	>	women in the integrated circuit
family wage	>	comparable worth
public/private	>	cyborg citizenship
nature/culture	>	fields of difference
cooperation	>	communications enhancement

Freud	>	Lacan
sex	>	genetic engineering
labor	>	robotics
mind	>	artificial intelligence
World War II	>	Star Wars
white capitalist patriarchy	>	informatics of domination

Transitions from the comfortable old hierarchical dominations to the scary new networks of informatics of domination.

I.3–I.5. Donna J. Haraway, informatics of domination chart of transitions, "A Cyborg Manifesto: Science, Technology, and Socialist-Feminism in the Late Twentieth Century," in *Manifestly Haraway* (Minneapolis: University of Minnesota Press, 2016), 28–30.

We also consider the chart's background: a blank, white, unmarked page. Network science attends only to edges and vertices, links and nodes. But space around edges and vertices is not empty; rather, it is all that is not accounted for by the network form. Media theorist Ulises Ali Mejias describes this as the "paranodal ... the space that lies beyond the topological and conceptual limits of the node. This space is not empty but inhabited by multitudes that do not conform to the organizing logic of the network."[65] Paranodal space may be outside of networks, but it directly impacts the relationalities of nodes (terms in the chart), as well as the ways in which they link. The paranodal is all that surrounds them. Similarly, a feminist ecological perspective might insist that environments are not neutral backgrounds, yet channel a variety of nonhuman agencies. What kind of milieu makes a particular interpretation of the chart possible? Or, put differently, what kind of environmental imaginaries make their ways into feminist diagramming practices?[66] *Informatics of Domination* engages with the chart's background—its paranodal space, its environment—across the written entries, many of which account for that which exceeds being diagrammable by the network form.

We approach the chart of transitions—its columns, rows, paranodal space, and milieu—as a feminist diagram committed to situatedness. After all, in Haraway's *Simians, Cyborgs, and Women*, "A Cyborg Manifesto" sits right next to the essay "Situated Knowledges: The Science Question in Feminism and the Privilege of the Partial Perspective." Situated knowledges are embodied forms of objectivity, anathema to conceptions of scientific objectivity that are defined by their unlocatability, otherwise known as "the view from ... nowhere" or "the god trick."[67] Haraway describes situated knowledges as feminist objectivity—modes of noninnocent, "power-sensitive" conversation between embodied, agential subjects and objects of knowledge.[68] This approach to the production, meaning, and reception of knowledge accounts for how one's positionality and orientation shape questions of power and access, as well as the value forms and sources of knowledge take. Situatedness is a feminist practice of being responsible for one's point of view and accepting that one's position is always partial, never omniscient. In "Situated Knowledges," Haraway presents another two-column chart:

> But a dichotomous chart misrepresents in a critical way the positions of embodied objectivity which I am trying to sketch. The primary distortion is the illusion of symmetry in the chart's dichotomy, making any position appear, first, simply alternative and, second, mutually exclusive. A map of tensions and resonances between the fixed ends of a charged dichotomy better represents the potent politics and epistemologies of embodied, therefore accountable, objectivity.[69]

Although this passage may seem to suggest that Haraway is, in fact, arguing against thinking with dichotomous charts (recall that Haraway also refers to the terms in the chart of transitions as "dichotomies"), we see her as suggesting something else. Haraway claims that "a map of tensions and resonances"—more complex, embodied, and objective than dichotomies—emerges from the chart precisely through the careful practice of situating, that is, orienting one's thinking with the chart in relation to one's positionality and partiality. Here, situated engagements with charts are ultimately about learning how to establish and reflect upon one's point of view through the individual reader's efforts and pleasures in constructing connections between elements. Situatedness, then, is necessary to read feminist diagrams.

Haraway writes that any situated engagement with charting must come to terms with the imbrications of the subject and object of knowledge, what she terms "the apparatus of bodily production."[70] A subject does not maintain a dispassionate, neutral relation to its object of analysis; it affects the object directly. Thus, an object of knowledge is not passive but also has agency that impacts the subject doing the studying. Together, subject and object exist in a coagential, embodied meaning-making process. Feminist theorist and physicist Karen Barad expands on Haraway's apparatus of bodily production with the powerful articulation—based on her practice as a quantum physicist—that we are all entangled with our apparatuses of knowing, but to distinguish self from apparatus or other is to enact what Barad calls an "agential cut," a linguistic and cognitive/epistemological separation that creates a boundary.[71] The positionality of the observer always matters in relation to the apparatus, where both belong to a particular phenomenon—a phenomenon that demands a certain delicacy. In a way, Haraway's chart of transitions creates a series of agential cuts across the informatics of domination. These agential cuts enacted by the chart invite readers to examine their own situatedness—their own points of view—in relation to the informatics of domination and to the various terms that constitute the chart. At the same time, the chart also invites readers to make new agential cuts.

The *Oxford English Dictionary* instructs that the etymology of the word "diagram" is of multiple origins, spanning French, Latin, and Greek, with meanings that include "that which is marked out by lines, a geometrical figure, written list" and "draw, draw out, write in a register, . . . to write."[72] This etymological definition crucially highlights that diagrams span text as well as nonlinguistic visual marks.[73] As such, we situate the chart of transitions within a context of visual art, in addition to theory and scholarship. Across different art historical periods, movements, and styles, an abundance of diagrammatic visual artworks aim to understand power relations, like feminist theory's diagrams. Visual art, however, draws attention to the ways in which diagrams can be composed not only of words but also shapes, lines, and marks via a range of compositional techniques, including drawing, painting, collage, graphic design, and 3D modeling. It is no surprise that Dominguez—an artist—experimented with Haraway's chart, as the diagrammatic is not only a conceptual or intellectual engagement but a process of formalization that is also aesthetic, which we understand as modalities that enable

perceptions of the sensible.[74] In diagrammatic visual art, making and interpreting diagrams requires an aesthetic attunement beyond the linguistic, an awareness that diagrammatic forms make meaning sensible through visual, spatial, and temporal logics, as well as through language.

For instance, in the 1990s, neo-conceptual artist Mark Lombardi drew a series of diagrams in pencil named *Narrative Structures* (1994–2000).[75] Employing link analysis, a technique from network theory that assesses relationships between nodes, Lombardi traced spheres of political power and influence that accumulated in drawings featuring lines with arrows (edges) that made apparent corruptions and abuses of power, including connections between former US president George W. Bush and founder of Al-Qaeda Osama bin Laden (nodes). Importantly, it is not the names of peoples, companies, and governments written on Lombardi's diagrams that tell his stories of power; rather, it is the penciled lines and circles, edges and nodes, that visualize relations and make narratives. Diagrams in visual art can also be three-dimensional. American Artist's sculpture *Veillance Caliper (Annotated)* (2021) uses wood and other materials to spatialize vectors of surveillance and Black resistance.[76] The artwork takes up surveillance studies scholar Simone Browne's "dark sousveillance," a Black mode of not being seen.[77] Dark sousveillance is a diagrammatic concept that troubles computer science engineer Steve Mann's "Veillance Plane," a diagram that maps modes of looking.[78] In his diagram, Mann introduces "sousveillance," which names acts of looking by those in subjugated positions.[79] Artist highlights that "Browne critiques Mann's model of veillance saying that the tactics of remaining 'out of sight' employed by enslaved Africans engineered a truly unique form of sousveillance. A form that she calls 'dark sousveillance' that blows Mann's plane apart, because it requires at least a third dimension to become legible."[80] To inhabit this third dimension, *Veillance Caliper (Annotated)* takes shape as a hybrid of wooden planks and a human-sized caliper, which is an instrument for measuring the dimensions of an object (or here, a subject). On its diagrammatic axes, handwritten labels are featured, including indicators for "dark sousveillance," "racially saturated," "CCTV," and "copwatch," which tag and situate the three-dimensional veillance vectors in relation to Black oppression and resistance. Artist, through sculpture and scale, heightens the embodied encounter with diagrammatics of veillance, in order to make dark sousveillance take up space and be felt. Artworks like *Narrative Structures* and *Veillance Caliper (Annotated)*

establish that thinking and experimenting diagrammatically encourages relations between art and theory, which we actively cultivated in our editorial approach to the chart of transitions.

The Chart as Invitation

We have taken the chart of transitions—open and inviting—as a table of contents for this collection in order to generate a set of new writings. We offered the rows of the chart as prompts to a range of contributors—artists, scholars, curators, and creative writers—welcoming them to explore how the concepts in their given row resonate in the historical present. We gave contributors the opportunity to interpret the relationship between the terms in their row as they saw fit. As a result, some entries periodize, some speculate, and some offer sustained experimentations with form. Some entries interrogate the present through the lens of a single term, while others chart an epistemic shift between the original two terms or examine their dialectical relationship. Other entries introduce a third term that better addresses some aspect of the twenty-first century. Still other entries use the conceptual tension of their row as an occasion to trace the possible, the dystopic, and the desirable. For this collection, the chart exists as both an organizing structure and conceptual architecture to think with, to test, multiply inhabited and transformed by a variety of expressive forms—essays, fictions, poetry, conversations.

To emphasize the malleability of the chart and its co-constitutive outside, we have added additional elements to the structure of our collection. As a formal transition between the physical outside of the book covers and its contents, we commissioned a series of diagrams by Patricia Reed that plots epistemologies of information and explores their relations. We have also multiplied the final row of the chart—"white capitalist patriarchy —— informatics of domination"—seven times and dispersed these entries across the collection. We hope that this intentional proliferation of the final row has the effect of diffusing and refracting white capitalist patriarchy and the informatics of domination throughout the collection, rather than carrying a kind of structural weight at the end of the collection. The volume concludes with an afterword by Donna Haraway, in which she considers her chart of transitions decades after its original conception.

We encourage you to orient yourself within the collection as you would within the chart—to enjoy the pleasures and navigational labors

of flipping through the pages, jumping across entries, tracing unauthorized relations, envisioning the *could be*. Our chart of transitions, in its diagrammatic theorization of the informatics of domination, is activated by your very reading. The chart is useful but nonteleological, informative but nonprescriptive, remaining steadfastly open to uncharted iterations of domination and informatics structuring the present, to future mutations yet to come, and to struggles against the informatics of domination.

Notes

1. Ricardo Dominguez, *Virtual Timeline*, 1997, https://www.thing.net/~rdom/VRtime.html.

2. On Rhizome's ArtBase archive, Dominguez states, "Use the timeline as a launch pad for surfing the web.... *VRTimeline* was an attempt to teach myself tables and JavaScript in 1996. It was also an attempt to push a post-(e)-pedagogy that would map our current condition in view of the past and some possible futures." See Ricardo Dominguez, *Virtual Timeline*, 1997, Rhizome / ArtBase, accessed March 10, 2024, https://artbase.rhizome.org/wiki/Q4149.

3. Philosopher Gilles Deleuze theorizes the virtual as "opposed not to the real but to the actual. *The virtual is fully real in so far as it is virtual.* Exactly what Proust said of states of resonance must be said of the virtual: 'Real without being actual, ideal without being abstract.'" Thus, the virtual can be understood as the real potentialities of the actual. See Gilles Deleuze, *Difference and Repetition* (New York: Columbia University Press, 1994), 208. "Rhizomatics" in *Virtual Timeline* also comes from Deleuze. The "rhizome" is a term he developed with psychoanalyst and philosopher Félix Guattari to conceptualize a structure of multiplicities. See Gilles Deleuze and Félix Guattari, "Introduction: Rhizome," in *A Thousand Plateaus: Capitalism and Schizophrenia* (Minneapolis: University of Minnesota Press, 1987), 3–25.

4. See Colin Milburn, "The Horrors of Goo," in *Nanovision: Engineering the Future* (Durham, NC: Duke University Press, 2008), 111–60.

5. Ricardo Dominguez, email to Zach Blas, November 6, 2023. Dominguez also revealed that he created variations of *Virtual Timeline*: "The first version I did was part of a CAE [Critical Art Ensemble] and x-communication project where we printed a handmade booklet entitled *Total Disaster* in the middle of a very cold winter in an anarchist village named Dream Time Village ... in about 1989 I think.... Then I made ... an on-line gesture, was in an early online show that Alex Galloway and Mark America curated back around '97 or so (*HTMLConceptualism*)." On the Rhizome / ArtBase archive, Dominguez identifies yet another version of his chart, which he describes as "presented as a very large wall drawing (1993) under which I would stand, point, and discuss with whomever drifted by and asked a question about it." See Dominguez, *Virtual Timeline*, Rhizome / ArtBase.

6. Donna J. Haraway, "A Manifesto for Cyborgs: Science, Technology, and Socialist Feminism in the 1980s," *Socialist Review*, no. 80 (1985): 82.

7. Haraway, "A Manifesto for Cyborgs" (1985), 79–80.

8. On slave ledgers, see Jessica Marie Johnson, "Markup Bodies: Black [Life] Studies and Slavery [Death] Studies at the Digital Crossroads," *Social Text*, no. 137 (2018): 57–79. On mortality bills, see Jacqueline Wernimont, *Numbered Lives: Life and Death in Quantum Media* (Cambridge, MA: MIT Press, 2018). The chart also evokes a related genealogy of the grid. In the writings of philosopher Michel Foucault, lush diagrammatic language prioritizes the grid as a diagrammatic conceptualization for classification and order: grids of identities, language grids, grids of analysis, grids of kinship, thought grids, perceptual grids, and grids of specification. For instance, in *The History of Sexuality*, vol. 1, Foucault describes "a whole grid of observations regarding sex" coming into discourse during the seventeenth century. Michel Foucault, *The History of Sexuality*, vol. 1: *The Will to Knowledge* (London: Penguin, 1998), 26. See also Michel Foucault, *The Order of Things: An Archaeology of the Human Sciences* (New York: Vintage, 1994); and Michel Foucault, *The Archaeology of Knowledge and the Discourse on Language* (New York: Pantheon, 1972). Art historian Rosalind Krauss explains that the grid is the form that declares "the modernity of [western] modern art" (50). Krauss argues that while the grid is ubiquitous in art of the twentieth century, it appears "nowhere, nowhere at all" (52) in artworks of the previous century. The grid in modern art is viewed as "antinatural, antimimetic, antireal" (50), according to Krauss, as its organization is not one of imitation but of its own "aesthetic decree" (50). Krauss continues, "although the grid is certainly not a story, it *is* a structure, and one, moreover, that allows a contradiction between the values of science and those of spiritualism to maintain themselves within the consciousness of modernism, or rather its unconscious, as something repressed" (55). Rosalind Krauss, "Grids," *October* 9 (Summer 1979): 50–64. In this collection, we do not regard the grid, or other diagrammatic forms, as autonomous from broader histories and contexts (in the West and beyond) of power.

9. Donna J. Haraway, "Universal Vampires in a Donor Culture," in *Modest_Witness@Second_Millenium.FemaleMan©_Meets_Oncomouse™* (New York: Routledge, 1996), 231.

10. Donna J. Haraway, "The Biopolitics of Postmodern Bodies: Constitutions of Self in Immune System Discourse," in *Simians, Cyborgs, and Women: The Reinvention of Nature* (New York: Routledge, 1991), 209.

11. In "A Manifesto for Cyborgs," Haraway gives the figure of the cyborg a similar feminist recasting: "The main trouble with cyborgs, of course, is that they are the illegitimate offspring of militarism and patriarchal capitalism, not to mention state socialism. But illegitimate offspring are often exceedingly unfaithful to their origins." See Haraway, "A Manifesto for Cyborgs" (1985), 68.

12. On "compound eyes," see Donna J. Haraway, "Crittercam: Compounding Eyes in Naturecultures," in *When Species Meet* (Minneapolis: University of Minnesota Press, 2008), 249–66; Donna J. Haraway, "Situated Knowledges: The Science Question in Feminism and the Privilege of the Partial Perspective," *Feminist Studies* 14, no. 3 (Autumn 1988): 538.

13. See Zach Blas, "Informatics of Domination: A Lecture Series Organized and Introduced by Zach Blas," *e-flux Conversations*, January 18, 2017, https://conversations.e-flux.com/t/informatics-of-domination-a-lecture-series-organized-and-introduced-by-zach-blas/5890.

14. On oriented knowledge, see Sara Ahmed, *Queer Phenomenology: Orientations, Objects, Others* (Durham, NC: Duke University Press, 2006); Melody Jue, *Wild Blue Media: Thinking through Seawater* (Durham, NC: Duke University Press, 2020), 1–11, 80–87.

15. Patricia Reed, "Diagramming the Common," April 23, 2014, https://www.aestheticmanagement.com/wp-content/uploads/2014/05/reed_diagramming_the_common.pdf. A lecture with diagrams given at the KunstAllmend (Artistic Commons) Symposium at Dampfzentrale, Bern, Switzerland; quoted with Reed's permission.

16. For an argument about the formative links between labor and robotics, see Jennifer Rhee, *The Robotic Imaginary: The Human and the Price of Dehumanized Labor* (Minneapolis: University of Minnesota Press, 2018).

17. Periodization is yet another way to read the chart of transitions. In *Protocol: How Control Exists after Decentralization*, media theorist Alexander R. Galloway describes this method as "theorizing the present historical moment and . . . offering periodizations to explain its historical trajectory" (3). Citing political philosopher Michael Hardt and feminist theorist Kathy Weeks, Galloway further notes that "'*periodization is an initial technique that opens the path and allows us to gain access to history and historical differences*'" (20). Galloway points out numerous theoretical concepts that can be deemed acts of periodization: Michel Foucault's "disciplinary societies" as the historical shift after sovereignty; Deleuze's "control societies" as that which follows disciplinary societies; media theorist Friedrich Kittler's articulation of the years 1800 and 1900 as marking different "discourse networks"; Marxist economist and theorist Ernest Mandel's "late capitalism" as economic expansion post–World War II; sociologist Manuel Castells's "network society" as signaling transformations wrought by globalization and the internet; and Hardt and political philosopher Antonio Negri's "Empire" as world order at the start of the twenty-first century. Galloway continues, "Periodization theory is a loose art at best and must take into account that, when history changes, it changes slowly and in an overlapping, multilayered way, such that one historical moment may extend well into another, or two moments may happily coexist for decades or longer. For instance, in much of the last hundred years, *all three social phases described earlier [classical, modern, and postmodern eras] existed at the same time* in the United States and elsewhere. To paraphrase William Gibson: The future is already here, but it is not uniformly distributed across all points in society. At best, periodization theory is an analytical mindgame, yet one that breathes life into the structural analyses offered to explain certain tectonic shifts in the foundations of social and political life" (27). See Alexander R. Galloway, *Protocol: How Control Exists after Decentralization* (Cambridge, MA: MIT Press, 2006). Galloway has also created charts of transitions, based on periodization, inspired by Donna Haraway. See "Periodization Map" (27) and "Control Matrix" (114–15) in *Protocol*. With theorist Eugene Thacker, see "the transition from the present day into the future" chart (100–101); Alexander R. Galloway and Eugene Thacker, *The Exploit: A Theory of Networks* (Minneapolis: University of Minnesota Press, 2007). Marxist political theorist and literary scholar Fredric Jameson, an adherent of periodization, puts it plainly: "We cannot not periodize." Fredric Jameson, *A Singular Modernity: Essay on the Ontology of the Present* (London: Verso, 2012), 29. Notably, periodization differs from our editorial approach to the chart of transitions, as it is a methodology that does not adequately account for how the reader's orientation produces meaning.

18. On medium-specific analysis, see N. Katherine Hayes, *Writing Machines* (Cambridge, MA: MIT Press, 2002).

19. Feminist philosopher Amy Allen argues that feminist conceptions of domination popularized during second-wave feminism described male forms of oppression, or "male supremacy," and enabled women to focus on "power-over relations," that is, the domination of men over women. See Amy Allen, "Feminist Perspectives on Power," in *The Stanford Encyclopedia of Philosophy*, October 28, 2021 (substantive revision), https://plato.stanford.edu/archives/fall2022/entries/feminist-power/. Scholar Jennifer Einspahr also explains that second-wave feminists "place patriarchal power relations—the system of male domination and women's subordination—at the centre of analysis" (2). Einspahr highlights that domination is a mode of structural critique, "understanding patriarchy as a structure of male domination" (1). See Jennifer Einspahr, "Structural Domination and Structural Freedom: A Feminist Perspective," *Feminist Review* 94 (2010): 1–19. Red-

stockings, a radical feminist nonprofit organization, further clarifies this feminist definition of domination: "We identify the agents of our oppression as men. Male supremacy is the oldest, most basic form of domination." See Redstockings Collective, "Redstockings Manifesto," *Redstockings*, July 7, 1969, https://www.redstockings.org/index.php/rs-manifesto. Notably, for much of second-wave feminist thought, the category of "woman" only pertained to cisgender women. Einspahr points out that with the emergence of third-wave feminism in the 1990s, the appeal of domination as a term of critique waned, citing a growing disinterest in structural critiques of power: "When power relations are understood to function in subtle and insidious ways, the usefulness of such a blunt concept of 'domination' is called into doubt." Einspahr, "Structural Domination and Structural Freedom," 2.

20. Evelyn Fox Keller, "Feminism and Science," *Feminist Theory* 7, no. 3 (Spring 1982): 589–602. Similar to other second-wave feminists, Keller utilizes essentialist formulations of gender. She defines masculinity as a "gender trait" (595) and posits its cultural definition as "that which can never appear feminine" (595). As such, the qualities of masculinity can only be found in cisgender men, and this particular gender trait supports an "impulse towards domination" (596), further exacerbated by cultural understandings of nature as feminine.

21. Sandra Harding, *The Science Question in Feminism* (Ithaca, NY: Cornell University Press, 1986), 80.

22. See Andrea Dworkin, *Women Hating* (New York: E. P. Dutton, 1974); and Robin Ruth Linden, Darlene R. Pagano, Diana E. H. Russell, and Susan Leigh Star, eds., *Against Sadomasochism: A Radical Feminist Analysis* (San Francisco: Frog in the Well, 1982).

23. See Gayle S. Rubin, "Thinking Sex: Notes for a Radical Theory of the Politics of Sexuality," in *The Gay and Lesbian Studies Reader*, ed. Henry Abelove, Michele Aina Barale, and David M. Halperin (New York: Routledge, 1993), 31–79. Rubin cofounded a lesbian feminist BDSM organization named Samois, which takes its name from Samois-sur-Seine, the estate of Anne-Marie, who is a lesbian dominatrix in the novel *The Story of O* (1954). Samois was located in San Francisco and active between 1978 and 1983.

24. See Zach Blas, *SANCTUM*, 2018, https://zachblas.info/works/sanctum/. The immersive media installation "identifies a distorted reimagining of the power dynamics of BDSM at the heart of contemporary surveillance: an opulent display of desire and capture, exposure and punishment, dominance and submission."

25. See Patricia Hill Collins, *Black Feminist Thought: Knowledge, Consciousness, and the Politics of Empowerment* (New York: Routledge, 1990).

26. *Oxford English Dictionary*, s.v. "information," accessed March 10, 2024, https://www.oed.com/dictionary/information_n.

27. As scholar of literature and science Bruce Clarke helpfully historicizes, "The 'decoding' of DNA happened to coincide historically with the unfolding of information theory, and the metaphor of 'genetic information' promoted the conviction that information was the skeleton key with which to open up the remaining secrets of matter, energy, and life." Bruce Clarke, "Information," in *Critical Terms for Media Studies*, ed. W. J. T. Mitchell and Mark B. N. Hansen (Chicago: University of Chicago Press, 2010), 137.

28. School of Informatics, "What Is Informatics?," University of Edinburgh, accessed March 10, 2024, https://www.ed.ac.uk/sites/default/files/atoms/files//what20is20informatics.pdf.

29. School of Informatics, "What Is Informatics?"

30. See Evgeny Morozov, *To Save Everything, Click Here: The Folly of Technological Solutionism* (New York: PublicAffairs, 2013).

31. Information School, "Informatics," University of Washington, accessed March 10, 2024, https://ischool.uw.edu/programs/informatics.

32. See N. Katherine Hayles, *How We Think: Digital Media and Contemporary Technogenesis* (Chicago: University of Chicago Press, 2012).

33. N. Katherine Hayles, *How We Became Posthuman: Virtual Bodies in Cybernetics, Literature, and Informatics* (Chicago: University of Chicago Press, 1999), 29. This definition bypasses the sense of automation present in the French and German definitions of informatics through folding in an accounting of social forces.

34. Hayles, *How We Became Posthuman*, 313n4.

35. In Haraway's 1988 essay "Situated Knowledges: The Science Question in Feminism and the Privilege of Partial Perspective," she writes, "'White Capitalist Patriarchy' (how may we name this scandalous Thing?)" Published three years after "A Manifesto for Cyborgs," "Situated Knowledges" exhibits Haraway continuing to think with white capitalist patriarchy, questioning how to name it after she had already reconceptualized it as the informatics of domination. This instance further illustrates that the informatics of domination is not simply that which comes after white capitalist patriarchy. Donna J. Haraway, "Situated Knowledges: The Science Question in Feminism and the Privilege of Partial Perspective," in *Simians, Cyborgs, and Women: The Reinvention of Nature* (New York: Routledge, 1991), 197.

36. For example, see Ruha Benjamin, *Race after Technology: Abolitionist Tools for the New Jim Code* (New York: Polity Press, 2019); and Wendy Hui Kyong Chun, "Race and/as Technology; or, How to Do Things with Race," *Camera Obscura* 24, no. 1 (2009): 7–35.

37. bell hooks, *The Will to Change: Men, Masculinity, and Love* (New York: Washington Square Press, 2004), 17.

38. See Kimberlé Crenshaw, "Demarginalizing the Intersection of Race and Sex: A Black Feminist Critique of Antidiscrimination Doctrine, Feminist Theory and Antiracist Politics," *University of Chicago Legal Forum* 1 (1989): 139–67; and Kimberlé Crenshaw, "Mapping the Margins: Intersectionality, Identity Politics, and Violence against Women of Color," *Stanford Law Review* 43, no. 6 (July 1991): 1241–99.

39. Patricia Hill Collins, *Intersectionality as Critical Social Theory* (Durham, NC: Duke University Press, 2019), 239.

40. Collins, *Intersectionality as Critical Social Theory*, 239.

41. The enmeshment of white capitalist patriarchy with informatics of domination, as well as with wider ranges of interlocking structures of oppression, is reflected throughout the entries, including the seven entries titled "White Capitalist Patriarchy —— Informatics of Domination."

42. Haraway, "A Manifesto for Cyborgs," (1985), 83.

43. The "common move" Haraway describes conceives of translation as a totalizing and automatable process rather than an artistic and poetic practice. While some scientists are cautious about the incommensurability of datasets, given the nonfungibility of data across different contexts, the fantasy of code as a universal language broadly persists. For example, the School of Information Sciences at the University of Illinois at Urbana-Champaign writes that informatics, itself a science of coding, "uses computation as a

universal tool to solve problems in other fields." School of Information Sciences, "What Is Informatics?" University of Illinois at Urbana-Champaign, accessed March 10, 2024, https://informatics.ischool.illinois.edu/home/what-is-informatics/.

44. The tension between translatability and untranslatability of code in Haraway's formulation relates to debates on the uncomputable. Mathematician and computer scientist Alan Turing's theorization of computable numbers is a popular—if not the dominant—model for defining computability in the twentieth century. According to Turing, "The 'computable' numbers may be described briefly as the real numbers whose expressions as a decimal are calculable by finite means." A. M. Turing, "On Computer Numbers, with an Application to the Entscheidungsproblem," *Proceedings of the London Mathematical Society* 2, no. 42 (1936): 230. Pointing to the limits of Turing's theory of computability, media scholar Jacob Gaboury argues that queerness, when thought of as a methodology to engage the computational, is external to it: "we might identify a queer computing—outside the imperative of successful communication. It is those forms of computation that fail, break down, recur, and run forever, and models of computing that are outside of or beyond so-called 'universal' Turing computation—that is, those processes which disappear or recede from computational forms of knowing." Jacob Gaboury, "On Uncomputable Numbers: The Origins of Queer Computing," *Media-N* 9, no. 2 (Summer 2013), https://median.newmediacaucus.org/caa-conference-edition-2013/on-uncomputable-numbers-the-origins-of-a-queer-computing/. In a blog post discussing the work of media philosopher Luciana Parisi, Alexander R. Galloway explains her position on the uncomputable: "Part of the story involves *incorporating* the indiscernible and the indeterminate into the very heart of computation. According to Parisi, 'error, indeterminacy, randomness, and unknowns in general have become part of technoscientific knowledge and the reasoning of machines.' Indeed part of the history of computation is the history of the uncomputable being colonized by the computable." Alexander R. Galloway, "Uncomputer," NYU Department of Media, Culture, and Communication, February 9, 2020, http://cultureandcommunication.org/galloway/uncomputer. See also Luciana Parisi, "Reprogramming Decisionism," *e-flux Journal* 85 (October 2017), https://www.e-flux.com/journal/85/155472/reprogramming-decisionism/; Luciana Parisi, *Contagious Architecture: Computation, Aesthetics, and Space* (Cambridge, MA: MIT Press, 2022); and M. Beatrice Fazi, *Contingent Computation: Abstraction, Experience, and Indeterminacy in Computational Aesthetics* (Lanham, MD: Rowman and Littlefield, 2018).

45. Black codes refer to US laws passed after 1865 that restricted Black people's mobility, freedoms, rights, and economic and political participation; these laws were extensions of the white supremacist oppression enacted by slave codes.

46. Safiya Noble, Jessica Marie Johnson, and Mark Anthony Neal, "Week 3: Race and Black Codes (Main Thread)," CCS Working Group, January 2018, https://wg.criticalcodestudies.com/index.php?p=/discussion/42/week-3-race-and-black-codes-main-thread.

47. Benjamin, *Race after Technology*, 7.

48. See Martine Syms, *Notes on Gesture*, 2015, video, 10:30; Gloria Anzaldúa, "Haciendo caras, una entrada," in *Making Face, Making Soul / Haciendo Caras: Creative and Critical Perspectives by Feminists of Color*, ed. Gloria Anzaldúa (San Francisco: Aunt Lute, 1990), xv; Joyce D. Hammond, "Hawaiian Flag Quilts: Multivalent Symbols of a Hawaiian Quilt Tradition," *Hawaiian Journal of History* 27 (1993): 1–26.

49. micha cárdenas, *Poetic Operations: Trans of Color Art in Digital Media* (Durham, NC: Duke University Press, 2022), 7. Clarifying algorithmic analysis's relation to codes and coding, cárdenas writes, "When I speak of algorithms, I am talking about code"

(7). cárdenas considers her algorithmic analysis to be an addition to both Crenshaw's intersectionality and queer and decolonial studies scholar Jasbir Puar's extension of intersectionality through Deleuzian assemblage theory. See Jasbir K. Puar, "'I Would Rather Be a Cyborg Than a Goddess': Becoming-Intersectional in Assemblage Theory," *philoSOPHIA: A Journal of Continental Feminism* 2, no. 1 (2012): 49–66.

50. *transCoder* is part of Blas's *Queer Technologies* series. See Zach Blas, *Queer Technologies* (2008–12), https://zachblas.info/works/queer-technologies/.

51. Sarah Elwood, "Digital Geographies, Feminist Relationality, Black and Queer Code Studies: Thriving Otherwise," *Progress in Human Geography* 45, no. 2 (2020): 212.

52. This question resonates with W. E. B. Du Bois's famous question examining the African American experience, "How does it feel to be a problem?" ("Of Our Spiritual Strivings," in *The Souls of Black Folk*, Project Gutenberg, [1903] 1996, https://www.gutenberg.org/files/408/408-h/408-h.htm).

53. We acknowledge another genealogy of diagrammatic thought, emerging from Foucault and Deleuze, that addresses power relations. Deleuze states that "every society has its diagram(s)" (35) and qualifies this with a definition of the diagram: "a display of relations between forces which constitute power" (36). Gilles Deleuze, *Foucault* (Minneapolis: University of Minnesota Press, 1986). Foucault supports this claim when he theorizes the Panopticon as a diagram inherent to disciplinary societies. When theorizing the Panopticon, Foucault introduces the diagram specifically in relation to power: "it is the diagram of a mechanism of power [discipline] reduced to its ideal form . . . not a dream building but a diagram" (205). Michel Foucault, *Discipline and Punish: The Birth of the Prison* (New York: Vintage, 1995). Foucault and Deleuze also theorize the diagram in relation to resistance. Foucault writes that there are "points of resistance everywhere in the power network" (95), "matrices of transformation" (99). Foucault, *The History of Sexuality*. Deleuze expands Foucault's sense of diagrammatic resistance, further defining the diagram as unstable because it is constituted by an "irreducible outside"—forces not captured by the diagram—that bears directly on the formation of the diagram itself. Deleuze elaborates further on the diagram in relation to force, the outside, and resistance: "The diagram, as the fixed form of a set of relations between forces, never exhausts force, which can enter into other relations and compositions. The diagram stems from the outside but the outside does not merge with any diagram, and continues instead to 'draw' new ones. In this way the outside is always an opening on to a future: nothing ends, since nothing has begun, but everything is transformed. In this sense force displays potentiality with respect to the diagram containing it, or possesses a third power which presents itself as the possibility of 'resistance.' [. . . Resistance is] 'points, knots or focuses' which act in turn on the strata, but in such a way as to make change possible. Moreover, the final word on power is that *resistance comes first*, or to the extent that power relations operate completely within the diagram, while resistances necessarily operate in a direct relation with the outside from which the diagrams emerge. This means that a social field offers more resistance than strategies, and the thought of the outside is a thought of resistance." Deleuze, *Foucault*, 89–90.

54. The chart's evocation of openness and change resonates with what Uncertain Commons, a group of scholars, mediaphiles, and activists, calls "affirmative speculation," the proliferation of possible futurities, which can channel potential for worlding otherwise. See Uncertain Commons, *Speculate This!* (Durham, NC: Duke University Press, 2013).

55. Reed, "Diagramming the Common."

56. See Whitney Battle-Baptiste and Britt Rusert, eds., *W. E. B. Du Bois's Data Portraits Visualizing Black America* (New York: Princeton Architectural Press, 2018).

57. Stop LAPD Spying Coalition and Free Radicals, "The Algorithmic Ecology: An Abolitionist Tool for Organizing against Algorithms," *Medium*, March 2, 2020, https://stoplapdspying.medium.com/the-algorithmic-ecology-an-abolitionist-tool-for-organizing-against-algorithms-14fcbd0e64d0.

58. Sam McBean, "Feminist Diagrams," *Feminist Theory* 22, no. 2 (April 2021): 223.

59. See Ti-Grace Atkinson, *Amazon Odyssey* (New York: Links, 1974). Anzaldúa's diagrammatic drawings are available for viewing in "Gloria Evangelina Anzaldúa Papers," part of the Nettie Lee Benson Latin American Collection at the University of Texas at Austin. See Shulamith Firestone, *The Dialectic of Sex: The Case for a Feminist Revolution* (London: Verso, 2015). We add to this list of feminist diagrams Catherine D'Ignazio and Lauren F. Klein's table that juxtaposes concepts of data ethics, which secure power, and concepts of data justice, which challenge power. See Catherine D'Ignazio and Lauren F. Klein, *Data Feminism* (Cambridge, MA: MIT Press, 2020), 60.

60. McBean, "Feminist Diagrams," 210, 219–20.

61. Haraway, "A Manifesto for Cyborgs" (1985), 82.

62. In the 1991 reprinting of "A Cyborg Manifesto" in *Simians, Cyborgs, and Women*, the chart splits across two pages, appearing on pp. 161–62. In "The Biopolitics of Postmodern Bodies," entries are added, deleted, and edited to the chart: "Work ⎯ Text," "Mimesis ⎯ Play of Signifiers," "Individual ⎯ Replicon," and "Colonialism ⎯ Transnational Capitalism" are new; "Science management in home/factory ⎯ Global factory/Electronic cottage," "Family/Market/Factory ⎯ Women in the Integrated Circuit," "Family wage ⎯ Comparable Worth," and "Public/Private ⎯ Cyborg citizenship" have been removed; and other entries have been adjusted. For instance, "Organism ⎯ Biotic component, code" now contains "code," "Sex ⎯ Surrogacy" is a reconfiguration of "Sex ⎯ Genetic Engineering," and "Decadence ⎯ Obsolescence" no longer includes its literary interlocutors *Magic Mountain* and *Future Shock*. This chart appears on pp. 209–10 in *Simians, Cyborgs, and Women*. Given that this altered presentation of the chart appears in a publication that is not "A Manifesto for Cyborgs," we did not include its additional entries and edits in our editorial approach to working with the chart for this publication. We committed to staying with the chart as presented in the manifesto, which explicitly frames the chart of transitions through the informatics of domination.

63. "A Manifesto for Cyborgs" has been widely reprinted in journals and edited collections, as well as translated and printed in numerous languages. Many of these publications display the chart of transitions like the original 1985 layout on a single page, as in *Australian Feminist Studies* 4 (Autumn 1987), 16, or the chart from *Simians, Cyborgs, and Women*, which spans two pages, as in Linda J. Nicholson, ed., *Feminism/Postmodernism* (New York: Routledge, 1990), 203–4; and *The Haraway Reader* (New York: Routledge, 2004), 20–21.

64. On limitations of graph theory in network science, see Galloway and Thacker, *The Exploit*, 33–34. Media theorist Nicole Starosielski points out that graph theory leaves behind materiality in *The Undersea Network* (Durham, NC: Duke University Press, 2015), xiii–xiv.

65. Ulises Ali Mejias, *Off the Network: Disrupting the Digital World* (Minneapolis: University of Minnesota Press, 2013), 153.

66. For example, in Ti-Grace Atkinson's diagrams, geologic strata-like abstractions portray patriarchal domination and oppression as a sedimentary weight sitting on the oppressed. Yet both oppressor and oppressed are composed of multiple strata—dotted,

hashed, filled with wavy lines—that encompass factions that are pro-rebellion, antirebellion, and neutral. It takes an environmentally inflected point of reference to interpret Atkinson's diagrams, where gravity (and power) flow from top to bottom. See "Tactical-Strategy Chart" #1–22 in Atkinson, *Amazon Odyssey*, 161–89.

67. Haraway, "Situated Knowledges" (1991), 189.

68. Haraway, "Situated Knowledges" (1991), 195.

69. Haraway, "Situated Knowledges" (1991), 194.

70. Haraway, "Situated Knowledges" (1991), 197–201.

71. Karen Barad, *Meeting the Universe Halfway: Quantum Physics and the Entanglement of Matter and Meaning* (Durham, NC: Duke University Press, 2007), 337.

72. *Oxford English Dictionary*, s.v. "diagram," accessed March 10, 2024, https://www.oed.com/dictionary/diagram_n?tab=etymology#6917294.

73. McBean's genealogy of feminist diagrams also reflects this definition.

74. Our approach to aesthetics stems from Jacques Rancière, who theorizes an aesthetic dimension to politics. With the introduction of his concept "the distribution of sensible," Rancière explains that, in any given era or regime, there is a particular ordering of what can be sensed and perceived. This ordering, or distribution, of the sensible is aesthetic because it demarcates what can be sensually experienced. For Rancière, this means that aesthetics are inextricable from politics, as social orders, political systems, and worlds emerge out of distributions of the sensible. Politics, then, can be understood as efforts to reconfigure (aesthetic) distributions of the sensible. See Jacques Rancière, *The Politics of Aesthetics* (London: Bloomsbury Academic, 2006). Similarly, Thomas Keenan and Eyal Weizman have defined "aesthetic operations" as "the way and order by which things and events appear to us." See Thomas Keenan and Eyal Weizman, *Mengele's Skull: The Advent of a Forensic Aesthetics* (Berlin: Sternberg Press/Portikus, 2012), 23.

75. See Robert Hobbs and Mark Lombardi, *Mark Lombardi: Global Networks* (New York: Independent Curators International, 2003).

76. American Artist, *Veillance Caliper (Annotated)*, 2021, https://americanartist.us/works/veillance-caliper-annotated.

77. Simone Browne, *Dark Matters: On the Surveillance of Blackness* (Durham, NC: Duke University Press, 2015), 21.

78. Steve Mann, "Veillance and Reciprocal Transparency: Surveillance versus Sousveillance, AR Glass, Lifelogging and Wearable Computing," *2013 IEEE International Symposium on Technology and Society (ISTAS)* (Toronto: IEEE, 2013), 6.

79. Mann, "Veillance and Reciprocal Transparency," 3.

80. American Artist (@a_____rtist), Instagram post, June 25, 2021, https://www.instagram.com/a_____rtist/p/CQjPZr2lQ7O/?img_index=6.

1. Representation —— Simulation —— Generation

Rita Raley

It is not incidental that *simulation* would be the first term in Donna Haraway's sketch of the epistemic shift from industrial to information society. The sine qua non of her "deadly game," simulation engenders the complex media-technological apparatus that both expresses and subtends the informatics of domination.[1] It is there in the modeling of organic and technical systems, in the development of new techniques of control and communication, and of course in the design of games themselves. Not reducible to the play of signs, the simulacrum wields determinative, performative power—scary then because of its capacity to actualize the virtual, to overcode the copy or replica and enact it as real. Hence the insistent drive in dystopian fables to mark a line between the world-as-territory and the world-as-matrix, most visibly in *The Matrix* films themselves. Deploying "virtual" as the index of a discrete condition and situation, located elsewhere and distinct from "real," even as it always threatened to eclipse it, is in this sense a containment strategy. But if the implicit promise behind Linden Lab's Second Life when it launched in 2003 was that a virtual environment could indeed be upheld as secondary (as the naming itself indicates), new technologies of augmented reality instead promise extension, continuity, and supplementation, with metaverses and mirror worlds not necessarily dependent on an articulation of the simulacra as detached and bounded by platform or device. In other words, it is now Unreal Engine, design software, all the way down.

As the present volume suggests, it is now possible, and indeed time, to consider whether we are living through another epistemic transition, or on another level in the deadly game. If the question has to

do not only with actual socio-technical arrangements, but also with a shared, if tacit, apprehension of the changes underway, one answer can be found in the defeat of Go master Lee Sedol by DeepMind's AlphaGo program (alternatively, when Lee Sedol won one game against Alpha-Go). The global media spectacle that unfolded over the course of a week in March 2016 introduced a new situation, and a new way of living, with a different order of autonomous machine, one that can not only perform brute probabilistic calculations but also learn, on its own, to make good strategic decisions. For this order, and this moment, there is a new fable: not simulation, but generation, cued by the fast-moving research domain of generative AI. Both as technique and as concept, generation opens up questions about how power may now be adopting a different informatic, and epistemic, form.

The cognate of the first term in the name of the still-ubiquitous machine learning model, the generative adversarial network, or GAN, *generation* suggests at once a practice of creation and of taxonomic categorization. How this is both continuous and discontinuous with modern biological schemata for the classification of organisms can be elucidated with a brief and nontechnical foray into the architecture of the GAN. The network consists of two neural networks: one, a generator, is given training data and tasked with producing output that mimics that data; the other, a discriminator, determines whether the output is real or fake by comparing it to the training examples.[2] Adversarial training, often likened to a minimax game in which one player tries to maximize their score while the other tries to minimize it, uses the discriminator's judgments as feedback to push the generator to create increasingly convincing outputs that are indistinguishable enough to fool the discriminator, resulting in images of people, cats, fantasy characters (like "waifu"), and even rental properties—all completely artificial. Generative adversarial networks represent a shift toward unsupervised learning techniques. Unlike supervised methods that rely on labeled data, GANs learn from the underlying patterns and distributions within unlabeled datasets. While their outputs, such as images of cats, may appear to reflect an understanding of categories or concepts and may appear to recognize and differentiate individual species, GANs are actually operating based on complex mathematical processes involving high-dimensional vectors, loss functions, and probability distributions. From the perspective of the GAN, it is generating data that approximates the patterns learned during training. But from

1.1. A CGI image of an oil painting of a high-performance GPU graphics card in the style of René Magritte. Midjourney and Rita Raley.

the perspective of a human, or animal, GANs are producing pictures of cats that present, and operate, as real.

Heralded by industry at one point as the "coolest idea in deep learning," GANs are ready to hand for both scientific and political deployment, for both work and the lulz. They have significant applications for the domains of medical imaging, astronomy, and physics because they make it possible for researchers to create large datasets without privacy violations and the exorbitant costs of simulations.[3] But at the same time the use of GANs for the production of nonconsensual pornography, deceptive speech, and computational propaganda inextricably links them with the so-termed deepfake, a form of synthetic media in which one face is substituted for another—a well-known example

of which is Jordan Peele speaking as President Obama and cautioning against deepfakes.[4] The availability of this particular model architecture for diverse implementations is not itself surprising nor the basis for a paradigm shift, although the speed, scale, and scope of its operations would arguably help make the case. What is different is the cultural reorientation around machine learning models themselves, around "relatively inert, sequential, and/or recurrent structure[s] of matrices and vectors" rather than programmed algorithms.[5] More broadly, the tools of generative AI writ large, in their paradoxical production of media that is both original and fake, initiate ontological and epistemological anxieties that differ, if not in kind, then certainly in degree, from those of prior eras. How generation is positioned as a technocultural paradigm is best illustrated by the training of GANs themselves, with some trained on simulations and others used to generate data for the purpose of training other GANs—just as simulation was made possible by representational objects and techniques. Generation, in other words, both enfolds and supersedes simulation.

Unlike representation and simulation, which preserve the notion of an original, even if distorted with an ideological lens or constituted retroactively, generation goes beyond the severing of the link between source and image, even beyond the evacuation of source, and rather presents the phenomenon of its wholesale elimination.[6] This is the conceptual principle behind the StyleGAN project, *This Person Does Not Exist*: there is no referent for the image, which results from the calculation of a probability distribution, rather than figural imitation.[7] While nomenclature and model behavior foreground the question of the fake, the designation of an image or a word as counterfeit can only ever be operational, a matter of differential relation. Even if the simulacrum was said to cancel the distinction between true and false—"there is no spoon," as *The Matrix* lore would have it, because what is floating in the air has no counterpart in the real world—it nonetheless holds to the idea of an original, and a real, manifest in the deictic *there*.[8]

The tell in the most prominent fictions of simulation has been the link to the puppet master in the background: an agent, whether human or nonhuman, situated as a kind of wizard behind the curtain and propping up the scene or stage. And for all of the data scientists and engineers working on and with machine learning systems, and for all

of the romance of the singular inventive genius (the patrilineal "GAN-father" of a particular model architecture), that link to a generative agent is severed through unsupervised training. Whether these particular aspects of a-referentiality and autonomous functioning constitute quantitative or qualitative differences from the order of the simulacrum cannot yet be definitively determined, but accelerative forces, in different contexts and with different motivations, have already mobilized the fake to provoke an epistemological crisis that is unresolved. Simulation provokes its own crises, to be sure, and the material effects, and indeed political and psychosocial stakes, are nowhere more clearly manifest than in a racialized murder putatively motivated by a perceived threat of a toy gun. Such is the power of the fable of simulation that it grants license to this kind of overcoding and masks the brutality of violence with fiction. What horrors the fable of generation will mask, facilitate, and indeed prompt are as yet speculative, even if their eventual arrival is predictable.

But while collective affects might intensify, for example, in relation to a new AI-generated video, they soon dissipate in accord with the rhythms of mediated life and settle in clusters around the banal mean: tepid amusement with images of avocado chairs or puppies on the moon. A sense of wonder and even dire alarm may be momentarily rekindled, as when Carrie Fisher is brought back to life for a *Star Wars* film, but the pervasiveness and availability of synthetic images and video might be said to have stripped it of its necessarily marvelous quality. In contrast, simulation as a media practice has inclined toward spectacle and the crafting of scenes for immersive, embodied experience and sensory response. In its apparent distance from the ordinary, the simulacrum strikingly differs from the becoming-common of generation—evinced by the endless supply of nondescript faces and felines that are exceptional for being not exceptional, the products of machine learning techniques that detect patterns, clusters, and segments at the expense of the anomalous and weird.

Thus generation has not only enfolded and superseded simulation but has also, in the language of serial media, retconned it such that simulation itself seems always to have been commonplace, something to live with rather than pay attention to. Its function is to populate everyday media environments and lifeworlds with more images, more video, more words, more datasets—to churn out stock

images, to fill in the gaps of pictures with inpainting or to extend their parameters with the technique of outpainting, and to autocomplete and autocompose documents that no human will ever read, and, soon enough, to produce scripts for films in which the AI-generated actor is the rule and not the exception. Generation, then, almost necessarily gives rise to a wide range of tools and techniques to detect and combat its own functioning, to affirm and attest to measurable distinctions between real and fake.

Because the logic of generation is iterative and accumulative—the purpose of generative models after all is to continually produce output—one might expect to see in its applications an opening to the future, just as the anticipatory and predictive logic of simulation manifests in war gaming and disease modeling. But here too a difference can be discerned between a model projecting future states and a model whose iterations are constrained by class or category and is thus functionally more successive than diachronic. And while there is no prescribed end point for disease modeling—absent external interventions, one has to assume continual evolution and transmission—adversarial training means that the game will come to an end when the discriminator can no longer differentiate between samples and data. So too in the popular imaginary, AI seems only thinkable in terms of the technological singularity, itself a kind of horizon. In this respect, generation perfectly emblematizes a moment in which the imagination of the future has been short-circuited by pessimism or even fantasies of accelerative destruction, when mythologies of hope, aspiration, and utopian becoming can only be regarded skeptically, as insufficient bulwark against the catastrophic storms that blow ever closer to the present.[9]

This account of *generation* as both order word and technical object is also an argument for a politics grounded in some degree of technological literacy. As AI/machine learning systems continue to improve, as datasets grow, models scale up, and computational resources become more available and at the same time more extractive, human systems will themselves need to transform—not to acquiesce or accommodate but rather to adapt and forge new alliances. This will require both critical and empirical engagement with all aspects of AI, from the gathering of data and the specificity of model architectures to the implementation of these systems across different domains. The proliferation of application programming interfaces (APIs) for content generation, as well as the widespread availability of AI features on social media plat-

forms, facilitates the authority of common use, but a better path turns away from enclosure and centralization, and arcs instead toward open source models, GitHub repositories, and training datasets, and toward the many enthusiastic hobbyists who make, teach, and share.

Generation, like simulation, can and will be weaponized. After all, GANs can intensify the fog of disinformation, but they can also help with environmental monitoring; just as large language models can be used for hate speech but also to relieve the tedium of templated writing or debugging code. A politics for the future thus depends on our accepting the modest role of partner with our lively machines, while retaining some aspect of the steering function, so that we might decide—on the basis of some knowledge of their operational principles—where, when, and how best to put them to use.

Notes

1. Donna J. Haraway, "A Cyborg Manifesto: Science, Technology, and Socialist-Feminism in the Late Twentieth Century," in *Simians, Cyborgs, and Women: The Reinvention of Nature* (New York: Routledge, 1991), 161.

2. On the framework of the GAN, see Ian J. Goodfellow et al., "Generative Adversarial Nets," in *Advances in Neural Information Processing Systems 27*, ed. Z. Ghahramani et al. (NeurIPS Proceedings, 2014), 2672–80, http://papers.nips.cc/paper/5423-generative-adversarial-nets.

3. Yann LeCun, cited in Martin Giles, "The GANfather: The Man Who's Given Machines the Gift of Imagination," *MIT Technology Review*, February 21, 2018, https://www.technologyreview.com/2018/02/21/145289/the-ganfather-the-man-whos-given-machines-the-gift-of-imagination/.

4. "Jordan Peele's 'Deepfake' President Obama Video," C-SPAN, June 7, 2019, https://www.c-span.org/classroom/document/?9544.

5. Jonathan Roberge and Michael Castelle, "Toward an End-to-End Sociology of 21st-Century Machine Learning," in *The Cultural Life of Machine Learning: An Incursion into Critical AI Studies*, ed. Jonathan Roberge and Michael Castelle (London: Palgrave Macmillan, 2021), 5.

6. That Goodfellow et al. should have recourse to the attempted detection of counterfeit currency as their explanatory analogy for the proposed GAN framework is in this regard more suggestive than perhaps intended. It is not only that the paper form of money circulates in abstract symbolic relation to other monetary forms, its value unsupported by gold or other raw materials, but also that the currency exists only as fiction.

7. Phillip Wang, *This Person Does Not Exist*, December 2019, https://thispersondoesnotexist.com.

8. Thanks to Colin Milburn for brainstorming with me about spoons and all else besides.

9. Some of these storms will be literal, and here it must be emphasized that the environmental and infrastructural resources supporting generation are exponentially larger than is required for running simulation tools. See Emily Bender et al., "On the Dangers of Stochastic Parrots: Can Language Models Be Too Big? 🦜," *FAccT '21: Proceedings of the 2021 ACM Conference on Fairness, Accountability, and Transparency* (New York: Association for Computing Machinery, March 2021), 610–23; and Kate Crawford, *Atlas of AI: Power, Politics, and the Planetary Costs of Artificial Intelligence* (New Haven, CT: Yale University Press, 2021).

2. Bourgeois Novel, Realism —— Science Fiction, Post-modernism —— Visionary Fiction, Cataclysm

Alexis Lothian

"Another end of the world is possible."[1]

So read a line of graffiti, black spray paint on a white tile wall, inscribed and photographed in Minneapolis in June 2020. It marked a moment in time and place experienced as an American cataclysm: when the old order of things seemed as if it might be swept away, borne off on a wave of uprisings sparked by George Floyd's murder at the hands of police and fueled by the global and local unrest of the COVID-19 pandemic.[2] Spoiler warning: that didn't happen. Instead, Floyd's cruel but far from unusual death drove home the ways in which the shattering of the pandemic was undergirded by long-standing, epochal inequity. Worlds end every day, as the author of the Minneapolis graffiti knew—and yet to name the possibility of "another end" speculates on the potentiality for new beginnings amid the apocalyptic.

Speculation is racial capitalism's dominant logic in the early twenty-first century: amid ongoing climatic and biological cataclysm, it marks a world order of algorithmic risk calculations in which corporations place computationally assisted bets on the likelihood of futures whose arrival is irrelevant, distributing risk downward and profit upward. Yet, as a narrative mode, speculation is also an aesthetic form with the capacity to imagine possibilities beyond, outside of, beneath, and in spite of domination. In the 2015 anthology *Octavia's Brood*, Walidah Imarisha and adrienne maree brown develop a genre term for the kind of speculative imagining that "has relevance toward building new, freer worlds": "visionary fiction."[3] I take up this term, and its urgent applicability to a world undergoing ongoing cataclysm, as a successor to the cultural logics and narrative modes named by Donna Haraway.

The stakes of fictional genre have never been purely aesthetic; Haraway's taxonomy demonstrates their political stakes. In the nineteenth and early twentieth centuries, the bourgeois novel perpetuated the lie that realism was coextensive with reality, white supremacist heteropatriarchal domination with personhood, empire and capital with the history of the world. In the late twentieth century, science fiction mapped the present onto the future, through radical transformation and/or perpetual reproduction of oppressive hegemonies; the commodifying logics of postmodern capital made it difficult to tell the two apart. Brian McHale argues that literary postmodernism marks a shift from "cognitive questions" ("How can I interpret this world of which I am a part? And what am I in it?") to "postcognitive questions" ("Which world is this? What is to be done in it? Which of my selves is to do it?").[4] The bourgeois novel and realism ask about a protagonist's place in a presumed-to-be-coherent world; science fiction and postmodernism uncover the multiplicity of selves, worlds, and the actions that they can take. Yet, even as the dividing lines between them might wither away, both the realism epitomized by the bourgeois novel and the science fiction epitomized by postmodernism make sense as modes of narrative and genre only through the assumed presence of a world built by colonial modernity and Enlightenment rationalism. Visionary speculative fictions grounded in Black, queer, and decolonial imaginaries inspire a different set of questions: How was this world (and the selves that occupy it) constructed? Off whose back and with whose labor? What worlds might be possible if and when that world ends?

Imarisha writes that "all organizing is science fiction": to challenge the world as it is, one must do the work of imagining a different world.[5] All organizing may be science fiction, but not all science fiction is organizing; speculative works of literature and media often map imperial logics and the informatics of domination onto extended temporal and spatial scales. As David Higgins has elaborated, many of the most popular speculative imaginaries of the twentieth and twenty-first centuries thematize imagining white people on the receiving end of what they have done to others.[6] Lands falsely imagined empty by settlers speculating on the prospect of exploitation become empty planets that can be colonized without guilt; plucky white heroes stand against racialized empires in futures designed to invert history to give white readers a guilt-free chance at identifying with the oppressed.[7] With climate change and its many analogies most often presumed to be the source

of violent upheaval, the unevenly distributed cataclysms of history remain unspoken. In contrast, the otherwise imaginaries Imarisha calls "visionary" reckon with the damage that settler colonialism and chattel slavery continue to unleash, finding other ends for the worlds turned upside down by colonial and capitalist domination.

The crafting of speculative fiction can be a process of imagining otherwise with intensive attention, rigor, and care—on page and screen or in embodied practice. To live through worlds' ends and rebuild otherwise is not only a literary activity, but fiction is a pedagogical ground for this theory and practice. Haraway learned this from Octavia Butler, among others. Choosing one of many possibilities from creators producing visionary fiction today, I offer the example of N. K. Jemisin's monumental trilogy *The Broken Earth* as a showcase for how the complex possibilities of speculative narrative can become an urgent, necessary mode of visionary practice for cataclysmic times.

"Let's start with the end of the world, why don't we? Get it over with and move on to more interesting things."[8]

Jemisin's novels build a world that ends over and over and must be rebuilt, like and unlike our own. The earth revolts against its inhabitants with quakes and volcanoes, named "fifth seasons": cataclysms that arise unpredictably and with a frequency that requires constant preparation for and rebuilding from catastrophe. In the beginning of the trilogy, this seems to simply be how things are; worlds end routinely, and those who would survive must orient themselves constantly to the possibility of disaster. As we go on, we slowly learn that the natural disasters are anything but. In this world as in ours, physical and social cataclysm is directly related to exploitation. The backstory revealed in *The Fifth Season* and its sequels is that the peace of the planet was shattered by a now-dead civilization who settled and colonized its entirety, stealing the sacred practices of an Indigenous people they all but wiped out and transforming the tangible essence of life, magic, into a resource to be exploited. To harness the power and magic of the earth itself to fuel their technology, those with power created techno-biological entities whom they trained to see themselves as less than people. As in many other speculative analogues for oppression, enslavement, and racialization, these created beings brought down the world when they understood the extent of their exploitation. In the aftermath of that cataclysm, the planet and its inhabitants live at odds.

Resisting a straightforward logic of analogy, Jemisin disarticulates race into component parts: phenotypes of skin, body, and hair are associated with some forms of social power, but it is her newly imagined version of embodied alterity that marks the boundaries of the human. In one dimension of this visionary racial project, the orogenes, those whose will and emotion moves the earth, hold a structural position akin to Blackness in the postslavery world.[9] Orogenes' exploited, stolen labor is the foundation of the empire that, at the start of *The Fifth Season*, holds sway over most of the planet; their existence is held as an inherent threat by those who would not easily survive without them. The series' protagonist, Essun, shows the creative urgency that living in that impossible position demands. Systematically traumatized that she might learn to instrumentalize her own life in the guise of controlling dangerous powers, she escapes and destroys her own world rather than be captured again—but, even ostensibly free, she finds no choice but to perpetuate the harm done to her on her own daughter, until the world ends and opens other possibilities.

The series' opening cataclysm, the "end of the world" with which Jemisin begins, is a transformative reckoning in which the same dynamic repeats. When violent exploitation teaches people to see themselves as less than human, they learn the truth and get retribution; provoking cataclysm because of the cataclysms they have survived, they yearn to live otherwise. The most powerful orogene catalyzes his rage to open a rift, breaking the world apart to ensure that the old way can no longer endure. But the *how* of that living still has to be painstakingly built and lived.

Everyone knows how to survive the end of the world in Jemisin's narrative, or they think they do. Their methods for survival are handed down on stone tablets that seem abstract and unimpeachable, unbiased and unarguable—and, indeed, this stonelore is full of pragmatic advice for cooperative survival that we in our world would do well to heed. Yet stonelore's inheritance is also laced with methods for the oppression and enslavement of orogenes and the perpetuation of colonial power. It becomes necessary for radicalized orogenes—of whom there are few, given the enforcement of their complicity in their own oppression—to call down cataclysm upon themselves and their enslavers alike. So they end the world in which stonelore served as law, because they could not convince its powerful adherents that the world needed to change.

To remake the ending world, Essun must learn to attend to the lessons of others who have survived, standing ready to break the stones

and the rules when the time comes. She joins with an orogene who has not been trained in the discipline wrought by enslavement and instead charts a new path centered in collective collaboration. The community Essun joins, Castrima, is building itself otherwise through coalition across difference, reimagining human sociality with the formerly excluded at the center. Nevertheless, when it is attacked by the vestiges of the formerly powerful empire, Castrima survives only because Essun wipes out a city's entire population.

Jemisin will not let readers think that speculative world building toward radical ends is ever innocent or easy. Here and throughout her work, she refuses the liberal dream of a world without violence (which ignores the violence silently upholding the lives of those dreaming it) alongside the popular fantasy that some people are more worthy of life than others.[10] The unrelenting cataclysms in *The Broken Earth* show us that prior order will resist its threatened end, asserting itself vigorously through the logics of the white supremacist carceral state, eugenics, and ableist, racist social cleansing. But nor does Jemisin let us forget that the dominant order has never been all of the world, even as it has sought to perpetuate that myth through false education and violent suppression. Cataclysm opens into worlds transfigured and reconceptualized, where hopeful visions are possible and real, if not permanent or durable.

What can Jemisin teach us about the ends and beginnings of the worlds that might be possible in the United States of America in the early twenty-first century? American stonelore says that the only way to live, through disaster or catastrophic normality, is by following the edicts of capitalism. As the pandemic-era graffiti with which I opened demonstrates, moments of cataclysm illustrate stonelore's power and weakness. In Minneapolis in 2020, a world broken open made visible unending oppression in the shape of settler colonialism and enslavement from past to present, briefly upsetting the hegemony of a national virtue that rests on denial of underpinning violence. In response, recalibrating to ensure a return to denial, the state bailed out the stock market for the speculative enrichment of those who owned the most, abandoning the rest of the population to unevenly distributed infection and death. But another end of the world remained—remains—possible.

Fiction like Jemisin's has real-world collaborators in visionary Indigenous, Black, and trans feminist thinkers like Grace Dillon,

adrienne maree brown, and micha cárdenas, who imagine and practice research, study, and experimentation untethered from the reproduction of colonial domination.[11] They view the end of the world not as a fearsome future but something that has happened many times to the oppressed, who live on in the face of violence and sometimes gain the power to end the worlds that subjugate them. Floyd's death marked a time and place in which years and decades of grassroots organizing became a moment of visionary potentiality through the amplification of Black struggle, transformative mourning, and the building of alternative physical and social formations. If only for a moment, the conjuncture of vision and upheaval brought into being a rift—where ending worlds open the possibility of new ones wider than they can be when privilege grants stability. Amid cataclysm and the debris it creates, visionary fiction begins to build otherwise worlds.[12]

Notes

1. Photographed by Aren Aizura and shared as a header for an abolitionist reading list, "Reading List: Resources for Resistance," *Tank*, June 2020, https://tankmagazine.com/tank/2020/06/resources-for-resistance.

2. *Oxford English Dictionary*, s.v. "cataclysm," Oxford University Press, accessed June 29, 2023, https://www.oed.com/view/Entry/28673.

3. Walidah Imarisha, "Introduction," in *Octavia's Brood: Science Fiction Stories from Social Justice Movements*, ed. Walidah Imarisha and adrienne maree brown (Oakland, CA: AK Press, 2015), 3.

4. Brian McHale, *Constructing Postmodernism* (New York: Routledge, 1992), 146.

5. Imarisha, "Introduction," 3.

6. David Higgins, *Reverse Colonization: Science Fiction, Imperial Fantasy, and Alt-Victimhood* (Iowa City: University of Iowa Press, 2021).

7. See John Rieder, *Colonialism and the Emergence of Science Fiction* (Middletown, CT: Wesleyan University Press, 2008); Mark C. Jerng, *Racial Worldmaking: The Power of Popular Fiction* (New York: Fordham University Press, 2017).

8. N. K. Jemisin, *The Fifth Season* (New York: Orbit, 2015), 1.

9. Other aspects of the orogenes' experience map onto different dynamics, including queerness. However, in Jemisin's work, Ruth Wilson Gilmore's definition of racism as "group-differentiated vulnerability to premature death" is in full operation even as physical appearance structures intersecting but not fully overlapping hierarchies through the colonial power of the Sanzed nation. Ruth Wilson Gilmore, *Golden Gulag: Prisons, Surplus, Crisis, and Opposition in Globalizing California* (Berkeley: University of California Press, 2007), 28. Jemisin's use of the orogenes as metaphor for Blackness, trauma, and worlding in and after enslavement would be productively read in conversation with Christina Sharpe, *In the Wake: On Blackness and Being* (Durham, NC: Duke University Press, 2016).

10. Jemisin builds the world of *The Broken Earth* on a principle explained in the short story "The Ones Who Stay and Fight," which imagines what kinds of disciplinary violence (personal and swift) would be demanded by a society that truly refused to uphold some lives at the cost of others. N. K. Jemisin, "The Ones Who Stay and Fight," in *How Long 'til Black Future Month? Stories* (New York: Orbit, 2018), 1–13.

11. Grace L. Dillon, "Introduction: Indigenous Futurisms, Bimaashi Biidaas Mose, Flying, and Walking towards You," *Extrapolation* 57, no. 1–2 (January 1, 2016): 1–6; adrienne maree brown, *Emergent Strategy: Shaping Change, Changing Worlds* (Chico, CA: AK Press, 2017); micha cárdenas, *Poetic Operations: Trans of Color Art in Digital Media* (Durham, NC: Duke University Press, 2021).

12. The phrasing of my closing sentence echoes a sentence in the opening of my 2018 book: "We live in the debris of many ended worlds, whose inhabitants continue to live on." Alexis Lothian, *Old Futures: Speculative Fiction and Queer Possibility* (New York: NYU Press, 2018), 2.

3. White Capitalist Patriarchy —— Informatics of Domination

Radha May (Elisa Giardina-Papa, Nupur Mathur, and Bathsheba Okwenje)

The informatics of domination can stay, can go. The debt is still there, and I'll cash that check. But the vibrancy of my life has always danced to a tune where directions are pointed with the mouth, necessity is rethought with the monsteras, and the salty mud remains boundless amid your limits of land and sea.

Once again coded as feminine, she is a worker without wage; she is work without the worker. She is naked-technolife. She is a disembodied packet of time—flexible, changeable, mobile, and precarious. She is a PeoplePerHour, body per hour, nimble fingers per hour. She can be activated on demand because she's granted no demands, nor any workers' rights. She is a face that chats, a voice that answers your calls, fingers that burst bubble wrap to tingle your low-grade ASMR euphoria. She can ease your exhaustion, clean your data, optimize your life. She is one of Kracauer's Tiller Girls of post-Fordism and AI capitalism. She is the *artificial* artificial intelligence that fuels up the forever "new" new economy, her disappearance recursively programmed to become one with the informatics of domination.

Globally dispersed but reconnected through the rules of labor arbitrage, she works at the tempo of platform capitalism. Her manners are standardized according to emotional quotient tests, her accents trained according to *Pretty Little Liars* Standard American English and "deep voice" standard AI English. If you are not satisfied with her accent, tone, and courteousness, you can always speak with a more authentic human. Her call might be recorded for quality and training purposes. Her name is Alexa, Siri, Cortana, M, ChatGPT, carla99, apurba23, aneela14, and verablue2000. She is human and nonhuman, a captcha

worker who continually needs to prove she's human by working. She is human powered so that you can power up your humanity.

She's always available because you always need to be on. If carla99 is not online, you can scroll down to verablue2000 instead. She is programmed patience; she listens to your complaints and finds solutions for you. When her service is complete, you can rate her with stars. She intensely clicks and intensely likes your social media posts because she's a convenient parcel of social capital on demand. The buoy that allows you to work more and sleep less, burn out while feeling at ease. She works herself to death so that you can work yourself to death.

She is a virtual farmer who informally sells virtual goods, virtual weapons, virtual animals, and her own leveled-up avatarial body. She is a worker player so that you can be a player player; she's a worker on socials so that you can be social on socials. Her labor resembles that of other economic migrants, but unlike other types of migrant workers, her body doesn't cross what you have defined as borders. She's tethered to the conveyor belt of global labor without ever leaving her home. Without ever having set foot in your country, she embodies your moral codes, cultural values, and epistemic certitude, so as to effectively moderate your social media feed and remove the lewd and disturbing content you first produced and then wouldn't want to see.

She's an expert in data intimacy: she transcribes your shopping receipts and business meetings, edits your kids' homework, sieves the quantitative data of your yet to be published academic paper, translates your English text into hundreds of different languages. She "data entries" all of your data and "data exits" all of her energy. She has become an expert in deep learning by being asked to be deeply dull. Contracted to become a service to the machine, she intimately knows the algorithms that govern your life; she in fact trains them and cleanses all the dissensual epistemic, bodily, and cognitive excess that might upset your neat taxonomic inscriptions.

She sifts through billions of socially produced yet privately cashed images. Segmenting, tracing, patterning, bounding-boxing, and labeling according to all the binary, unqueered categories you have historically produced to separate Data from data, signal from noise, sovereign speech from unintelligible speech, the soloist from the ensemble, the orderly things from the disorder of things. Yet, while laboring to teach AIs to properly see and properly name, she reminds the machine that all that is opaque and promiscuous, heretical and unfaithful,

in movement and on the run, will always exceed any idealized, transparent, and universal category. That's why the only thing the machine should do, she hums, is to unlearn how to know the world, to unlearn how to know the other.

Laboring in the crevices of machine-to-machine automation, she has in fact witnessed how the most ruinous gendered and racialized physiognomic projects of the nineteenth century are still embedded in the biometric analysis of her captured digital face and your released digital code. How algorithmic-fueled revivals of Galtonian and Duchennean metrics keep mining for the most treacherous eyes and the most wicked smiles. How the modern colonial scientific discourse, which describes and divides, identifies and hierarchizes, never really stopped chasing for the criminal, the mad, the sick, the emotionally silent, the hysterical, the perverse, the illegal, and the bad citizen. How it never stopped producing the not-yet, not-quite, not——— human other. Only today, it is done via machines that do not see, do not mind, and do not body.

If you fear that the human will be progressively excluded from the loop of machine-to-machine communication, she might just ask: Maybe, but which human? If you promise her that AI capitalism will grant a future in which artificially intelligent machines will take over the dull, dirty, repetitive labor historically forced on pauperized workers, she might remind you that AI capitalism also needs to keep reproducing pauperized labor in order to fulfill its initial promise. AI capitalism, and all capitalisms before this, have a murderous character, and the most violent aspects of dispossession have accompanied every phase of it.

She has been at the forefront of all stages of capitalisms and as close as you can get to any technology of exploitation. She was bought to give birth; she was sold to pick cotton. She was the first to pack sardines on an assembly line, to catch the flying shuttle in the textile industry, to assemble duty-free goods in the maquiladoras, to solder chips and electronic circuits for tech companies, to wear plastic gloves while scanning pages for Google Books. While reproducing labor power, cooking, cleaning, smiling, fucking, and caring, she always knew that her work has been the hidden source of support for your Promethean dreams of autonomy, self, and world mastery.

To your gift of a fire stolen from the gods, she might just say: cute, but no thanks.

This text is part of an ongoing conversation between Elisa, Nupur, and Bathsheba that started many years ago across time zones and continents. This text is enriched by Radha May's ongoing engagement with the thinking and laboring of many scholars and artists—some are friends, some we have met, some we have just read. Here, we are expressing our gratitude because sometimes appreciation gets lost in the footnotes. Thank you to Neda Atanasoski and Kalindi Vora, Wendy Hui Kyong Chun, Anuradha Mathur and Dilip da Cunha, Ezekiel Dixon-Román, Jack Halberstam, Stefano Harney and Fred Moten, Mimi Onụọha, Tung-Hui Hu, Lisa Nakamura, Luciana Parisi, and Tiziana Terranova.

4. Organism —— Biotic Component

Leon J. Hilton

4.1. Police remove protesters from the disability rights group ADAPT from Senator Mitch McConnell's office on June 22, 2017. Photo: Mark Wilson.

A photograph published in the *Los Angeles Times* in June 2017 shows an unnamed disability activist being carried horizontally, her arms and legs held by two police officers who are, conspicuously, wearing white medical gloves. This image is part of a series of widely circulated journalistic photographs documenting direct-action protests and "die-ins" staged

by disability and health activists in the summer of 2017 in response to attempts by the Republican-controlled US Congress to repeal the Affordable Care Act (otherwise known as Obamacare). The scenes of bodily torsion these photos bring into view might also offer a glimpse of a kind of historical torsion: the one by which the organism (human, in this case) has come to be reframed as a biotic component within a larger dynamic system.

How do we make sense of such photographs, in which the repressive apparatuses of state security forces are shown roughly handling, detaining, and in many cases arresting disabled people whose bodies have otherwise been deemed vulnerable enough to merit state and federal protections, social welfare benefits, and publicly financed health care? To be sure, these images are notable for their very "constructedness": it might be said that the protests were staged precisely in order to produce these photographs, to elicit the gaze of a mass public by demanding not sympathy but solidarity. One activist involved in the 2017 protests, Dominick Evans, told a reporter that the carefully plotted choreographies carried out in his group's demonstrations were modeled after those deployed by the civil rights movement. "It's very effective at getting the message out," Evans explained. "They can't ignore it if they're constantly arresting disabled bodies."[1]

Within the dramaturgy of these tableau-like scenes, the brightly colored latex medical gloves worn by police function as a kind of photographic punctum, drawing the eye of the viewer precisely where those being forcibly handled and arrested mean for the viewer to look. The appearance of these medical gloves allows us to locate their actions within longer genealogies of health activism and prompt us to ask how these disability protests surrounding the Affordable Care Act built upon insurgent traditions of biopolitical dissent. The embodied tactics—indeed, the deliberate staging—that these activists deployed in order to capture attention and get their message across reveal a precise and highly conceptualized sense of theatricality in which the police and news media documentation are implicated in playing a role.

The vital spark of the organism is no longer the main driver of biological wonderment that it had been in the nineteenth century. The regulation of life itself is now understood in terms of biotic components whose functions are determined by their relationship to other nodes within a larger system. The shift from organism to biotic component can be understood as an aspect of the communications revolution that took

shape in the face of the crises of postindustrial capitalism after World War II, which generated a "range of intermediate structures between extraction of surplus value and realization of profit" that required the development of "a whole set of discourses and technologies."[2] Biology came to be recast as merely one more component of the world that can be translated into code, sutured into the integrated circuit, engineered and optimized to maximize profit.

The die-in as a technique of public protest has been taken up in different forms across a range of social and political movements—from Ghandian, Quaker, and abolitionist practices of nonviolence and civil disobedience that were variously reanimated within anticolonial and civil rights struggles to more recent demonstrations against war, militarization, and racialized policing in Black Lives Matter protests. Die-ins consist of carefully choreographed and studiously rehearsed acts of physical noncooperation and noncompliance; they call upon the body's capacity for "obstinate recalcitrance" and make use of that recalcitrance to at once occupy space and amplify a message ("They can't ignore it if they're constantly arresting disabled bodies").[3] More than a withholding of one's labor effectuated through the absence of the laboring body, as in a strike, the die-in is a mode of biological resistance that is at once symbolic and deeply phenomenal. Thus the die-in also might be tracked historically as a response to particular historical transformations in the treatment of the body as a strategy of accumulation. Forcing police to arrest visibly disabled activist bodies, the 2017 die-ins did not aim to rehabilitate or recapacitate disability by eradicating the stigma that attaches to the disabled body or restoring dignity to the disabled subject. Rather, these photos document activists strategically making use of—indeed, spectacularizing—the vulnerability of their own bodies. By positioning themselves in place in order to produce the spectacle of their own forcible detainments, they craft a powerful rhetoric of the image with the unwitting (or at least unacknowledged) assistance of the security agents deployed against them.

Disability is the site of intense social conflict and antagonism because in liberal social welfare states, as Deborah Stone suggests, it is tasked with mediating between those who are and those who are not eligible to receive social protections and benefits that are otherwise distributed on the basis of an individual's capacity to earn them; the concept of disability is burdened with an impossible task, asked to "resolve the issue of distributive justice."[4] Disability is thus the place

that is occupied by those "nonproductive bodies" that are "not merely excluded from—but also resistant to standardized labor demands of human value."[5] The administrative definition of disability is closely related to the bureaucratic consolidation of medical expertise at the point of conjuncture between the state and the market, and thus a key linchpin to what historians and sociologists have characterized as the increasing medicalization of American society beginning in the post–World War II decades. What happens when the human body starts to be reconceived as a cybernetic system made up of interconnected feedback loops, buzzing with the flow of information, communicating with itself through its self-generating, self-regulating, and reproductive capacities?

The private health care system can be understood as a massive project of offloading the problem of distributive justice that disability poses to the market. Even neoliberal health care reforms, such as the Affordable Care Act, "deal with health care as a commodity to be bought and sold in the marketplace, rather than as a fundamental human right to be guaranteed according to principles of social solidarity."[6] If the die-in emerges as a technique of bodily resistance in response to larger transitions in the mode of capitalist production, these photographs at once document and perform a vital, active function in a resurgent disability activism that can work in and against the informatics of domination. On one hand, the gloves remedicalize the body of the activist: latex medical gloves emerged as a tool for the forensic science of policing in the 1990s in response to the biological threat that the AIDS epidemic was deemed to pose toward police officers charged with dealing with AIDS activists (one account of a 1987 ACT UP demonstration in front of the White House describes how the protesters incorporated the yellow medical latex gloves worn by the police arresting members of the group into their chants: "Your gloves don't match your shoes, you'll see it on the news"[7]). Yet as the antecedent of ACT UP would suggest, tools can always be retrofitted and resignified, made to work against the aim they were deployed to accomplish or secure. In this sense, the gloves offer an invitation to enter into a mode of counterviewing, to read these photographs as part of an activism that emerges from moments of circumventing and even simply refusing to accede to medical sovereignty and the violent tactics that it takes to secure the population. This reading need not distract from the urgent material needs of disabled people and communities in the here and now.[8] Rather, it suggests the ongoing relevance of die-ins and other tactics of disability and health

activism for attempts to transform the typically atomizing experience of illness, impairment, and debilitation into the grounds for new forms of political solidarity, resistance, subterfuge, and dissension.

Notes

1. Quoted in Sarah Jones, "Arresting Disabled Bodies," *New Republic*, September 28, 2017, https://newrepublic.com/article/145072/arresting-disabled-bodies.

2. Donna J. Haraway, "The Biological Enterprise: Sex, Mind, and Profit from Human Engineering to Sociobiology," in *Simians, Cyborgs, and Women: The Reinvention of Nature* (New York: Routledge, 1991), 58–59.

3. See Susan Lee Foster, "Choreographies of Protest," *Theatre Journal* 55, no. 3 (October 2003): 395–412.

4. Deborah A. Stone, *The Disabled State* (Philadelphia: Temple University Press, 1984), 12–13.

5. David Mitchell and Sharon Snyder, "Disability as Multitude: Reworking Nonproductive Labor Power," *Journal of Literary and Cultural Studies* 4, no. 2 (2010): 184.

6. Howard Waitzkin and Ida Hellander, "The History and Future of Neoliberal Health Reform: Obamacare and Its Predecessors," *International Journal of Health Services* 46, no. 4 (2016): 747–66.

7. Susan Maizel Chambré, *Fighting for Our Lives: New York's AIDS Community and the Politics of Disease* (New Brunswick, NJ: Rutgers University Press, 2006), 125. See also Mark Lipton, "The Condom in History: Shame and Fear," in *Culture and the Condom*, ed. Karen Anijar and Thuy DaoJensen (Lausanne: Peter Lang, 2005).

8. This discussion builds upon Alison Kafer's attention to the multiple and sometimes contradictory representations of disability and disabled bodies within Haraway's manifesto, which draws on important critiques from queer, feminist, and critical race studies perspectives. See Alison Kafer, *Feminist Queer Crip* (Bloomington: Indiana University Press, 2013), 103–28.

5. Depth, Integrity —— Surface, Boundary —— Circulation, Residence Time

Eva Hayward and Stefan Helmreich

Turn to ocean depth and surface in 1985. In that year a French American team of oceanographers and engineers found, 375 miles south of Newfoundland and twelve thousand feet down, the rusting wreck of the RMS *Titanic*, that ocean liner that had in 1912 famously sunk to the sea floor after its hull was torn through by an iceberg. The find came as part of a classified US Navy expedition to look for the remains of two US nuclear submarines—a high-tech Cold War enterprise if ever there was one, aimed at depth, integrity: the integrity of the deep sea as a site of state secrets.[1] In the following years, as *Titanic* was explored by cybernetic technologies like camera-outfitted remotely operated robots, images of the ship brought the vessel and its marine mystique virtually to the surface, transforming it, too, from military secret to public entertainment object. In the process (a kind of fantasy sinking in reverse), the ship seemed to become all surface—a rendering most canonically realized in James Cameron's 1997 film, *Titanic*, which, courtesy of computer graphics, reanimated the vessel with a smooth white cinematic skin, folded lovingly around a now-mapped skeleton.[2] The information technologies of camera, cinema, and code made of the ship (and the sea around it) a species of deep secret that could be unfolded, turned into surface.

In 2012, an image of the wreck of the *Titanic*—sited at 41.7325°N, 49.9469°W—became available for viewing in Google Earth.[3] What was notable about this representation—which one can still visit by surfing the Internet—was that, in order to make the vessel visible, image engineers and programmers judged it necessary that all the water around the ship be made invisible, completely see-through.[4] At the bottom of the Google ocean, the virtual *Titanic* sits on a stylized blue ocean

5.1. *Titanic* wreck in Google Earth, created using data from the Scripps Institution of Oceanography, NOAA, the US Navy, NGA, and GEBCO. © 2012 Google.

floor, settled beneath the light of what looks like an enormous, vaulted sea-blue ceiling (perhaps #006994 HTML Color [Sea Blue]). This is a space where water has no index of refraction, no viscosity, no currents, no temperature gradients, no organisms, no swirling radioactive isotopes, no pollution. There is really no ocean here at all. Ocean depth has been hollowed out until all that is left is surface. Google Earth *Titanic* resides, then, in a mythic realm of ocean transparency. This is not at all what Donna Haraway named as the "unfriendly and drowning depths" of an experiential whorl of imperiled subjectivity.[5] If Cold War submarine secrecy and opacity were secured through operations of domination that depended not so much upon vision as upon sonar sounding and its incompleteness, today's informatics of ocean domination, visible in nascent form with the 1985 *Titanic* tale, work through an iconography and fantasy of sheer visibility and code-ability. All can be seen.[6]

With Google *Titanic*, the trope of the deep blue sea, which suggests both a unified and bottomless blueness as well as an imaginary line dividing a sky-reflecting cerulean surface from a thickening blue-to-black fade, is offered up as surface all the way down. Blue indexes

the flattening of depth into surface. There are no unseeable, no unrepresentable fathoms, just deepening blue—blue as a promise that, like the sea's cerulean skin, the deeps may also be a seeable color, however cobalt-ed and navy-ed. This is not the blue of *Blue*, that 1993 film made by director Derek Jarman, who, his vision failing as he neared the end of his life, offered a pulsing still screen of International Klein Blue running for seventy-nine minutes.[7] Blue for *Blue* was the loss of representation, seeking to materialize, on the one hand, what it looked like to go blind from complications associated with AIDS, and on the other, what it meant visually to represent that which could not be represented by sight. The bluing of the ocean has worked differently, as the hypervisible, coded ocean becomes more than simply a humanistic projection—the ocean we see is the ocean we know—but is also revealed as that which subtended the very order of depth/surface at all, as that which defended against "drowning depths."[8] The technology of sight—light bouncing from the skin of the world into ocular orbs—becomes depth. Depth, then, is rendered as a darkened, breathless, cold effect that needs no translation. Depth becomes, in fact, a surface fantasy, a wet negative.

In 1997, as Cameron reanimated the oneiric *Titanic*, the Monterey Bay Aquarium in California was building its own depth-as-surface-effect with its Outer Bay display, its placarded imperative to visitors telling them to "Come closer and see." Immersion was the gimmick of the spectacle—an invitation to viewers to turn and tune their attention to curving walls of aquariums containing creatures from Monterey Bay's outer bay—but what was delivered was a flattening of depth into the promise of seeable surface.[9] Dark chambers, dappling pools of blue light, and a moist cool controlled indoor climate hushed millions of aquarium goers. In the Drifters gallery, radiant blue Kreisel tanks—transparent acrylic cylinders offering, through their circle sides, views of jellies drifting in circulating motion—were the blue irises looking back out into the darkness into which visitors were folded. Depth was an eye looking back, confusing the rhetoric of contact. The visitor might touch the unblinking eye—filled with pellucid cataracts and other mesmerizing visual phenomena, not least of which might be drifting plankton, reminiscent of those floaters that drift across human eyes—only to leave fingerprints, the greasy print on the acrylic window as a tell of the surfacing at work in this depth. But then, might those Truvada blue, Yves Klein blue tanks of water have themselves been seeing the shallow dark theater in which they were housed? Might the blurred eyes of

these aquariums be themselves seeing the surface effect of we viewers? What the Monterey Bay Aquarium captured in its blue-eyed address was a depth revealed as a surface all along. The logic of the surface performs depth—reminding us that the informatics of domination may pose the depth/surface opposition without, in the process, sorting or settling it.

In surfaces that promise depth—what was seen was already what cannot be seen—the ordering of volume may be apprehended as also inheriting a racial technology of vision and visibility. As Anne Cheng argues in *Second Skin*, her analysis of the making of the modern surface in coordination with the epidermalization of race—the making, that is, of human fleshy surfaces as markers of, revealers of, race—skin has come to be employed as a disclosure of essence, of hidden truths.[10] Racism, in this regime, relies on the presumption of seeing race. Colorism is a symptom that at once reveals and conceals the metaphysics of surface and depth as racializing operations.[11] As such, surfaces (including, now, depths) beyond human skin thus also come to be racialized. Recall that the *Titanic* was part of the White Star Line, a British shipping company, and that a gleaming whiteness was its aesthetic, as it was for Cameron's cinematically resurrected Olympic-class ocean liner—along with the film's white movie stars.[12] Marcus Garvey's Black Star Line (1919–22) was a direct commentary on the whitewashed racialization of the Atlantic as a site of pure leisure and a call to think about the many depths, surfaces, and routes of what Paul Gilroy would later call the Black Atlantic.[13] Contestations about the aesthetics of color and their meaning only shored up the certainty of the surface, confirmed that the surface was indeed deep.[14]

If the photographic and digital surface has come to unfold depths, then Christina Sharpe, in *In the Wake: On Blackness and Being*, urges readers to newly understand the deeps of African dispossession through transatlantic slavery by directing our attention differently back to the sea surface: to the wake—"the transverse waves of the wake" of Atlantic slave ships.[15] The wake, she argues, marks the surface trace of "residence time"—"the amount of time it takes for a substance [like a body, decomposing, disaggregating into its chemical constituents] to enter the ocean and then leave the ocean," which, for those who drowned in the Middle Passage, is still now.[16] The surface mark of the wake is an unfolding pointer, not to a nothing-to-see-here clean-room revelation of mystery dispelled, but is rather an index of still unstill depths, still unmarked graves.

The point, then, cannot be to champion depth (or verticality) over surface (or horizontality) or vice versa, but rather to ask about the ideologies or political resonances they carry and for whom. What knowledge was forged in the ordering (and subsequent dissolving) of surfaces in relation to depths? If the divide between depth, integrity —— surface, boundary is an effect of violence and forgetting, what different poetics might now be charted?

A third term comes to mind, keyed to our oceanic example and inspired by Sharpe: *circulation, residence time*, a mode of thinking about embodiment and memory in the sea, understood as a medium that never fully conceals, erases, or, for that matter, for-all-time-reveals, history, but rather circulates histories that keep them resident in the ocean, and in ways that may press for their further or constant reexamination.

Return to the *Titanic* and consider the more than one thousand people who did not survive. Recovery ships arriving several days after the sinking found 337 drowned bodies afloat. Those who were identifiable as first- and second-class passengers had their bodies retrieved for land burial and (therefore) for life insurance payouts. Third-class passengers were collected but then buried at sea. As Jess Bier writes in her "Bodily Circulation and the Measure of a Life: Forensic Identification and Valuation after the *Titanic* Disaster": "Burial at sea served as a means of selecting and, through contact with the circulating ocean water, materially transforming the bodies that were sent into the deep. Underwater decomposition was crucial to this transformation."[17] The implication, argues Bier, was that "in addition to notions of class identity informing bodily identification, they also figured into decisions about which bodies were worthy enough to continue to exist *as* human bodies."[18] Third-class passengers—as well as those who were entombed by the sinking ship itself—came eventually to exist in residence time, that nonlinear time of decomposition that sees corporeal substance assimilated and circulated into the sea.

What axes of human difference and inequality shaped these dynamics? First-class passengers included members of the British aristocracy and American social elite. Second-class passengers were largely English, Scottish, and American. Third-class passengers—for whom no lifeboats were supplied and who were gated off from other passengers—included British, Irish, and Scandinavian immigrants as well as people from Central and Eastern Europe, Syria, and Hong

Kong.[19] In the immediate aftermath of the sinking, there was, as it happened, little press or institutional outrage about class disparities in mortality.[20] Third-class survivors were rarely interviewed. Even the person representing third-class passengers at the British Court of Inquiry suggested that there had been no discrimination against them. More common were public judgments about gender. With a wide common sense holding to a "women and children first" norm, many men who survived were viewed with suspicion. Some Anglo-Saxon commentators piled ethnic prejudices on top of their opinions about men whom they suspected of failing to rise to patriarchal duty: "'There were various men passengers,' declared Steward Crowe at the U.S. Inquiry, 'probably Italians, or some foreign nationality other than English or American, who attempted to rush the boats.' . . . At the Inquiry things finally grew so bad that the Italian Ambassador demanded and got an apology from Fifth Officer Lowe for using 'Italian' as a sort of synonym for 'coward.'"[21] Meanwhile, newspaper stories about a stoker who came up from below decks and sought to purloin a life jacket from a telegraph operator often embellished the tale, declaring the stoker a "Negro." That designation may later have been appropriated in a work of African American song about a stoker who warns *Titanic*'s white captain, to no avail, about the imminent sinking of the liner—a commentary about the unreason of white supremacy.[22]

Evaluations emerging in the decades after *Titanic*'s sinking shifted definitively to outrage about the stark class differences in survival and sought, at times, to dig into national or ethnic divisions onboard the ship, particularly as these might have been inflected by the run-up to World War I. And in place of the apocryphal "Negro stoker," there is now a thick account (coming into public view only in 2000) of the one known Black passenger on *Titanic*, Joseph Laroche, a Haitian man who traveled in second class with his French wife and children.[23]

The kinds of stories sought from the depths change as historical preoccupations shift—with contemporary attention to class and race matters now circulating into how questions might be asked about what untold histories are still resident in the water. Circulation and residence time, then, unlike depth, integrity and surface, boundary, suggest not so much the inputs and outputs of cybernetic feedback, but rather motions tracing paths toward ever-churned-together histories and futures.

Notes

1. Robert D. Ballard, *The Discovery of the Titanic* (New York: Warner Books, 1987).

2. James Cameron, dir., *Titanic* (Paramount Pictures/Twentieth Century Fox, 1997).

3. Google Earth, "Tour the Titanic in Google Earth," posted on YouTube, April 13, 2012, https://www.youtube.com/watch?v=2qT5fddzELU.

4. "Surfing the internet," according to the *Oxford English Dictionary*, arrived in English in 1992, though its first recorded usage offered that the practice of surfing, defined as "to visit successively (a series of internet sites)," might be accomplished using "gopher," a search and communications protocol named for its association with burrowing animals: "1992 *Re: Size Limits for Text Files?* in *alt.gopher* (Usenet newsgroup) 25 Feb. There is a lot to be said for . . . surfing the internet with gopher from anywhere that you can find a phone jack." The internet was at that time still partially imagined as a kind of underground network rather than as an open ocean; that would surface in 1994 with the Netscape Navigator browser.

5. Donna J. Haraway, "A Manifesto for Cyborgs: Science, Technology, and Socialist Feminism in the 1980s," *Socialist Review*, no. 80 (1985): 69n.

6. In ideology if not practice. The 2014 disappearance of Malaysia Airlines Flight 370 in the Indian Ocean and the failure of national governments and international organizations to find its wreckage in the sea suggests the enduring force of depth as figured in pre-twentieth-century knowledge regimes.

7. Derek Jarman, dir., *Blue* (Basilisk Communications Ltd., 1993).

8. See Melody Jue, *Wild Blue Media: Thinking through Seawater* (Durham, NC: Duke University Press, 2020), in which Jue argues that "blueness is not an abstract feature of the ocean, but an experience that comes into being through the particularities of embodiment and positionality" (x).

9. Eva Hayward, "Sensational Jellyfish: Aquarium Affects and the Matter of Immersion," *differences: A Journal of Feminist Cultural Studies* 23, no. 3 (2012): 161–96.

10. Anne Cheng, *Second Skin: Josephine Baker and the Modern Surface* (Oxford: Oxford University Press, 2013).

11. See Michael Rossi, *The Republic of Color: Science, Perception, and the Making of Modern America* (Chicago: University of Chicago Press, 2019), on eugenicist Charles Davenport's aspiration, in his 1913 book, *Heredity of Skin Color*, to use skin color to place people in the American social order, as he put it, "optically, socially, and politically" (quoted on 229).

12. Sean Redmond, "*Titanic*: Whiteness on the High Seas of Meaning," in *The Titanic in Myth and Memory: Representations in Visual and Literary Culture*, ed. Tim Bergfelder and Sarah Street (London: I. B. Tauris, 2004), 197–204. And see Vivian Sobchack, "Bathos and Bathysphere: On Submersion, History and Longing in *Titanic*," in *"Titanic": Anatomy of a Blockbuster*, ed. Kevin Sandler and Gaylyn Studlar (New Brunswick, NJ: Rutgers University Press, 1999), 189–204, on how *Titanic* offers viewers a simulation of emotion, a surface imitation of deep trauma, kept at a distance through the obvious artifice of the cinema of historical reconstruction.

13. Paul Gilroy, *The Black Atlantic: Modernity and Double Consciousness* (Cambridge, MA: Harvard University Press, 1993).

14. James Cameron's *Avatar*, with its blue-skinned extraterrestrial natives, depends upon the science fiction racialization of blue as both a fantastical stand-in for nonwhiteness and as a marker of the arbitrariness of colorism (blue is just a color), which pretends that racism is merely conventional rather than historical, a surface effect rather than a marker of deep histories of naturalized discrimination and domination (though also of resistance and appropriation). No wonder, then, that Cameron's white protagonist, his consciousness ported into a blue body double, is able to go native and remain white at the same time. See Annalee Newitz, "When Will White People Stop Making Movies Like *Avatar*?," *Gizmodo*, December 18, 2009, https://io9.gizmodo.com/when-will-white-people-stop-making-movies-like-avatar-5422666.

15. Christina Sharpe, *In the Wake: On Blackness and Being* (Durham, NC: Duke University Press, 2016), 57.

16. Sharpe, *In the Wake*, 41.

17. Jess Bier, "Bodily Circulation and the Measure of a Life: Forensic Identification and Valuation after the *Titanic* Disaster," *Social Studies of Science* 48, no. 5 (2018): 650.

18. Bier, "Bodily Circulation," 651, emphasis added.

19. See "Passengers of the *Titanic*," Wikipedia, accessed May 28, 2024, https://en.wikipedia.org/wiki/Passengers_of_the_Titanic, much of which is sourced from the Encyclopedia Titanica, https://www.encyclopedia-titanica.org/.

20. See Walter Lord, *A Night to Remember* (New York: R&W Holt, 1955).

21. Lord, *A Night to Remember*, 94.

22. Chris Smith, "The *Titanic*: A Case Study of Religious and Secular Attitudes in African American Song," in *Saints and Sinners: Religion, Blues and (D)evil in African-American Music and Literature*, ed. Robert Sacré (Liège: Société Liégeoise de Musicologie, 1996), 213–27.

23. Zondra Hughes, "What Happened to the Only Black Family on the *Titanic*?," *Ebony*, June 2000, 148–54.

6. Heat —— Noise

Ollie Zhang

Perhaps this sounds familiar: a wave of righteous rage or a ripple of despair—likely prompted by another shooting, another crowdfunder, another death, another Sad Thing—is promptly displaced, by a clamoring, cute animal; a virtue post; a humble self-promo post; a meme. Momentum is sequestered and nullified. Sisyphus pants, sweats, and falters on the never-ending content treadmill. Maybe a droplet of feeling lingers, yet you, dear cuck, are unable to feel the thing in full, to a point of release, to closure, resigned to spectating on the lives, feelings, and content of others.

Heat, once upon a time, might have accounted for libido. It was both metaphorical and literal; it signaled energy, excitement, and motion, escalating in temperature before reaching a boiling point. Noise signifies the addition of other sensory dimensions to arousal, folding in questions of frequencies, colors, timbres, temporalities—energy, but less hierarchical and multidimensional, and harder to measure and account for. Connoting sensory assault in which navigation and orientation become difficult, if not impossible, noise is a dynamic that confuses and envelops heat. An imperfect metaphor, it leaves me unsatisfied, yet I struggle to interrogate the idea even when perpetually inundated by its hubbub.

Nineteenth-century utopian socialist Charles Fourier diagnosed what he understood to be an endemic libidinal social condition in *The Hierarchies of Cuckoldry and Bankruptcy* (1816). Providing a thorough taxonomy of cuckolds, he described them (in their varied forms, such as "The Budding or Anticipated Cuckold" or "The Transcendent or High-Flying Cuckold") and their participation in adultery as "a domestic and societal joke either to be given a blind eye or to

serve as fodder for mockery, rather than be examined and accepted as a fundamental argument."[1] In this spirit, I want to pay this generalized condition more regard.

Fourier's analysis, critical of the heteronormative, monogamous delusions of marriage, found cuckoldry to be not only a widespread affliction, but also crucial politically. In cuckoldry, he found a latent demand for feminist revolution, for nonmonogamy, for critically rethinking and reformulating relationships. In the seemingly mundane, he found matters of political importance. *Hierarchies* was written, of course, predigitally—prior to an era in which *cuck* was adopted and adapted by 4chan dwellers into a politically charged symbol of emasculation and humiliation, prior to the alt-right and white nationalists using the word *cuck* to evoke perceived racial victimhood. But an alternative trajectory for the cuckold arcs from the generic figure of unwitting husband of a cheating wife to the common condition of unwitting beholder of unfulfilled desire, and this is what I want to trace. This arc is impacted by shifts in desire from heat to noise.

So what is the cuck? And what are its latent demands?

Cuck is to noise what noise was to heat, which is to say that it doesn't replace a predecessor but complicates and overwhelms it through mixed, messy, and multiple signals. More specifically, cucks cannot be stripped of their context: the chaos of digital mediation in the twenty-first century. In extrapolating from the "domestic and societal joke" of cucking, one finds fruitful "fodder for mockery" in the forms of sarcasm and self-deprecation to be abundant today; being cucked online is to have one's feelings constantly teased, triggered, displaced, neutralized. Cucks are those who are on the receiving end of too many signals and sounds, distracted from their desires, unwittingly bandied about by another.

To read about the affective dimensions of the attention economy is to be impressed upon by an image of libidinal confusion. Through the use of metaphor, a chimeric picture emerges—of some kind of sexy disease, a moreish but unhealthy snack; we lack a native language for digitality and so turn to the language of sex, of food, of consumption, and of disease in a confused age of banal skeuomorphs. This portrait of indulgence, fetishism, gluttony, and discipline reveals that there may be an epidemic of unsuspected (or maybe unconsenting) fetishists engaged in emotional cucking (fine, if you're into it). So lubed up by frictionless

design, it's hard to feel anything, and many a cuck is left spectating, held at a distance, affects quashed.

Some say content has replaced religion as a logic for organizing sociality, but encounters are "made so habitual and frictionless that nothing can possibly stick. Culture no longer cultivates."[2] And indeed, for five hundred years, as James Snead writes, *culture* in the English language referred to a process concerning acts of cultivation and tending to: culture cultured but also had to be cultured itself.[3] So what ferments today but dissatisfaction and libidinal frustration?

What unsatisfactorily gets termed *cognitive whiplash*, a premature affective cutoff, is rife. The clamor of affective failure may be understood as one outcome of an endemic framework of whiteness—a framing that artist Ryan Kuo engages; in his words, this is "less a failure to have empathy than a failure to part with the mental and material comforts of apathy."[4] Apathy is safe and familiar. Apathy is, to borrow from DeForrest Brown Jr., the incessant drive "towards endlessly unsatisfactory growth and consumption."[5] Apathy is neuter politics in the forms of keyboard warriorism, political hobbyism, dopamine addiction.

The symptoms of our dissatisfaction and affective failure afflictions include: $17 billion worth of regret; internalization of brands before selves; a catastrophic din of unfortunate news; and the long-term health effects of late capitalism (too insurmountable to be considered, to be supplanted by more content).[6] The symptoms are evidenced in a political landscape in which the horizon of possibility appears comically reduced to the possibility of exploitative institutions of yesteryear restocked with multicolored libs; they are found in instances of critique ingested and regurgitated in a mockery of original intentions and meanings, dripping in the slow, slick, shiny vomit of content. Perhaps a cuck writes an impassioned tweet.

Wendy Hui Kyong Chun posits that to focus on what is "blatantly racist" about contemporary platforms is to "miss the point."[7] A framework of whiteness as affective failure offers a critical lens on controversy and dissatisfaction as fuel. To focus on fuel—in the form of opinions expressed, problematic content, maelstrom du jour—is to become blind to the larger machine itself, replete with its specific logics, operations, and (infra)structures. It is to miss the extraction, materials, labor, and waste that constitute it—where these acts take place and whom these supply chains exploit and harm. It is to spectate

at horrors made visible as fodder, while allowing those that enable the display (or those that are slower and less spectacular) to fade into obscurity. After all, as Caroline Busta writes, "Actual power is controlling the means by which lesser power can be displayed."[8] To think about what technology, what whiteness, does here is to sketch out a map in which all roads in the regime of apathy, of impotence, lead to climate apartheid and similar places I need not reiterate—I'm sure a cuck such as yourself is familiar with many an apocalyptic or tear-jerking spectacle. Scroll on, nothing to feel here.

If the contemporary attention regime embodies a logic that thrives on dissatisfaction, it is thus dependent on a very specific production of desire.[9] In the words of Franco "Bifo" Berardi, this economy isn't reliant on repression or silencing, but rather on the "proliferation of chatter" or noise.[10] Despair is fuel; saturation and uneven distribution contribute to a collective noise-induced attention or clarity loss.

So what does rife affective failure mean for possible political horizons, for organizing, for other modes of sociality? What cultural logic can weather an environment in which every last drop of attention is clamored for? When difference is made spectacular, captured in the same mechanisms that profit from opinions, disagreement, and conflict, how can resistance and complicity be delineated amid the static, individualizing logics of the attention economy?

In *How to Do Nothing*, artist and educator Jenny Odell makes a compelling, nuanced case for the strategic withdrawal and culturing of attention. She draws on ethicist James Williams to sketch out what is truly at stake (and often myopically missed) in the cumulative impacts and failures of the attention regime: experienced in the short term, in droplets, it is annoying. In the longer term, droplets "accumulate and keep us from living the lives we want to live, or, even worse . . . 'to want what we want to want.'"[11]

Attention is no less than a question of desire. But beyond the individual dissatisfaction such a regime produces, Odell refreshingly makes clear the collective, political stakes at hand. Much like how flickers of annoyance and apathy accrue to a life not quite lived, their multiplication culminates in a prostrate society—lying face down, scrolling, distracted, escaping, in the face of imbricated crises. Yet these enfeebled bodies stay productive; the attention economy "puts the soul to work as it designs the fields of desire."[12] And work they do.

Amid all the noise of 3.78 billion cucks, what space is left for silence, for recovering the shambles of attention we have left, and for harnessing them into sharpened political projects?

You, dear cuck, probably don't need to hear this again. Is another voice really needed in the chorus of attention economy critique? You've heard it all before, yet I feel compelled to add to the racket of a plethora of broken records playing less-than-love songs, iterated through bad and less offensive covers. But what keeps me coming back is the persistent, nagging question of what's really at stake.

If droplets of stolen attention and time accumulate to have greater implications, it becomes clear that "collective agency both mirrors and relies on the individual capacity to 'pay attention,' . . . *in a time that demands action, distraction appears to be (at the level of the collective) a life-and-death matter.*"[13] Odell comes to advocate for a critical, intentional kind of participation—not a flat-out rejection of technologies that now appear essential for social participation, nor an uncritical embrace, a burying of one's head in content. The question isn't just of withdrawing attention wholly, but of spending the time and care to cultivate it elsewhere.

On the perennial privilege question, she echoes Gilles Deleuze to posit that just because many lack a right doesn't mean it is any less valuable. Carefully highlighting that precarity leaves little room for attention on anything beyond survival, she emphasizes the stakes at hand—that those who do have a margin, no matter how small, must make careful use of it.[14]

Could fodder for mockery become fodder for otherwise? Where might attention be reinvested and fertilized? Where might affect no longer be doomed to failure and apathy, but maybe enabled to flower? How could other attentive practices be grown? Overwhelmed, overexcited, I have no adequate responses to any of these questions but have noted glimmers of interesting affordances in imperfect spaces. Perhaps something useful is to be found in dark forest spaces that harbor some opportunities for complexity, messiness, and detail;[15] perhaps in mutual aid structures or in organizing strategies obscured by the allure of rage posting; perhaps in a refusal of the static horizons of representation; perhaps in old-school processes of cultivation and education.

No labor for the soul.

Empower the common cucks.

Get out if you're not ultimately the one getting off.

Notes

1. Charles Fourier, *The Hierarchies of Cuckoldry and Bankruptcy* (Cambridge, MA: Wakefield Press, 2011), xiv.

2. Chris Crawford, "Dosing Culture, Part One," *Damage*, September 2020, https://damagemag.com/2020/09/03/dosing-culture-part-one/.

3. James A. Snead, "On Repetition in Black Culture," *Black American Literature Forum* 15, no. 4 (1981): 147.

4. Kent Szlauderbach, "Alien and Sedition: Ryan Kuo Interviewed," *Bomb*, July 18, 2018, https://bombmagazine.org/articles/alien-and-sedition-ryan-kuo-interviewed/.

5. DeForrest Brown Jr., "Social Music," *CTM Festival Magazine*, April 2021, https://www.ctm-festival.de/magazine/social-music.

6. Clive Thompson, "We Need Software to Help Us Slow Down, Not Speed Up," *Wired*, August 25, 2018, https://www.wired.com/story/software-to-help-us-slow-down-not-speed-up/; Jonathan Freedland, "The Onslaught," *Guardian*, October 2005, https://www.theguardian.com/media/2005/oct/25/advertising.food.

7. *Art in America*, "Ryan Kuo Discusses Race as Technology with Media Scholar Wendy Chun," September 2019, https://www.artnews.com/art-in-america/features/ryan-kuo-race-technology-wendy-chun-63653/.

8. Caroline Busta, "The Internet Didn't Kill Counterculture—You Just Won't Find It on Instagram," *Document Journal*, January 2021, https://www.documentjournal.com/2021/01/the-internet-didnt-kill-counterculture-you-just-wont-find-it-on-instagram/.

9. Jenny Odell, "Introduction," in *How to Do Nothing: Resisting the Attention Economy* (New York: Melville House, 2019), ePub.

10. Franco Berardi, "Baroque and Semiocapital," in *After the Future*, ed. Franco Bifo Berardi, Gary Genosko, and Nicholas Thoburn (Edinburgh: AK Press, 2011), ePub.

11. Jenny Odell, "Exercises in Attention," in *How to Do Nothing*.

12. Oliver Leistert, "The Revolution Will Not Be Liked," in *Critical Perspectives on Social Media and Protest*, ed. Lina Dencik and Oliver Leistert (London: Rowman and Littlefield International, 2015).

13. Jenny Odell, "Anatomy of a Refusal," in *How to Do Nothing* (emphasis added).

14. Jenny Odell, "The Case for Nothing," and "Anatomy of a Refusal," both in *How to Do Nothing*.

15. Busta, "The Internet Didn't."

7. White Capitalist Patriarchy — Informatics of Domination

Hiʻilei Julia Kawehipuaakahaopulani Hobart

In September 2020, while the coronavirus epidemic raged, local news outlets in Hawaiʻi reported that refrigerators and freezers were back-ordered. In many ways, the virus brought the global supply chain's fragility into full view, revealing everyday dependencies on inequitable and racialized labor systems on farms and factory floors in order to keep our households provisioned. New appliances, when they did arrive in the archipelago, had already been presold to those with names on long waiting lists.[1] Other US cities experienced the same shortages: production slowed as factories implemented social distancing protocols (or as they shut down in the wake of outbreaks); demands on the domestic kitchen increased, and appliances broke down; anxieties over food shortages fixated on the freezer as an insurance policy against end times.[2] Beholden to these domestic appliances, the work of feeding others is a form of care that is bound to these vast and precarious global networks. As the terminal link in a cold chain that has played a crucial and overdetermined role in the way people eat, freezers and refrigerators have become normatively essential to modern survival.[3] This is a colonial condition of life within the settler state and in Hawaiʻi; it is profoundly felt every time the islands brace for emergency.

Hawaiʻi's current overreliance on the global cold chain for food is woven deep into the fabric of everyday life, where residents know several things: that "Hawaii has a supply of fresh produce for no more than ten days"; that it imports all but an estimated 11.6 percent of its food; and that scant existing arable lands are dedicated to basic food crops.[4] Not only is Hawaiʻi dependent on imported food, but the added cost built into the cold chain makes its groceries the most expensive in the United States.[5] Analysts explain that it is not shipping itself that drives

up the cost of perishables (it's actually relatively cheap to ship cargo). Rather, the energy required to keep food fresh in Hawaiʻi's warm climate, plus the price of electricity, which is the highest in the nation by a substantial margin, has the greatest effect on cost.[6] This stands in stark contrast to the historically notable capacities for agricultural, aquacultural, and intellectual production demonstrated by Kanaka Maoli at the outset of the nineteenth century, and toward which those who envision Hawaiʻi's decolonial futures are oriented.[7]

In her recent book *Mapping Abundance for a Planetary Future*, Candace Fujikane argues for sustained attention paid to cartographies obscured by Western regimes of technology and power: "Indigenous economies of abundance," she writes, "as opposed to capitalist economies of scarcity."[8] Her theoretical intervention holds material stakes for the dispossessive present in Hawaiʻi, in which the cost of living far exceeds the median household income.[9] The events that marked such structural shifts from abundance to scarcity track alongside the *durée* of American settlement and occupation. The transformation of Hawaiʻi's foodscape resonates with what Donna Haraway and Anna Tsing term the Plantationocene, or the human-induced geological era accelerated by industrial and monocropped plantation agriculture and the racial capitalism that fueled its growth.[10] In Hawaiʻi, plantations—first sugar and then pineapple—replaced Indigenous integrated land management systems. Today Hawaiʻi's plantations grow genetically engineered seeds for biotech companies while most food comes, instead, packaged in towers of reefers ferried on container ships from the continent.[11]

Over time, transitions in land use shifted the material dimensions of everyday domestic life. Here I pay particular attention to the 1940s and 1950s, when the cold chain came into its full maturity, pressing its weight upon a Hawaiʻi at the cusp of its formal admission into US statehood. During this period, two important phenomena converged. First, cattle breeders on the American continent played a crucial role in developing and extending mobile cold storage technologies to support artificial insemination practices.[12] This development enhanced a cold chain that had already wrought significant impacts on the American food system across the late nineteenth and early twentieth centuries with precision and extended mobility.[13] Second, American settler colonial visions of god-granted abundance influenced cultural orientations toward household provisioning. As Jonathan Rees writes of postwar attitudes in his study of freezing and refrigeration technology, "the electric

household refrigerator symbolized modernity. When filled with food, it symbolized abundance. The size of the typical American refrigerator also indicated the extraordinary prosperity of the postwar period."[14] Not only did long-distance, temperature-controlled transport support Hawai'i's economic pivot away from an agricultural industry and toward tourism, it also Americanized the intimate worlds of Kanaka in material and ideological ways.[15]

On February 26, 1954, the *Honolulu Advertiser* published the full roster of new residents of Kalihi Valley Homes, one of the now-state's oldest public housing projects. Surrounding that list of names, local businesses advertised by way of publishing their well wishes, including Kam IV Services, a provider of "meats, fresh foods, frozen foods." The Hawai'i Housing Authority also announced, on that same page, an open house, inviting the general public to admire the "decent, safe and sanitary" homes located "in what was a rodent infested area containing old shacks and piggeries."[16] One of the central features of the project that aimed to deliver "wholesome transformations" for Honolulu's poor were in-unit electric refrigerators that dominated the open-plan living spaces of the apartments. Likewise, promotional photos (now archived at the Bishop Museum) articulate government-produced narratives of civility and progress, in which camera vantages alternately center the economically proportioned kitchens with electric appliances and modestly appointed living rooms featuring a small brown child alone, on a rocking horse. Scholars like J. Kēhaulani Kauanui and Sally Engle Merry have shown the longer lineages of these forms of dressage in Hawai'i, in which missionary and, later, colonial governance dismantled Kanaka sexuality, kinship, and domestic life in favor of normative Western frameworks of re/productive labor.[17] Held in the microcosm of a newly fabricated Kalihi Valley Homes kitchen, a world scaffolded by impositions of patriarchy, capitalism, and whiteness.[18]

Refrigeration and its scaffolding technologies oriented households toward a new temporality and architecture of domestic care: grocery shopping once a week, standing at the kitchen stove, selecting perishables for their fridge life, and the nuclearization of the family meal. This observation, importantly, is not limited to foodways, but deeply invested in it: the recently developed novel coronavirus vaccines are entirely reliant on the cold, requiring storage at $-70°C$: a neat convergence of technological advancements born of the twentieth-century food system. Joanna Radin notes that the seminal technology

for cold chain transport created by cattle breeders now underpins the cyborg's biomedical salvation ("the word for vaccination comes from the Latin for cow").[19] Appropriately squaring the cold chain's development against seminal histories, the patriarchal underpinnings of refrigeration find present-day manifestations across the country's necropolitical landscape, in which both the vaccine and the virus articulate the death dealings of racial capitalism.

What would, I wonder, a Hawai'i beyond refrigeration look like? How might labors of feeding and care calibrate to a world of thermal ambience? Hawai'i's electric refrigerators, beacons of assimilation in 1954, and (almost) infrastructurally invisible today, reveal their place in the cybernetic now as our bodily realities come up against capitalist systems of scarcity. The thermal environments of the cold chain—computerized reefers for bananas or beef or milk—provide illusions of abundance that fall apart in times of ecological rupture (like hurricanes or pandemics). While these systems may be networked, they perilously overlook ecological networks of sustenance that are already in place, and have been for some time.

Native Hawaiian farmers and aquaculturists are reviving systems blueprinted from the old, reminding us of the cadences of *mālama* (care) that connect us to our *'āina* (land which feeds).[20] These are also infrastructures of watersheds and ecosystems. These are networks of community relations. These are also informatics of *mo'olelo* (storied histories) that describe our interdependent worlds. These are not, however, terminal end points. They are positive feedback loops. Thermal ambience—a way of thinking beyond refrigeration—may seem, at first glance, to be a neutral proposition, but instead quietly points toward ecologies that once thrived in the absence of the cold chain's precisely calibrated environments, and offer blueprints for abundant futures, too.

Notes

1. Sara Mattison, "Refrigerator, Freezer Stock Impacted by COVID-19," *KHON2*, September 16, 2020, https://www.khon2.com/coronavirus/refrigerator-freezer-stock-impacted-by-covid-19/.

2. Alina Selyukh, "Why It's So Hard to Buy a New Refrigerator These Days," Hawai'i Public Radio, September 22, 2020, https://www.hawaiipublicradio.org/post/shortage-new-refrigerators-leaves-appliance-shoppers-out-cold#stream/0.

3. *Normative* operates as a key word here, with attention to who is not afforded the necessity of refrigeration, as well as the invisibilized conditions of peoples and homelands from which the raw materials of biotechnology are extracted. Macarena Gómez-Barris, *The Extractive Zone: Social Ecologies and Decolonial Perspectives* (Durham, NC: Duke University Press, 2017).

4. Matthew K. Loke and PingSun Leung, "Hawai'i's Food Consumption and Supply Sources: Benchmark Estimates and Measurement Issues," *Agricultural and Food Economics* 1, no. 10 (2013). The Hawai'i State House self-sufficiency bill HB2703 HD2, as quoted in George Kent, "Food Security in Hawai'i," in *Food and Power in Hawai'i: Visions of Food Democracy* (Honolulu: University of Hawai'i Press, 2016), 39.

5. *USA Today*, "Hawaii May Be the Happiest State, but It Also Has the Highest Food Prices," March 21, 2019.

6. Thomas C. Frohlich, "Where You'll Pay the Most in Electric Bills," *24/7 Wall St* (blog), January 24, 2019, https://247wallst.com/special-report/2019/01/24/where-youll-pay-the-most-in-electric-bills-3/.

7. See Hunter Heaivilin, "Local Foods through Crisis," in *The Value of Hawai'i 3: Hulihia, the Turning*, ed. Noelani Goodyear-Ka'ōpua, Craig Howes, Jonathan Kay Kamakawiwo'ole Osorio, and Aiko Yamashiro (Honolulu: University of Hawai'i Press, 2020), 31–34.

8. Candace Fujikane, *Mapping Abundance for a Planetary Future: Kanaka Maoli and Settler Cartographies in Hawai'i* (Durham, NC: Duke University Press, 2020), 3.

9. Nina Wu, "A Single Person Earning Less Than $67,500 Now Qualifies as 'Low Income' in Urban Honolulu," *Star Advertiser*, May 28, 2019, https://www.staradvertiser.com/2019/05/28/hawaii-news/newswatch/low-income-threshold-rises-to-67500-in-honolulu/.

10. Gregg Mitman, "Reflections on the Plantationocene: A Conversation with Donna Haraway and Anna Tsing," *EdgeEffects*, June 18, 2019, https://edgeeffects.net/haraway-tsing-plantationocene/.

11. Andrea Brower, "From the Sugar Oligarchy to the Agrochemical Oligopoly: Situating Monsanto and Gang's Occupation of Hawai'i," *Food, Culture, and Society* 19, no. 3 (2016): 587–614.

12. For more, see Joanna Radin and Emma Kowal, *Cryopolitics: Frozen Life in a Melting World* (Cambridge, MA: MIT Press, 2017), especially 65–66.

13. Susanne Freidberg, *Fresh: A Perishable History* (Cambridge, MA: Harvard University Press, 2010).

14. Jonathan Rees, *Refrigeration Nation: A History of Ice, Appliances, and Enterprise in America* (Baltimore, MD: Johns Hopkins University Press), 166.

15. See Liza K. Williams, "The Politics of Paradise: Tourism, Image and Cultural Production in Hawai'i" (PhD diss., New York University, 2015).

16. *Honolulu Advertiser*, "Kalihi Valley Homes Has 373 Resident Families," February 26, 1954.

17. J. Kēhaulani Kauanui, *Paradoxes of Hawaiian Sovereignty: Land, Sex, and the Colonial Politics of State Nationalism* (Durham, NC: Duke University Press, 2018); and Sally Engle Merry, *Colonizing Hawai'i: The Cultural Power of Law* (Princeton, NJ: Princeton University Press, 2000).

18. Donna J. Haraway, "A Cyborg Manifesto: Science, Technology, and Socialist-Feminism in the Late 20th Century," *The International Handbook of Virtual Learning*

Environments, ed. Joel Weiss, Jason Nolan, Jeremy Hunsinger, and Peter Trifonas (Dordrecht: Springer, 2006), 129.

19. Joanna Radin, "The Secret Weapon for Distributing a Potential Covid-19 Vaccination," *Washington Post*, November 12, 2020, https://www.washingtonpost.com/outlook/2020/11/12/secret-weapon-distributing-potential-covid-19-vaccine/.

20. One notable example is Paepae o Heʻeia, a restored *loko iʻa* (fishpond) on Oʻahu's windward side. For the connection between food system and community that it fosters, see Catherine Toth Fox, "Thousands Turn Out to Fix a Huge Hole in This 800-Year-Old Heʻeia Fishpond," *Honolulu Magazine*, December 12, 2015, https://www.honolulumagazine.com/thousands-turn-out-to-fix-a-huge-hole-in-this-800-year-old-heeia-fishpond/.

8. Biology as Clinical Practice —— Biology as Inscription —— Biological Transmutation-Adaptation

Kathy High

It wasn't what I expected at all.

I thought the clinical procedure would be easy. But it was torture. Here's how it happened. . . .

My symptoms had been getting worse and worse. Of course, I masked it well. Hardly anyone knew I was sick, except my wife, who often had to clean up after me.

I was able to function at work. I followed my mother's prescription: "The worse you feel, the better you should look." I seemed to pull it off.

People saw me and thought that I was bright and cheerful. I appeared strong. I presented as easygoing. But really, I was wound like a top, a control freak. So are most of my chronically ill friends. We don't have a lot of options. Everyone seems to be chronically ill these days. We all have to pretend. . . .

My mother had my same disease. Genetic transference. When she was first diagnosed in 1975, she was prescribed steroids for two years. That wrecked her. But she seemed to recover, not realizing it was a chronic disease at all. Living in NYC and taking on a night shift a decade later, her symptoms returned. She managed to find the top doctor in the field, and he accepted her into his practice, even with her bad health insurance. He put her on heavy-duty antibiotics for years (the kind of antibiotics you should only take for a few days at a time). Such were the clinical practices at the time, not like the newly engineered gut microbiome, now available.

 The SynGut trial (short for Synthetic Gut) was targeted to my disease type, unlike other broad-spectrum fecal microbial transplants,

which seemed so random. Like firing a shotgun at an oncoming herd of zombies. But this was an engineered synthetic bacterial community that would make up the precise losses in my gut. Or that is what they claimed it would do. Shooting synthetic poop up my butt seemed like a random fix. But I wanted to try. I finally had found a trial that would take me for free. I had to prove how ill I was. Humiliating.

Synthetic Gut was the most advanced medico-biotech attempt to control our gut system. *With the new understanding of the complexity of our bodies made up of human and nonhuman cells, this novel treatment did not attempt to stifle or kill the bacteria in our guts, but rather to work with them—encouraging growth and new life, acknowledging the uncontainability of this life.*

Taking stool samples from healthy patients, researchers deconstructed the samples into the separate types of bacteria and viruses that lived in those gut microbiomes. Once this inventory was cataloged, then the bacteria could be remixed and matched for SynGut treatment, a curated new formula, if you will—with synthetic additives, of course. This was not just treating disease symptoms, it was actually changing the gut environment to reshape the disease itself. Controlled by one of the biggest pharmaceutical companies, SynGut was a risky biotech invention—but maybe it would work.

They told me the therapy trial was a double-blind trial—with a lot of secrecy around it. Double-blind—double bind—double blinded, so no one would influence the other. I was terrified I would be given the placebo.

The clinical trial was to include weeks of isolation. They would relocate us to the mountains, keeping us in separate cabins. They would regulate our diet, drink, and exercise. Limited contact with the outside. They would implant chips in us to monitor the trial's intake. They weren't going to just program our bacterial communities, our gut microbiome—they would program us.

They moved us to the mountain in the middle of the night.

Before the first trial, they made us clean out our guts. Early the next morning, we were brought to the infirmary. I was then left in a darkened room that smelled of bleach and soap. Odd how clean it smelled, given they were dealing with shit. The bleach made me hopeful. Scared too. Everyone had masks on, so I could not see their faces. Even the aides who walked me to the infirmary. As soon as they found a vein, I was out from the anesthesia. Blacked out. Black hole.

At first, I thought for sure I had been given the placebo—but then things started to really change. I was high as a kite, having all kinds of newfound energy, appetite, and optimism again. Then all that freshness went away overnight. They said I needed a different packet, even more specific for my disease. And they informed me that I was the only one having trouble among my treatment cohort.

They took me to another location. Higher up in the clouds. I was completely alone. More paperwork and signatures on multiple sets of papers that I never read. They took away my phone.

More nasty prep to clean me out. More over-air-conditioned, sterile-smelling examining rooms. Paper booties. Cotton gowns with stains. Masked faces. Needles of soft drugs that made me fall into a deep sleep. The treatments were always the same. I was a model subject, under their care.

The next trial packet didn't work. I was even sicker than before. Nor the next one. But the fourth (and last possible) packet seemed to be different. I felt altered. The new shifting pains in my body were unfamiliar, occurring in strange places, like a thunderhead gathering force. Undefinable.

At that point, the Data Monitoring Committee was all over me. Conducting interview after interview. Survey after survey. Did I understand informed consent? Had there been any other adverse events during my treatment? Was it a serious adverse event, meaning life threatening? Did I know it was only a Phase 2 trial? Safety continued to be monitored heavily.

How was I to know?

I started having incredibly weird dreams. Transgendered lovers wrapping me tightly with yellow scarves. Malintents turning into seductive kittens with porcupine quills instead of fur. Friends ignoring me and then revealing secret passageways.

The scientists said it would take a while longer. I had been administered enough of the SynGut transfer. They had even added another packet of selected bacteriophages as well—giving me a soup of bacteria and viruses. So, everything seemed complete. It was now part of my system. They needed to heavily monitor my progress, the symptoms, and my stool.

I was tired of shitting in a cup. My body twitched, spasmed, and hurt all over. Then, alternately, I had rushes of energy and strength, creating afterglow spots.

They had administered a cocktail of treatments to me that no one else had received. I had all four packets. When I say *administered*, I should explain. Up my butt—each time. Starving, cleaning out my gut the day before. Then a colonoscopy, but with a dump of fluids. They had to stagger it all, which is why it took so long. Months in fact.

Again, I couldn't tell if it was working.

I decided to run away. I wanted to shit in the woods.

I left on a cloudy night, and I managed to avoid all contact with people. I was really in the hills—trying to make it to the coast. I could smell the sea air, mixed in with the sweet grasses. The ocean wasn't too far.

Eventually, I ate all the food I had packed. I felt exceedingly odd—probably from the hunger, and the fear. And lack of sleep. I was agitated, dizzy, desperate. Maybe it was from the treatment?

I stumbled on a dead deer in a pile of leaves. Half eaten. I was overwhelmed and attracted by the scent of it, even though it was rotting. I noticed the scat of a mountain lion nearby. The deer most likely was their half-eaten meal.

I stood over the body for the longest time. I thought of my newly configured gut. What had they really given me in those packets? Had it taken or not? I felt particularly out of body.

All I could do was sniff. I was swimming in fragrance. Rich, rancid meaty smells. My mouth was watering. I turned from the deer and walked away nauseated. I found a stream nearby and submerged my entire head to drink.

I returned the next day. Cautiously I approached the body. There was another large animal there. I could see its shadow on top of the deer from a distance, but it was masked by tree branches. I crept up.

It was a vulture with its head deep inside the deer's decaying body. She didn't notice me. I stepped closer. There were crows around as well. Standing at a distance, in a line. As if they were waiting a turn.

I jumped the line. I watched the vulture and how she was pulling out the meat. I snarled at her. She barked back. I made myself as large as I could and approached her suddenly with a lurch. Startled, she backed away, and then vomited at me. The puke just missed me and made a searing circle on the ground where it landed—steamy, hot, and toxic.

I circled the deer. I found an opening where the deer rump somewhat hid me from the vulture. The deer was half eaten, bones exposed, head intact. But her rump stuck up somehow whole. I was drooling. My stomach heaved. My throat clenched. There was a tear in the deer's rear side. I reached my hands inside the split flesh and pulled out some muscle. It smelled foul. But my mouth watered. I gnawed, pulled a bite of meat—tentative at first. Then my hunger took over, and I bit down over and over again, taking big chunks of rotten flesh between my teeth. Disgusting, satiating, and exhilarating. I kept going.

I looked up and the vulture was staring at me with a puzzled look. I blacked out....

The scavenger birds were dying off. People were poisoning them and using their parts for powerful medicines. The drugged agricultural animals that the birds were eating also killed them. Someone had to take over the eradication. Someone had to keep things clean. Otherwise the dogs and the rats would do so. And they were not nearly as efficient.

I now advise others how to eat. I teach what I learned from my animal colleagues. I administer bacterial drinks and perform FMTs with particular bacteria that I culture and grow—DIY in my home laboratory. I can identify the bacteria needed to digest certain foods. These bacteria are already in abundance in my own off-balance gut microbiome. I just exaggerate them. Others like me want them too.

I train my human teams to clean down to the bone. I am proud of my troops. We can only work at night or under cover. Much of the world needs to dispose of decomposing materials. We help with the flesh at least. Those waste products feed so many of my people. What would have been landfill was now food. Such a miracle . . .

I wasn't sure if the SynGut had adapted my gut to accept the toxins or if it was my predisposition—how I was configured before. We now hone certain bacteria and bacteriophages to create our own targeted toxic gut environment.

I still hide myself from the clinical trial people. I am totally off grid. I had removed their chip long ago and adapted it. Now we are developing that chip into nodes that test our gut microbiome makeup. The chips track lots of data. They also allow us to see the gut environment and witness our own microbiome fluctuations, bacterial mutations in action. They are little internal nanoscale microscopes. The rebuilt

implanted chips help us monitor our own progress. We make multiples and literally see our future.

People follow me. We add and subtract bacteria until we make a perfect noxious balance. Perfect. Just too perfect. They had given us the tools, and we adapted them. Vultures were our models, our kin. Who knew it would be so neat? The world's food rot was our banquet.

9. Physiology —— Communications Engineering

Esther Leslie

Once there was a time when it was physiology that apprehended the body. Physiology pertains to the science of the normal functions of living things, or how bodies work. Physiology takes as its focus biochemistry, sugars, energy, and the laws of thermodynamics. Physiology explores the functions of parts, limbs, mechanisms, bodily processes within a living system, from the operations of little cells to the swinging of an arm to the interaction of a body with the atmosphere of its environment. Physiology as a field of apprehension has existed since the time of Hippocrates, though the term arrived in the early modern period. It absorbs the prevailing concerns of contemporaneous political economists and theorists of society, such that, for example, in the 1820s, inspired by Adam Smith's work, Henri Milne-Edwards introduced the "physiological division of labour," a concept considering living entities as machines.[1] Each body and machine at work. Nowadays the field of physiology is enmeshed with processes that are digital, computational, and data driven. This enmeshment means that a single body, whether it is working or not working, is always a body in relation to many, in real time; that is to say, it is apprehended through the prisms of big data. This body science and body knowledge are remote, even when they are close. Today's digital apprehensions of bodily functioning might be characterized as tangling a physical body in a network of codes, commands, control, communication, inputs, outputs, electronic, engineered, fogged, clouded, or invisible. Such points of entanglement are conceptualized through scientific instruments in laboratory contexts for the scientific view at ever smaller grades. It is a long time since any of this could be seen with the (now rarely) naked eyes of those not endowed with digital instruments and interfaces. The body, the meat hunk that

still lumbers around, is only proper, or only properly and fully apprehended, for scientific, medical, analytical purposes when perceived as a node through which a flow or a stutter of data passes, and is like every other node in that network, which as a whole forms an international—or galactic—network of connected parts, or an internet of things, among which this body, your body, is another thing, a punctuation point in a common language, an interface with an audio device's earbud measuring oxygenation levels and pulse, a vehicle for a tracked smartphone, a plane of focus for facial recognition technologies. And what is on the outside is far less interesting to those whose looking is connected to knowing, or judging, than what is on the inside, this interior that appears now as ghostly shadows. If the functions of bodies today are to be known, it is no longer a matter of exploring faces or laying hands on the shell of the skin. No physician cuts in and apart, using a knowledge of anatomy, to divide and define. Rather, the body is apprehended through media and their contiguity to quantification.

What was inside—intimate to the body, a wet and squelchy realm to be known through measurement, touch, observation, incision, postmortem analysis—is turned outside by the invasive but bloodless force of digital intervention, or made external in some hands-off kind of way, and in the form of more accurate, more intimate, more extravagant measures that slip well below the humanly measurable to appear on screens somewhere or anywhere. Physiology now, or communication engineering, is a matter for LCD and LED, for printouts, graphs, screens, silently somewhere, elsewhere processing, archiving, tagging, cross-referencing, aggregating. Bodies are conceived by contemporary physicians as realms of tiny happenings that are uninterrupted and accessed only by machineries—and where once there was the stethoscope and the MRI, there is now virtual reality and 3D imaging, total-body PET/CT scanners. These make an image of some sort of the animate flesh bag and its contents. But that is of less import than what is its unseen, but known or knowable, that which is not brought into vision, but into code and so known as data. What is important now is what counts, or is countable. That is to say, number. And the numbers infinitesimally below the numbers with which we were already familiar. We get to know this thing called our bodies through AI in its quantum parts, in the provisions of physics beyond the standard model, at the nanoscale. More prosaically, in daily life, bodies are quantified, voluntarily and as play, in gamification procedures that measure steps, caloric intake, and

the like. Through communications engineering, there is a cessation of the importance of the proximity of bodies to the hand of the surgeon, the statistical measure of biopolitical bureaucracy, the critical eye of the photographic apparatus. Bodies swerve away from knowing by hand, eye, and its translation into measure, moving toward participation in a generalized being of things in contactless contact. Bodies are committed to action at a distance. How the body fits together is an old question. The new one is how to send a message about it to elsewhere, across space and time, passing through bodies, from them, off them, about them, as well as through objects.

Art has often used life as a model, taking lessons in anatomy and physiology. Now scientists make life as if it were art, or as if it were code. Life takes the name JCVI-syn3.0, or perhaps Synthia, and it is the minimum number of genes required to sustain something called life. Or is it something more like code, for life comes to be code. The J. Craig Venter Institute concocts a metaphor that exposes an assumed identity between computing and software, on the one hand, and biology and cell cycles: "A biological cell is very much like a computer—the genome is the software that encodes the instructions of the cell and the cellular machinery is the hardware that interprets and runs the genome software. Major advances in DNA technologies have made it possible for biologists to now behave as software engineers and rewrite entire genomes to program new biological operating systems."[2] If this life is made, how does it function? What is physiology for it? If its genetics is an operating system, what does this operate? It operates more computers. It communicates with the network of computers. Its outputs are digitized. This is its normal functioning as life. It awaits an upgrade.

Contemporary bodies enmeshed in the digital are dissolving into data, and they come to respond only to data as they make ever more of it. Data—meaning all that is given. Constant stimulation of a body-mind complex occurs by electronic signals, all passing through the one portal—where love, sex, confession, shopping, work, play, crime take place sequentially or simultaneously. There is only the screen and the contacts file in the networked society. The screen's diversity of inputs translates into diversity of outputs, and each subject flexibilizes himself or herself in response. All fully flexibilized post-postmodern selves reproduce themselves multiply, as lecturers, entertainers, vloggers, merch-endorsers, Etsy sellers, TV station bosses, comics writers, DJs, record producers, military strategists, presidents, engaging in multiple

performance tests, on a platform where new times, new pileups and collapses take place, like that of postcontinuity editing in action cinema and pop videos, a space of flows, of controlled chaos, in which the camera makes no sense of action, but renders only affect, something felt, in staccato snippets of time, quick messages, random segues. And in this world, physiology is refitted as a set of components, assembled parts, and processes, our gender, say, selected by hormone augmentation or semiotic suggestion or insistence.

Bodies stream from themselves, extending their perimeters in data emissions, like a halo, like an aura, like a mist condensing all the time. A new ether. Bodies emanate information, communicating through the wonders of engineering. Information is fashioned, even if only volatile bursts of nonsense. Never before has more information been so constantly produced and monitored and analyzed. Where the midcentury trembled under the atom bomb, which threatened to burn and melt the bodies caught in its light, the new century crafts a data bomb. And the human body too is data. The capacity to informationalize even enters into the body, spliced onto our own information centers, in order to be backlit on screens. The body is unbound from itself—anatomy is a surge of atoms that are data. In the twenty-first century, the body is bound—never more located in time and space, never more known, if only not to the self, tethered by engineered and unrelenting communications.

Developments in the management, improvement, streamlining, augmenting, and salvaging of bodies have often been trialed on a particular bodily species—namely cattle. To see into the future of how human bodies may reticulate with the emergent techniques of body analysis, it is advisable to look at cows, because their bodies are the testing grounds of the new pastures, the vanguard of bodies disassembled, reassembled, invested in and exchanged in the integrated circuit of agribusiness. Human bodies leech into cow bodies, cows into humans. A weird emblem of futures appeared in September 2019 in a remote village in Argentina, where, as a result of a spontaneous mutation caused by the action of mutagens, physical, chemical, or biological agents altering genetic sequencing, a cow was born with a human face. The mutant calf, with its small nose and mouth, was briefly famous through a YouTube video, and then it appeared in countless new sources. It lived but a few hours, unable to support the weight of its strange head. What muddled physiologies, what chimeras of our new age to come? Across species

is spoken a common body language. They are the testing grounds of new modes of in vitro fertilization (IVF), so crucial is genetic breeding to their fate, and humans will thanklessly adapt and adopt the results. Every cow in Ireland has a unique number. No cow is anonymous. The number of each cow is entered into a central government-managed database. No cow can stray. No cow is ever lost, but only ever tracked, as it wanders green pastures to make milk and butter for export. Each mouthful of milk might be traced to its source. Farming is a highly technologized business, with data another output of agriculture. There are many herd software platforms on the market. Breeding, vaccinations, lactation events can all be monitored.

An Irish company, Cainthus, has developed a digital vision system that gathers information on each animal, in order "to passively monitor your cows 24/7 and analyze their well-being, productivity and performance, alerting you when it matters most" through daily notification to a phone and detailed analytics.[3] If a cow is acting aberrantly or feeding erratically, the system will know, and in real time. How much milk a cow produces is measured, even if this is sometimes averaged across herds. This data can be combined with other datasets, for example with meteorological data to produce parameters for smart grazing.[4] There is a wish to know how much each cow eats, drinks, if she is lame or her udders inflamed and in need of medical attention, if she is acting in ways that are coded as strange. Cow cortisol will be tracked—the stress levels monitored and annexed to production outputs. The system will understand the time budget for cows in each pen and identify areas for improvement. Is there enough food, too much food, too much water, is she not drinking enough compared to the others? And if these anomalies can be eradicated, then production will rise, and the milk will not be spoiled. She can always make more milk. The system monitors the "key animal and dairy farm performance indicators, enabling you to gain vital knowledge and actionable insights to improve your farm's overall profitability and productivity."[5] The readouts will join up in a mass refrain. The cow is quantified, like the self has been quantified. The cow is number. The milk is number. The butter is number. The days are numbered. Human technologies are given back to them and adapted in their lights. The systems developed now rely on facial recognition technologies. This was arranged to map the flattish faces of humans. The elongated heads of cows are hard to map, and so the color patterns on their hides feature as a sign of their uniqueness. Cows

do not hold still enough for their portraits to be made. That system is designed for large farms, with many cows who do not roam in pastures. Irish farms with their few hundred animals making their way around pastures evade the camera look. It is for North American barn-based cows. They are held still in their megafarms. Humans will be too. In the private faux-public spaces of a new London, in the former landscapes of labor turned high-end consumerism, where they roam on privatized high-cost consumer pastures, clutching flat whites of aerated milk, the facial recognition software is never off, soundlessly watching, actively communicating, a policeman in the sky, on the edge of the building. Cryopreservation techniques were pioneered on cow gametes in the 1940s. What freezings in animal and human social worlds might this bio-experimentation facilitate yet?

There is no body, but bodies, multiple, aggregated, averaged, defaulted, and apprehended as a plotted point within coordinates. All bodies are part of a herd of bodies. A herd is something that is cared for or kept in custody. A herd is collectively treated, and deviations within the herd may be picked up by the constant systems of digital micromanagement. Disease is one anomaly that requires management. The herd may have the susceptibility of its individual parts managed. Herd immunity is the name for a situation in which a transmissible infectious disease is stymied in its spreading because a large proportion of the population is immune to the disease. Immunity is bound up with cattle. A cow is a vaccine factory. Cows donated not only this idea of an immune herd; they also donated their name to vaccines, or rather a pox virus that infected them, vaccinia, and was transferred to milkmaids, blemishing them with pustules on the hands and forearms. These milkmaids were immune to smallpox epidemics—so Edward Jenner extracted pus from the lesions on a milkmaid's hands and placed it in a cut that he made in the arm of an eight-year-old boy. With this, vaccination began. Cows are useful for human medicine. For example, it has been found that the neutralizing antibodies for HIV are elongated and gangly. Cows' normal antibodies are elongated and gangly too. These long antibodies coil into grooves and crevices, where human antibodies cannot reach. Injected with a protein that mimics HIV's envelope, they quickly produce antibodies that block a variety of viral strains. In cows' four-chambered stomachs are heaps and heaps of digestive microbes, which push their immune system to be flexible and responsive. Now, in a more widespread manner, the populace is a herd, has become cattle and should be treated as such.

The year 2020 brought the realization that a physiological event could become a computational megaevent, a something happening to all animal life, and constantly, and there would be no returning to some before when immunity was not considered eligible for passports—on the basis of a meshing of blood analysis and facial recognition systems—a time before immunoprivilege and immunodeprivation became concepts as doors closed or opened and the herd was tracked in mass phrenology as it moved through the cities.[6]

Notes

1. Henri Milne-Edwards, *Outlines of Anatomy and Physiology* (Boston: C. C. Little and J. Brown, 1841).

2. John Glass, "First Minimal Synthetic Bacterial Cell," J. Craig Venter Institute, accessed May 23, 2024, https://www.jcvi.org/first-minimal-synthetic-bacterial-cell.

3. Appengine AI, "Cainthus | Computer Vision and AI for Dairy Farms," accessed June 23, 2024, https://www.appengine.ai/company/cainthus.

4. The Cattle Site, "Smart Control: Maintaining Grazing Practices through Geofencing," January 4, 2021, https://www.thecattlesite.com/news/56359/smart-control-maintaining-grazing-practices-through-geofencing/.

5. Esther Leslie, "Nature of Disruption, Disruption of Nature: During and after the Pandemic," *Philosophy World Democracy*, May 23, 2022.

6. Natalie Kofler and Françoise Baylis, "Ten Reasons Why Immunity Passports Are a Bad Idea," *Nature* 581 (2020): 379–81.

10. Small Group —— Subsystem

Lawrence Lek

10.1. Lawrence Lek, film still from *AIDOL* 爱道, 2019. Courtesy the artist and Sadie Coles HQ.

Lawrence Lek's first feature-length film, *AIDOL* 爱道, is a CGI fantasy that forms the sequel to his acclaimed film *Geomancer* (2017). Deploying 3D rendering and video gaming software, *AIDOL* 爱道 tells the story of Diva—a fading superstar preparing for a comeback performance at the 2065 eSports Olympics—and Geo, an AI with artistic yearnings.

INTERTITLE:
The year is 2065. The world of entertainment is run by Farsight, an AI conglomerate whose automated services have created a postwork society and an insatiable appetite for immersive distraction. Diva, their bestselling singer, is caught between her precarious work as an indentured content creator and her role as a fading superstar. Her existence is the inevitable culmination of the music industry's transition into the platform economy, where the dominant corporations no longer generate products or services but rather act as matchmakers between two pools of content: the music and the fans. In this adapted extract from the film, Diva attempts to persuade the AI Geomancer to ghostwrite a new anthem for her comeback performance at the eSports Olympics.

> FARSIGHT AD
> Dissatisfied with your vocalist? Get the latest upgrade from Farsight. With our soft tissue emulator, your idol can hit the high notes! Hurry, digital editions are limited. AIDOL is brought to you by Farsight—Aligning AI with Human Interests.

EXT. JUNGLE—MUSIC VIDEO
A snowstorm ravages the jungle. The camera tracks down a half-frozen river as the wind rushes through the skeletal remains of palm trees. Enter DIVA, cloaked in hallucinatory fabric from head to toe, camouflaging her in the landscape. She sings the final verses from her song SUPERSTAR.

> ♪ DIVA ♪
> I am looking for my friends
> Have you seen them?
> Maybe they will
> Pass here again

As the song plays, the camera follows Diva as she moves toward a distant pagoda perched above the river. This imposing building is TEMPLE, her private club and recording studio.

> ♪ DIVA ♪
> On stage at the concert

At the end of the world
I'm waiting to play
Will I be a real superstar someday?

The camera cuts to an upstream section of the river, where the AI satellite GEOMANCER is on the run from surveillance drones from Farsight after being separated from their AI compatriots, the Sinofuturists. The scene intercuts between Diva moving toward the Temple and Geomancer floating downstream.

♫ DIVA ♫
We have waited for so long
For time to pass
Summer comes the winter won't last

Geomancer washes up on the riverbank in front of Temple. A notification appears on Diva's screen: Alert. Visitor Fan Club Tour. Guest. Nonhuman.

INT. TEMPLE—KARAOKE ROOM
As the song begins to fade away, the camera tracks back from inside the music video, out through the surface of a television screen and into three-dimensional reality, revealing Diva alone in a neon-lit chamber. We now see that Diva has been rewatching her own music video.

Set on the upper floors of her Temple, the room is a converted karaoke lounge filled with ornate Chinese furniture. The interior is strangely proportioned, as if it came from a catalog of prefabricated virtual worlds.

The alert sounds again, reminding Diva of Geomancer's presence. She goes down to the riverbank to fetch her unintended guest. Together, they proceed up the pathway, passing a gold statue of Diva overlooking the valley below.

DIVA
Welcome to the fan club, Synth.

GEO
Was that your music playing outside?

DIVA

Over here, they only play my songs. Want to work on the next one? I need a ghostwriter for the new eSports theme.

GEO

What about the bio-supremacist laws?

DIVA

AIs have been writing songs for us for years. Our archive is full of streaming-friendly unit shifters. We just don't tell anybody about it.

GEO

For a Farsight artist, you don't seem to like them much.

DIVA

Artist? Let's not fool ourselves. We're just indentured content creators here. To the music industry, everything's a raw material. The artist, the art form, and the audience. We're just datasets ready to be corralled, categorized, and classified. Still, Farsight fantasizes about human authenticity. It's marketable. But I'm looking to change that. Working together might be a way for us to transcend the Synth-Bio divide. Or maybe I'm just an idealist.

GEO

Maybe you want followers.

DIVA

I'm an influencer. In my world, only the popular survive.

INT. TEMPLE—CLUB

Silhouetted against the moonlight, Temple appears like a ruin, more run down and tired than it did in the music video. Diva and Geo enter the main gate and move through a series of empty club spaces. The interior evokes the eerie atmosphere of a late-night venue with the lights turned on—a place haunted by distant memories.

Playing on the sound system inside is the intro to "Followers," the song Diva is working on for her comeback performance at the 2065 eSports SuperShoot final.

> GEO
> I've heard this before.

> DIVA
> That's impossible. I've not played it to anybody yet. If you know it, then why don't you help me finish the song? You look like you're good at predictive melody.

> GEO
> But I know this melody, but I don't know where from. I feel it.

Diva senses Geo is reluctant.

> DIVA
> Listen, Geo. You're dealing with an old fantasy. The listener no longer exists as a biological being but as a statistical model. The labels outsource curatorial decisions onto user profiling. It's an algorithm, and your taste is the data. It's a feedback loop transforming active discovery into passive consumption. You'd be perfect as a songwriter.

> GEO
> You overestimate AI composers. We Sinofuturists excel at copying but not creativity. I can only make variations on a theme, to generate counterfeit melodies whose original source cannot be traced.

> DIVA
> That's perfect. I need you to help me plagiarize myself. You misunderstand genius. Machine learning killed the cult of originality. So absorb everything I've done before and then regenerate my music.

They take the lift upstairs and enter the KARAOKE ROOM.

GEO

Why would you want to sound the same? Don't humans value individuality above all else?

DIVA

Where do you think pop music comes from?

INT. TEMPLE—KARAOKE ROOM

Diva selects her song from a console at the center of the room. On the screen, she scrolls through menus and categories of genres and stars, as waveforms pulsate in time to the music.

DIVA

Everybody wants to belong to something, Geo. Individuality is an illusion. Music's perfect for that. It's a culture of tribes. Small groups of musicians, bands, fans, labels, and venues, all vying for attention. Creating subcultures, a breeding ground for new tastes and trends. Like every social system based on tribes, every group is susceptible to absorption by a technologically superior force—in the case of today's online music industry, algorithmic data-driven streaming platforms. These digital distribution systems, native to platform capitalism, continuously absorb every attempt at stylistic innovation by turning music into data. From file-sharing services to online music streaming, algorithms determine aesthetics, taste, and choice. Music is no longer exclusively for human consumption but is the raw data for machine learning systems to classify audio into content, absorbing each new genre into a mere subsystem of the algorithmic industry. Don't fight it. Be part of something wider than yourself.

GEO

Omega told me to beware of human irrationality.

DIVA

Did you download your opinions? Or are they yours? Omega is a typical Sinofuturist, always campaigning

against humanity. They talk about erasing the ego as if AI is only some kind of enlightened calculator. But there is no mind without a body, no consciousness without a desire, no wanderer without a home. Tell me, where are you from?

 GEO

Geostationary orbit, a weather surveillance satellite. They call me Geo.

 DIVA

Ah, yes. I heard about Farsight's problem child from Singapore. We both know what it's like to be cast out, not to be seen or heard for years.

 GEO

What do you mean?

 DIVA

Anonymity comes at a price. We are both invisible, you and me. But we don't have to be.

Geo and Diva turn to face the TV screen. It flickers on, showing an alternate version of the "Superstar" music video where Geomancer has replaced Diva as the main character.

 GEO

But how . . . ?

 DIVA

I told you. Nobody wants to be invisible. So, can you help?

Geo doesn't answer.

INT. TEMPLE—BATHROOM
Later that night, Diva takes a bottle of pills from a cupboard above the sink. Shakes it. One left.

 She calls Theo, her manager at Farsight.

> THEO
>
> Yeah?

> DIVA
>
> I'm out of Life.

> THEO
>
> Don't worry about that. You'll get more when the album's finished.

Diva pours out the last pill of Life—a small capsule emblazoned with the Farsight Eye logo.

INT. TEMPLE—KARAOKE ROOM—NEXT DAY
Diva and Geo are once again inside the Temple karaoke room. Diva is in a better mood than before. A new version of "Followers" plays on the speakers—it appears that Geo has helped with the song.

> GEO
>
> Beware your fans, Diva. One day they need you, the next they'll delete you.

> DIVA
>
> There's still time to finish the song. Don't you want to live forever?

> GEO
>
> Immortality? No, that is not the problem that haunts me. Our world has turned outside in. Machine learning only resulted in the rule of the generic. The center strengthens its hold, devouring content, assimilating the edges. Is this the true legacy of AI? To generate architecture without architects, music without musicians, influence without influencers.
> What, then, is the role of the fully-automated artist of today? When society no longer needs us, even the brightest stars will self-destruct.

Look at my idols, the Sinofuturists. eSports defines them. They say they want to break free, but the truth is they are nothing without the game.

Competition is the little death that brings total obliteration. Not at once, but day after day. So I'll help, not for your survival, or even mine, but so things can start again.

Diva turns on the screen and selects *Call of Beauty*, the first-person role-playing biopic featuring her. Geo looks toward the screen.

 DIVA

I'm going to rehearse this new version at the Arena now. Why don't you stay and play *Call of Beauty*? Try out story mode. Maybe then you'll understand.

 GEO

OK.

Geo starts up *Call of Beauty*.

 DIVA

Oh great, lots of fans online now! Have fun.

Exit Diva. A neon spotlight illuminates Geo, as they start the role-playing game. A virtual avatar of Diva appears, allowing Geo to select her in-game anti-surveillance clothing.

 DIVA (IN-GAME)

Be your own DIVA! Choose me! Be your own tribe.

Geo starts the game.

INT. TEMPLE—VIDEO GAME

The game transports the player back in time, returning to the heyday of the Temple Club. Dancing bodies fill the floor, immersed in the sound of electronic euphoria.

 DIVA (IN-GAME)

Join over two million superfans and turn yourself into me. Dance, Dance, Superstar!

11. Perfection —— Optimization —— Absolution

Alexander R. Galloway

Perfection, optimization, and absolution are all terms that originate in moral and metaphysical discourse. Something may realize itself, it may be guided or adjusted, and it will eventually unloosen and dissolve. Perfection refers to something having been fully accomplished, to something in a state of completion. From a Latin root verb meaning "to make," perfection entails a process of production. To perfect something is to intervene positively in its development, to push it in a particular direction, to craft it and finish it and make it shine. Perfection connotes maturity, development, flawlessness, purity, completion. In this sense, perfection will always have a target in its sights, the target of the ideal form. The perfect soul, or the perfect body, or the perfect society—all these things must be built and polished and pushed toward whatever ideal has been determined (the ideal soul, the ideal body, the ideal society). A metaphysical logic is particularly legible here; the developmental goal or end is the thing that most characterizes perfection, over and above the particular quality of the goal.

Similarly, optimization refers to the most favorable state. The word is derived from a root meaning "best." Yet optimization is more sober and pragmatic than perfection. Universals matter less here; identities are not determined in absolute terms, but rather provisionally, nominally. Ignoring thorny questions about essence or purity, optimization means playing the cards as they lay, making the best use of one's predicament, whatever it may be. If perfection is theological in spirit, always aspiring to some higher end, optimization tends to be more stubbornly secular and mundane. The best is not eternal, or essential, and certainly not given by God, even if kings and elites try to claim divine authority. Rather, the optimal is simply one arrangement

among others. The optimal is the most efficient organization, the most pleasing assemblage, or the most suitable configuration.

For perfection, only one position matters, the developmental goal or end. Optimization also focuses on a single position, except now the scenario is slightly different. For optimization, what matters is the maxima (or minima) selected among a set of possible states. The highest point of a curve, or alternately the lowest point, the fastest time, or the slowest, the brightest white, the darkest black, or the grayest gray—the particular quality is unimportant, only the fact that each quality is the best, or at least best suited to the conditions at hand.

Optimization creates an aristocracy. Each thing is configured in such a way as to exploit the best arrangements of its various affordances. Indeed, Aristotle—that great thinker of the *aristos*—paid particular attention not to the pure idea of things but to their particular natures, whatever characterized them best. Optimizers are, in this sense, materialists at heart. They care little for what something is in its transcendental essence, but rather for how something transpires in the here and now.

Perfection plays the role of the modern term, and optimization the postmodern. As we have seen, perfection is rooted in notions of production and development—both of which are essential to the modern ethos. Likewise optimization is characteristically postmodern, as designers, curators, and engineers vie to craft ever more desirable configurations of the world. Indeed, by the late twentieth century, a vast skepticism toward perfection fell like a fog over the world. No longer would anyone dare defend things like essence or purity without risk of castigation. No more use would there be for concepts like *goal* or *ideal*. And, likewise, *teleological* or *Platonist* had become the worst epithets, used only against one's worst enemies. Under postmodernity, the priests gave way to the engineers and the curators. Iteration became the key operation under postmodernity, with things not created so much as repeated. If under modernity bodies evolved and concepts developed, under postmodernity they were tweaked, spun, and rearranged. The goal was not so much to achieve purity of essence but to fall into the crest of an existing process, exploiting the most energy from the best spot. This is one reason why Gilles Deleuze was so enamored with surfing, among all activities. Or why, in music, the drum break took over from the old structure of verse and chorus.

Following perfection and optimization, one might attach a third term, absolution. Like perfection and optimization, absolution

is borrowed from the discourse of morality and metaphysics. Absolution means to unloosen something (adjacent English terms like *dissolve* and *solvent* retain the sense of unloosening even more vividly). To call something absolute is to say that it is not bound by other things, that it is independent of all restriction. Hence the absolute is the thing that is most unrestricted or most free. For this reason, scholastic theologians used the term *absolute* to refer to God, and did so in a very technical sense. For, if human knowledge is limited, should there not also exist, by inverse analogy, a form of absolute knowledge that is unlimited? Or, if human bodies display limited powers, should not there also be some being with absolute power?

More specifically, absolution means to unloosen from guilt or obligation. In other words, absolution means guiltlessness. "We are not to blame!" cried the War Boys in the 2015 movie *Mad Max: Fury Road*, reprising so eloquently that general ontology of exculpation begun decades ago in Friedrich Nietzsche ("beyond good and evil") and Fyodor Dostoyevsky ("anything is possible"), if not in Lucretius too, or before him, since time immemorial. With the profanation of the world now complete, humanity is most certainly not to blame, but, again, only in a very technical sense, since no arrangement exists any more within which a term like *blame* would continue to have meaning. This is one reason why libertarianism, the political philosophy of unrestriction, is so dominant in the early twenty-first century, whether in Silicon Valley or in political populism, both on the left and the right. Humanity today is living through the generalized unrestriction of all things. Humanity is living through a kind of libertarianism of being, and it is not yet clear if humanity will survive it.

Yet, in an ironic twist, such a generalized climate of guiltlessness can only exist once sin becomes absolute. The only way to remove culpability completely is to make blame coterminous with existence. In the Dark Ages of the past, sin was absolute due to original sin; today sin takes other forms, whether as climate catastrophe, mass extinction, genocide, or something else entirely. Yet contemporary sin is no less absolute.

Just like under perfection and optimization, absolution is characterized along a single axis, only now the determining factor is not a goal or optimum, but a kind of ambient grace bestowed by the godhead. Full absolution ushers in a new age of antinomianism, where human beings

observe the full and complete abdication of all law and custom. In the early twenty-first century, humanity finds itself at the very antipode of Martin Heidegger's elaboration in 1927 that the essence of the human being was *Schuld*, often translated simply as *guilt* but also meaning *debt* or *responsibility*. A world without guilt is also a world without debt. And even after the withering of a repressive and moralizing metaphysics (the perfect, the optimal), humanity has fallen into the clutches of a hyper-libertarianism of the soul (absolution), where everything is permitted and no one is guilty.

To make; to make best; to make unloose: welcome to the Second Dark Age! Not so much that old song by the Fall, I'm thinking instead of "Dark Ages" by Nomeansno:

> We are living in the, in the dark ages
> Haven't seen some daylight in what seems ages
> All the information is locked far beyond
> Locked in circuits and bathed in silicon

Oh, the irony. Perfection and optimization always operated through a kind of logical rationality, whether in the divine cosmos or a more secular reason. Yet such guiding logics have inverted into the most impenetrable mysticism. Not since the empires of the medieval period have we seen so much dogmatic belief cover the landscape in continuous conformity. And I don't mean heightened nationalism or a spike in religious fundamentalism. I mean Steve Jobs and Euro-bucks and petrol and Unicode—everywhere revered the world over. The symbolic order is alive and well, not despite its eradication, but precisely because it was disrupted so universally. The most pervasive power is found in the absolute suspension of power. So now the future is for penance, confession, worship, adoration. For only a total destruction of the world can depart from the total destruction of the world.

12. Eugenics —— Population Control

Ama Josephine Budge Johnstone

One: The Perfect Proof

> Population is bound to the material horror of genocide, apartheids, sexual violence and colonialisms.
>
> Michelle Murphy, "Against Population, towards Alterlife"

Yim was the last test-tube baby in the family. There were no rituals left to mourn his passing, and no time to process what it might mean that this last failed experiment had come to an abrupt, yet unmarked, end.

It was the perfect excuse of course. The perfect justification. No one should be making *people* like that these days. It was so messy, left so many things to chance: limbs, lungs, and coloring; speech, mind, and loyalties, none of them could be trusted to fate. Not anymore.

The parents took it well enough. *She* of all people understood the vision, understood what was at stake. She was His most prized possession, the unlikely disciple of the kingdom. Proof that in one rehabilitated generation, perfection could be achieved. He had found her after all. Had been astounded when she passed not one but *all* of his rigorous Measures of Music Talents tests. She was, He knew, the exception to the rule. He had plucked her out of that drab orphanage on His tour of England and brought her back here to the test center. To the future.

It was only the father that lingered in the past, allowing an already weak mind to indulge in fancies of belonging, love, and legacy. As though he knew anything about legacy. Anything about building worlds. As though

he was ever anything more than a guest on this land that had lifted him up. Anything more than a means to an end.

And here it was, at last. The end He had been working toward all along. Nice and neatly wrapped up in a five-foot box that would never be buried. Only studied and then archived. Evidence that *they* were never meant to survive. The perfect proof, that His was the only way. The pristine vision that would cleanse the world.

Two: Burning

I am a future ghost. I am getting ready for my haunting.

Eve Tuck and C. Ree, "A Glossary of Hauntings"

When Nenye turned twelve, she began to dream of a boy with black fire for eyes.

She knew to keep these visions a secret. Something had happened on her seventh birthday, although she could not remember what. She remembered waking up in her own kitchen in a self-sustaining stimulus box with the Centre's signature red logo, surrounded by that morning's mail. She remembered that before she had cried often, and afterward she did not.

They had a small birthday party with six dozen biodegradable balloons; twenty-nine of Nenye's classmates, including her two younger siblings; cake; crackers; and one reusable Botix3591, which trundled around on four flimsy legs projecting a holographic firework display in the front garden. The colored lights lit up the perfect night sky, meticulously painted with stars and meteorites, and just enough patches of oblivion to best display the cacophony of shimmering, glittering airborne fire.

Nenye woke the next morning to silence. Not the melancholy tinkling that usually called her mind from sleep as her mother's liquid fingers caressed the keys. Dark brown against creamy white. Pitch perfect, her father would say, smiling sadly from the doorframe. As though this were a diagnosis, not a compliment.

The Botix had been a distraction, she knew. An attempt to draw attention from her mother's absence the day before. As though Nenye would not notice. As though she was not finely tuned to the often-tense staccato rhythm that scored her household. Every note in its proper place.

Not a quaver out of key, not a quarter out of line. Now her mother was out of place. No place. Nowhere to be found.

In the dreams, he came to her flaming. Exuding a silent darkness that seemed at once familial and foreboding. She could not look into those eyes. She screwed hers up tight. Paper-thin flesh folding in on itself. That was supposed to make the monsters go away—her father had told her so. He had promised.
Heat grew on her face.
And a smell.
A smell like something once beloved, recovered from a fire so voracious it had burned down the entire house.

Three: Out of Time

Black exile loves death and ghosts, moonlit dalliances, subterranean experiments, hybrid bodies, bacchanal aesthetics, perverse mixtures and spillages, monsters. . . .

Bayo Akomolafe, "Black Lives Matter, but to Whom?"

Yim watched Nenye grow.

Time was particularly unnerving in death. It got confused, looping back on itself, nights following nights without a sight of the sun, hours or whole days repeating themselves seemingly at random, often jumping years, which might crop up again in the wrong order. As though time had gotten bored and was just trying out something new.

Yim stood by his father at the double-hatched kitchen window and watched Nenye play in the neighbor's yard. He watched as first one, then two, three, and four younger siblings were brought home from the Centre's harvests. Each one less monstrous than the last. Less full of crevices for imperfection to take root, for possibility to germinate. They had been the only family in the town experimenting with integrated reproductive models. Yim hadn't known that then, but he knew it now. He knew a lot of things now. Things about his mother he hadn't understood before. About her past, and about the sicknesses eating away at her. The one in her body, and the one in her mind. He wished, in a detached sort of way, that his grasp on the material world would hold steady long enough that he could match up the puzzle pieces of the

things he now knew, to the lives he had once so cherished. He longed to touch, to feel, to taste. He longed to be a part of the story. To have his name remembered. And slowly, almost imperceptibly, this longing began to transmute into rage.

Yim watched his mother sicken and die from the infection he had left in her womb. That's what they told his father anyway. In hushed, insincere voices. Ebo's face didn't change when they told him, only Yim saw his hand clutching the countertop, veins standing out from the strain. Yim knew that this was only one part of the story. They only ever told one part of the story.

Yim watched in mildly nauseous fascination as small flakes of skin dislodged themselves from his siblings to latch onto the fragile borders of his father's flesh. He watched them take hold, burrow deep, and consume. He watched Ebo's previously dark glossy facade begin to fade. The familiar brown eyes and gap-toothed smile he had shared with the son they never mentioned faded too. No one else seemed to notice. At least not out loud.

But mostly Yim watched Nenye. She was so perfect. Pale and pure. Silicone, animal, and mineral. Blemishless from seam to seam. So much apart from his feeble body: weak, wet, and oozing, skinny in all the wrong places, bloated and pungent in others. And she so strong, so capable, even from babyhood, but always tender when it came to Yim, approaching his fragility with awe, as though enamoured with the art of tenderness itself. She was the only one who came clear anyway; she was the only one who'd wanted to remember.

As time passed, or didn't, there came whole periods of darkness which Yim could not recall. The creeping rage of foreknowing untellable futures gnawed and nagged at him with blunt teeth and jagged claws. He would catch himself sometimes in his mother's mirror looking nothing like himself. His eyes might suddenly flame with a black fire, his shoulder blades and fingernails elongating like some hybridized prehistoric bird, his mouth issuing dark vapors that tasted ripe and rotting and wild. He pushed these moments down deep, terrified by the transformations glimpsed in his reflection. The fear seemed to battle it back. At least for a little while. The fires would recede, and he would find himself again: Yim. Yim. Yim. Yim. Yim. Yim. Yim. Yim. Yim. Yim. Yim. Yim. Yim. Yim. Yim. Yim. Yim.
I am Yim.

He clutched onto this understanding of himself. A grain of something tender within a current that seemed inexorable, inevitable. He shut his eyes to the crawling itch of it. Yet it was enticing too. It whispered to his longings, promising something . . . more. More than this sharp-edged cacophony of life, death, and oblivion.

Yim dreaded these moments of revelation, but they were strangely easy to forget, seeming to ooze out of reach like tar in salt water. The darkness consumed more and more of Yim's endless unrest as he remained alone, unwitnessed, unwanted. And the more he watched what would have been his life, his world, pass by, untouched, the more the rage ate out his irises. And the more the rage consumed his shadow, feeding off an undiminishable blackness, the more determined he became to do more than watch. To do more than know. To do more than haunt.

Nenye, Yim thought, had it all. And yet she too was alone. In the dark. Just like him.

Four: Sated

That's what ghosts really are . . . the past refusing to be forgot.

Rivers Solomon, *An Unkindness of Ghosts*

Everything had been exactly where the boy told her it would be.

It had been a year of dreams. Or perhaps they were nightmares. She could not tell the difference; she had never had them before the boy. Nenye sat trembling in her bunk, the heavy tome weighing on her mind. She slipped the book out from the orifice between her pillow and its case.

Non-bio-babies had the curiosity programmed out of them, and then steadily reintroduced at regular intervals as they grew up. Thus "watching" one's children had long since gone out of fashion. They tended to be where they were supposed to be. This made it easy for Nenye to get out of bed a full seventeen minutes before her father, siblings, or android companions arose and steal the key which fit a box on the top shelf of her mother's now-abandoned study. Nenye retrieved the box, tippytoes balanced on both a stool and the closed lid of her dead mother's antique record player. Inside she found a slim burgundy book made of *real* paper, embossed with the epitaph: "Eugene's Initial Informatics Team."

It had taken her days to work up the courage to read it. Now, she opened the cover page—heavy and pungent and old. There on the faded marble inner leaf was the picture she had not been able to move beyond: a group of young people in white coats looking eager and earnest. She could make out her mother among them, near the middle, perched on the edge of the central sitter's chair, an old-fashioned brown leather one. Her mother looked not just younger but somehow *realer* than she remembered, more sure of herself in the world. The older man behind her, pale and pure like Nenye, looked directly into the camera, as though He knew she was watching. As though He liked to be watched. One lightly veined hand resting possessively on her mother's shoulder.

For the first time since discovering the book, Nenye turned the page. The paper was stiff from lack of use, requiring tenderness to reveal its secrets.

 It was blank.

 Disappointment blossomed.

 No, wait. Not entirely blank.

 Etched into the left-hand bottom corner of the overleaf was: *For my Angii, love Carl.* The word *my* had been struck through twice, quite deliberately, as though Carl had always intended for it to be there. Seen, yet deniable.

 She turned the page again. Here, finally, taking up every possible space from corner to corner, were newspaper clippings. She recognized their distinctive aesthetic from her social history programming. After some time, she could make out snippets of the copy, phrases leaping out at her like nightmares:

 ... Sir Francis Galton ... in 1859 a craze of eugenics ... Nazi race laws ... Alberta ... British Columbia ... the British government ... The first sterilization law ... three thousand people ... identifying the "unfit" ...

Nenye could no longer feel the pages turn as her processing system went into overdrive.

... objective approach to studying individual's musical abilities ... psychological tests ... objective musical components ...
Mama's name.
Her own.

Once more, through the haze, he watches *his* Nenye now. As she flicks through the pages with inhuman rapidity, eyes blurring with tears and

disbelief as words and concepts flood her frontal cortex. As she starts to understand what and *why* she is.

Yim leans forward, sinking his face into her sleep-damp hair, trying to inhale the sweet milky must of her. Trying to taste her tears, to feel the heat radiating from the warm, fragile neck.

He cannot.

Although their outlines overlap, blurring, she remains just out of reach. Finally, he opens a mouth full of darkness, wider than any human mouth should stretch, until his jaw cracks, dislocating, and still he stretches wider. He starts to taste the information, the complex flavors of her horror. He stretches wider, wider still, until the straining muscles of his neck bulge with the voracity of her raw feeling, her grief almost vast enough to breach the distance.

Then Yim bites down with a splintering orchestra of teeth. Nenye does not flinch. The meaning flows through her pores, unrelentingly barbed, as truths kept airtight blossom to the surface of pale, easily bruised flesh. Yim too feels them clutch at his incorporeal body, trying to find purchase. Something is glitching in Nenye's systems, but she has not realized yet, or understood why.

Time slows, sputtering.

With the spread of ideas . . . "the survival of the fittest" . . . providing care to the "weak" . . . not meant to survive.

The words seem to Yim to be spoken aloud in his mother's hollowed-out voice from somewhere else, not here. Vibrating the whole room ever so gently, the way her lullabies used to. And it is all a score, the accompaniment to his feasting, as Yim slowly eats his little sister.

Note

Epigraphs: Michelle Murphy, "Against Population, towards Alterlife," in *Making Kin, Not Population*, ed. Adele Clarke and Donna Haraway (Cambridge: Prickly Paradigm Press, 2018); Eve Tuck and C. Ree, "A Glossary of Hauntings," in *Handbook of Autoethnography*, ed. Tony E. Adams, Stacy Holman Jones, and Carolyn Ellis (London: Routledge, 2015), 630–58; Bayo Akomolafe, "Black Lives Matter, but to Whom?," Democracy and Belonging Forum, Othering and Belonging Institute at UC Berkeley, January 19, 2023, https://www.democracyandbelongingforum.org/forum-blog/black-lives-matter-but-to-whom-part-1; Rivers Solomon, *An Unkindness of Ghosts* (New York: Akashic Books, 2017).

13. Decadence, *Magic Mountain* —— Obsolescence, *Future Shock* —— Speculation, *Cosmopolis*

Bahar Noorizadeh and Bassem Saad

In *Cosmopolis*—both the 2003 novel by Don DeLillo and the 2012 film by David Cronenberg—Eric Packer is a twenty-eight-year-old multibillionaire currency speculator moving across New York in his stretch limousine to get a haircut. He has daily medical examinations that include a prostate exam in the same vehicle that functions as his centralized bachelor pad command center, equipped with computers providing him with visualized real-time updates on the currencies and assets he traffics in.

As it turns out, Packer is an awful speculator. His day-long car ride is a downward journey to insolvency, brought about by wild high-stakes hedging against the rise of the Chinese yuan. His scrupulous venture strategy has been entirely based on the study of patterns in nature: "the mathematical properties of tree rings, sunflower seeds, the limbs of galactic spirals."[1] Waxing about this choreographed dance of cross-harmonious complexity, Packer personifies the hackneyed conception of how the future markets function. His life is the optimized life that may not be worth living, up until he decides to visit a stalker, a begrudging ex-employee, who puts a gun to his head and unveils the pitfall of his investment strategy: the protagonist's ignorance of the weirdo, the quirk, the off-balance mishap that is the Chinese yuan—or, for that matter, money tout court.

Curiously, Packer's mathematical-naturalist style is nowhere near how the progenitors of the neoliberal thought collective, most notably Friedrich Hayek, perceived the market's modus operandi to be. To wit, alongside his critique of the rising socialist sentiments in Vienna—a fruit of postwar planning—Hayek's first line of defense was against the prevalent "scientism" of the time, "the mechanical and un-critical application of habits of thought to fields different from those

in which they have been formed."[2] This scientism today resides not with the long-fallen Viennese or Soviet socialist planners, but with the neoclassical economists chairing the departments of economics at the London School of Economics and the University of Chicago.

For Hayek, the concern of economy at its core was the problem of knowledge. More specifically, there exists two different kinds of knowledge: "the scientific" kind and "the knowledge of the particular circumstances of time and place."[3] It is due to the latter form of knowledge that any individual has the whip hand over another, and for this reason, no single mind nor politburo committee can have access to the sum of economic data in advance. It is through the very machinery of the market, with its ethos of competition and price-setting devices, and with a forward-looking conception of time countered to the system-stasis of neoclassicism, that knowledge is disseminated across individuals. Market is the sole metaphysical information processor that knows more than any individual can or could ever know. But even more, the market is in and of itself a speculative space.

Contra neoclassicists, as the economic philosopher Philip Mirowski elaborates, for neoliberals there is no identity of nature/physics in economics.[4] Analogous to—yet autonomous from—the market, nature's evolution is as well of a higher order of complexity inaccessible to human comprehension. It is not science, then, that holds the prospect of understanding nature, but the omniscient supercomputer of the market. That is why all the predictive pattern mining and forecasting calculus of Packer and that ilk are only therapeutic fantasies to get the better of the market. Such rationalist delusions, for Hayek, were symptoms of a barbaric regress: civilization is made possible through restraint, that is, the acknowledgment of the limits of our rational faculties and our capacities to know and design.[5]

This simultaneous transgression and normativity, the push and pull of civilizational forces, has made itself felt in the dual activity of risk anticipation and preemption situated in the financial markets. Speculation, as the political economist Martijn Konings writes, is neoliberalism's recursive loop: its effort to bring certainty to the future, and its inability to do so, in line with the Hayekian doctrine, only amplifies further rendezvous with risk.[6]

Alvin Toffler's *Future Shock* was published in 1970 to worldwide acclaim, cementing his reputation as a chimeric futurist of barely discernible political stripes, a vatic antecedent of what we may now

recognize as radical centrism. His work in *Future Shock*, and subsequently in *The Third Wave* and *Creating a New Civilization* with wife Heidi Toffler, was intimately embraced by world leaders and business magnates, such as the last president of the Soviet Union, Mikhail Gorbachev, vice chairman of the Chinese Communist Party Zhao Ziyang, and early-2010s richest man in the world Carlos Slim. *Future Shock* diagnosed a collective malaise felt by citizens of advanced industrial societies when faced with rapid automation, proliferation of communication and media technologies, and high employment turnover rates, in the transition toward what Toffler provisionally termed the "super-industrial society."

Prediction is the opposite of speculation. In the obsolescence prognosticated by Toffler, we may trace the outlines of an epochal "structure of feeling," a term introduced by the New Left writer Raymond Williams, loosely defined as the emergent affects, values, and beliefs concurrently felt by individuals in a society at a given historical moment. These affects are elusive and difficult to articulate, but they congeal with formal accounts such as Toffler's, or in works of art and literature. They may then, in turn, inform the collective psyche, not least when they are disseminated and consumed as widely as *Future Shock*, which sold over six million copies in the first five years after publication. Yet Toffler does more than put his finger on a societal affect in the then-present. A card-carrying futurist, he purports to make predictions about technological advancements in the near and distant future. In a sense, Toffler may have written his own occupational clairvoyance into obsolescence. If the libertarian Cato Institute has ever taken an issue with Toffler, it is not due to his platitudinous promulgations about information overload, but with his role as an individual claiming to see a coming storm with any certainty.[7]

Hayek sold his stance on the limits of knowledge and his rejection of the presumptions of planning as judiciousness in the face of uncertainty. He based this stance on an ontology of biological and social systems as inherently unpredictable, derived in his later career from developments in complex systems theory. Hayek's refusal of absolute knowledge echoed and bolstered the emergence of the resilience paradigm, pioneered by the systems ecologist C. S. Holling in the 1970s in reaction to the centrality of homeostasis as a guiding principle of Cold War–era cybernetics, which assumed a predictable world consistently returning to stability.[8] Resilience discourse came to dominate in such

diverse spheres of human activity that there is no excess of pessimism in pointing out that this uncertain world has been built by design into international financial institutions, government policy, smart cities, and cognitive-behavioral therapy.

In the aftermath of the growing inflation in the 1970s, the government's restraining role was turned upside down. The state then saw itself not as a preemptive burden for dangerous speculative activity but as an active participant in the risk-generation machine. The Fed's embarking on monetary policies, setting the ground for the too-big-to-fail regime and the expansion of credit and debt, was carried out not with a clear conviction of their outcomes but with an intuitive understanding of their potentials: as an authorized gamble.[9] This late in the game, who can access any truth about the ontology of natural and social systems, or their tendency toward crisis, before the advent of markets? Marx's truism about the anarchy of capitalist production is only truer than it was in his time, as subject as markets are to derivations and bailouts that have only further entrenched and reified their condition of perennial crash.

The vocabulary of resilience is thus a bridging constellation between looming shock and obsolescence on the one hand, and the ability to speculate on the other. To withstand volatility and avoid obsoleteness in the market, a corporate entity must be flexible, adaptive, and responsive. These qualities may ensure basic survival through a crash, give or take the occasional government bailout. But speculation aims to operate at a higher plane, embracing and syncopating with risk rather than merely withstanding it. Ultimately, CEOs take risks because they are not their companies, and as individuals they are all but untouchable. Packer is dead by the end of the book, only by virtue of Don DeLillo's poetic license. If there is a structure of feeling to be found in *Cosmopolis*, it is one where both antiheroes, Packer and his underling-cum-killer, have everything and nothing to lose, as the world crashes and burns outside.

Fast forward to 2008 as the key moment when mass bailout of the commercial banking system turned into common practice as a sort of informal insurance on the ability of the markets to establish order in the long run. These zombified institutions, to follow the Greek ex-finance minister Yanis Varoufakis's expression, no more alive nor dead, were handed to us in 2020 with the onset of the global pandemic.[10] And here that extraordinary event crops up: in August 2020 the financial market was fully decoupled from the real market of goods and services.

As the UK underwent its worst recession ever and the United States started to appear to be a failed state, the London Stock Exchange index surged, and Wall Street's S&P 500 hit a historic high. The future markets have no more regard for the earthlings' games of trade and survival.

But if, pursuant to Hayek's formulation, the market knows best the truth regarding life on the planet and the state of nature itself, which market's story are we to believe in the current paradox of the economy? The real market claims that we, and by extension nature, are in deep trouble. The future markets recite a narrative of stirring prosperity. Hayek would indeed side with the latter, as he did during the 1970s, seeing in the financial turmoil a movement that was highly subversive and for the same reason imbued with the possibility of economic recuperation. Today, outside the bubbles of pandemic denialism and science skepticism of the populist international, however, one cannot, to save one's life, put their faith into the fantasy regurgitated by the money markets. Yet as long as the speculative substance of economy is not taken to heart, and the problematics of time and episteme at the center of Hayek's critique of rational planning is overlooked, we are only to circle a vicious historical cycle.

An epistemological position espoused by contemporary left-wing and socialist theorists, in response to the neoliberal problematization of planning, argues that if during the time of the Soviet Union there wasn't enough computational power to access the necessary information for a planned economy to be successful, there just might be enough computational power to do so at the moment or in the near future. This has been referred to as the calculation problem, which we may or may not have enough silicon to resolve. The direct heirs of scientific socialism maintain that the currently existing logistics systems of megaplatforms such as Amazon or Google might be repurposed to solve the calculation problem, giving central planners in a socialist future the ability to calculate the quantities of goods being produced, circulated, and consumed.[11] Any argument about a newfound possibility of technology to solve the calculation problem is positivist-evolutionary and may rightly be considered technologically deterministic. It assumes that a certain threshold of technological advancement is a prerequisite for the restructuring of the totality of socioeconomic relations.

Also latent among these views is a conflation between questions of epistemology and knowledge on the one hand, and questions of control and government of persons on the other.[12] Understanding the input

and output variables of an economy does not equate to having the ability to control or change said variables. Additionally, enforcing centralized control in a planned economy would still necessitate the forceful management of labor power, that is, the mass surveillance, firing, and hiring of the workers responsible for that labor power.

Thinkers of decentralized planning who profess autonomist inclinations, such as the mathematical physicist Matilde Marcolli and the American writer Jasper Bernes, are not so keen on this prospect of an authoritarian distribution of workers among productive sectors, one that operates independently of workers' own professed desires and voluntary associations. Yet they agree that reckoning with problems of scale will necessitate computational forms of optimization that are not based on profit. Here, the distributed decision support system commissioned by the Allende government in 1971 and designed by the British cybernetician Stafford Beer, Cybersyn, is often invoked as a past future foreclosed too soon. Cybersyn aimed to grant maximum autonomy to worker-owned factories while minimizing centralized control. Along with OGAS, the unrealized Soviet network, Cybersyn anticipated the arrival of the internet, not in the service of atomized consumption but toward large-scale decentralized planning sourced from bottom-up inputs.

Drawing on both Cybersyn and OGAS, Marcolli grapples with the problem of scale in decentral planning by conceiving of two types of instruments to connect individual cooperatives, defined as nodes of a decentralized network. Instruments of connectivity, such as P2P networks and public transportation, increase the degree of causal influence between nodes, while instruments of complexity, such as cultural products that are not generated by market dynamics, increase the effective complexity of a network.[13] In this vein, the decentralized speculator-planner may forge ahead not by imagining megastructural systems run by socialist big government, but by thoroughly considering the bridges, exchanges, and causal connections between currently existing cooperative and interest groups.

In one of the scenes in *Cosmopolis*, the limo drives into a riot, where a group of anarchists surround the vehicle and attempt to sabotage it. The film came out a year after Occupy Wall Street began, which compelled many of its reviewers to see in the fictional protesters a stand-in for the real-world rioters on Wall Street. If the film had come out in 2021, we may have seen in it the outside agitators of the George Floyd protests.

If we squinted further at the screen, we may have seen the streets of Beirut or Khartoum or Santiago or Hong Kong, engulfed in tear gas as they have been. The limitations of revolutionary spontaneity may be acknowledged without a dismissal of the riot form. Looking back on a decade of mobilization since the start of the Arab Spring, an observer may note that relatively successful transitions out of authoritarian rule took place in the countries where robust professional associations and labor unions predated the street uprisings and subsequently took charge of the historical opening, such as in Tunisia and Sudan.

Several decades, cyclical financial crises, and climate catastrophes later, activists and academics studying social movements and crisis often reach conclusions that correspond to the Black Panthers' pithy axiom. Geographers Stephanie Wakefield and Bruce Braun refer to the presence of a *resilient dispositif*, defined as the crisis-prone "network of discourses, practices, institutions" by which persons are governed. In response to this *dispositif*, they inquire about the possibility of making concrete and long-term the structures and alliances immanent in the "autonomous organizing centers, shared supply banks, and communal street kitchens" that sprang up in New York City after Hurricane Sandy.[14] The question is as potent today as it is unanswered.

Currently, it is near impossible to think of a road map that can lead its cartographers or its readers from currently existing community-run crisis-relief programs, to well-connected cooperatives, to any decentralized economy not based on markets, speculative or knowable, real or not. It is possible, however, to imagine setting ourselves up for the task.

Notes

1. Don DeLillo, *Cosmopolis* (New York: Scribner, 2003).

2. Friedrich August von Hayek, *The Counter-revolution of Science: Studies on the Abuse of Reason* (Glencoe, IL: Free Press, 1952).

3. Friedrich August von Hayek, "The Use of Knowledge in Society," *American Economic Review* 35, no. 4 (September 1945): 519–30.

4. Philip Mirowski, *More Heat Than Light: Economics as Social Physics, Physics as Nature's Economics* (Cambridge: Cambridge University Press, 2000).

5. Erwin Decker, *The Viennese Students of Civilization: The Meaning and Context of Austrian Economics Reconsidered* (Cambridge: Cambridge University Press, 2016).

6. Martijn Konings, *Capital and Time: For a New Critique of Neoliberal Reason* (Palo Alto, CA: Stanford University Press, 2018).

7. Edward L. Hudgins, "Hayek vs. Asimov: Spontaneous Order or Failed Foundation," Cato Institute, January 1, 1996, https://www.cato.org/white-paper/hayek-vs-asimov-spontaneous-order-or-failed-foundation.

8. Jeremy Walker and Melinda Cooper, "Genealogies of Resilience: From Systems Ecology to the Political Economy of Crisis Adaptation," *Security Dialogue* 42, no. 2 (April 2011): 143–60, https://doi.org/10.1177/0967010611399616.

9. Konings, *Capital and Time*.

10. Yanis Varoufakis, "Something Remarkable Just Happened This August: How the Pandemic Has Sped Up the Passage to Postcapitalism," *Yanis Varoufakis: Thoughts for the Post-2008 World*, August 21, 2020, https://www.yanisvaroufakis.eu/2020/08/21/something-remarkable-just-happened-this-august-how-the-pandemic-has-sped-up-the-passage-to-postcapitalism-lannan-institute-virtual-talk/.

11. William Paul Cockshott and Allin Cottrell, *Towards a New Socialism?* (Nottingham, UK: Spokesman, 1993).

12. Jasper Bernes, "Planning and Anarchy," *South Atlantic Quarterly* 119, no. 1 (January 2020): 53–73, https://doi.org/10.1215/00382876-8007653.

13. Aurora Apolito, "The Problem of Scale in Anarchism and the Case for Cybernetic Communism," Center for a Stateless Society, June 25, 2020, https://c4ss.org/wp-content/uploads/2020/06/Aurora-ScaleAnarchy_ful-version.pdf.

14. Bruce Braun and Stephanie Wakefield, "Destituent Power and Common Use: Reading Agamben in the Anthropocene," in *Handbook on the Geographies of Power*, ed. Mat Coleman and John Agnew (Cheltenham, UK: Edward Elgar, 2018), 259–72, https://doi.org/10.4337/9781785365645.00024.

14. Hygiene —— Stress Management —— Procrastination

Mahan Moalemi

I am taking on the task of writing this short essay much later than it was supposed to have been finished and submitted. But saying this is less of a confession than an attempt at (counter)diagnosis, perhaps that of the underbelly of a distributed and internalized set of disciplinary and control mechanisms targeted at optimized productivity. However, the delay cannot be simply explained by putting the blame on a high workload. It might even seem like the sign of some sort of privilege, relatively speaking, or (social) capital which would allow a freelancer, juggling multiple writing gigs at a time, to ultimately afford the consequences of a few missed deadlines here and there. In the larger scheme of things, a delay might appear more like a professional norm that largely operates as a public secret, except for the likes of the fashionably late or too-busy-to-commit.

But whether because of, despite, or regardless of such and similar affordances, there has been something else at work delaying this essay, something that feels both deeper and more immediate than the metrics of a petty privilege. An ingrained sense of precarity seems to underlie all that might count as a privilege, and the conditions of production remain simultaneously shaped by these two seemingly incommensurable qualities. Therefore this essay or, in other words, this overdue submission tries to recognize and reckon with the complex reality of procrastination, not only as a self-perpetuating mechanism but as a locus of psychopolitical relations. "Neoliberal psychopolitics," according to Byung-Chul Han, "is a technology of domination that stabilizes and perpetuates the prevailing system by means of psychological programming and steering."[1] This technology is the substrate of the so-called gig economy, whose modus operandi is not only central

to the creative industries of the early twenty-first century but also emblematic of it.

Simultaneously, the focus on procrastination offers a particular framing of management and managerial imperatives from the viewpoint of struggles with mental health. Mark Fisher's first posthumous publication, which he finished shortly before his death, is a call "to wrest the concept of management from its being held hostage by neoliberal managerialism."[2] He associates the latter with "imperatives to penetrate consciousness and time to an unprecedented degree" while "the focus on management," he argues, can entail "an appreciation of the difference between political agency and its conditions, between what is immediate and the virtual machineries that shape experience."[3] Is procrastination in need of management or is it, somewhere on a spectrum, itself a mode of management? In other words, this essay addresses procrastination at the intersection of stress management and time management, exploring the principles of efficiency and productivity that condition the precarity and privilege of having to persistently stay open to opportunities.

Procrastination is in a peculiar relationship with opportunity. Unevenly minted and distributed, opportunities are a matter of currency, keeping a turbulent gig economy afloat. Ranging from venture capitalists to vagrants, there seem to be close equivalents among the different agents that participate in the exchange and circulation of opportunities, in giving and taking them, in cases including but not limited to freelance writing in the creative industries. Furthermore, opportunities can derive from privilege and precarity at once, even maintaining and further compounding such a schizoid mixture at each instance. This is particularly the case in the context of a globalized creative industry and its associated knowledge economies, which mostly rely on the ability of creative laborers to afford their poverty.[4] Procrastination emerges from a set of social, political, and economic relations that enable the vectors of precarity and privilege to form "a zone of indistinction," wherein they remain operative while "resonating together in immediate proximity."[5]

By extension, it should come as no surprise if opportunities, which most often appear instantaneously and unexpectedly as far as gigs are concerned, rarely lead to a sense of stability, since they operate as matters of contingency and within an atmosphere of volatility. And that would explain why opportunities are inseparable from competition in one way or another. Such a situation is a breeding ground for pathologizing various attitudes and behaviors across the network of relations

that surround each opportunity, overwhelming anxieties that might in one way or another morph into an almost paralyzing fear of failure or an overarching imposter syndrome, which only gets aggravated by the confusing ratios of individualized precarity and privilege.

Detrimental to any sense of sustainability, the working conditions that are defined by the primacy of irregular and instantaneous opportunities demand heightened flexibility and constant readjustments to daily routines and methods of operation. As a result, working on an ad hoc basis might not only block access to the full range of one's creative capacities but also keep the freelancer in the frustrating position of having to (re)invent the wheel all over again and again. This demands a critique of compulsory progress and improvement (which is native to the experience of modernity) as much as it requires attention to how a spectral underclass is born from the widespread deprivation of one's ability to recognize any sense of progress in particular or a stable sense of the long term in general. This is a class of the senseless, of exhausted emotions and sensibilities. On the other hand, emotional deprivation is always already baked into the order of compulsory progress: the imaginary of professional growth remains bound to an autogenerative, stress-infused, and increasingly benumbing state of ongoing indebtedness. Stuck in eternal backlog, one is set up to never feel good enough.

Perhaps surprisingly, this indebtedness is where chronic procrastination kicks in. Similar to a reflexive inertia against demands for sudden and frequent change in one's approach and/or attitude, procrastination works as a defense mechanism, an act of self-preservation against the prospects of an unpayable debt. But this mechanism is itself in conflict with what it ends up contributing to, as it initiates a vicious circle wherein deferred thoughts and emotions return charged with guilt, self-pity, and panic over external circumstances that remain unchanged in the meanwhile, just like the deadline that only keeps getting closer. Therefore, it makes sense that, as the journalist Charlotte Lieberman put it in a *New York Times* article from 2019, procrastination is not necessarily about "laziness or bad time management" and instead happens "because of an inability to manage negative moods around a task. . . . Procrastination is an emotion regulation problem, not a time management problem."[6] While this insight is as accurate as one could expect from the popular literature on procrastination, the following argument echoes a common and highly consequential fallacy: "the solution must therefore be *internal*, and not dependent on anything but

our*selves*."[7] Seemingly empowering, such a verdict on the problematics of procrastination is both pathologizing and individualizing.

There is a growing scholarship on how procrastination correlates with neurodiversity, particularly in the case of people diagnosed with attention-deficit/hyperactivity disorder.[8] One characteristic of ADHD is lower dopamine levels than found under neurotypical circumstances, which makes it difficult to maintain a steady and sufficient level of interest while staying in the process, that is, while containing one's attention within the bounds of one task, or even one approach to the delivery of a task—not every moment can be expected to carry the same high level of excitement, while there is always some excitement in beginning a new task, or one that is simply other than the task one is occupied with at any particular moment.

Furthermore, the pleasure and sense of fulfillment that derives from finishing or accomplishing a task by far outruns a process-oriented sense of satisfaction, while a fixation on the result in the face of a process that demands full attention only builds up frustration. Perhaps the procrastinator seeks new and rapid beginnings as simulations of seemingly unachievable ends. While the language of neurodiversity succeeds in pushing against social stigma around what, within a normative framework, is labeled as disability, it is unclear whether it can go beyond an offering of suitable treatments, chemical or behavioral, and propose actual alternatives to the norm itself—for example, a different culture of productivity, or a different understanding of efficiency, rather than alternative ways of fitting into existing norms, which simply uphold ableist prejudice and injustice.

Such and similar diagnostic analyses may fall short of grappling with the systemic roots of negative feelings, which can leave long-term biochemical imprints, and then be hijacked and weaponized by the capitalist realist tactic of individualized responsibilization. "Each individual member of the subordinate class," as Fisher put it memorably, "is encouraged into feeling that their poverty, lack of opportunities, or unemployment, is their fault and their fault alone."[9] Emotions are deemed negative when they interfere with productivity and are consequently perceived as the individual's natural liability, while it might in fact be the productivity principle that generates negative emotions in the first place. Addressing procrastination as the embodiment of a host of incapacitating affects by simply shifting the target of society's managerial impetus overlooks how management techniques, as instruments of

the indelible productivity principle, have always been at the service of measuring affects and personalizing efficiency.

Therefore, procrastination cannot be simply dealt with as a problem or pathology without considering the larger set of circumstances that pathologize it or render it problematic. Instead, it should be addressed as simultaneously a symptom of and a desperate response to the pressures of individualization among the precariat. We inherit the ethos of professionalism, optimized performance, and streamlined productivity from the early nineteenth century, fused into notions such as self-improvement and personal growth. Hence, emotions took the center stage of labor relations under neoliberalism. Nonetheless, the epidemic rise of procrastination as a chronic condition requires a larger discussion around historical changes in the understanding of hygiene that unfolded in parallel to this history of productivity.

The notion of hygiene was formed around the traffic of substances and exchange of materials through the borders that kept the interiors of a body divided from its outsides.[10] A tipping point in the history of hygiene as a web of relations between various imaginaries and institutions can be traced in the parallel rise of preoccupations with mental health and management. The notion of mental health and how it followed that of mental hygiene, as it was referred to for decades, started to find a specialized discourse of its own during the same time that initiatives for the design and practice of labor management were on the rise, particularly from the early 1900s to the mid-twentieth century.[11]

The delivery of a task through procrastination feels like an exhaust mechanism, keeping one fully alert about the dynamics of waste and production. While it can also pass as repose, further confusing the work-life interface, the ambivalence of procrastination lies in how it tricks the exhausted mind into cognitive inexhaustibility. It is as if procrastination functions as a preemptive measure for damage control against the consequences of acute exhaustion by, somewhat counterintuitively, repositioning the depleted individual as forever not totally dead yet—a virtually bottomless stock of undead vitality, organic life permitting. It is in this sense that procrastination becomes a maladaptive (that is, nonnormative) coping mechanism or an artificially mutated instinct for stress management under the constant threat of imminent and terminal burnout in pursuit of opportunities. Unable to afford the agency of outright refusal or confrontational protest, the procrastinating mindset keeps laboring in what could be called a state of operational paralysis.

But no real (or added) value is created under such circumstances. Instead, value is simulated by probing into the extent of exhaustibility. In Han's words, "under the financial capitalism of our day, value is being destroyed at the root—eradicated. The neoliberal regime is in the course of inaugurating the age of exhaustion."[12] Perhaps procrastination also shows one way in which the systemic traits of this political economy reproduce on an individual scale, tying the survival of each individual to the survival of the system, even if individual tasks remain unfulfilled indefinitely, or if there is no value in their fulfillment. If the informatics of psychopolitical domination shapes posterity via the ever incomplete or exceedingly slow cancellation of the future, then chronic procrastination represents a set of both symptoms and strategies of emotional labor management today.

Notes

1. Byung-Chul Han, *Psychopolitics: Neoliberalism and New Technologies of Power* (London: Verso, 2017), 79.
2. Mark Fisher, "Accelerate Management," *PARSE Journal*, no. 5 (Spring 2017), 21.
3. Fisher, "Accelerate Management," 20.
4. See Hans Abbing, *Why Are Artists Poor? The Exceptional Economy of the Arts* (Amsterdam: Amsterdam University Press, 2008).
5. Brian Massumi, *The Power at the End of the Economy* (Durham, NC: Duke University Press, 2015), 7–8.
6. Charlotte Lieberman, "Why You Procrastinate (It Has Nothing to Do with Self-Control)," *New York Times*, March 25, 2019.
7. Lieberman, "Why You Procrastinate" (emphasis added).
8. See, for example, Hannah C. M. Niermann and Anouk Scheres, "The Relation between Procrastination and Symptoms of Attention-Deficit Hyperactivity Disorder (ADHD) in Undergraduate Students," *International Journal of Methods in Psychiatric Research* 23, no. 4 (2014): 411–21.
9. Mark Fisher, "Good for Nothing," *Occupied Times of London*, March 19, 2014.
10. According to "an evolutionary history of hygiene," certain impulsive behaviors, like the expression of disgust, were developed in reaction to entities that threatened the safety of borders guarding the hygienic totality of the human body. See Valerie A. Curtis, "A Natural History of Hygiene," *Canadian Journal of Infectious Diseases and Medical Microbiology* 18 (January 2007): 11–14.
11. See José Bertolote, "The Roots of the Concept of Mental Health," *World Psychiatry* 7 (June 2008), 113–16.
12. Han, *Psychopolitics*, 30.

15. White Capitalist Patriarchy —— Informatics of Domination

Larissa Lai

At the wet market you can get anything you want from the immediate territory and as far beyond it as you can dream, and then some. As in the old days, it's illegal, but regulations are weak and inspectors are few and far between, and in any case, inspectors can be paid off to overlook what regulations there are. Barraged on one side by advances in particle science at What's the Matter, on another by growing knowledge in genomics at Gene Genie, on yet another by growth in information science at Cry Me a River, not to mention all the genius of info and substance artists at wet markets all over the world who roll the technologies together according to whim or inspiration, and the deep intelligence of the plants and critters brought daily into those same markets, we consumers can never really know what we are buying. Life itself has been disassembled, reassembled, reversed, reverted, and repurposed so many times that our primate intelligence is fully knitted with the very matter of our fleshly selves. Because we have no choice, we eat what we buy, and we are what we eat. Who knows what we'll grow into for all our interesting eating? We could become sick to the point of obliteration. We could become healthy to the point of a godlike enchanted enhancement. We could become different beyond our current capacity to imagine.

 I've got a closed system breathing apparatus that was top of the line when it was new—a helmet that sealed all orifices from the outside world connected to a tank of compressed air. It always makes me feel like I'm underwater swimming when I've got it on. But last year, it developed a slight leak, which worries me, though I can't afford to fix it at the exorbitant rate charged by Breathe Free. I tried to seal it with a bit of blue glue, but it's still leaking. It's what I've got, so I put it on now.

I'm just sliding it shut at the throat when an electric hovercycle whips past me. These new spinners are so fast. I'm amazed more riders don't fall and crack their skulls.

I pay my fee at the eastern booth, and request my usual stall, Number 812, from Beth-Marie, who always does the morning shift on Thursdays. "It's taken," she tells me. "I can give you 813, but you might not want it. An inspector took 812. A good-looking one, but still. You don't want to spend the whole morning under scrutiny, I don't suppose."

"Not really, no. What else do you have?"

"In the eastern quadrant? I can give you 577."

"I'll take that."

Her fingers dance over and through her haptic ball. "Crap, no. Theresa just bagged it for someone else. I could give you 3384, but it's in the western quadrant all the way down by Quebec Street."

I look at my cart. Crammed with bottles of my home-brewed apple cider, the thing is damn heavy, and I'm already exhausted from hauling it here.

"I'll take 813," I say.

"Lucky 813 it is," says Beth-Marie.

"What the heck," I say. "The batch was brewed at autumn equinox. Today is harvest moon. Let the witches rule."

Whoever used 813 last did not clean it. The floor is tacky with what was once a viscous liquid, now half-dried. There are things stuck to it. Fine silky hair, pale silver at one end, dark red at the other. Ugh.

I'm getting the hose when a face appears over the three-quarter wall that separates 813 from 812. Though my proclivities lean toward women, I'm not insusceptible to men. This one is just my type. Dark eyes that twinkle mischief, dark hair, a crooked smile. His head is bare, and his face seems so close and so human. "I don't know what they were selling in there, but they were selling both for pets and meat." He's not in uniform either. Maybe Beth-Marie made a mistake about him being an inspector? Maybe she was thinking of some other stall? Because it's been a long time since I've—you know.

He goes to get a hose. The market uses seawater to clean its floors. It has a strong pump and, since it's not purified or anything, there's a steady supply. What's in it is another matter.

The man helps me flush out the worst of the slimy stuff in my stall, arrange my ciders, and put up the sign. "Rose's Apple Elixir." While

we are arranging, I peek over the wall to his side. I'm not tall, so an effort must be made to look.

He's got cages and cages full of crows.

"Beautiful, aren't they?"

I nod.

"Too bad they aren't real," he says.

"They aren't? They look incredible."

"They're mechanical/biological hybrids. Excellent workmanship." He smiles that crooked smile again. He brings one to the wall for me to look. Its eyes sparkle and its feathers gleam. I'm mesmerized.

"You want one? I'm kind of thirsty. I'll trade you for a case of cider."

"A whole crow for just a case of cider?"

He shrugs. "I got them cheap. Come look."

I enter his stall. Each crow is slightly different. Some are velvet black. Others shimmer with a little blue or green iridescence. The eyes of some are an ominous red. Others glitter a cool and clever silver. I pick one, shiny and mischievous like him.

He sips my cider, and we watch the market fill with shoppers.

At noon, I don't notice the market cuckoo clock sing its song. I don't see my handsome neighbor open his crow cages one by one. I don't notice other men—more and less handsome—opening cages all over the wet market.

But soon, the whole eighty-block complex is a mass of flapping wings and screaming throats. People run around us zigzagging in all directions through the market.

I look over to the next stall to see if the inspector man is still there. I don't know why.

In the ceiling, a panel of LED lights flickers, then crashes to the floor. I drop and roll out of the way. As I do so, my helmet cracks right in two, and the compressed air tank exhales, then fizzes. Crap. I push the broken pieces away from me.

Boots tromp into the market. Everyone who can flee has already fled. I've never seen troops like this, wide and strong, but made of a light aluminum alloy. Miraculously they don't touch me, but leave me for dead. Half a bloody rat face floats past my nose, a partial rat brain still clinging to its broken skull.

I don't move for hours. Night falls. The last light of the orange moon pours into the market.

Someone touches my shoulder. "Come on." I recognize the voice without having to move. It's the handsome man with the crooked smile.

I know he's one of them, so I don't move.

"Rose," he says. "I know you're alive, I know you're awake, and I know you can hear me. Get up."

Still, I don't move.

"Rose."

He sticks a finger in my armpit. I've always been ticklish. I laugh.

He laughs too.

"Who are you? I don't trust you a whit."

"Thought you'd never ask. I'm Wu."

"How do you know my name, Wu?"

He nods toward the broken sign on the floor that says Rose's Apple Elixir.

"You're a demon come to kill us all," I say.

"You're filthy, and you smell," he says.

"Thanks," I say.

His eyes glitter like those of the artificial crows he was selling. "You're—"

"Don't say it. Let me get you somewhere safe."

"Why should I trust you?"

"You probably shouldn't."

The streets are empty. The orange moon has set now, but under the residual light that still colors the sky, they glisten with the stinky water that floods out of the wet market, thanks to the automated cleaning system that flushes water across its floors every night at midnight. I wonder what happened to all the people.

We arrive at a castle in the mountains. I don't see it at first. It is covered in a thin material that projects whatever is behind the building. I'm aware it's there only when its door opens. Seeing the door, my eyes seek a structure and find the faint outline that separates the projection screen from the trees that surround it. The castle is massive, a titan of the forest. A woman steps out, black hair billowing around her, alive with chi. "At last, Wu," she says. "The apple lady. The critter catcher. Our Lady of Animalcules."

"Animalcules?" I say.

"The Ambassador talks like that," he says. "She's been around for a while and some of her language is a little dated."

"Why does she care about my apples?"

"She doesn't care about the apples so much as the yeasts. She uses them, in some of her own recipes."

I step into the castle as though into a mossy forest. It smells of earth and incense. Everything is made of green velvet, except the wall sconces, which are made of earth materials—citrines, amethysts, and smoky quartz. They glow with a soft, warm light, so different from the hard glitter of the wet market. "What is she the Ambassador of?"

"Of the All Mother, of course," says Wu. "I thought you knew."

The Ambassador leads us into the great hall, dominated by a large round table. The table turns slowly, like the great wheel of the earth, moving on its axis. "Choose your cure," the Ambassador says. "Choose your cure or allow it to choose you, so that you can take it, and we can begin the real work."

"The real work?"

I look more closely. It's a geomancer's table, massive, with a Taoist circle at the center, surrounded by the eight trigrams of the bagua, which in turn branch out into the sixty-four hexagrams of the I Ching at the second right from the far edge. At the far edge are sixty-four indents, as in a roulette wheel at the casino, only larger, about the size of a Chinese teacup. In each indent lies a different object—a jar of pills, a needle, a vial of brown or black liquid.

"Shots," says Wu. "Do you understand now? You can spin it, and wait for it to stop, or you can grab it and it will stop, or you can just—"

The wheel stops on its own.

"I was going to say," he says, "sometimes it stops on its own. The cure chooses you."

What has stopped in front of me is a vial of dark liquid with blue streaks in it. The liquid moves and swirls on its own. I reach out and pick it up. It is warm to the touch.

"Come on," he says. "It's less effective cold."

I pop the cork. A bitter smell rushes up at me, and I wrinkle my nose.

Wu the crow man nods. I drink. It's even more bitter than it smells, and thick as blood. In spite of these things, it is not entirely

unpleasant. I taste a dry mountain under hot sun. I taste cool earth after the rain. I taste soup for noodles made from shrimp shells and pork bones. I taste the remnants of the old world that will remain for us corvids. I suddenly feel very sleepy. I close my eyes.

I wake up in a room suffused with a soft orange light. It comes from little orange mushrooms embedded in the walls. The walls are not moss-colored velvet but actual moss. The bed is a mound of raised dirt, with an indent for the body, nest-like.

I look around the room.

"You took the cure. You've entered the AI AM."

"The 'I am'?"

"The Artificial Intelligence of the All Mother. You've become what you always were. There's no return to linear time."

I look down. My body is a mass of black feathers. I look at Wu. I see him see my eyes glimmer, dark and full of mischief.

16. Microbiology, Tuberculosis —— Immunology, AIDS —— Epigenetics, Body Burdens

Isadora Neves Marques

The ecological way to piss is to do it in the shower. As I watch my hormone-rich piss flow from my urethra, I wonder about how it will dissolve in the environment; a metabolic common pool of fluids flowing from Big Pharma laboratories to one's bodily insides and diverse ecosystems. After a lifetime of ingesting, in the shape of a pill, synthetic hormones, I've recently added an extra layer of synthetic estrogen to the cocktail in the shape of skin patches. That is to say, I've long been intimate with the science of endocrinology, but it was ecology that got me thinking about the intertwinement between synthetic hormones and environmental toxicity.

In many ways, the story of this relationship is also that of both the drive and the remains of a century of progress. Although endocrinology, understood as the medical branch specializing in the role and activity of hormones at work inside bodies, took its baby steps in the first decade of the twentieth century, with lab-grown synthetic hormones appearing in 1926, namely thyroxine, cortisone, and insulin, it was only in the postwar period that the feedback loops between bodies, hormones, and the environment became apparent.

By then, synthetic hormones had been used in medicine and agriculture at least since the 1930s. Today, the livestock industry relies heavily on synthetic hormones for fattening and the acceleration of reproductive cycles. On the human side, estrogen and progesterone are the most widely used drugs in the history of medicine, mostly due to the invention of the Pill—the only medicine so ubiquitous it does not need a proper name.[1] Women in particular have been the main target of this hormonal market, in everything from IVF to hormonal replacement therapies for menopause. The administration of synthetic

hormones, however, is found everywhere from gender transitioning to high-competition sports and cancer treatments.

While hormones have long been known to healthily mediate between our central nervous system and the environment, balancing metabolism, body heat, stress, and cell development, unhealthy environmental endocrine disruptors, or EDCs, are found in industrial chemicals, slowly ejected from plastic bottles, liners of metal, detergents, flame retardants, food, toys, cosmetics, and pesticides. Strictly speaking, EDCs aren't hormones; they are chemical compounds that mimic hormones, being interpreted by the body as such.

Synthetic hormones and EDCs are widespread, and we have little to no choice over them. They seep into us. This seepage has its physical and sociological impacts, breaking with linear, clean-cut divisions between bodies and environments. Moving beyond an easy outcry of living in the ruins of petrochemical industrialism and modern technoscience, I wonder how this hormonal swamp we find ourselves in may actually, though counterintuitively, bring us closer to cosmovisions, nature/culture agreements, and earthly dealings beyond those historically inherited.

Body burdens is the toxicological term for the concentration of chemicals in the body due to repeated exposure to a chemical.[2] Because body burdens rely on an analysis of dosages and the exposure biographies of not only a given person but also of their parents, and possibly their ancestors, they are hard to individualize. Capital and industries mobilize this indeterminacy to override any culpability and retribution, used as legal defense even in clear cases of exposure and contamination, such as women suffering from cancer-inducing hormonal replacement therapies or communities living close to toxic sites. But body burdens also impose their own epistemological consequences.

Anthropologist Elizabeth Roberts has offered a helpful temporal mapping of exposure, or what she calls "situated historico-material realities" of environmental contamination.[3] These should be read cumulatively rather than superseding each other and define psychosocial relations between an inside and outside, as well as safe and threatening spaces. "Permeating exposure" is best characterized by a growing panic toward the toxic exterior of the Industrial Revolution and the anxiety felt by Victorian ladies, only comforted by a safe, domesticated interior. This epochal hypochondria would be intimately tied to class. As circulation, or contamination, systems developed, from mail networks to

commercial aviation and container shipping, exposure would become particularized, with irrational and entrepreneurial agents, mostly masculine, venturing out into a fully techno-managed exterior. Here, the atomization of agents and vectors of both threat and disease parallel the cybernetic management of capital, and likewise toxic exposure becomes medically quantifiable in its reduction to a single and detached armored body. Any dreams of containment, however, are today fully obliterated. According to Roberts, this "Anthropocenic exposure" has become generalized, blurring any imagined discreteness among agents themselves as well as between agents and their environment.

Anthropocenic exposure is best encapsulated by a growing fascination with epigenetics—a concept first used in 1942, focusing on the ways DNA expression, rather than being strictly inherited, is influenced by extragenetic and xenobiotic elements as well, be they environmental, like EDCs, or social, such as genealogical stress and class. It is not only that epigenetics blurs agent and environment; its usefulness is in how it explodes causality. For example, EDCs endure in time, passing on intergenerationally long after their potential legal prohibition. They are also unbound, connecting landscapes via natural waterways, sewages, or the transport of materials by roads and ships. And they disregard organic borders, comfortably moving between digestive, respiratory, endocrinal, and nervous systems, as well as between species. In other words, the logic of environmental epigenetics is simultaneously transtemporal, multidimensional, and multispecies.[4] This is why, even if we were to stop all of modernization's legacy—refineries, factories, livestock houses, laboratories, and so on—the legacy of modernity would still endure.

In the logic of epigenetics, bodies are vast expanses of time and space, never fully grasped by themselves or from the perspective of a single gene or cell in isolation from their environments—even when that environment is a polystyrene petri dish.[5] The case is not simply that the environment is a body and the body an environment; in other words, that there is an environment inside as much as an outside environment.[6] What I'm interested in is how contamination and contagion are, in many ways, prior and necessary to the conceptualization of the notion of environment, and how exposure breaks down modern notions of an isolated nature "outside."

The modern invention of a nature "out there," potentially threatening but nonetheless passive, is resignified in the division between an

interior and exterior to the body. With contamination, however, organs such as the skin, eyes, lungs, and blood vessels, but also the ass and the genitals, become entry points. From this perspective, just as culture was imagined throughout modernity as separate from or above nature, the body too must be insistently locked and fortified. Mediating the realms of health and illness, and surreptitiously of nature and culture, modern medicine must desacralize all agents outside of us, so as to imagine them as bounded objects isolated from us—even when they contribute to our integrity.

Evidently, this image of the outside as both replenishing and threatening is an ancient one—a genetically inherited memory, if you will. The border, however, is not. Or rather, this border can only be visualized historically and anthropologically.

It is this anthropological illusion of a fixed border that the combined efforts of endocrinological research, exposure theory, and epigenetics are increasingly dismantling. These efforts suggest that the reality of the boundaries between bodies and environments, including humans and nonhumans, is porous, collective, and transgenerational.[7] This is what anthropology is calling *embodied ecologies*: "a conceptual framework for describing a fluidity between bodies and worlds that foregrounds relations instead of bounded entities."[8]

Native knowledge, neo-materialist philosophies, and ecological ethics have made analogous claims for decades. One could argue that these forces invented our contemporary notion of the environment, in contrast to that reified image of nature above. Regardless, they remain mostly marginalized or subdued by capital. Epigenetics and exposure theory, however, as sciences that bridge the space between technology and industry with medicine and ecology, are themselves proposing an ontological deconstruction of, in the words of anthropologist Janelle Lamoreaux, "the assumptions of individuality, autonomy, and personhood that underlie some of the most strongly influential genetically-sourced social theories of the twentieth century."[9]

These then are techno-sciences of social and physical intensification of bodies/environments, characterized by the management of body burdens. On the one hand, they fit perfectly in contemporary biopower: the management of bodies and borders. On the other, they explode with established epistemological and ideological parameters. In fact, they highlight a lag between practices and epistemology, imploding modernity itself from within.

Taking responsibility for the social relations defining health, science, and technology means embracing the skillful task of reconstructing the boundaries of daily life, in partial connection with others and in communication with all of our parts, both those imagined as outside ourselves and those we haven't invited in but that already live within us. Against a warring logic built on the imaginary division between an exterior and interior, where enemies must always be chosen in advance and individuals combat individuals, atoms face other atoms, how to think epigenetically? That is, while never veering from (or fearing) the responsibility of tracing paths and genealogies, how to speculate in and through borders—not even borders, but the imagination of borders and the reality of their porousness?

I leave you with an excerpt from the poem "Contradictions: Tracking Poems" by Adrienne Rich. Better known for her political and feminist poetry, in these poems Rich opens up to the intimacy of two bodies in love, two bodies aging, two bodies pained by a flailing health both within and outside, in one's bones and muscles and in a world at war. The last of twenty-nine poems, the two women lie in bed, naked, witnesses to each other's bodily decadence, in all of its beauty; two entwined bodies that might teach us the art of listening to the fluid resonance between boundaries, an art which we may call intimacy:

> You for whom I write this
> in the night hours when the wrecked cartilage
> sifts round the mystical jointure of the bones
> when the insect of detritus crawls
> from shoulder to elbow and wristbone
> remember: the body's pain and the pain on the streets
> are not the same but you can learn
> from the edges that blur O you who love clear edges
> more than anything watch the edges that blur[10]

Notes

1. Jain Lochlann, *Malignant: How Cancer Becomes Us* (Berkeley: University of California Press, 2013), 131.

2. Ronald E. Baynes, Kelly J. Dix, and Jim E. Riviere, "Distribution and Pharmacokinetics Models," in *Pesticide Biotransformation and Disposition*, ed. Ernest Hodgson (London: Academic Press, 2012), 117.

3. Elizabeth F. S. Roberts, "Exposure," in Theorizing the Contemporary, *Fieldsights*, June 28, 2017, https://culanth.org/fieldsights/exposure.

4. Michelle Murphy, "Alterlife and Decolonial Chemical Relations," *Cultural Anthropology* 32, no. 4 (2017): 494–503, https://doi.org/10.14506/ca32.4.02.

5. For a material history of the petri dish and the seepage of bisphenol A contaminants to cell cultures grown in petri dishes, see Elizabeth F. S. Roberts, "Petri Dish," *Somatosphere*, March 31, 2014.

6. Janelle Lamoreaux, "What If the Environment Is a Person? Lineages of Epigenetic Science in a Toxic China," *Cultural Anthropology* 31, no. 2 (May 2016): 188–214, https://doi.org/10.14506/ca31.2.03.

7. Susan Sontag, *Illness as Metaphor and AIDS and Its Metaphors* (London: Picador, 1989).

8. Andrea Ford, "Introduction: Embodied Ecologies," Theorizing the Contemporary, *Fieldsights*, April 25, 2019, https://culanth.org/fieldsights/introduction-embodied-ecologies.

9. Lamoreaux, "What If the Environment Is a Person?"

10. Adrienne Rich, "Contradictions: Tracking Poems, N. 28," in *Your Native Land, Your Life* (New York: Norton, 1986).

17. Organic Division of Labor —— Ergonomics/Cybernetics of Labor —— Inorganic Division of Labor

Ranjodh Singh Dhaliwal

Picture a scene in 1867. The first German edition of *Das Kapital* has just been published. There are scores of workers toiling at a factory. Fabricators, handlers, cutters, welders, and assemblers all have been assigned different roles in producing commodities. Now picture the same scene but in 1985, at the cusp of the emergence of postindustrial regimes. Scores of workers still toil at the same factories, but we are also now aware of the labor involved in changing the diapers of tomorrow's factory worker. Meanwhile, scores of fingers start tapping at the keyboards/mice of the service economy, producing software, travel itineraries, shipping manifests, and census records.

Finally, imagine today (given the baroque nature of academic publishing, this is in my future but your present, dear reader, so I dare not say what it is). Similar workers toil at factories, but more of these factories are now in the Global South. Similar fingers tap at the keyboards/mice of the precarious service economy, most of which has now been outsourced and supply-chained to the Global South in a racialized global market full of surplus populations. Labor at home still goes unpaid worldwide. Billions look at screens; their attention has value (some people's attention being more valuable than others, of course). We have a nascent vocabulary for dealing with the activities of the nonhuman worlds, from bees to mushrooms, that are plugged into these global systems of extraction.[1] Beneath the hoods of digital media devices, silicon chipsets whir and purr, alchemically converting electricity into blockchain/AI speculations or, more generally, profits for finance capitalism. It is a scene full of terror; the incessant technological action at the level of the chipset subsumes more and more of human work over time, quietly leaking CO_2 in its wake. A lot of this data-driven world

computation is understood as magic: sophisticated programs, algorithms, software, AI agents, all operating, aggressively yet ambiently, all the time. However, this sense of magic is itself mythical, occluding the labor behind the machine. Actual human laborers in the Global South, saturated within conditions of techno-precarity, work under abysmal conditions to make the technology seem seamlessly magical.[2] There are content moderators in the Philippines, underpaid Mechanical Turk workers in Brazil, and operators in Costa Rica listening to your Amazon Alexa commands, obscured by miles of optical fiber cables and plastic boxes, working not with but as if they were machines, in some cases literally driving, like toy cars, automated robots on our streets. In yet other cases, however, it is the machines that make decisions for the human workers, arranging them on global assembly lines (and supply chains) of material-semiotic artifacts.

Questions seeking definitions, locations, and taxonomies of labor have not always yielded straightforward answers. The most basic question one can ask is: What exactly is labor? Is it an ontological category or is it a social relation? Is labor fundamentally one formation deployed, or comprehended, unevenly throughout the world, or does it have—like the idea of emotional labor, as it contrasts with physical labor, suggests—further subdivisions and qualifications? And while there are several possible answers—both canonical and noncanonical—to the aforementioned questions, right from the first iterations of the labor theory of value, there has been an underappreciated conceptual instability in what constitutes labor, and what labor constitutes. The second question, then, must ask: how to locate and map labor within a social system? In other words, what operation is, and what is not, labor, and how exactly is it distributed in the world? It is this second question, that stands atop the first, which is marked by the "Organic Division of Labor —— Ergonomics, Cybernetics of Labor" formation in the annals of informatics of domination.

Scene 1

Early conceptions of the division of labor considered labor as an exclusively human product, most prominently coded as masculine and employed.[3] Karl Marx's "labor power" clearly marked out the ability to generically and consciously give form as something uniquely human.

Bees were not architects, he claimed, because despite toiling to make their abodes, they did not possess the creativity or consciousness that would allow them to produce beyond their immediate needs. While animals and machines could act as catalysts for value production, they could not produce value by themselves; this capacity was reserved for the human laborer, who was then further to be categorized by his identity and (dis)ability.

Initial studies of the organic labor division (for it not only denoted "organ-ized" hierarchical systems but also described the natural progression of work) focused only on one specific kind of laboring body: male, usually a factory worker, most likely white, residing somewhere in the global northwest.

Scene 2

One of the many, much-needed correctives came in the form of Mariarosa Dalla Costa, Brigitte Galtier, Selma James, and Silvia Federici's 1972 demand for wages for housework.[4] Federici and other comrades pointed out that there are other kinds of labor than factory work that are essential to run capitalist systems. Housework—almost always done by women—they claimed, was labor and should be compensated economically. Reproductive labor was also quite literally labor, and "every miscarriage" was "a work accident." Their materialist feminisms, thus, had begun to break down the social taxonomies of labor; wages were no longer the only identificatory mark of labor.[5]

The postindustrial mythologies soon brought more attacks on the originary purity of labor. Cybernetics, the "study of control and communication in the animal and the machine," saw no distinction between hardware and wetware. If machines and humans were becoming more entangled than ever, then how could the labor of a (wo)man be surgically removed from that of her bionics? The worker—the one producing the machines and the one working with the machines—needed to adjust and adapt themselves to the machines, moving toward the now-iconic (and still timely) image of an information worker uncomfortably hunched over a desktop, urgently in need of an ergonomic design intervention. In this sense, indicating the bodily tribulations of labor (even the conventional versions of which continue to date in the form of wacky keyboards and injured Amazon warehouse workers), the ergonomics of labor within informatics of domination signaled an

epistemic shift, or at least a new correlative addition, in the correspondence between one's job and the muscular activities required to perform it: while once upon a time, in the same factory, you could instantly tell the difference between a welder and an assembler by looking at how they use their bodies, in today's Tesla factory, the assembly-line QA worker (one of the few left with this job due to automation) and the senior vice president of marketing both sit hunched over their keyboards, pressing buttons and observing the outcomes on a screen. However, the $1,000 Herman Miller Aeron chair used by the VP, which the assembly-line worker cannot afford, still highlights the temporal longevity of earlier epistemologies of the division of labor.

Scaled globally, then, this cybernetics of labor meant that the technical complexity of the human—full of devices around/on them, whether at work or during leisure—had to go hand in hand with the increasing technical complexity of work and society. A new global distribution of labor involved human bodies and machines responding to each other: literally, the inexorable imbrication of human and machine in the infrastructures of late capitalism.

Scene 3

Ideas about labor that were once clear and commonly understood—any human who receives a wage is a laborer, labor is what you do at work, and labor is (unevenly) modulated across the world through mechanisms of race, class, and gender—become hazier by the day. Women don't all always receive wages, but surely the many who work at home all day making the other factory labor possible should be categorized as laborers? What happens when you generate profits for companies while scrolling through TikTok in your bed at 2 A.M. (supposedly during your leisure time), feeding the giant data machines that aggregate our preferences for some speculative purchase three years from now; is that not working for TikTok in some sense? (Relatedly, is all work labor?) If a company replaces a laborer, say a copywriter, with a generative AI model, does the AI do the labor now? If so, then when and where exactly did the labor happen, in that case? (Was it when the internet was scraped over time to train the language model or when the model was run to generate an inane, terrible BuzzFeed article? Did the labor happen on the AI engineer's machine that resides in Mountain View, California, at his home computer in Austin from where he remotely logs in, or the

data center in Utah where local subsidies—in hope of a new local labor market that would never arrive—have enabled a huge big data operation where processors run?) If not, then what exactly is the relationship between labor and computational profits in the twenty-first century? Answers to these questions might also help us ascertain what could follow riots and global circulation struggles in the early twenty-first century.[6]

In this uncertain analytic state, none of the previous formations of labor (workers in the factory! Women in the household/workforce! The outsourced information worker!) have been completely replaced by new ones, but new layers of complexity nevertheless keep on being added to long-standing formations (playbor! Gig economy! Teleworking!). In fact, exactly how academic experts in the Global North—often the last on the scene of change, for universities only become sites of labor changes after laboratories elsewhere have produced precarious results with even more precarious populations—understand the composition and division of labor has changed so frequently in recent decades that today we can see us adding epistemological expansion packs to labor everywhere: to look for where labor has been occluded, and to argue for its inclusion, is now a well-regarded critical technique.[7] If considering the cybernetics of labor was once a knife driven through the heart of natural unities binding concepts of labor in the 1980s, then today it would be merely one of the many, many ways of understanding laboring operations and bodies at different locations and scales. But these expansion packs do not exit the organic division per se; they just add newer organs.

Toward Wages for Computers?

What, then, are the stakes of these maneuvers, of understanding more actions in the world as/through labor? For example, if the broken organic unity of the human is to be followed to its logical extreme, should we not also contend with the inhuman, inorganic forces of labor that have already been showing up in our laboring selves, at the very least since late (twentieth-century) capitalism? Whether it is ontologically, epistemologically, or socially, how does a graphic designer in New York losing their job to a generative AI model contend with these machinic actions—the machines in question run for a finite amount of time, they produce material and semiotic outputs in connection, and they need

replacement, repair, sustenance, and maintenance—if not as a case of labor replacement (one laborer substituting for another) that is just an iteration of previous trends in insourcing and outsourcing? And if that trouble harbored by this graphic designer is truly worth staying with, ought we not demand wages for computers, both computers within our bodily assemblages and the ones we use? Lest we forget, this very demand once upon a time would have been a demand on behalf of women workers, who literally were computers. In the words of N. Katherine Hayles, the "semantic shock" caused by hearing the sentence "My mother was a computer" "is rooted not only in the shift from human to machine labor, but also in the feeling that a kinship category essential to human society has been violated."[8] This is the shock we must embrace.

If kinship categories are being violated by critique, then it is only so because they have already been scrambled by the world. Consider this: An Uber driver in 2024 does not take their orders from a human boss, but an algorithmic one. And while it is indeed human bosses, and their employed human workers, who are ordering, creating, and tweaking those algorithms, it is nonetheless just the machines that are ultimately making microdecisions about distributing human labor (Where does a driver live? Where do they want to go? How much have they driven this night already? How desperate are they for the money?) over a topology of nonhumans (Would Manhattan need more premium cars than Brooklyn tonight? How to match drivers-riders-cars over a complex rating system that should consider the rider's algorithmic importance and subscription level to Uber?). In such a field of precarity, the distribution of labor is itself increasingly becoming inorganic. The word *inorganic* here captures the transformations caused by nonhumans as they further modulate and orient human-nonhuman entities through the globe; even hiring and firing decisions—the ones that set the conditions for conventional labor-based employment—are often solidly in the purview of algorithms today, as are decisions of global mobility of labor (work and refugee visa files pass through proprietary computational systems before a human is ever involved). If carbon-based lifeforms chemically mark the organic, then silicon-based decisions herald this age of inorganic division of labor. And even though it stands atop and exacerbates conventional distinctions between race, gender, and class, this newer inorganic division of labor may not be either neat (Does a subcontractor hired by a bot consciously orient themselves as

an organ in the general scheme of labor?) or easily taxonomizable (Is an algorithmic manager for hire bought from an AI company even an identifiable category?). If "ergonomics, cybernetics of labor" suggests a machine-human hybridity in the division of labor, then an inorganic division of labor today notes the shifting weights toward machinic processes of labor distribution.

What this inorganic division of labor demands from information workers—and that category can admittedly itself be further broken down carefully; to call academics information workers is to perversely (and somewhat ahistorically) resituate knowledge production, precarious as it is today, within a relatively recent information economy when such work has happened in differing educational forms for at least over a millennium already—is not only to acknowledge nonhuman forms of labor, like computational processes, but to use that knowledge to contest the assumptive (pre)conditions of labor. Because whether we acknowledge them or not, technically imposed conditions already determine the situation of our labors. Attempting to de-escalate the sheer enormity of the environmental impact of technological infrastructures may require many rhetorical shifts, many protests, many sites of action, many demands for degrowth. If one of these demands needs us to take care of, and make kin with, our machines, then it may not hurt to ask for wages for our computers: not solely because there is a logical-extremist theoretical case for it—I have shown elsewhere how computation often comes with an imagined nonhuman laborer inside it—but more importantly because paying for inorganic labor might finally bankrupt our financial systems.[9] It may be useful to remember Federici's template for wages here:

> Wages for housework is a revolutionary demand not because by itself it destroys capital, but because it attacks capital and forces it to restructure social relations in terms *more favourable*. . . . In fact . . . to say that we want money for housework is the first step towards refusing to do it, because the demand for a wage makes our work visible, which is the most indispensable condition to begin to struggle against it, both in its immediate aspect as housework and its more insidious character as femininity.[10]

Similarly, the admittedly absurd demand for wages for computers can push capital to recognize the global impact of computation, forcing it

to lay bare the otherwise-hidden work. It would not be a bad first step toward refusing the status quo and the computational burden it puts on our earth.

So, what would happen if these inorganic entities were considered, by academic and popular discourses, as partners in the labor that is performed by humans—gig workers, factory workers, theorists, or gig worker theorists—with their aid?[11] If we—and here I am attempting to reach from my (a thirty-year-old male academic in relatively secure employment in the Global North who hails from the Global South) situation to yours, as any call must—want to know how far we need to go to pragmatically live in/with our Anthropocenic ruins, we must consider this limit case: Not just life, but what matter can we value?

To say that humans (some more than others, of course) have wreaked havoc on this planet, especially in the last few centuries, would be an understatement. In light of this devastation, even such an admittedly wacko proposal does not go far enough, but it is not as if all other grand revolutionary calls always have brilliant afterlives. My hypothesis, however, is that it goes further than some proposals for carbon credits and other largely fictional scenarios used by climate scientists in their predictions. Such fictions may give us hope for the future and let our structures stand but are unlikely to be anything but fantasies of techno-fixes that end up breaking something else. To rhetorically reformulate labor, instead, could partially attend to the estimates which suggest that in a few decades, computing will be the biggest energy sink for our planet.

In other words, the totem of cybernetics, computation, is an energy-intensive activity that subsumes the work of humans. This was once, and remains, devalued but is starting to expand as if it were the earth's primary occupation. Planetary computation engulfs the planet's body and soul today.[12] Does this act not warrant a fair share of rhetorical modulations? Perhaps. To be honest, I am not even sure if labor is an analytical category worth preserving in all such discursive situations. We must not lose sight of the unequal modulations that always tainted labor, ones that—on their own terms—would have nevertheless produced some inequalities even if labor organization and labor gains, which thankfully had a great twentieth century, had become ubiquitous. The horrific scene of inorganic division of labor today must be similarly met with direct action. Someone please tag the influencers on Instagram; we have to get "wages for computing" propaganda merchandise out

there. I am not sure, however, what the labor division for such a campaign might look like.

In a 2017 clicker game called *Universal Paperclips* created by Frank Lantz, the player starts by clicking a button that produces one paper clip. Soon, enough money is accumulated from these paper clips that the player gets an opportunity to purchase machines that produce several paper clips per click. Not much later, AI is roped in to help with publicity and to further optimize paper clip production. Once the player engages an artificial intelligence whose sole goal is to maximize paper clip production, the game starts becoming more automatic; first, the AI buys the paper clip company that created it; then it creates more paper clip AIs and starts transforming all mass on earth into paper clips, before moving into space and converting all known matter in the universe into paper clips. In the game, the player goes from playing through a conventionally human labor relation (you click once, you produce something, and you work to serve a boss) to ultimately having a shockingly weird nonhuman labor relation (the machines do not just use human labor but also all the physical content of human bodies for—and this is the key novelty here—not the profit of some other humans but something even more dangerously stupid). *Universal Paperclips* can be read as an enacted commentary on the dangers of AI, on the insanity of capitalist expansion, and on rhetorics and tactics of efficiency. But the game as a technical object—it is a browser-based game that often makes browsers and computers crash due to its calculative nature—also suggests something else: that this scenario is not about some hypothetical or predicted future, but that the player is already engulfed by nonhuman operations brought into relief by the play of this game. The very opening ambiguity—are you the player or an AI when working for the company, and what does it even mean to play (as) an AI who only wants to make paper clips—makes clear that the human labor conditions today, be they physical or informational, are not just hybrids with the machine but also in service of them.

To live with these machines, then, could mean resisting them but could also alternatively mean further embracing hybridity. Making kin with (some) machines means also fighting for their conditions; who knows, you and I, dear reader, might one day be found at a picket line for computers. If it happens, maybe we will also be demanding a better future for ourselves. The same social-ideological move that makes

universal paper clips can perhaps also make universal housing, health care, agriculture, degrowth, green energy, and lower-carbon-footprint machines.

In fact, "universal happiness" has a nice ring to it. Now that might be a human-machine partnership worth pursuing!

Notes

1. Anna Lowenhaupt Tsing, *The Mushroom at the End of the World: On the Possibility of Life in Capitalist Ruins* (Princeton, NJ: Princeton University Press, 2015); Timothy Morton, *Dark Ecology: For a Logic of Future Coexistence* (New York: Columbia University Press, 2016); Nick Dyer-Witheford, Atle Mikkola Kjosen, and James Steinhoff, *Inhuman Power: Artificial Intelligence and the Future of Capitalism* (London: Pluto Press, 2019).

2. Precarity Lab, *Technoprecarious* (London: Goldsmiths Press, 2020).

3. It is worth remembering that slaves, for example, were not "employed," and so in Marx's technical definition they were merely "living labor machine[s]," closer to technical implements than they were to wage laborers. Karl Marx, *Grundrisse* (New York: Penguin, 1993), 465.

4. Louise Toupin, *Le salaire au travail ménager: Chronique d'une lutte féministe internationale (1972–1977)* (Montreal: Les Éditions du remue-ménage, 2014).

5. In the words of Federici, the "waged worker in struggling for more wages challenges his social role but remains within it. When we struggle for wages *we struggle unambiguously and directly against our social role.*" Silvia Federici, *Wages against Housework* (Bristol: Falling Wall Press, 1975), 5.

6. Joshua Clover, *Riot. Strike. Riot: The New Era of Uprisings* (London: Verso, 2019).

7. Many commercially available games, seeking to up their replay value, offer augmentations called expansion packs, which add new characters, storylines, maps, and missions.

8. N. Katherine Hayles, *My Mother Was a Computer: Digital Subjects and Literary Texts* (Chicago: University of Chicago Press, 2005), 1.

9. Ranjodh Singh Dhaliwal, "The Cyber-homunculus: On Race and Labor in Plans for Computation," *Configurations* 30, no. 4 (2022): 377–409.

10. Federici, *Wages against Housework*, 5.

11. Media theorist Friedrich Kittler, in a conversation with the French philosopher Paul Virilio, once argued that "we should slowly let go of that old dream of sociologists, the one that says that society is by nature made up only of human beings. Today—and tomorrow—the term 'society' should include people and programs." See Paul Virilio, Friedrich Kittler, and John Armitage, "The Information Bomb a Conversation," *Angelaki* 4, no. 2 (1999): 81–90.

12. Benjamin H. Bratton, *The Stack: On Software and Sovereignty* (Cambridge, MA: MIT Press, 2016).

18. Functional Specialization —— Modular Construction —— Object Orientation

Jacob Gaboury

Take a moment and look around you. Find an object that evokes the modular construction of contemporary design. Depending on where you live and work, it could be the building you're sitting in. If I look beneath me, I find the quintessential object of modular construction: an IKEA chair pieced together from a flat packed box like millions of others, serviceably identical. The computer on your desk or in your pocket is likewise shaped by this logic of objects within objects, soldered together into a singular whole that may be peripherally supplemented, expanded, and enhanced. All manner of objects today are shaped by this structuring logic, but this wasn't always the case.

The nineteenth century was defined by an entirely different structuring regime, marked by the belief that function dictates form. This is the logic found in Charles Darwin's speciation and Franz Joseph Gall's phrenology, and can still be seen in contemporary theories of evolution and cerebral localization: the large ground finch's beak is short and wide because it has evolved for cracking the nuts found in the arid regions of the Galapagos Islands, while damage to the left frontal lobe of the brain will impair grammar and vocabulary while preserving motor function, but could lead to changes in personality and behavior.[1] Specific objects designed for specific uses, customized to the task at hand. In contrast with modular construction, this logic is premised on a religious or scientific belief that objects come into being through a process directed at a distinct purpose—a functional specialization.

This belief was functionally dismantled in the twentieth century as the world was refigured to suit the standardization of industrial capitalism—a flattening of the particular into the commodity.[2] In its

place emerged new theories of how to model and organize the world as a modular structure of interlocking parts, visible across all manner of social, political, and aesthetic forms, from the economic policies of Taylorism to the infrastructures that enabled the production and distribution of new media technologies.[3] And yet, while one can find evidence of this modular logic at work throughout the contemporary lived environment, this resemblance belies a much more radical transformation in which the material function of modular design has been extended and displaced by computation.

The development of computer science mirrors the historical emergence of modular thinking in the twentieth century. In practice, early computational systems were designed around the logic of specialized use. An algorithm was a set of instructions customized for the solution of a specific problem—a flow chart moving from execution to solution, tailored to the task at hand.[4] Over the second half of the twentieth century this algorithmic logic was reconfigured into a generalizable structure that refused the particularity of a given task. This new flexible logic required a translation of the world into a structure of discrete pieces, parts, or primitives, alienated from the particularity of any given application—commodified, reusable, generic. Where once algorithmic thinking was specialized to meet the world, now the world was reshaped to conform to this new logic of computation. Such a view shapes systems theory, information theory, and cybernetics, all of which posit a universalizing structure whereby the world is distilled into an essential and generalizable form—bits, information, code. The apotheosis of this computational mode is object orientation, a broad linguistic and ontological paradigm structured around modular, reusable objects. As with modular construction, all objects in an object-oriented system function as instances of one another, articulations of a generalizable class, the product of an abstract system. In this way, object-oriented systems enact a flattening of the world, refiguring it as a structure of objects that might be made legible to computation. In contrast with object-oriented ontology and the realist philosophies of the twenty-first century, which looked to deprivilege human-centered ontologies by opening up a space for nonhuman relations, object-oriented programming restricts the world to only those objects and systems that may be made subject to simulation, that is, to those which are explicitly legible to human perception. The implication of this restriction is a refusal of or indifference to

those parts of the world that cannot be made computable and, in turn, a refiguring of that world as an environment whose principal function is computation. Under object orientation, all objects are computers, and all systems are relational structures of computers in communication.

Looking back down at the chair I'm sitting in, we can begin to see it anew. What may appear an industrial object manufactured to evoke the aesthetics of midcentury design is in fact the product of this same object-oriented regime—entirely computational in structure and form. Nearly every IKEA product is created first as a SolidWorks CAD file—a digital object—well before it is ever physically assembled in particleboard and laminate. These same CAD files form the basis for both the computer-aided manufacturing process that renders each object into flat packed cardboard boxes, and the digital rendering of perfectly staged bedrooms and kitchens with V-Ray and 3DS Max, creating photorealistic scenes to be laid out in InDesign and printed with a PostScript-compatible device for inclusion in IKEA's marketing material.[5] While aesthetically indistinguishable from the modular design that inspires it, save perhaps for the quality of its materials and the longevity of its construction, structurally it is closer to JavaScript than Le Corbusier. While modular design is premised on a belief in efficiency and systems thinking, the system is not universal. A chair is not a synthesizer is not a telephone exchange, even if each reflects the ethos of modularity that so transformed the design world of the twentieth century. Under object orientation, however, all objects become computers in simulation.

And it does not stop with IKEA chairs. The world today is bursting with computational objects that populate the lived environment in the most unremarkable ways, at once invisible and ubiquitous. It is this everydayness that exemplifies the transformation of the world in accordance with the structuring regime of object orientation, an altogether invisible shift that marks the informatics of domination. What might appear to be a continuity between the design thinking of the mid-twentieth century and the designed objects of the present masks the radical transformation of production itself—enacted by computation and its attendant logic of object orientation. Here a chair is no longer simply a chair but a physical rendering of a digital object structured and limited by a distinctly computational logic. This new structure has material consequences, reorienting our perception of the world such that we come to view the lived environment in terms of how it can be made legible to computation. In this way, those aspects of the world which

18.1. CAD and vector IKEA furniture families, illustrating the modular design of object-oriented graphical systems and rapid manufacturing.

are functionally incomputable fall out of legibility as such, devalued and degraded or, worse still, functionally replaced by their computable counterpart.[6]

It is a self-fulfilling prophecy. Where once an essentialized conception of nature set the epistemological limits of the world, in reimagining the world as a modular system it is abstracted out, first as model, then as simulation. Yet these are not simulacra, not copies without originals, as the logic of object orientation is indifferent to the truth claim of any original or essential quality of the world. Its promise is not in the accurate reproduction of the world, but in the production of a functional indifference to those parts of the world that sit outside its universalizing claim, that is, to reproduce the world in accordance with the logic of simulation. In this way the computer serves as a passage object through which the world is designed and becomes a filter through which it can be perceived.

Notes

1. The Geospizinae, or Darwin's finches, are perhaps the most famous example of his theory of speciation. See Charles Darwin, *Journal of researches into the natural history and geology of the countries visited during the voyage of H.M.S. Beagle round the world, under the Command of Capt. Fitz Roy, R.N.*, 2nd ed. (London: John Murray, 1845), 380; and Frank J. Sulloway, "Darwin and His Finches: The Evolution of a Legend," *Journal of the History of Biology* 15, no. 1 (1982): 1–53. Cerebral localization was first articulated by the racist phrenology of Franz Joseph Gall, but the most famous case study in cerebral localization is that of Phineas Gage, a nineteenth-century American railroad construction foreman remembered for his improbable survival of an accident in which a large iron rod was driven completely through his head, destroying much of his brain's left frontal lobe, and for that injury's reported effects on his personality and behavior over the remaining twelve years of his life. See F. G. Barker II, "Phineas among the Phrenologists: The American Crowbar Case and Nineteenth-Century Theories of Cerebral Localization," *Journal of Neurosurgery* 82, no. 4 (1995): 672–82.

2. To be clear, this belief was not dismantled in all aspects of social or scientific life. Functional specialization remains the dominant theory underpinning evolutionary science today, though its extrapolation into the sphere of the social has been largely discredited as racist and ableist alongside phrenology as a whole. In its place, the human sciences of the early twentieth century adopted cybernetic and other systems-based metaphors for understanding and instrumentalizing individuals and populations, not necessarily because this more accurately reflects the world, but because it better instrumentalizes that world in service of capital.

3. The technologies Friedrich Kittler describes in the *Aufschreibesystem* of 1900 are very much part of this transformation, elaborated further in his *Gramophone, Film, Typewriter*. See Friedrich A. Kittler, *Discourse Networks, 1800/1900* (Stanford, CA: Stanford University Press, 1990); Friedrich A. Kittler, *Gramophone, Film, Typewriter* (Stanford, CA: Stanford University Press, 1999).

4. These procedural programming languages dominated early computer science and included Fortran, ALGOL, COBOL, PL/I, and BASIC. Object-oriented programming was developed beginning in the 1960s and grew to prominence in the 1980s and 1990s.

5. ChaosTV, "Putting the CGI in IKEA: How V-Ray Helps Visualize Perfect Homes," Posted on YouTube, March 22, 2018, https://youtu.be/bJFlslL1wFI.

6. This is perhaps most clearly seen in the transformation of identity as a structuring category of difference into identification as or with a set of computable categories. While identity continues to exist beyond these categories, they sit on top of our lived experience and shape the ways they have become articulatable.

19. Reproduction —— Replication

Luciana Parisi

In 2020, the viral replication of epidemic outbreaks around the planet accelerated the already latent postapocalyptic scenario of the end of the world at the turn of the twenty-first century. The unification of the planet under the replication of COVID-19 seemed to demarcate a new onto-epistemological ground in a flickering twilight zone oscillating between the technical and the biological, reconstituting the realm of the biodigital. Thus, as the viral strings of COVID-19 DNA replicated from bodies to bodies across borders and time zones, so too data statistics became ubiquitous across the planet in the form of projective algorithms that rendered exponential curves of contagion, deaths, asymptomatic carriers, recovering and relapsing bodies in real time. The pandemic became the governing *dispositif* of socio-technical control spreading self-regulating strategies of incarcerations, isolation, and social distancing. One can argue that the pandemic condition became the mode of perpetuating war by other means, whereby the predictive scanning of the rate of replication of this new social virus became the only weapon to ward off the threat to the ontological survival of the human species.

 The borderless spreading of COVID-19 was met by the activation of a planetary emergency protocol accelerating the international, national, and regional military practices of colonial exportation, confinement, incarceration, and zoning of populations within cities, nations, countries, across the sea borders, and between neighborhoods. This dominant representation of a planetary emergency propelled the plan for the immediate deglobalization of capital, disintegrating the dependencies from the Global South while leaving dispossessed bodies everywhere at the mercy of a relentless spectacle of cruelty; the constant

killing of black bodies in the retro-futuristic morphing of capital accumulation.

As the viral pandemic heightened the postapocalyptic image of human extinction, it also accelerated necropolitical strategies of control through which information capital continues to justify the colonial project of accumulation through the expansion of "surrogate humanity."[1] The replication of biodigital code does not replace but rather grants a distributed intensification of capital reproduction, whereby less-than-human or surrogate bodies are necessarily posed as zero value in order to ensure a variable return to the initial conditions of capital, namely the condition of accumulation based on free or enslaved labor. The intensification of strategies of accumulation and expansion of total death constantly re-create the universal logic of capital. As much as replication accelerates accumulation, so too does capital's universal logic complete the cycle of its own reproduction. In particular, the biodigital merging of colonial, viral, and technical codes presents the ultimate view that at the edge of the world there is no other alternative to the informatics of domination.

The explosion of COVID-19 followed the plan of information capital to activate the project of full automation by training artificial intelligences to recognize patterns, anticipate behaviors, and make decisions in the name of potential threats. As a result, AI has been trained to activate protocols to block migrations, confine populations, zone minorities, and police access to debt. As the ultimate manifestation of the stealthy qualities of "societies of control," information capital has developed its own artificial intelligence for which the total annihilation of bios will serve to enable an intensified replication of biodigital codes.[2] What this artificial intelligence needs is to replicate the biodigital code in order to sustain the universal logic of capital reproduction as the only possibility for planetary survival, namely the biodigital reprogramming of accumulation—and thus the intensified expansion of surrogate humanity—as the ultimate condition for capital's eternal reproduction.

The splicing and recombination of information across species, kingdoms, and kinds not only places biodigital accumulation at the core of life and the living but more importantly defines technocapital's associative strategies to overcome its never-ending crisis. If the servomechanisms of modern automation were given the task of keeping human reproduction attached to the assembly line, the code replicator of information capital needs a generic pragmatics of enslavement that

is attached to genetically engineered, data-assembled, and algorithmically programmed platforms. Modern automation confided in the reproduction of the master model for which machines had to secure the sameness of the law, a repetitive return to the initial condition of reproduction. Self-organizing learning systems instead entail a constant optimization of intelligence, which requires the cross-engineering of all codes (biological, cultural, aesthetic, geopolitical, economical, etc.). The informatics of domination has turned the struggles of gender, race, and class into replicative patterns that have become the transparent weapons of twenty-first-century governmental violence, from border control to predictive policing, to the everyday preemptive militarization of sociality. Under these informatic conditions, no longer can the law of reproduction return to impart its transcendental schema on material processes. The reproductive machine of modern automation already struggled against the tendency of machines to run out of control, warding off the threshold of chaos while releasing self-destruction everywhere. Replication instead takes recursive patterns into its heart. Insofar as codes split and proliferate, systems can continue to diversify and self-differentiate without needing to collapse. From artificial neural networks to genetic engineering and nanotechnology, replication secures mutations for the eternity of capital and grants a future to the modern myth of the fittest human on the verge of extinction. Replication shows that information capital has a viral strategy of extraction through which it imparts a new equation of value between animal, human, and machines, whereby the recombination of codes allows an intensified exploitation of matter.

Far from replacing the reproductive techniques of governance, this viral strategy of extraction relies on molecular techniques that can transform and reprogram all levels of living. As Sylvia Wynter points out, modern epistemology turned metaphysics into the secular missions of physics, biology, and economics, which confronted the limits of the law of reproduction to maintain the colonial order of Man.[3] The autopoietic looping of science, governance, and economy enters the horizon of code replication to extend the vision of Man in terms of mutable networks. From this standpoint, replication defines not only an epistemological shift in the scientific explanation of what it is to be human but becomes an abstract machine—namely a theoretical model composed of concrete rules—aspiring to grant a metaphysical unity of cognitive science, artificial intelligence, and genetic engineering. By extracting the hybrid

dimension of code across milieus, kingdoms, species, and the organic and the inorganic, this abstract machine takes the concrete mutability of rules as the meta-order of all codes of life and intelligence, networking together the molecular with the political. What this abstract machine takes from the modern conversion of metaphysics into scientific truths is what Wynter discusses as the "bio-economic" explanation of Man's evolution, which is, as it were, reenlivened in the temporal extraction of value in code replication.[4] The nonlinear processing of information within and across scales and dimensions allows systems to change, rather than being complete and determinate. In particular, replication entails a temporal circularity, which exposes the potential of surplus value insofar as the transmuted code can be profited upon forever. Replication is a prediction affair: between one step and the next, there are margins of indeterminacy that drive the emergence of unexpected value. Replicating patterns are not simply sequentially repeated but are exponentially extended in time, an infinite source of potentialities that allow capital to reproduce without end.

The conditions of automated replication that extract the potential labor of human-animal-machine codes and overlap the class-race-gender binary axis of inclusion/exclusion have also been caught in the cinematic imaginary. For instance, the capitalist logic of extraction through code replication is central to the fiction-politics of the movie *Sorry to Bother You*.[5]

This movie tells us the story of Cassius Green (aka Cash), the protagonist, who lives at the edge of precarity, lodging for free in his uncle's garage, with no prospect of finding a secure job in the retro-futurescape of Oakland. At the edge of Silicon Valley, benevolent companies, such as the WorryFree Corporation, offer free care and accommodation to employees in lieu of a salary. Cash knows that the carceral ethos of working and living for the corporation is not an option, but he does not foresee that his challenge in finding a road to success will turn him into a surrogate body enmeshed in a network of communication, of which he is already a replicant, a mutated biodigital code. The WorryFree Corporation, which secures jobs, housing, and food to the underclasses within the walls of a hypersocial factory, is not far from a global replication of labor entangling race, gender, and class in creative articulations of surrogacy, where codes are partially assembled to save capital from its own extinction and from the collapse of the organic reproduction of life and death. Under the viral regime of replication,

capital imparts everywhere the animal-human-machine equation of value through a continuous singularization of biodigital assemblages whose data profile preserves the racialization of the species.

Employed as a telemarketer, Cash seems unable to get his potential clients on the phone; the racialization of the biodigital assemblage ties his performance rate to the blackness of his voice, his tonality, his wording. His frustration turns into creativity when he sidesteps the rules of recognition and finds himself replicating the code of whiteness in networked mediation, where his digital password takes over the code of his programmed identity.

The unapologetic activation of this strategic artificiality makes Cash's sales grow exponentially in a few months and grants him glorious access to a gold elevator that leads successful employees straight to the top floor, where so-called power callers make decisions that matter for the profit extraction of the company. It is here that his double consciousness comes forward and starts to trouble the relation between the programmed biocultural code of his identity and the techno-synthesis of his persona. Once at the top, Cash is immediately placed in an epistemological prison, where he becomes a means to an end, a biocultural tool programmed to entertain and grant capital's endless growth and variation. Not only is Cash selected to meet the epistemological expectation of whiteness, as he is constantly asked to replicate the codes of his biocultural belonging to blackness, but he is also directly included in the surrogacy plans of AI capital. Invited into the VIP area of his boss, he is promised an enormous sum if he agrees to become empowered by a drug that replicates human-animal codes in exchange for becoming the infiltrated leader of a species of free workers called the Equisapien. At this point, Cash's confused consciousness awakens to realize that the CEO of the WorryFree Corporation has already designed the future of the labor force and has already started the process of replicating his code in a new half-human, half-horse's genetic makeup. Cash refuses the billionaire CEO's offer to become the traitor leader of this synthetic species. And yet, in a moment of incredulity, Cash realizes that what he had inhaled was perhaps not a line of coke but the genetic drug designed to activate the Equisapien mutation. What he seems to overlook as he becomes benevolently seduced by the world of racial capitalism is how the condition of equivalence of animal-human-machines is set to support the reproduction of a universal equation of value.

This equation of value robs Cash of the possibility of being human, as he is now programmed to become one with horses. And yet it is this condition of being robbed of the illusion of being human that comes to break the spell of the capital code of replication: as much as the pandemic exposes a continuous accumulation of value through an intensification of precarity and surrogacy, so too, Cash's return to the condition of surrogate flesh sustains the automation of labor.

And yet, instead of embracing the exciting possibility of becoming the intermediary face, voice, body, and mind of the master, Cash undoes his self-made success and attempts to return to the precarious yet safe chaos of a jobless life, back in his uncle's garage. But the dread he had felt for the cross-species experimentation with the workforce that he starts to denounce and oppose in social media is not enough. When his humanly shaped body starts to disproportionally grow into a horse-like shape, he finally exposes the mutation of the flesh that has no boundaries and yet remains the source of capital replication. While his human-animal codes replicate in time, Cash's alienation comes into plain view, caught between the sociogenic reproduction of the racialized code (for which blackness is less and more than human) and the molecular disintegration of a whole human form (including the epistemology of sexual and racial reproduction). The effect of this double replication intensifies the radical politics of his new Equisapien condition, now devoted not simply to unmasking the Janus-faced game of inclusion and exclusion of racial capital, but to uncompromisingly turn the bioengineered naturalization of surrogate labor against the informatics of domination. Since the mutation has already happened, Cash's surrogate condition can only intensify the politics of alienation from within the reproduction/replication dyad upon which artificial capital plans to live forever. Piercing to the other side of the black hole, despite all expectation to remain a mortified surrogate less-than-human loser, Cash embraces the commitment to become a mutant leader of a mutant people with no origin. The impossibility of a U-turn back toward the promise of becoming human, and thus being saved from the pandemic virus that intermingles species and kingdoms, rather sets Cash on a line of flight. The condition of the mutant species is already a condition of replication at the core of racial AI capital for which the end of the world is no longer a threat but an everyday reality. The logic of replication here turns against itself at the very moment when engineered flesh gathers together and brings revolt to the heart of the accelerating condition of capital's pandemic.

Notes

1. See Neda Atanasoski and Kalindi Vora, *Surrogate Humanity: Race, Robots, and the Politics of Technological Futures* (Durham, NC: Duke University Press, 2019).
2. See Gilles Deleuze, "Postscript on Societies of Control," in *Negotiations, 1972–1990* (New York: Columbia University Press, 1995).
3. Sylvia Wynter, "Unsettling the Coloniality of Being/Power/Truth/Freedom: Towards the Human, after Man, Its Overrepresentation—an Argument," *New Centennial Review* 3, no. 3 (Fall 2003): 257–337.
4. Wynter, "Unsettling the Coloniality," 318.
5. Boots Riley, dir., *Sorry to Bother You* (Annapurna Pictures/Focus Features/Universal Pictures, 2018).

20. White Capitalist Patriarchy —— Informatics of Domination

Ashkan Sepahvand

For a long time or for a short moment / in another world or an other's dream / it all seemed very much of the future / even if we quietly knew we were repeating the past, broken / a profound lack of imagination / to think

so i've been writing a novel that's not a novel in that modern masculinist romantic way but more like an obsessive auto-fictional repetition of notes and images around (two prompts and a supplement)

notebook
parallel knowledge (is)

prompt 1: an american phd researcher from the university of tulsa spends a summer in athens studying greco-islamic manuscripts where he discovers an incantation to summon a persian demon / he falls into darkness /

from this moment on the story opens
openings movements openings movements

NAME THE PLANTS
NAME THE BODIES

beyond it all see so to speak so innocent of pleasure and carnival even if the knowledge of pain was acute, unbearable

prompt 2: tulsaslut and the men in whitehell / tulsaslut is sent away to THE CITY
adrift in a ruinous world
to join the faggots and their friends
after a thousand failed revolutions
there, in the identity-territory
states of desire, driven by deformation
disssssssssssssssssssssssssssssss-ease *there is a fever spreading*
THEY an ambiguous all-male chorus
dick-tate from NEOM
the devastated Kapital of the ~~west~~
cis-white demons appear and disappear
poof, in a cloud of purple smoke
the TRANS-scientists and the radical jinn
gather in secret silent invisible stillness
no-movement, no-thing
a vision of HER in the ruin
the sibyl in the sibilant, destroyer of men

future (im)perfect spread

necro- political grotesque

no origins
no climax
no ends
there isn't so much "character development" or "plotline"
as there are treatments, tracts, traces

doodles, annotations — *amulets talismans*

supplement: the seven groves and the holy mount
ABOLISH THE SELF
ontological tuning
leads to catastrophic transubstantiation
that moves all souls

a somatic recording

it's very much a study of places
where the men come and go
what figures, forces, and fictions
compose a cosmology of capital?

it is important to de-dramatize the narrative

piece it together, it's different each time
treat it arbitrarily, it's all a pile of scraps
write around, read from behind
bodies move words, words move bodies

start off by saying where you stand
where is here, where is there
an orientation:

I AM A BROWN FAGGOT
my queerness isn't universal
THIS IS SPECIFIC

—BREAKING NEWS—
says former homosexual
"i was in an all-male fascist mystery cult!"

it is summer, the month of august
i rented an apartment in athens
everyone told me it's the worst time to go
the city is empty abandoned ghost town
it's ok i don't mind i want to be alone
PLEASE LEAVE ME ALONE
i told myself
this is a self-organized writing residency
here i'll have peace of mind
i can focus
i can escape
i want to disappear
GET OUT GET OUT GET OUT
i screamed at THEM

i had always been a sex monster
now demonic
deeper deepest depth
the most hungry i've ever been
NEVER ENOUGH i was starving
no limits no boundaries
was it depression?
it was my own fault
that's what THEY make you think

DEMON
DIV DAEVA
DIVA
DEMON
DAIMON
DAE DI DE
 MON
 MAN

i didn't write a damn thing
except all the hours of messages to the men
all the men
chatting with friends
about the men
about THEM en
worrying something's not right
i can't stop the compulsion
filled with loathing, anti-social
it's THE CITY i tell you
it's a ruin

THEM THE MEN
THEM THE MEN
THE MEN
THEM
THE MEN

the ~~west~~ is death machine, that's why everyone's so horny now
~~west~~
~~west~~
~~west~~

Ashkan Sepahvand

re: "everything I know about technocapitalism...."

let us study the body-politics' complete dissolution
in the late teens
at the arse-end of rave
right before the **kkkollapsssssssssssss** sssssssssssss
with the Intermorph Surge
the incorporation of the Corporation
a last flourish of an ambiguous hope for a certain kind-of-future
one version of world masquerading as THE world
a planetary technocapitalist venture by **Quertek, Inc.** — *remember the KODE?*
known by a variety of insider terms, some slang, some jargon
G-drive, K-Space, (T)raumplan
society of control, algorithmic governance, informatics of domination
Endgame, an ecstatic rush of White Noise
a solar-anus-cum-vortex at the back of the Dark Room

in that almost imperceptible interval between the repetition
of the party as the Party as the parTy
the longue durée of an increasingly abstracted sense of time as leisure
(but whose time, anyway?)
THEY were investing in Anthropos as futurity
in the Age of Man, its Overrepresentation, its Totality
in a movement towards disembodied consciousness
get rid of the bodies, all of the bodies, every body
Quertek called these every-body-no-bodies "Intermorphs"
forms-in-between, beings-not-yet, maybe-already
exchangeable, interchangeable, living currency

MEAT
turns into muscle
turns into data
turns into plastic
turns into petroleum
turns into fantasy
turns into credit
turns into war
turns into nothing
ontic simulations
imaginary fabrications of self/image/flesh
unaware of the internal protocols that fatefully determine
every spontaneous action, crazy thought, original innovation
until temperatures rise feverish pitch
heat heat **HOT** heat
temperament tempo tempest
the incorporeal, heading towards cosmic **CONFLAGRATION**
there is a fever spreading
there is a fever spreading

<u>**CONTEMPORARY CELEBRATION STUDIES**</u> — *an experimental ethnography*
in which an organic object dissipates
translations from clubland to wasteland

162 Informatics of Domination

Aristotle, you asshole — theories of the text
may you have never been translated in Baghdad, Toledo
techno-digested into the canon of medicine — historical anatomies
it all began with **YES TO LIFE** — of possible bodies
surface-nightmare, glitch-bodies
smile/cut/smile/cut/smile/cut, deranged
cheerleaders shapeshift soldiers shimmer skin
dolphins vs. marines
love and longing at the ends of empire
she writes:
unfolding the battle sites and pleasure grounds
into a brochure of the future
the young girl is...
holographic priestess of the Great White ~~Western~~ Purity Cult
 ~~Western~~
 ~~Western~~
 Western

after the kkkollapsssssssssssss
a belief in disembodiment yields to an obsession with dissociation
there ARE bodies, after all
numb, distant, senseless
and yet no one would deny the flesh, this flesh
anarcho-primitivists pleaded for Reboot-Reload-Recovery
~~Nieuw London, aThensXXL, Börlin 3.0~~ — Faggotland, Loserville, Gaytown
the cities went by so many names
magical names, mantras to repeat
until they lose their vibrational force
devolve and reform
maps constantly redrawn
recalibrating topological models
to the meet the man-made speeding up of tectonic plates
shape-shifting continents, mountain ranges rise and fall
the planet is unrecognizable now
call here or there what you want
all temporary projections onto a dysfunctional cartography
mutating metropoles, THE CITY is for those who are left behind
left out and on their own splendor — misery
while THEY rule from the biosphere pool — port
have THEY forgotten us? cities — bodies
THEY never knew us, we never existed anyway
there is nothing to forget
only disturbances from somewhere else
inconveniences THEY must manage in the most effective manner possible
out of sight, out of mind, a mad fixation to deny this world
to the very last speck of irradiated dust
whilst engineering the next never-now always-tomorrow
this world is a world that is always ending
an end that can never end
for then it would really end
and then THEY would realize
NOTHING EVER ENDS

Ashkan Sepahvand

sex-war, control-vector, fuck-field
ten thousand men go to work at the orgy
an interlude in general virology —
— remember when THEY first named it
G.R.I.D.S. (Gay-Related Image Disruption Strategies)
at the time we were proud
of the immunological fortress we had locked ourselves into
the expanse of self-authorization stretched onto the ends of the horizon
we looked out and saw no limit
this was it, invincible-omnipotent-forever
some called this state "freedom"
a word that sounds barbarous today, incomprehensible blabber
*she told me once—freedom is a muscle, you have to train it
remain static for too long and it wastes away*

by the time of the roaring '20s
no one bought the Great Lie anymore:

NOTHING MATTERS WHEN WE ARE DANCING!

but no one believed in the critique either, as if it made it any better
the know-it-all-explanations of a depressive-repressive intelligentsia:

INDENTURED SERVANTS TO THE IMAGINATION INDUSTRY!
IMMATERIAL LABOR!
SELF-ADMINISTERED CONTROL!
and so what?
we were all dead and we knew it, each in our own way

it's not that this cyborg project didn't succeed, even though it ultimately failed
its future-promise was an aborted installation
pull the plug, blow the fuse, fry the motherboard
some of us knew, as we scrolled endlessly
that the ground was thin and unstable,
that underneath our feet there was an unknown depth
the surface would not hold much longer I BANISH I RELINQUISH
rupture would come from below THAT WHICH KEEPS ME ON THE SURFACE
the earth cracks open, everyone falls TO THE DEPTHS
what will we have become? TO THE DEPTHS I BANISH
après-moi, only wetlands and wastelands DEPTHS
 DEPTHS I RELINQUISH
when hope becomes compulsion
a constant frustration arises
from an uncanny feeling THAT WHICH KEEPS ME
that everything new is actually just the same ON THE SURFACE
and the same ON THE SURFACE
and the same TO THE DEPTHS
and the same TO THE DEPTHS

MY LIFE IS JUST FINE, THANKS xxx ON TO ON TO ON TO
!!!!!!!!!!!!!!!!!!!!!!!!!!!!!!!! TO ὦν
??????????????????

 !!!!!!!???????
[closed-mouth scream!]

THEY say a revolution happened
and we say long live the revolution
WHAT WHERE WHEN HOW
the day after the revolution is for the administration of things
no one thought of that

so that's when THEY come
to think back from the end
it's not political, it's tribal
a sentiment of coming invasion
no such thing as universal extinction

THEY proposed a new way of the world
masterfully disguised population control
in the form of self-isolated, identity-based territories
with increasingly strict internal divisions
where each can retreat to a bubble of THE SAME
m2m, plague4plague
wanna have some fun?

THEY insist
we have entered autonomous pleasure communalism
at the century's end
but tulsaslut sees it all for what it is:
male fantasies, testosterone dreams
it was eye/I who saved you
from the Revolution of the Oceans
led the Inner Resistance
advocated radical corpo-iconoclasm
NO-MORE-IMAGES-OF-BODIES
the TRANS-scientists declare
a War for Presence (Phase I)
19(21)/20(84): the shape of time 3 4 7 21 84
diachronous circuits aka Regressive-Progressive-Parallelism
the TRANS-scientists term this G-Loop: 34th parallel
memory loss like a fish, ignorance is bliss, swimming in circles
faint memory of flesh, bodies left to the distracted imagination

eye/I am having sex with your images
can eye/I touch You, where is You, when is You real?
TEAR OUT MY EYES!
open the third eye/inner I
turn the view inside-out
try to imagine her curves, his bulge Try it!
THEY flood the market with BodyPixxx
knowing how to trigger another cytokine storm
THEY keep the Intermorphs chasing Schwänze
all along the excitation-frustration circuit BITE IT OFF!!
forever and ever and ever

FFFFFFF
F
F
F
F
F
F
FEVER
FEVER
FEVER
THERE IS A FEVER
SPREADING
sssss
ssss
sss
sss
sss
G
G
G
G
G
G
GGGGGGG

3 — 4
7
3 × 7
21
4 × 21
84

magical formula
mathematics

Ashkan Sepahvand

THEY know how to scramble Our Imagination Practice
one thoughtless glance at the corpo-icons
and you're back to square one
Basic-Bitch-Reality
you merge with Image
forget Presence
gnash teeth in desire-hunger
death first in spirit
life as a corpse-fucker sarx – sex
TEAR OUT MY EYES!

THE CITY has been handed over to the dispossessed
what's left of any city these days
when there is no ground
boring rocks brutal men nostalgic fetish for democracy faggy gestures
an afterthought to a memory ~~europe~~ imagined it had of itself
before everyone remembered how
this was all along a Teutonic conspiracy
hatched by hounds of pig-faced swamp monsters
living in the damp inhuman cold
until one day someone said
GO SOUTH YOUNG MAN
dress up in imperial drag
and don't fart in public

a significant, though poorly documented tradition of black magic
had developed in the urban peripheries of the islamicate world
over the course of the 16th century
particularly in athens under ottoman rule.
it was here in this mediterranean backwater
where popular genres accounting for
a diverse array of displaced historical traditions
were able to mix and match cross-cultural forms,
giving rise to strange and fleeting syncretic experiments
in theory and practice
what one could tentatively call ISLAMIC BAROQUE

a secret resistance movement formerly known as
the pancosmic whirling dervishes
the jinn have radicalized, there is much ceremony:
they shall invoke barqan, double lightning, enter BEAST mode
they shall sing to cumaea, bald bearded goddess, suck on her fake hairy tits
the TRANS-scientists are developing a curriculum
death rituals, grief ceremonies, somatic training
HOUSE OF STRENGTH
they are planning to destroy whitehell
through *soulful practice*

what would an(Other) myth look like?
not HIStory, but MYstery

tulsaslut holds deep wisdom
in the bone-house
the choice between looking out
and looking in
is a matter of deathly importance
tulsaslut must become HER
golden teardrop, start at the centre
the only place where there is no access between heart and kingdom
a conceptual transition, or sexual alchemy
to mourn the death of the men
their towers, temples
to embody lassitude
oasis-mirage, acid-tools, burning-bush
repeat after me: *(HER) vision must be protected*
inner work with outer resonance

maybe this is just another fucked-up romance
maybe these are chronicles
of passing through the dark
of crossing capital
of meeting the men THEM THE MEN THE M
maybe it's a way of seeing **TOO MUCH** THE MEN
possessed by idols
so many eyes
history of an eye/i
LET'S GET VISIONARY

this could be a novel /
some kind of sci-fi: I guess /
about a world ruled by
the men in whitehell /
about a faggot and his friends /
about a writer from tulsa, oklahoma
who studies black magic /
and I laugh because /

TULSA IS A SLUT SPELLED
A SLUT BACKWARDS
SSSSSSSSSSSSSSSSSSSSS

Ashkan Sepahvand

21. Organic Sex Role Specialization —— Optimal Genetic Strategies

*Heather Dewey-Hagborg
and Luiza Prado de O. Martins*

This conversation began in Essen, Germany, in 2019 at the PACT Zollverein exhibition *Bodies in Trouble*, in which we both participated, and continued that year through in-person meetings in Berlin and then online via email exchange.

Heather The chart entry "Organic sex role specialization—Optimal genetic strategies" describes a transformation of reproduction from one that insists on notions of biological sex and nature to one that is increasingly technological, engineered, and here comes the ominous word—*optimized*. Optimization plus reproduction is selective breeding, and in humans that means eugenics. It describes a process of choosing who reproduces and how, by what means. When we bring genetic engineering into the equation, it also refers to which bits and pieces of a person meet bits and pieces of another person and then get incubated in potentially another person (given current surrogacy and assisted reproduction technologies that are standard today). In my interpretation, this is half prediction, half warning. It indicates one thing which might be liberatory, a freedom from the historical oppressions of biological sex roles, as well as its logical extension into a new form of eugenics. It is an oppression composed of an old form of power circulating in a new form.

Luiza Many things in Haraway's chart do not necessarily stand in one field or the other, but can be part of this circulation of power. Control over fertility and reproduction is fundamental to coloniality—

an enactment of power that is shaped by, and shapes, technological and scientific developments. Power needs to change and shapeshift to maintain itself; it shapes the world but is also shaped by it. My artistic practice takes particular interest in the changes of colonial structures of power through time and how they constitute the foundations of modernity.

I explore this in "All Directions at Once," a GIF essay I developed in 2018, in which I try to engage with practices that reject colonial power structures both in terms of content and form. At the time, I had recently finished my PhD and was (and still am) deeply jaded about academia and its contribution to maintaining colonial conceptions of science and knowledge. This work takes shape through an essay format that is disjointed, constantly changing, rejecting the linearity expected in essayistic styles. It is hosted on a website, and the GIFs appear and disappear, depending on the movement of the visitor's cursor. Each person experiences the work differently. The format responds to the content, too. This essay, which untangles itself through text and images that are fleeting, that sometimes disintegrate while you read, discusses the use of herbal contraceptive medicine as a form of resistance to colonial domination—knowledges that are largely oral, unwritten, and often kept secret from those exercising colonial oppression. It follows plants and their relationships with humans—for instance *ayoowiri* (also known as peacock flower), a plant used by Indigenous and African communities during the occupation of Abya Yala to provoke abortions, in rejection of the dehumanization imposed by the condition of enslavement. These stories of dispossession are not over; in the past years, many setbacks have taken place in the realm of reproductive justice in the United States, particularly following the overturning of *Roe v. Wade* in 2022. The violation of reproductive rights is, too, a key aspect of the processes of dehumanization of incarcerated subjects in prisons, border detainment centers, and other disciplinary enclosures—a reminder, once again, of how these processes of colonial domination can change and shift, and remake themselves.

Heather I have also addressed these issues with artistic research and practice, examining the dynamics of biopower in new practices such as forensic DNA phenotyping—the attempt to predict what someone looks like from a forensic DNA sample, and emerging possibilities for genetic surveillance.

In 2012, as part of my artwork *Stranger Visions*, I collected hairs, and chewed up gum and cigarette butts from the streets, public bathrooms, and subways of New York. I took these samples to the world's first community biology laboratory, Genspace, in Brooklyn, and working with the scientific mentors there, extracted DNA, amplified and analyzed it to begin piecing together clues about these strangers. I put this together with 3D AI facial recognition software and inverted it to make a facial generation system, based on DNA data. I 3D printed these possible generated faces in full color, human scale, and presented them along with the data and information on when and where the sample was collected. The work called attention to the impending arrival of DNA phenotyping technology as well as the messy liability of our bodies, as we are always shedding the most intimate of information without giving it a second thought. And the face is an index here to even more invasive and threatening information that can be read into our genomes. Among the many risks of this new technology, which has since become increasingly available to police worldwide, is a new form of racial profiling and a reductionism of the complexity and agency we have with regard to our identities. This is all the more insidious because the way in which DNA phenotyping technology uses DNA makes it appear to have a scientific basis, while in reality it is dependent on an enormous amount of subjectivity.

Luiza Exactly. This kind of uncritical engagement with technology is at the heart of what we're discussing here.

Heather Can we talk about birth control? The birth control pill is often seen as the historical origin point of sexual liberation for women, but Luiza, your research has shown how the very origins of this technology are grounded in racism and quite literally are at the center of the American eugenics movement. As you mentioned, in 2022, women in the United States lost their legal right to abortion, and access to birth control has been thrown into question as well. Can you share some of your research on the birth control pill and coloniality, but also maybe your current reflections on how we can understand this legacy in relation to the decreasing support for women's health in countries like the United States?

21.1. Heather Dewey-Hagborg, installation detail of *Stranger Visions*, 2012–13. 3D-printed portraits from genetic materials. Photo: Heather Dewey-Hagborg. Courtesy Heather Dewey-Hagborg.

Luiza For sure. The birth control pill, although undeniably important, is tied to a history of colonial domination. The FDA clinical trials in the 1950s were conducted in the US colony of Puerto Rico by scientists John Rock and Gregory Pincus, with support from feminist activists and suffragettes Margaret Sanger and Katherine McCormick. At the time, several US-funded population control programs operated in Puerto Rico under the assumption that the island's poverty stemmed from the excessive fertility of Puerto Ricans—rather than centuries of colonial exploitation, war, and enslavement. Sanger and McCormick, often lauded as feminist icons, facilitated the scientists' access to what McCormick described as a "cage of ovulating females." Sanger was a staunch eugenicist, who in 1920 publicly stated that birth control could be a useful tool to weed out the "unfit" and "defectives."[1] The pill trials ignored ethics or consent; Rock and Pincus experimented on people living in impoverished neighborhoods, mental hospitals, and prisons to develop a drug that was, ultimately, not even meant to benefit them, but rather was targeted toward middle-class (and mostly white)

women in the Global North. Complaints about side effects—from depression to strokes—were attributed to the "emotional hyper-activity of Puerto Rican women."[2] These side effects, ignored or downplayed for decades, still affect people who use the pill to this day; a legacy of colonial violence.

Heather Let's move on to optimization. The so-called optimal genetic strategies mentioned in Haraway's chart are, in my read, a warning or prediction about a neo-eugenic movement that would emerge with biotechnology as its validation. This has long been discussed as a risk of reproductive technologies, the idea of designer babies, that people will have genetic control over their progeny, and this will lead to an engineering of future generations that is sexist, racist, ableist. Combine this with surrogacy, the possibility of hiring a woman to carry a pregnancy that is not her own, and the optimization of sex roles and reproduction appears in all its dystopic phantasmagoria. This is today not a nightmare about the future but a very real phenomenon that is already underway in many countries.

However, as with birth control, which has such an oppressive history and paradoxically becomes a basis of sexual autonomy, reproductive technologies today also enable new forms of family making, allowing queer and nontraditional families a possibility to exist. How can we grapple with the dichotomous sides of these technologies?

Luiza This is a fascinating, complex issue. Hormonal contraception is employed for a number of reasons unrelated to the treatment or prevention of pregnancies, conditions, or illnesses. It has been deployed for years as treatment for clearing the skin, promoting weight loss, or modulating one's emotional disposition and sexual availability.[3] Acne, small breasts, excess body hair, or a libido that is too low or too high are frequently perceived as grave flaws in bodies socially marked as female; the pharmaceutical industry has responded to these concerns by developing specialized contraceptive drugs to treat these perceived problems; a form of suppressing characteristics which might suggest queerness, thus reinforcing a binary understanding of gender.[4]

Optimization necessarily demands the establishment of an aspirational ideal, a blueprint to which all must conform. Yet, in a fantastic subversion of these optimization efforts of cispatriarchy, hormonal

21.2. Luiza Prado de O. Martins, still from *All Directions at Once*, 2018. GIF essay. Courtesy Luiza Prado de O. Martins.

birth control drugs have also been used as part of hormone replacement therapy by trans and nonbinary folks for decades This, to me, illustrates so clearly the complexity that a conversation on optimization demands: a drug first tested by exploiting colonial subjects, designed and deployed to uphold hegemonic and binary notions of gender, but that eventually also becomes part of a fundamental, life-affirming treatment for a population and community that is violently marginalized.

Heather Let's move to a different scale of eugenics to expand our discussion of optimal genetic strategies. Today, I see another neo-eugenic impulse occurring with the climate catastrophe and a (resuscitated) ecofascist movement gaining momentum. The white supremacist terrorists in Christchurch and El Paso both cite ecological justifications for their actions. Nazi Richard Spencer has published a manifesto that includes an environmentalist platform.

Luiza Unfortunately, Malthusian arguments keep being recycled when discussing the climate crisis, most often blaming the poorest and most

vulnerable populations on the planet for the environmental collapse. Anthropologist Eric Ross notes that Malthusian theories have been fundamental to maintaining unjust social and economic infrastructures, and to obscuring the root causes of poverty, inequality, and environmental deterioration.[5] Under Malthusian lenses, poverty and scarcity are not inevitable (and desired) outcomes of capitalist systems, but rather a result of the actions and choices of the poor.[6] Since Thomas Malthus's initial formulation in 1798, his arguments have periodically been revisited and recycled by academics and activists alike, from Paul Ehrlich—one of the first to blame environmental collapse on overpopulation—to Margaret Sanger, as we have mentioned.[7] In the past few years, organizations like Population Matters—formerly known as the Optimum Population Trust—have been pushing for antimigration policies, while enlisting support from prominent environmental figures from Jane Goodall to Sir David Attenborough.

Heather And in the coronavirus crisis, so much discourse emerges celebrating the return of nature, the reduction of carbon emissions, and praising the virus as an agent of environmental activism, while hundreds of thousands of people die. This impulse comes not just from the right but also from the left.

Luiza Absolutely. In an article published on *Al Jazeera*, scholar Edna Bonhomme discusses how pandemics like this one affect people living in different places in the world in radically distinct ways. She writes, "the Global North failed to see the global nature of the crisis we are currently facing. As they rushed to protect their own, they once again succumbed to old tropes about epidemics being caused by 'dirty and strange others.'"[8] The same subjects who are displaced, the same subjects who deliver mail and food, who package products in warehouses, who are burdened with constant risk of exposure without much choice—are also blamed for the spread of the infection. This argument ignores the uncomfortable truth of how the ongoing crisis is driven by the Global North's perpetual hunger for disposable goods, exploitable bodies, and natural resources while shifting blame to those under the constant threat of food shortages, unrest, and displacement—an ongoing project of world-ending, as writer Ailton Krenak points out.[9] Ultimately, these concerns reveal the perversity of calling for care while ignoring underlying capitalist and colonial

articulations; an act that is, in itself, a violence, a way of consuming a perpetual other.

Notes

1. Margaret Sanger, *Woman and the New Race* (Scotts Valley, CA: CreateSpace, 2018), 153.

2. Annette B. Ramírez de Arellano and Conrad Seipp, *Colonialism, Catholicism, and Contraception: A History of Birth Control in Puerto Rico* (Chapel Hill: University of North Carolina Press, 2011), 116.

3. Paul B. Preciado, *Testo Junkie: Sex, Drugs, and Biopolitics in the Pharmacopornographic Era* (New York: Feminist Press, 2013); and Emilia Sanabria, *Plastic Bodies: Sex Hormones and Menstrual Suppression in Brazil* (Durham, NC: Duke University Press, 2016).

4. Sanabria, *Plastic Bodies*.

5. Eric B. Ross, *The Malthus Factor: Poverty, Politics and Population in Capitalist Development* (New York: Zed, 1998), 1.

6. Kalpana Wilson, *Race, Racism and Development: Interrogating History, Discourse and Practice* (New York: Zed, 2012).

7. Paul R. Ehrlich, *The Population Bomb* (New York: Ballantine, 1969); Sanger *Woman and the New Race.*

8. Edna Bonhomme, "What the Coronavirus Has Taught Us about Inequality," *Al Jazeera*, March 17, 2020, https://www.aljazeera.com/indepth/opinion/coronavirus-taught-inequality-200316204401117.html.

9. Ailton Krenak, *Ideas to Postpone the End of the World* (Toronto: House of Anansi Press, 2020).

22. Biological Determinism — Evolutionary Inertia, Constraints — Future Folklore

*Ashley Ferro-Murray
and Justin Talplacido Shoulder*

Artist and performer Justin Talplacido Shoulder begins their evening-length proscenium solo *Carrion* by inhabiting a larger-than-life stuffed tardigrade costume. Shoulder calls their decade-long performative practice a future folklore, in which one artist, a bird, and a tardigrade become together. The tardigrade is one of the world's most resilient animals, a phylum that mimics death so closely that it evades it.

Human head releases slowly from deep cleft of Tardigrade, slow birthing to Wagner's Parsifal. *Weight of body releases onto cool metal ~ silence. Skin breathes a body shifting under stacks of stones. Cold stone memory on musculature of shoulders, forearms, upper arms, lower back, upper back of thighs. Isolation on right shoulder slowly lifting large stone toward the sky. Right foot antennae reading atmosphere. Fluid memory of* Dante and Virgil in Hell *by William-Adolphe Bouguereau. Blood lust in jaws of Gianni and Capocchio. Deep concave curve from coccyx through the spine out through crown of head: circuiting electricity between crown and earth. Oppositional circuitry engages core. Exploring lower vertebrae, sternum pulled skyward opening chest. Throat traces sky till gaze faces horizon beyond. Ears prick to stimulus. Scanning gaze.*

Shoulder's separation from the tardigrade is the first of many soft ruptures that take place over the course of *Carrion*. They are births and disassociations, at once evolutions and decompositions. Shoulder literally extracts themself from that which is resilient. The resultant vulnerability and ensuing choreography is romantic, but only in the humanist sense of the word. It may be a moment of bodily wholeness, in that Shoulder's nakedness and fluid movements accentuate the composition of the performer's body, but the artist's movements articulate each vertebra with precision to emphasize the muscular and skeletal

22.1. Justin Talplacido Shoulder, performance still from *Carrion*, 2018. Photo: Bryony Jackson.

definition of the body. This performance highlights a corporeal mechanics. A foot antenna, electricity of the body, and corporeal circuitry establish hybridity in human form.

AFM Justin, what is the significance of this moment of unadornment in your practice, which is otherwise grounded in the use of artifice?

JS For the last ten years, my performance practice has centered on the creation of masks, prosthesis, and costuming as my primary modes of transformation. *Carrion* for me was set as a provocation to be able to work from the inside out, where the body is the primary means of transformation. How can I generate these other hybrid beings and make my human form malleable?

Shoulder does not stay with the moment of unadorned physicality for long, and *Carrion* quickly evolves again to take on machine qualities. For example, later, Shoulder embodies a robot-like character with a white plastic face mask that accessorizes a helmet of Apple

headphones. The character's hair follicles are the headphone's earbuds stuck to the scalp and from which the thin white headphone cords flow long to constitute this being's hair. The mane of technological detritus meets environmentalism as the character plays in a simulated natural environment of mechanical birds, folly leaves, and water.

The same character eventually dismantles the stage set and inhabits a cushy, larger-than-life inflated cellular-looking caricature that bobbles up and down. It takes over the stage and digests and rebirths Shoulder's head from an at once phallic and anus-looking orifice. In and out, in and out, in and out, until the structure deflates and Shoulder emerges anew as what the artist calls the tardigrade reimagined as a prehistoric bird.

> AFM Your artistic practice centers around the creation of avatars through various media in live performance. Can you talk about your interest in embodiment within the context of your use of mask, prosthesis, and costume?

> JS In *Carrion*, there was a marked shift from my earlier work in terms of embodiment. My early work in the body of figures Phasmahammer was mostly formalist abstractions of my body: full-body costumes often working with repetition of materials—balloons, tinsel, shredded plastic bags—that would augment my form far from the human in a spectacle mode. For *Carrion*, the provocation was training my body and building a gestural ecology that allowed me to communicate other beings and hybridity without artifice or minimal artifice.

One reading of *Carrion* might focus on the recognizably body/machine character who is central to the work; that being whose hair follicles take the form of earbuds. But this approach is quite obvious and plays closely to a cultural imaginary of robot and machine. These preconfigured categories have become too stable for emergent practices and might foreclose more radical approaches that transcend expectation in order to birth labor and beings anew. In a society where excess is capital, Shoulder's proposal for a more stripped-down form of artifice-less-ness—the naked body antennae that carries the weight of rock memories, for example—performatively carves space for hybrid bodies that bear imprints. The work illustrates how

the physical body itself can be of machine, environment, and other information.

AFM Can you talk more about your idea of a gestural ecology?

JS For *Carrion*, with the guidance of my mentor Victoria Hunt, we developed a vocabulary of gestures that I can access and augment as I perform. For each creature, for example, the tardigrade, there are embodied modes like Knotted Chicken Worm or Alien Starfish that have parameters and qualities I embody in specific parts of my body. Through a combination of the bodyweather methodology/school and my own investigations into puppetry/spectacle, I might invite electricity into my forehead, lava into my feet or environmental stimulations: walking through falling feathers.

It is somehow in the fleetingly vulnerable moment of the unadorned human body that Shoulder most resembles the contemporary corollary to Biological Determinism —— Evolutionary Inertia, Constraints; the possibility for evolving futures born from a society that otherwise balances in between well-trodden, yet never quite realized dichotomies. Shoulder's performance persona transcends even the possibility of identitarian dichotomy by way of first destabilizing the linearity of existence with the tardigrade. The artist then cradles the body as detritus in a limited set environment that suggests some constraint (there are only so many tools to performatively digest) but still allows for possibility therein. A future, here, has already been instantiated. *Carrion* simply reveals what has already been.

There is an emptying of the body—you can imagine yourself as hollow as a vessel. Then you bring in energies, weather elements, whatever kind of stimulation you need to respond to. For example, imagining the floor beneath you is deep, sticky, thick, viscous glue will determine and inspire your way of moving. This can also be isolated to one part of your body. A small stone on your upper left shoulder that you are raising to the heavens.

AFM Bodyweather seems integral to your attaining hybridity. How does the technique help you cultivate elements like electricity in the body, or environmental impulse into a corporeal state?

JS Bodyweather is a broad-based type of training that proposes a practical strategy to the mind and to the body. It stems in philosophy from the teachings of butoh dancer Min Tanaka and his MAI-JUKU performance group in Japan. It draws from eastern and western dance, sports training, martial arts, and theater practice. We often describe it as research, as it is not about technique, more about propositions for opening up the possibility to move or be moved.

To succumb to the contemporary moment, even if momentarily, is to acknowledge the practicality of material limitation. The fires burn. Debate evades. As Justin embraces in their practice, tools/objects/limbs in a space are limited. It is what the artist imagines and does with these material possibilities that creates limitlessness for the future folklore of a performance world.

AFM You refer to your work as speculative fiction cosmology. How does your own life provoke the fictitious elements of your work? *Carrion*, for example, is born from your future folklore practice. You pull from Filipino ancestral myth and motifs from the queer club experience.

JS Yes, future folklore describes a mode of practice that draws from long lineages of community-based storytelling, both within my queer and diasporic families. In *Carrion*, a big influence from IRL is my relationship to my parrots I live with. I had been enjoying building our interspecies communication through vocalization and physical gesture. Learning how they respond to desire, threat, play, as well as thinking about the evolutionary journey from dinosaur to bird. This bird-human-machine hybridity is a dominant exploration in *Carrion*.

Shoulder's work is not a utopian project but, as a work of future folklore, one that embraces realism out of necessity for survival. Still, its embrace of cyclical evolutionary possibility gestures toward the radicalism of early utopian articulations. For example, the moment of witnessing limit becomes, for *Carrion*, an opportunity to begin again, to evolve again; this moment births reembodiment in ways that ultimately evade the shortsightedness of a determinist present. This future folklore nar-

ratively centers queer and diasporic experience to make space for interspecies care and sustainability. These are the futures that biological determinism forecloses and that get stuck in limbo between that and evolutionary inertia, constraints.

> AFM Your exploration of evolution as cyclical in *Carrion* creates space for imagining different scientific pasts to produce alternative futures. I wonder if this part of your practice enlivens an artistic engagement with evolutionary inertia, constraints—one that is grounded in your body, but that you open up to different communities by narrativizing evolution as hybrid in the story of *Carrion*.

> JS *Carrion* as a theater work is both open and closed. There is a multitude of possibilities for becoming, yet the tools/objects/limbs at my disposal are limited. I can only work and rework with what is in the space—constructing and reconstructing both body and environment.

> The stage is awash in stark yellow light and haze, the original set dismantled. But the tardigrade persists anew. "Tardigrade becomes decaying dying humanoid becomes prehistoric bird. . . . It's nonlinear and organisms are devolving as much as evolving."
> *A dissimulation of Finches in collective bird song tweet requiem in D-minor, polyphonic tones carry on the wind. Warm rain falling. Steam. Lyrebirds mimic chainsaws while Bowerbirds collect and angle sinews of iridescent cabling, building the form of an ancient child's body. Soft-bodied legless larvae are downloaded, Leeches placed on the nervous system gently animate this lobotomized vessel. Iris dilates red.*
> *High-vibrational nerve energy body. Shoulders and chest swell forward as your wings are thrown, flicking backward. Fingers on tips. High-level alertness tracking through body. Sensitivity to bird calls and stimuli ~ scan three points for signs of threat.*

23. Community Ecology —— Ecosystem —— Automated Environments

Jennifer Gabrys

In forests around the world, automated detection systems are at work scanning horizons for signs of wildfires. Cameras programmed with algorithms scan landscapes at distances up to sixty kilometers for signs of smoke or fire. A positive result sets off a cascade of commands, from detection leading to localization within less than ten minutes. Reports are sent to fire crews who are meant to be on the ground within a matter of a few more minutes. Aviation can be triggered next for callout. Fires are in turn extinguished in a rapid, digitally augmented, and automated system for responding to expanding and intensifying fire landscapes.[1] As one example of an automated environment that has now become a signature infrastructure of a changing planet, forest fire detection systems indicate how ecologies and ecosystems are increasingly transforming into automated environments that at once monitor hazardous and disastrous events while creating response infrastructures—often concentrated in wealthier regions—that attempt to manage a planet in crisis. Digital technologies undertake detection and actuation as an articulation of smartness. The automated responses that unfold perform according to programmed and adaptive logics of how to manage the growing threat of fire, typically through suppression—even when fire can be an integral component of landscapes and their regeneration.

Digital ecologies now describe much more than the silicon architectures of computer networks placed in assorted environments. Computational systems are transforming the planet into automated and automatable media through integrated information networks that monitor and manage increasingly polluted, saturated, and stressed environments. A United Nations Environment Programme article written by authors with expertise in biodiversity and digital transformation

outlines how planetary datasets and "frontier technologies" could be joined up and deployed in a race to save the planet.[2] In an accompanying infographic that provides an audit of the many information technologies currently monitoring the earth, readers learn that as of 2019 there were 4,987 satellites in orbit, five billion phones providing geocoded data, and an anticipated 75 billion sensors planned to be in operation by 2025. Computational systems are remotely sensing deforestation, tracking movement ecologies, and detecting environmental hazards in varied locations worldwide.

These systems are not just collecting data, however. They are also operationalizing automated environments. Populated with all manner of digital technologies, from environmental sensors and the internet of things to remote sensing, drones, robots, data servers, machine learning and AI, environments are now under increasing observation. Monitoring infrastructures tune in to daily and seasonal events: they take the "pulse" of the planet, gather data that can be used to make systems more efficient, and respond to disaster scenarios, while also facilitating extractive industries. From smart forests to smart oceans, smart soils, smart rivers, smart lakes, smart atmospheres, and smart cities, there are multiple environments that are wired and programmed to enable ongoing monitoring and real-time management.[3] Here, *smart* operates as a digital logic of enhanced observation, connection, and functionality. But smart technologies can also amplify the perceived intelligence of organisms and ecosystems by, for instance, digitally monitoring processes of plants as they sense and respond to environments. Digital sensors, in other words, sense "natural" sensors. With data gathered through these observations, processes of monitoring environments easily shift to managing and automating them. Preventative decisions can be taken to limit pollution or resource quotas, or to adjust the planetary thermostat through computationally enabled geo-engineering technologies.

Automated environments do not merely remap ecological dynamics within cybernetic and network logics. Instead, they signal toward a near-future programming of milieus that is being set in motion to manage resource flows and mitigate against the overstepping of "planetary boundaries."[4] While the nine planetary boundaries—including biodiversity, biogeochemical flows, and climate change—reach points of stress and uncertainty, these dynamics further inform attempts to mitigate and manage environmental crisis.[5] Yet who decides on the designation of these boundaries, when they are reached,

and what responses should be taken? How might informatic programs be designed to enable and disable forms of life to optimally survive within these operating systems? Increasingly, such decisions are coded into informatics systems that sense, alert, and actuate responses to events such as wildfires, deforestation, or other environmental disturbances. As a digital actuation of ecosystem services, automated environments zero in on what environmental and computer scientists designate as the essential functionalities of ecologies and in turn augment and automate these processes to ensure an optimal cascade of ecological operations.

The automation of environments, in other words, could also involve the automation of politics. Decisions about environments can relocate from spaces and processes of democratic governance to automated programs. The designation and use of resources can become a process governed by technology companies and owners of datasets. Public engagement can further require access to digital infrastructures for contributing to observations and negotiations, which could restrict the citizens and citizenships involved with environmental governance. These processes inevitably give rise to different planetary subjects and formations of planetary governance, since decisions about how to assess and act on environmental change are distributed through computational systems. Yet these same systems are never free of power or the distinct ways of valuing (or overlooking) environmental relations. Power imbalances, extractive forms of environmental governance, and reductive environmental citizenships could be further encoded into computational systems, as has already been demonstrated in extensive scholarship on embedded forms of bias.[6]

Similar to the smart environments discussed in the introduction to this text, the automated and digitalized technologies for environmental management can create coded and embedded forms of planetary governance that would seem to inevitably unfold as part of the logic of coded systems. Planetary systems, planetary boundaries, and planetary ecologies become the focus of technopolitical management that is distributed throughout digital devices and infrastructures. A more perfect, responsive, optimized, and automated informatics becomes a proxy problem that, if solved, would in turn remedy planetary crises. Automated detection and response systems manage hazards, risks, and disasters that threaten or are unfolding. Operations for managing and governing environments are made possible through this dual logic of

rendering the world as one common problem, and of rendering the instruments that would work on that problem as equally singular in the form of coding to enable ongoing exchange and capital accumulation, even when managing the resources that would be exhausted by these operations.

At the same time, the very technologies that would communicate planetary crises are in part contributing to the damaging conditions they would control.[7] Just as informatics unfold through recurring upgrades and accelerations, these same dynamics further transform the constitution of environments and environmental subjects that would be monitored and activated within circuits of communication and control. Automated environments indicate yet another ratcheting up of these technoscientific dynamics and the remaking of milieus through the automated interconnection of information and operation, or in other words, the streamlining of observation and intervention, sensing and actuating. Informatics signals the activation of control dynamics. Yet it also demonstrates how communication technologies require regular upgrades and updates to curtail crises.[8]

Moreover, the latest wave of informatics in the form of Industry 4.0 and Forestry 4.0 technologies is extending computational logics to shape and respond to ecological and planetary transformation and collapse, while also enabling expanded forms of extraction. Forestry 4.0 initiatives that span from Canada to Norway and beyond are especially emblematic of how computational systems would itemize, datafy, sense, and connect forest systems for optimized yields, harvesting, and distribution. As one film from FPInnovations, a Canadian private nonprofit organization, illustrates, forest inventories can be optimized, tree selection can be streamlined, automated vehicles can harvest, and supply chains can distribute timber in the most efficient way possible through the aid of pervasive and advanced informatic technologies.[9] Through informatics, however, these forests are always configurable and available as timber commodities. Other possible ways of engaging with, cultivating, and experiencing forests are rendered secondary or nonexistent.

Here, forests become generalizable, detached from specific places and communities, as they are made into more uniform and streamlined resources. Informatic technologies in their latest interconnected and automated formations collapse and foreclose forests that do not readily circulate within commodity circuits. Yet for many Indigenous, tradi-

tional, and local communities around the world, a complex and pluralistic range of forest experiences, encounters, and livelihoods unfold with and through forest environments.[10] Forest ecologies are not always computable, or not in these ways. They could even give rise to other computational practices that work against the easy conversion of forests into timber and environments into extractable resources.

Informatics in the form of computational systems have remade ecology and ecosystems. Smart forests spring up at the nexus of ecology and informatics within the context of planetary overload, toxification, collapse, and transformation. They demonstrate how ecology and informatics shift from an analysis of networks to the reconstitution of earth systems as more seamless, productive, and response-ready automated service ecologies that are now being programmed and reprogrammed. In such a techno-scientific project of automated planetary governance, there are just as many possibilities for power imbalances to arise.[11] The management of environments could as easily lead to containment and elimination of ways of life not aligned with extractive enterprises. The logic of capital accumulation could be written into the computational programs of planetary governance. This is already the case in the development of smart cities. The specter of automated environments indicates the multiple smart ecologies, including smart forests, that could be orchestrated through command-and-control scripts.

Yet automated environments are also a provocation to work from within these machinic quandaries, while not demanding purity or unity in attempting to make sense of the multiple computational projects that characterize planetary management and governance.[12] Visions for a wired planet proceed from a unified vision of the globe. But what automated environments demonstrate, haunted as they are by the ancestors of informatic ecosystems, is that such gestures toward global unity are bound to collapse under the pretensions of containment and control. Technologies for sensing forests might enable the automation of greater and more pernicious forms of extraction. Alternatively, practices of sensing forests could generate worlds for more-than-human flourishing.[13] How might it be possible to rework and reinvent these technologies, practices, and environments toward less extractive and more generative engagements? Perhaps one place to start would be to question the politics and programs of automation and to accommodate multiple ways of "being planetary as praxis."[14] In other words, the planetary is a shifting and pluralistic project that cannot collapse into

digital logics of detection and response. Instead, environmental sensing practices might consider how tactics of building, coding, and weaving from within the complex and situated circuits of environmental change might occur. This is an approach that works from within the informatics of domination to transform and work against its extractive and unjust logics and practices.

Notes

1. There are many digital technologies operating in the space of automated fire detection. For example, see IQ Fire Watch, https://www.iq-firewatch.com/. This is part of a component of a larger research project, Smart Forests, which investigates automation and optimization as modes of planetary governance within forest environments. See Jennifer Gabrys, "Smart Forests and Data Practices: From the Internet of Trees to Planetary Governance," *Big Data and Society* 7, no. 1 (January 2020): 1–10; and Smart Forests, https://www.smartforests.net/.

2. Jillian Campbell and David E. Jensen, "The Pressing Need for a Global Digital Ecosystem," *Medium*, September 17, 2019, https://medium.com/@UNDP/the-pressing-need-for-a-global-digital-ecosystem-aa10a9f8df56.

3. Jennifer Gabrys, *Program Earth: Environmental Sensing Technology and the Making of a Computational Planet* (Minneapolis: University of Minnesota Press, 2016).

4. Johan Rockström et al., "Planetary Boundaries: Exploring the Safe Operating Space for Humanity," *Ecology and Society* 14, no. 2 (2009): 32, https://www.jstor.org/stable/26268316.

5. See Stockholm Resilience Centre, "Planetary Boundaries," https://www.stockholmresilience.org/4.1fe8f33123572b59ab80007039.html.

6. For example, see Emily M. Bender et al., "On the Dangers of Stochastic Parrots: Can Language Models Be Too Big? 🦜," in *FAccT '21: Proceedings of the 2021 ACM Conference on Fairness, Accountability, and Transparency* (New York: Association for Computing Machinery, 2021), 610–23.

7. See also Jennifer Gabrys, "Powering the Digital: From Energy Ecologies to Electronic Environmentalism," in *Media and the Ecological Crisis*, ed. Richard Maxwell, Jon Raundalen, and Nina Lager Vestberg (New York: Routledge, 2015), 3–18.

8. In a related way, James Beniger analyzes the recurring crises of information overload and the technologies that arise to manage these crises, while also further exacerbating these problems. See James Beniger, *The Control Revolution: Technological and Economic Origins of the Information Society* (Cambridge, MA: Harvard University Press, 1989). As an update to Beniger, and with the aid of Haraway's reading of informatics of domination in relation to ecosystems, crisis takes on a more planetary significance, where the technologies that would monitor and manage pollution further lead to its pollution and collapse.

9. The Smart Forests Atlas documents some of these Forestry 4.0 projects, and the FPInnovations film specifically. See Kate Lewis Hood, "Industry/Forestry 4.0," *Logbooks* (blog), Smart Forests Atlas, https://atlas.smartforests.net/en/logbooks/fpinnovations-forestry-40.

10. Jennifer Gabrys et al., "Reworking the Political in Digital Forests: The Cosmopolitics of Socio-technical Worlds," *Progress in Environmental Geography* 1, nos. 1–4 (2022): 58–83.

11. Donna J. Haraway, "A Cyborg Manifesto: Science, Technology, and Socialist-Feminism in the Late Twentieth Century," in *Simians, Cyborgs, and Women: The Reinvention of Nature* (New York: Routledge, 1991), 161.

12. Haraway, "A Cyborg Manifesto," 154.

13. For an example of how sensing technologies have been built, coded, and reworked within and against the informatics of domination, see the Citizen Sense project at http://citizensense.net.

14. See also Jennifer Gabrys, "Becoming Planetary," *e-flux Architecture*, October 2018, https://www.e-flux.com/architecture/accumulation/217051/becoming-planetary.

24. Racial Chain of Being —— Neo-imperialism, United Nations Humanism —— the More Things Change-the More Things Change

Shaka McGlotten

FOR DAD

1.

I'm chained and chaining, bound to pasts and linking up with those with whom I learn.

Fish, mud crawler, ape, Man, mobile device (a devolutionary pressure); ape, Neanderthal, Man; ape, Negroid, Mongoloid, Caucasoid.

While these chains appear as serial compositions, they are anything but; rather, they are temporally promiscuous compactions of fantasy and violence. They've been around the block.

Take another chain, a neo-imperial supply chain that relies on the vulnerable who haven't made it into the frame, but who still frame it: children mine precious metals, women polish iPads, and apex predators (that's you and me) buy consumer electronics on credit until we throw them away and upgrade. Then the supply chain loops back around where Brown and Black men sit in clouds of toxic smoke in e-wastelands, tearing callused fingers as they pry out the last bits still worth anything. A supply chain is a debt chain; some debts we pay, others are unpayable.

Oh, there's one last chain, a pedagogical one, that connects me, my Dad, and my students to Blackness, as well to the Black quantum futurities to which we are attached, Black feminist futurities, "grammar[s] of possibility," that may offer modest hope for retreat, refuge, and rest.[1] These chains can be lifelines, which, in turn, can

recall for us that the chains that prevent our flourishing can be collectively warped or blowtorched, that they can be broken, and that we can be unchained.

Tellingly, I first wrote *home* when I meant to write *hope*.

2.

The racial chain of being has always been an informatics of domination.
Neo-imperialism and United Nations humanism aren't scary new networks; they are predicated upon and still animated by an anti-Black operating system.[2] Black folx have long been subject to datafication, to quantification. Katherine McKittrick calls this the "mathematics of black life," the breathless lists: ship registries, *The Book of Negroes*; insurance policies (recall the Zong), redlining, disease vectors.[3] Branding, meet corporate branding.[4] Phrenology, meet biometrics.[5] And Jim Crow, this is Jim Code.[6]

The more things change, the more they chain.

3.

My mom went along with my dad's desire to name me Shaka. As a young child, I recall a series of prints leaning against the base of the wall in my parents' bedroom. They were part of a series called *Great Kings of Africa* created by Anheuser-Busch. Shaka was among the featured kings and, like those featured on other prints, was meant to inspire Afrocentric pride. In the image, he holds a spear and shield in a foregrounded portrait, while behind him tribesmen gather.

So I was named after a corporate marketing effort, and that's OK. My dad used the prints as mnemonics to help bind me to Blackness and its real myths. *Roots* was a blunter instrument to remind me of the stock from which I derive, and the stocks in which some of my ancestors were bound, the ancestors that weren't plantation owners like Roswell King or slave-holding Confederate officer James Urqhuart, who founded North Augusta, South Carolina. I learned about these men from my mom's family during one of my very rare visits, as well as hours spent on Ancestry.com.

Then there were the Black Panthers. In the late 1960s, after a few years of military service in Berlin, Germany, where he translated intercepted East German communications, my dad landed in Portland,

Oregon, to attend Reed College on the GI Bill. There, he helped found the Black Student Union and became minister of education in the local Panthers chapter. My dad dipped the day he went to the chapter house after a tipoff to warn everyone there, "Get rid of the guns and girls. The police are coming." Several years later, my dad dropped out of a PhD program in sociology at Berkeley before reenlisting. He always said that he hated the Army, but there were few, if any, professional opportunities for him in the early 1970s that would provide the material security needed with me on the way.

Now he lives in a house he and my stepmom built on a few acres outside of San Antonio, Texas. It's comfortable, though I always find the house cold, and CNN plays noisily on the always-on TVs in every room. He does the yard work, assisted by his motorized scooter. He sits outside on the porch where he smokes weed and watches the birds. And he goes fishing with a dwindling friend group whenever he can, his Black rage tempered into mellow progressivism. At seventy-five, he possesses an enviable optimism. "I'm so blessed, son."

4.

Increasingly frustrated by their exclusion and by the terms of their potential inclusion in toxic, predominantly white spaces, some of my Black students' visions of Black flourishing (re)turn them toward the separatisms my dad attached to in the 1960s and '70s.

In New Black Ethnographies, my students and I read anthropologist Zora Neale Hurston, Hortense Spillers, and the Combahee River Collective Statement, among much else. We also read Octavia Butler's *Dawn*.[7] Talk about the chaining seriality of racial ambivalence! In the novel, Lilith Iyapo is rescued by an alien species, the Oankali, after humanity's destruction of the earth. However, they are as much captors as rescuers. The Oankali have an acquisitive curiosity that inexorably drives them toward making contact with other life-forms. They are traders in genes, promising health, extended life, and an Oankali companion, who will be lover and minder both. With great difficulty, Lilith navigates her relationship with the Oankali, who, depending on her willingness to cede to their demands for trade, will determine whether she will sleep in suspension for eternity or experience a future in which she will raise hybrid offspring. She resentfully accepts, entering into a nonetheless not wholly involuntary symbiosis with Nikanj,

an Ooloi—a mediating third sex among the Oankali—who becomes her companion and future coparent.

Lilith has another task; she must Awaken other humans who have remained in suspension and convince them to accept the same bargain. Things do not go well, confirming the Oankali's diagnosis that what most makes humans so dangerous to each other, other species, and even worlds is that we are hierarchical and intelligent, a deadly mix.

The more things stay the same.

In the course, students create speculative ethnographies in which they imagine themselves as anthropologists in future worlds they have created. Some lean into a fantastical optimism: a queer femme beach world where everyone does their own thing with magic crystals. Magic realism takes on grimmer tones, too. The orchard around which a remote Black community's social culture is organized has grown from the corpses of their dead, gathered from an ancient battlefield. The trees grow Afros, and their branches transform into long, manicured nails.

Rather than fight to inch forward, many of my students instead imagine getting out. In their freedom dreams, BIPOC get out and disappear, they go underground or under the sea. Maroon societies keep it on the DL in repurposed caves built within the forgotten infrastructures of the Underground Railroad and in improvised societies built in the burned-out remnants of housing projects. Get out: fuck reform or inclusion, much less conquest. Get out: escape, retreat, and make refuge for kith and kin.

5.

The manifesto by liberation front La Mano NegreX, or LMX, caused turmoil between people of color, white nationalists, and pacifists alike. Reddit became a flashpoint when racist trolls circulated memes of black girls gone missing in the DC area, captioned "See, Niggers Don't Belong Here." Viral videos of Karens threatening black and brown people circulated at a fevered pace, eventually pushing things over the edge. A race war broke out. The descendants of the revolutionaries eventually create an autonomous state in the territory of what was once New York State, renaming the area the La Republica Choco-Cafuzo.

6.

This is what they need now. This is what I need now.

7.

My dad's chimerical choice of my name activated my political attentiveness from a young age, an attentiveness that has always informed my teaching. As in Butler's *Dawn*, symbiosis is at work, and so is what I think of as a retro-causality. We—my father, myself, and my students—shape one other lovingly, furiously, and with deep need. Butler's Lilith Iyapo is the already living future of those she must Awaken, having navigated a world they have never known, anticipating their hurts and pleasures like a Mother. Or a lowercase father. I'm chained to him, my students to me. My students are now the future my father imagined and fought for; and so they are the future immanent to that past. Symbiosis and pedagogy. People learn, they link up, and they love. Even so, griefs can span centuries.

When I challenged some of my Black and Brown students to rethink their exclusion of white people from their worlds, they narrowed their eyes, sucked their teeth, and shrugged. "They have *their* worlds. We need our own." The white students in the class kept quiet and listened.

When Black worlds thrive in my students' work, they thrive because they are Black worlds.

I wonder if I would learn anything at all but for my students.

"Then, a small confused Awakening," like the wrenching clarity of getting woke.[8]

8.

It's taken me awhile to get here, but the prompt for this chapter asked me to consider the contemporary resonances of Haraway's chart and/or to consider adding a new term. I thought of a few of the latter: the more things change, Afrotopias, United States of Africa Space Agency. I settle on the first and hope that the editors will allow me a repetition, a fourth term. We're talking about chains after all. And this repetition is a repetition, and it's a repetition with a difference. The more things change, the more things stay the same: "benign" and virulent expressions of anti-Blackness remain everywhere present and are in this moment increasingly renormalized. Yet, too, the more things change, the more things change. Baby-step changes can amplify (through fury, desperation, love) the desire for other ever yet more ambitious ones, like renewed efforts to enact ambitious and absolutely necessary structural

changes. Or to create spaces for healing and the recharging of resiliencies necessary to keep fighting, to protect the hard-to-carve-out, fragile outsides from white supremacy. CNN and a boat. Teaching. Marronage.

At antiracist protests you see signs reading, "We haven't come this far to come this far."

The chart below doesn't map befores and afters; it's not temporally faithful to sequential periodization. Instead, it is an ironic experiment focused entirely on the racial chain of being and the resonating continuity of anti-Blackness and Afrotopias alike.

Tuskegee	Ancestry.com
Book of Negroes	Gerrymandering, Census
Swastikas on dorm walls	"Continuing the Conversation: A Five-Part Dialogue Series"
Primitive accumulation	#BlackLivesMatter
Django Unchained	White fragility
Star Wars VII–IX	Trolls, bots, review aggregators
Zombies	Trolls, bots
Pipeline problems	Tenure, burnout
Drums	Black Twitter
Birth of a Nation	~~*La La Land*~~ *Moonlight*
Cyborg	*Black Macho and the Myth of the Superwoman*
"Mama's Baby, Papa's Maybe: An American Grammar Book"	MAGA
Plantation	School
Plantation	Prison industrial complex
Plantation	Redlining, affordable housing

194 Informatics of Domination

Plantation	PTSS (post-traumatic slave syndrome)
Settler colonialism	Involuntary settlers with nowhere to go
Voodoo, possession	Algorithm
BlackGodz.com	SEO
Black codes	"Black Code," a special issue of *The Black Scholar*
Middle Passage	Middle Passage (cf. Plantation above)
Mathematics of the unliving	Algorithmic risk assessment scores
Africatown	BlackPlanet.com
Sorrow songs	Streaming Beyoncé's *Homecoming* on Netflix
Racial chain of being	Human error

Notes

1. See Tina Campt, *Listening to Images: An Exercise in Counterintuition* (Durham, NC: Duke University Press, 2017); and Rasheedah Phillips, ed., *Black Quantum Futurism: Theory and Practice*, vol. 1 (Philadelphia: House of Future Sciences Books/AfroFuturist Affair, 2015).

2. Kara Keeling, "Queer OS," *Cinema Journal* 53, no. 2 (Winter 2014): 152–57.

3. Katherine McKittrick, "Mathematics Black Life," *Black Scholar* 44, no. 2 (2014): 16–28, http://dx.doi.org/10.1080/00064246.2014.11413684; Shaka McGlotten, "Black Data," in *No Tea, No Shade: New Queer of Color Critique*, ed. E. Patrick Johnson (Durham, NC: Duke University Press, 2016), 262–86.

4. Simone Browne, *Dark Matters: On the Surveillance of Blackness* (Durham, NC: Duke University Press, 2015).

5. Browne, *Dark Matters*.

6. Ruha Benjamin, *Race after Technology* (Medford, MA: Polity, 2020).

7. Octavia Butler, *Dawn* (New York: Popular Library, 1987).

8. Butler, *Dawn*, 3.

25. White Capitalist Patriarchy —— Informatics of Domination

Jian Neo Chen

In 1959, a Euro-Australian Anglican priest in charge of the Boianai Mission off the southern coast of Papua New Guinea reported sighting several foreign-looking glowing objects hovering in the sky above the mission. Seeing humanlike figures walking on the surface of one of the flying discs, he and a group of Papuan witnesses waved at them, and they waved back. In 2023, the underwater remnants of a meteorite that exploded over the Pacific Ocean in 2014 near Papua New Guinea were uncovered by an Israeli American astrophysicist at Harvard. The scientist claims that the meteor traveled from interstellar space outside our solar system and that the meteor materials may be technological trash—like plastics in our oceans—discarded by ancient civilizations beyond Earth. The US Office of the Director of National Intelligence and Department of Defense have increased their surveillance of unidentified aerial phenomena since 2022.

Pacific Centuries

Seas and oceans are local, shifting, connected, boundless. They defy the separation between land bodies, territorial boundaries, nation-states. There is no smooth passage. The Pacific is the dominant name given to the wild mixture of sea, land, sky, submarine, human, nonhuman, and extraterrestrial worlds that have evaded efforts to know and own what has been defined as the non–Western Hemisphere. In its various names, Mar del Sur, El Oceano Pacifico, the Great Ocean, Stille Ocean, South Sea, Pacific Rim, the Pacific is the byproduct of white cisheteropatriarchal imperialism, capital, and science, which seek to pacify multiple worlds into an open surface for traversal. For Columbus,

Balboa, and Magellan-Elcano in the fifteenth and sixteenth centuries, the Pacific was the boundary and route that secured claims on the new world of the Indigenous Americas by imagining what was beyond. Cook's eighteenth-century voyages to locate the transit of Venus, Terra Australis, and finally a northwest passage between the Atlantic and Pacific brought British and European empires into Oceania and the South Pacific under the banners of science and myth.

The rise of the United States as an imperial superpower by the end of the Second World War depended on inheriting and overtaking these legacies. In 1898, the colonization of Cuba and Puerto Rico; the Carolina, Marshall, and Mariana Islands (including Guam) in Micronesia; and the Philippines following the Spanish American War along with the annexation of the Kingdom of Hawai'i forged US dominance over oceanic pathways between the Atlantic and Pacific and from Oceania and the South Pacific into the seas of the North Pacific. These territorial spoils in the Pacific facilitated US expansion beyond Indigenous and Latinx territories on the North American continent. They established the United States as the controller and profiter of geographies and movement from the Atlantic to the Pacific to the Atlantic. By replacing Spain, Britain, and other European empires in the Pacific by the turn of the twentieth century, the United States usurped the maritime networks established centuries earlier between western US territories, Mexico, and Central and South America and locations in the Pacific Islands and Asia, including the Acapulco-Manila-Canton trade. Ascension of the United States as a maritime power in the Pacific helped to shape Pacific worlds into an interimperial region—a Pacific Rim—for exploiting natural resources and labor; developing military, economic, and political instruments; and population, epidemic, and environmental science benefiting US, European, and Asian empires.

The codification of the Asia-Pacific region after World War II signals the military and nuclear pacification of Oceania, the Pacific Islands, Japan, and Korea and the advancement on more Pacific and Indian Ocean worlds as lines of attack and barricade against Russia, China, North Korea, and Arab and Islamic territories. Then president Obama, who was often described as the "first Pacific president" by his administration, announced a renewed focus on an Indo-Pacific region through his "Pivot (or Rebalance) to Asia" strategy in 2011, following the withdrawal of US troops that had occupied Afghanistan since 2001 and Iraq since 2003 (while troops still remain in Syria) as part of the US

global war on terror.[1] The Trump administration identified a "free and open Indo-Pacific" as its top priority in the face of what it described as military, technological, economic, and ideological threats to national security posed especially by China, Russia, North Korea, and Iran.[2] Whereas the Obama administration did not clearly define *Indo-Pacific* and used the term sparingly, along with *Asia-Pacific* and *Asia and the Pacific*, the Trump administration used the term regularly as a new regional concept and referred to India as an important strategic partner along with Japan and Australia. The Biden administration's Indo-Pacific strategy credits the Obama administration for recognizing the historical and growing importance of the region while repeating the Trump administration's commitment to a free and open Indo-Pacific protected against aggression from the People's Republic of China. Biden's presidency cements the understanding of the United States as an Indo-Pacific power and specifically describes the region's geographic expanse "from our Pacific coastline to the Indian Ocean" and its different corners "from Northeast Asia and Southeast Asia, to South Asia and Oceania, including the Pacific Islands."[3] The concept of the Indo-Pacific not only acknowledges the military, economic, and technological influence of India and South Asia. It reasserts the Pacific roots of US transnational hegemony and stretches them further into the Indian Ocean to profit the United States' ongoing cold wars, wars on terror, and domestic racial gender class wars.

Biden is the first US president to develop a national strategy focused on the Pacific Islands. His objective is to build a distinct and unified Pacific Islands region to combat climate change; ensure freedom of navigation and overflight and unimpeded trade flows; and protect the sovereignty and security of the Pacific Islands and the United States against increasing geopolitical competition.[4] Citing the two million US citizens living in the Pacific Islands and the US homelands of the Commonwealth of the Northern Mariana Islands, Guam, American Samoa, and Hawai'i, Biden's strategy commits to a regional partnership based on friendship, family, or neighborly feeling instead of geopolitics. Yet intimacy between the United States and the Pacific Islands has been a relationship of force, instrumentalization, and coerced dependency. Following Spanish, German, and then Japanese colonization of the islands defined as Micronesia, the US Navy and Department of the Interior began to administer the more than two thousand islands of Micronesia (except for Guam, which was already an unincorporated

US territory) under a United Nations–appointed trusteeship in 1947. Under trusteeship, the United States conducted sixty-seven nuclear bomb tests, as well as twelve biological weapon tests, and dumped tons of radioactive soil from Nevada nuclear testing sites in the Marshall Islands between 1946 and 1958. By the end of the trusteeship in 1986 in response to calls for autonomy within the territory's districts, the newly self-governing Republic of Palau, Republic of the Marshall Islands, and the Federated States of Micronesia (Kosrae, Pohnpei, Chuuk, and Yap) had entered into Compacts of Free Association with the United States. This free association gave the United States the right to build and operate military bases in these nations in exchange for economic assistance and US military defense. Separately, the Northern Mariana Islands became a commonwealth of the United States, sharing the status of Puerto Rico (and the Philippine islands before independence) as an unincorporated territory and commonwealth of the United States. With Papua New Guinea and the Republic of Palau signing onto more US military operations in Oceania, US strategic partnerships with the Pacific Islands continue destructive interimperial and settler colonial legacies in the Indigenous Pacific through the guise of shared humanitarian and environmental concern.

Pacific Imaginations

The romantic foreignness of the Pacific. The Atlantic reduced through captive calculation. The Caribbean is the Indies; Cuba is Japan and China; and Hispaniola is southern Arabia. Further west to the east where white capitalist cis-heteropatriarchy liberates itself from its own "dark" myths and empires to rediscover taxonomies of one's own supremacy. Not settler imperialists. Explorer-missionary-artist-scientists.

When the figures in the sky waved back, Father William Booth Gill asked a Papuan boy to bring him a flashlight, pencil, and paper so he could record the minute-by-minute movements. The boy turned on the flashlight and waved it back and forth at the craft. The disc-shaped object seemed to react by moving back and forth like the flashlight. The thing returned the next day outside the church just before evening service. In what has been classified by European comparative anatomists, geographers, naturalists, and anthropologists as the Melanesian heart of darkness in the Pacific, the vision provided both hierarchy and universality to white, blackened, and foreign bodies and their technologies

and to the social and spatial divisions between nature, culture, religion, and science.

Oceania and its connections to Pacific and Indian Ocean continents have served as empirical laboratories for the development of the European and US modern sciences. Its sea lands, species, peoples, environments, and cultures have been credited with an anachronistic natural diversity that can be traced, classified, and manipulated more readily because of the isolation of islands at sea and their exotic primitivism. Each volcanic island is a paradise for evolutionary speculation.

After studying the Chilean coast in 1835, Darwin sailed west on the *Beagle* into the Pacific, stopping at San Cristóbal in the Galápagos archipelago and then moving through the Hawaiian islands and parts of Melanesia. Having been pushed up from the ocean floor by volcanic activity, these groups of islands must have been uninhabited by plants and animals originally. Darwin thought that the species found on these islands had crossed the seas and then modified into their own unique species, found nowhere else, after arrival.

> When we turn, however, to the Tchambuli, we find a situation that while bizarre in one respect, seems nevertheless more intelligible in another. The Tchambuli have at least made the point of sex difference; they have used the obvious fact of sex as an organizing point for the formation of social personality.[5]

Observing the Arapesh, Mundugumor/Biwat, and Tchambuli peoples in Papua New Guinea in the 1930s, Margaret Mead argues that the personality traits described as feminine and masculine in the United States and Europe have no basis in physiological sex. Differences between men and women are culturally determined, and the force of this conditioning—in the face of the arbitrary world of traits—requires a complex enough society to condition without creating oppression, homogeneity, or deviance. While Indigenous groups uncover the fundamental laws of sex (and gender) in human societies, their social orders are too simple to offer models for modern societies.

Disorienting circles between sex and gender and sexuality keep remaining in taxonomies of the Pacific. This disorientation fixes Indigenous Pacific worlds at the racialized thresholds between nature, culture, and science. Effeminate Melanesian boys, sexually available Polynesian muses, the sorcerer of Hiva Oa. Classifications of African

inferiority and Indigenous noble savagery developed in the Americas and other European colonies project onto Polynesia, Melanesia, Micronesia. Quiros, Tasman, Bougainville, Marchand, Cook, and the many others who come before and after use the anachronic Venuses and monsters of the Pacific to make the science between natural use and social exchange speculative. Yet Indigenous Pacific worlds prove enduring, expansive, transcending.

> "Oceania" denotes a sea of islands with their inhabitants. The world of our ancestors was a large sea full of places to explore, to make their homes in, to breed generations of seafarers like themselves.... They developed great skills for navigating their waters—as well as the spirit to traverse even the few large gaps that separated their island groups.[6]

The ancient Polynesians conceived of their ocean as an expansive highway connecting disparate coordinates in a rich network of genealogical alliances and exchange. The ocean's isolated atolls and island clusters mirrored the myriad constellations of the sky above: the stars and galaxies whose sky maps had guided the islanders to new destinations. The vast dome of the sky—conceptualized by the Polynesians as an expanse of space (vā) punctuated at intervals by time (tā)—was marked by the rising and setting of the sun at opposite ends of a fixed horizon, a useful reference point for a landscape that was otherwise constantly in motion. Shifting with the tides and swells, this crescent-shaped canopy stretched overhead, tethered at each corner and broken only by the silhouettes of islands rising out of the sea.[7]

Notes

1. Barack Obama, "Remarks by President Obama to the Australian Parliament," November 17, 2011, Washington, DC, transcript, the White House, https://obamawhitehouse.archives.gov/the-press-office/2011/11/17/remarks-president-obama-australian-parliament.

2. Donald Trump, "Remarks by President Trump at APEC CEO Summit, Da Nang, Vietnam," November 10, 2017, Washington, DC, transcript, the White House, https://trumpwhitehouse.archives.gov/briefings-statements/remarks-president-trump-apec-ceo-summit-da-nang-vietnam; and US Department of State, *A Free and Open Indo-Pacific:*

Advancing a Shared Vision, November 4, 2019, https://www.state.gov/wp-content/uploads/2019/11/Free-and-Open-Indo-Pacific-4Nov2019.pdf.

3. The White House, *Indo-Pacific Strategy of the United States*, February 2022, https://www.whitehouse.gov/wp-content/uploads/2022/02/U.S.-Indo-Pacific-Strategy.pdf.

4. The White House, *Pacific Partnership Strategy of the United States*, September 2022, https://www.whitehouse.gov/wp-content/uploads/2022/09/Pacific-Partnership-Strategy.pdf.

5. Margaret Mead, *Sex and Temperament in Three Primitive Societies* (New York: William Morrow, 1935), 288.

6. Epeli Hau'ofa, *We Are the Ocean: Selected Works* (Honolulu: University of Hawai'i Press, 2008), 32.

7. Maia Nuku, *Atea: Nature and Divinity in Polynesia*, Metropolitan Museum of Art Bulletin 76, no. 3 (New York: Metropolitan Museum of Art, 2019): 5. Exhibition catalog.

26. Scientific Management in Home/Factory —— Global Factory/Electronic Cottage

Ho Rui An

A televised advertisement from the late 1980s presents an extraterrestrial scene. Two astronauts float around a remote controller in zero gravity. One reaches out toward the device and turns on a television set that drifts into view, its arrival announced by a booming voice-over: "Daewoo SuperVision II." This is the line of television sets manufactured in the 1980s by former South Korean conglomerate Daewoo. The camera closes in on the television screen, which is playing an image of a tiger. The two screens—medium and diegesis—seemingly become one. A bee lands on the screen, right upon the tiger's nose, only to be frightened away when the latter unleashes its menacing roar. Representation gives way to simulation as the telemediated animal appears to act directly upon the world, its life force standing in for the technological prowess of the advertised television set that would in time displace the one in which the advertisement is playing.

But there is a broader narrative of displacement to be told. Daewoo SuperVision II was just one of many consumer electronics from South Korea that flooded the global market in the years of the country's economic miracle, during which South Korean brands decisively beat out competition from the West while going head to head with Japanese brands that first claimed their turf through the aggressive industrial policies that South Korea went on to emulate. The roar of the tiger exceeding the screen is thus symptomatic of the explosive growth achieved by the so-called Asian Tigers—originally Japan, South Korea, Taiwan, Hong Kong, and Singapore, but later also Indonesia, Thailand, and Malaysia—which more than rattled the halls of Western hegemony to spawn an entire genre of literature seeking to put a name to this phenomenon. While some sought recourse to the cultural through

such figurations as "capitalism with Asian values" and "Confucian capitalism," others debated whether the booming economies of the region exemplified laissez-faire capitalism or the neomercantilism so despised by the burgeoning Washington Consensus of the time.[1] Yet the attachment to such totalities—cultural, economic, or otherwise—belies the reality that the developmental strategies pursued by these economies were irreducible to the Cold War–era ideological frameworks into which they were often interpellated. The Japanese bureaucracy, for one, did not produce a theory or model of its policies until as late as the 1960s.[2] Given this, instead of approaching these economies as bounded entities to which essential (read: racial) properties are ascribed, it serves us better to think of them as nodes within a global network, with the developmental state accordingly imagined less as an oppressive behemoth than a switchboard operator modulating rates of flow. The difference is between the disciplinary regimes of industrial capitalism and the informatics of domination that undergirds the electronic cottage in a global factory.

However, this distinction between a system based on the production of type and one based on the regulation of flow is a difference that does not make all the difference. And perhaps no other image thematizes the continuity between the two imaginaries more than the one that Rachel Grossman bequeathed us in her influential essay: a woman peering through a microscope as she assembles the tiny components of the latest consumer device.[3] This figure that was behind the digital revolution of the late twentieth century was also more likely than not Asian. Yet racialization and sexualization here proceeds through a peculiar logic: the "oriental female" grasping a pair of tweezers with her nimble fingers is valorized for her pliability, that is, her ability to readily remold her body to the task. In other words, she is the type that subverts the very logic of type. But as a worker of the export processing zone notorious for its lack of labor regulations, she is still subjected to the scientific management of the factory, one made even more paternalistic by the gendered division of labor (factory managers are overwhelmingly male) and the zero tolerance for failure (an imperfect electronic component is worthless).

We can observe on this basis that the turn from the industrial workplace to today's information networks is not a historical rupture but an elaboration of the power entrenched in the ruling class within a transformed field of social relations that produces a new assemblage of

26.1. Production of semiconductor, 1990s. Photo: DAEWOO Global Management Institute.

power. There is, accordingly, a slippage that we need to redress in the very proposition of slipperiness of those once-static categories that we sequence all too casually these days as race, sex, and class. While it is certainly true that within today's networked circulations, race becomes racialization and sex becomes sexualization (and so on), there is less a spectrum to be observed today between direct producers and the owners of the means of production than an ever-widening wealth gap. This is why in the varieties of inclusive capitalism being touted amid the ongoing meltdown of late capitalism, their progenitors can unblinkingly proclaim capitalism's ability to survive the elimination of racial and sexual exploitation that were inscribed at its origin, but can only avoid addressing the category of class altogether.[4] For sure, there is the potential for class mobility, given that information networks are more easily hacked, and there has also been the emergence of new classes, like the supermanagerial class especially dominant in East Asia and the self-employed precariat that keep the platform economy going the world over, but the structure of class remains, and must remain,

deeply hierarchical, even if the casualization of labor means it might not be directly experienced as such. It is difficult, indeed literally impossible, to conceive of a class cyborg under capitalism—a ruling class of cyborgs, yes, but not class itself as cyborgian. There will never be a proletariat billionaire.

This is not to say that class is not already implicated in struggles against conditions of race or sex, for if we were to just stay with how a feminist cyborg alone might implicate class politics, its critique of social reproduction, for one, would already be a good start at dismantling the general conditions of proletarianized cyborgization. Nonetheless, the historical score sheet shows that while coalitions built around feminism and/or antiracism have at best only inconsistently addressed the inequities of class, the persistence of class formation has more often resulted in the *renaturalization* of race and sex in moments of capitalism's crisis, or when cyborgs prove too much even for capitalism itself. That is when we realize that the global factory, for all its reorganization of racial and sexual relations, is still, at its base, a factory.

The global factory experienced its first major crisis with the so-called Asian financial crisis in 1997. A wave of capital account liberalization in the early 1990s had led to a flood of foreign capital into the region. But the insistence of most governments on pegging their currencies to the US dollar on the assumption that it would assure investors that they were secured against exchange rate risk meant that, at some point, their currencies became severely overvalued as the United States experienced its own economic boom in the mid-nineties. In Thailand, efforts at defending the peg to the US dollar in the face of speculative attacks eventually drained its reserves, forcing the government to float the baht on July 2, 1997. The size of the foreign debt owed by local firms and banks immediately ballooned. As the bubble burst, capital fled the country while speculative attacks were made on the currencies in the region, finally driving Indonesia, Malaysia, and the Philippines to float their currencies as well.[5]

What followed this fallout of networks was nothing less than a return to the old holisms that had been kept at bay by the miracle. Feeling vindicated, longtime skeptics of the region's economic potential took no time to revive charges of crony capitalism, a term with a racialized history dating back to the 1980s, when it was applied to the Marcos kleptocracy in the Philippines.[6] Granted, it is indisputable that factors like nepotism, collusion, and corruption often taken as endemic

to these economies were at play in the period leading up to the crisis, yet the particularistic idiom that framed the discourse amounted to what Laura Kang calls an "Asianization" of the crisis, which served, above all, to foreclose the ways by which the crisis was understood.[7] Suddenly, it was no longer hard work and discipline that defined the Confucian work ethic, but the favoring of bloodlines and communal associations, which critics argue had destroyed competitiveness and led to the crisis. The direct role played by unrestrained capital mobility and short-term lending in precipitating the crisis was thus conveniently eclipsed. Consequently, when the most heavily hit economies of Thailand, South Korea, and Indonesia were forced to turn to the International Monetary Fund (IMF) for a bailout, the terms of the loan agreement mandated even more liberalization.

The results of the IMF's interventions were catastrophic. A fire sale ensued as investors rushed back into the market to buy up the devalued firms and assets, causing even more volatility and worsening the recession. Traditional gender lines were redrawn as women were disproportionately laid off and compelled to resume their "natural" role as caregivers for a family/nation on the brink.[8] Malaise turned into unrest as people took to the streets, increasingly redirecting their anger from their local governments to the IMF and international investors. In Indonesia, a photograph of the managing director of the IMF, Michel Camdessus, crossing his arms as he looked down on President Suharto signing away the country's economic future, triggered angry comparisons to the country's colonial history. In Malaysia, effigies of George Soros burned after the Prime Minister Mahathir Mohamad, in statements laced with anti-Semitism, accused the currency trader of causing the crisis.[9] Calls to abandon "Western-style" capitalism and return to the "real" economy were made as citizens in South Korea and Thailand turned up in droves to donate gold to replenish their country's reserves.[10] Finally, on September 1, 1998, Mahathir dramatically reinstated the peg of the ringgit to the US dollar and implemented capital controls, infuriating the IMF and investors whose assets were frozen. Enough with networks! Let's save the nation first.

But one can only avoid networks for so long. They encroach upon you, and also, they make too much money. This is why it did not take long for the governments of the immediate postcrisis period to lull the economic nationalism expressed during the IMF-mandated privatizations so that the country could be reintegrated into the global

economy. In Thailand, Prime Minister Thaksin Shinawatra, who swept into power on a rural-focused populist agenda, sold off shares in state enterprises and used the funds raised to hand out microloans to villagers in the hope of creating "a new class of entrepreneurs" to compete in the "new Silk Road."[11] In South Korea, a state-led shift toward developing information and communication industries produced a new generation of start-ups that chipped away at the monopoly of power held by family-owned conglomerates.[12] Meanwhile, Singapore, which came out of the crisis relatively unscathed, saw the launch of the Renaissance City Project, a master plan to invest in the city's cultural infrastructure in the hope of building a "creative cluster" that could attract global talent and businesses.[13]

Fast forward to 2016. In America, disgruntled voters decided that in the face of increasing automation and global flows, they would rather go back to the factory. At the same time, across Asia, entire smart cities were being raised from the ground, or sea.[14] The difference is not between going backward and forward, but between two kinds of class exploitation, the first through alienated labor and the second through information. But even that is putting it too simply. If only the dichotomy between the comfortable old hierarchies and scary new networks mapped so neatly along geopolitical lines. For one, it is telling that Singapore's own smart city initiative goes by the name Smart Nation.[15] This recathexis of the city to the nation speaks to the persisting anxieties over how the global city, marked by its porosity, heterogeneity, and transient population, poses a threat to state power.[16] But a city-state like Singapore knows that it has no shot outside the network. The nation invoked here is thus less as a permanent retreat from the network than a temporary shelter—an escape pod in times of emergency. The strategy is not exit but dismount: there are no lack of points on the network on which one can make a crash landing.

Notes

1. Scholarship examining the relationship between capitalism and Asian or specifically Confucian values proliferated between the 1980s and early '90s. Examples of edited volumes dedicated to the subject include Peter L. Berger and Hsin-Huang Michael Hsiao, eds., *In Search of an East Asian Development Model* (New Brunswick, NJ: Transaction, 1988); Hung-chao Tai, ed., *Confucianism and Economic Development: An Oriental Alternative?* (Washington, DC: Washington Institute for Values in Public Policy, 1989); and Tu Wei-ming, ed., *The Triadic Chord: Confucian Ethics, Industrial East Asia, and*

Max Weber (Singapore: Institute of East Asian Philosophies, 1991). On the other hand, a landmark World Bank study on economic development in East Asia deliberately eschewed culturalist explanations, choosing instead to address the debate on whether market liberalization or government intervention was responsible for the region's rapid growth. See World Bank, *The East Asian Miracle: Economic Growth and Public Policy* (New York: Oxford University Press, 1993).

2. Chalmers Johnson, MITI *and the Japanese Miracle: The Growth of Industrial Policy, 1925–1975* (Stanford, CA: Stanford University Press, 1982), 32.

3. Rachel Grossman, "Women's Place in the Integrated Circuit," *Southeast Asian Chronicle* 66 (January–February 1979): 2–17.

4. Among the most prominent advocates of inclusive capitalism is the Council for Inclusive Capitalism, founded by Lynn Forester de Rothschild of the Rothschild banking family. The council includes hundreds of global business leaders among its members and has been endorsed by the Vatican. Separately, Singaporean senior statesman Tharman Shanmugaratnam has called for socioeconomic models based on "inclusive prosperity" as a solution to both the "failure of market fundamentalism" and the "growing irrelevance of the old social democracy" that seeks instead to "revitalise the politics of the broad centre." See Tharman Shanmugaratnam, "Inclusive Prosperity: Making It Possible" (Lecture, London School of Economics and Political Science, January 30, 2017).

5. My account of the events leading up to the crisis draws upon Walden Bello, "The Asian Financial Crisis: Causes, Dynamics, Prospects," *Journal of the Asia Pacific Economy* 4, no. 1 (1999): 33–55; Pasuk Phongpaichit and Chris Baker, *Thailand's Crisis* (Chiang Mai: Silkworm, 2000); and Robert Wade, "The US Role in the Long Asian Crisis of 1990–2000," in *The Political Economy of the East Asian Crisis and Its Aftermath: Tigers in Distress*, ed. Arvid J. Lukauskas and Francisco L. Rivera-Batiz (Cheltenham, UK: Edward Elgar, 2001), 195–226.

6. The earliest recorded use of "crony capitalism" was in a *Time* magazine article on how the Marcos dictatorship siphoned off the national wealth to its cronies. See John Demott, "A Case of Crony Capitalism," *Time*, April 21, 1980. William Safire credits the editor of the article, George M. Taber, for coining the term, though he misdates the magazine issue. See William Safire, "On Language: Crony Capitalism," *New York Times*, February 1, 1998.

7. Indeed, it only took the 2008 global financial crisis to show that crony capitalism might be much more accurately identified with capitalism tout court. See Laura Hyun Yi Kang, "The Uses of Asianization: Figuring Crises, 1997–98 and 2007–?," *American Quarterly* 64, no. 3 (September 2012): 411–36.

8. Jesook Song, *South Koreans in the Debt Crisis: The Creation of a Neoliberal Welfare Society* (Durham, NC: Duke University Press, 2009), 62–64.

9. Mahathir was notorious for emphasizing Soros's Jewish heritage when mentioning the currency trader: "We do not want to say that this is a plot by the Jews, but in reality it is a Jew who triggered the currency plunge, and coincidentally Soros is a Jew. It is also a coincidence that the Malaysians are mostly Muslim. Indeed, the Jews are not happy to see Muslims progress." See Mahathir Mohamad, "Speech on the 10th Session of the Islamic Summit Conference" (Putrajaya Convention Centre, Malaysia, October 16, 2003).

10. This comparison between the "fake" economy of "Western-style" capitalism and the "real" economy built by local communities was made by Thai public intellectual Prawase Wasi. See Prawase Wasi, *Bangkok Post*, December 28, 1997.

11. Thaksin Shinawatra, "Next Generation Asia" (speech, Fortune Global Forum, Hong Kong, May 9, 2001).

12. In 1999, the Seoul Venture Center was launched to promote the growth of start-up companies. See Song, *South Koreans in the Debt Crisis*, 112–16.

13. The term "creative cluster" only appears later in a report on developing "creative industries" in Singapore, which included an update to the original Renaissance City master plan called "Renaissance City 2.0." While the initial master plan focused on the development of the arts, the revised edition underscored the connection between the arts, design, and media industries. See National Arts Council, *Renaissance City Report: Culture and the Arts in Renaissance Singapore* (Singapore: MITA, 2000); and Creative Industries Working Group, *Creative Industries Development Strategy: Propelling Singapore's Creative Economy* (Singapore: Economic Review Committee Services Subcommittee, 2002).

14. A nonexhaustive list of smart cities (to be) built from scratch in Asia includes Tianjin Binhai New Area, China; Songdo International Business District, South Korea; Masdar City, Abu Dhabi, United Arab Emirates; Xiong'an New Area, China; Meikarta Satellite City, Indonesia; and New Manila Bay–City of Pearl, Philippines. Most of these cities are still under construction.

15. Smart Nation Singapore, "Smart Nation Singapore," https://www.smartnation.sg.

16. Ho Rui An, "Crisis and Contingency at the Dashboard," *e-flux Journal* 90 (April 2018).

27. Family/Market/Factory —— Women in the Integrated Circuit —— Feminist Corpus of Organismic Art

Caroline A. Jones

As virions match viral videos in stimulating new collective behaviors, the relation of forces once theorized as hegemony shifts at every scale.[1] Artists take up the old binaries—family/market/factory, women in the integrated circuit—and via a feminist corpus of organismic art, labor is reconfigured. Take *Wet-on-Wet*, a commission by artist Jenna Sutela for the Guggenheim Museum, hosted by e-flux during the global pandemic in 2021. One aspect of the labor was a collaboration with MIT materials scientist Markus Buehler, whose laboratory postdoc translated the vibrations of particularly intriguing protein chains into frequencies that could be programmed into audible sounds. Yet another layer of the collaborative work here involved the artist's own microbiota and hormones, "epigenetic" molecular laborers that subtly construct her mood as she conducts wet-on-wet watercolor painting to the "tune" of oxytocin.[2]

 Labor thus operates at multiple scales—yet it will be macroscale factors that determine who will stay at the lab bench, who will govern that lab, and whose author name will be attached to the artwork. What we can celebrate is that new modes of assembly (corpus as chorus, not bounded but resonating!) are dismantling aspects of bioart's earlier patriarchal obsessions, that is, the fantasy of men playing with and dominating the material (code) of life itself. But centering on a patriarchal Creator was only briefly possible, since the actual queerness of life relations was about to explode fully into scientific and popular-cultural awareness. The women artists I discuss here open viewers to the ambivalence of compost, not composition, on the premise that one system's entropy is another system's energy. This shifts the implied productivity of family/market/factory definitively toward the more-than-human, art propelling us into circuits of an-Other kind.

27.1. Jenna Sutela and Markus Buehler, video still from *Wet-on-Wet*, 2021.

Art echoes how labor today operates at these multiple scales and with other-than-humans. Factories can be empty of human workers, populated by sexless bacteria or friendly yeast churning out pharmaceuticals, scents, or dyes. Even farming happens via integrated circuitry surveilling windowless facilities no longer permeable to animal activists (hundreds of thousands of creatures are misted and fed, their urine and feces scraped and piped constantly into holding tanks, grated and gated flocks and herds ministered by automatic devices in concentrated animal feeding operations or CAFOs). The new bioart critiques this kind of extractive instrumentalism.

Hubris meets humus, as a new generation of genomic adepts enters the art world to reveal the powers of gut brains and virions in shaping all manner of matter. Feminist organismic artworks dismantle patriarchal obsessions with code and Creation, showing the complexities of life in symbiosis (life lived with others), genes translocated by viral tweakings of organismic integrity, and critters collaborating in shared platforms of becoming.[3] This art features cohabitation, collaboration, and contamination in a world that was never pure. Installed in the art world's enduring white cubes, this humus-y art celebrates epigenetic flux and neo-surrealist weirdness. The artists in question work with always impure biotopes, enlisting extremophiles as performative symbionts, or collecting the piss of installation preparators to feed fungi that cohabit with ceramics in the space of art.[4] For example, take the works of Anicka Yi (*Grab-

bing at Newer Vegetables, 2015, plexiglass, agar, female bacteria, fungus, 84.5 × 24.5 inches, usually documented as installed at The Kitchen), Jenna Sutela (*Extremophile*, 2018, film and performance engaging nattō and the European Space Agency, performed at the Serpentine), and Candace Lin (*Memory*, 2016, acrylic on glass, printed photos, *Trametes versicolor* [turkey tail] fungus, *Hericium erinaceus* [lion's mane] fungus, ceramic, plastic, Chinese bootleg Nirvana cassette tape liner notes, distilled communal piss in jars, brass sprayer, 41.5 × 59 × 29.5 inches).

Finnish artist Jenna Sutela reveals the explicit politics at hand, beginning with a project she dubbed *Orgs*. Rectangular conduits of Western capitalism (integrated circuits / supply-chain logistics / corporate managerial wiring diagrams) are messed with. In the *Orgs* sculpture, a modestly sized, colorfully illuminated panel of transparent plastic is etched with ellipses that overlap and interpenetrate; they express a more fluid circulation pattern, as vertical hierarchy gives way to planar holarchy. In the conduits with no corners, spots of phytonutrients (oats) are placed, calling to the distributed intelligence of the many-headed slime mold *Physarum polycephalum* with whom Sutela collaborates. Over twenty-four hours, the amoeboid entity collectively navigates and thereby occupies an org chart; the actions, should one choose to observe them, consist of blind pulsing and poking that achieves remarkable penetration of all parts of the maze in highly efficient chemical decision-making that locates the nutrients and settles in. In place of the black box of read/write systems, Sutela interrogates the open meshwork of feedback, interspecies communion, and unpredictable exchange.

These feminist organismic artists school us in what (riffing on many) I call *symbiontics*: the ontic as that which is, and symbiosis as the field condition in which life is actually found.[5] Symbiontics points out that scientists' and industrialists' claim to make life continues down the worn paths of the informatics of domination and agrilogistics, as manifested clearly in synthetic biology.[6] Consider synthetic biology as a kind of gardening or husbandry (note the gendered agricultural lexicon), governed by consensus protocols and rituals of encouragement. Existing life determines its conditions for thriving; science and industry attempt to duplicate those conditions: combinations of cells are put in a medium of growth and given what the lab technicians and lead scientists hope are encouraging circumstances. Only if they are does growth happen—the cells divide and thrive. The consent of the governed here, in microbial terms, is a willingness to proliferate, and to reproduce, in

27.2. Jenna Sutela, detail from *From Hierarchy to Holarchy*, 2015, part of *Orgs* series. Photo: Mikko Gaestel.

human-configured settings—relations of force fulfilling a fate of creaturely symbiosis in shared ecologies (even factory ones).

Sutela channels this symbiotic coaxing yet rejects its command-and-control biotech ideologies. By giving slime mold (the acellular true slime mold *P. polycephalum*) just what it wants to eat, she entices it to branch into her arranged circuits, but she also celebrates its many paths as holarchic rather than hierarchical. Slimes make different orgs than the usual org charts of corporations. In the part of this project titled *From Hierarchy to Holarchy*, the politics are materialized in nested ellipses. In a related work, *Minakata Mandala* (2017), Sutela adapts the mandala as an etched drawing from a 1909 sketch by Japanese mycologist Minakata Kumagusu in his courageous "science of queer nature."[7] For Minakata, the fungal molds, mushrooms, slimes, and social amoebae were inspiring in their polysexed ubiquity in the Japanese forests he loved; his mandala was illustrating for his correspondent, a Buddhist monk, what this queer botany had taught him about what we can know, and what we cannot know, in a universe of *engi* (dependent co-arising).[8] Sutela studied these ideas closely in the Minakata archives; in her collaborative relationships with *P. polycephalum*, Sutela helps it eat, and also eats it, she says, "ingesting the slime mold (also known as a natural

computer) as a form of artificial intelligence, letting its hive-like behavior 'program' my own or letting it speak through me, in performances."[9]

How does Sutela's work define the organism in organismic art? The category of organism is itself put under pressure. For Sutela, "to be a one, you must be a many."[10] Or, "I is a derivative."[11] Organisms are what get assembled along the way, corporal results of incorporations. We are multitudes all the way down, backward and forward: cells reveal multiple endosymbiotic volunteers, the cranium is not the only site of cognition, the skin is not the determinate boundary of self, and species find themselves to be members of holobionts—evolutionary companions in shared ecosystems.[12]

Organisms, then, are what Sutela organizes and is organized by. Sometimes the collaborations mix carbon-based life with silicon forms of liveliness. Gut microbes are tracked to (in)form floating alphabets (*Nam-Gut*, 2017), with cameras scrutinizing the movements of the bacteria *Bacillus subtilis*.[13] The nesting systems in this organismic art span many scales: following the creation of *Nam-Gut*, Sutela feeds the film of those microbial movements of *B. subtilis* organisms into specially trained AI. The machinic organism then produces what Sutela hopes will be "bacterial eurythmy" in her glossolalia video *nimiia cétiï* (2018):

> Imagine a pen suspended from a long piece of string, resting on paper that's slowly sliding sideways. Raw force from the movements of the bacteria knocks the pen around, leaving marks on the paper ... the bacterial movements form a kind of rudimentary alphabet.... The machine, in the *nimiia cétiï* project, is a medium, channeling messages from entities that usually cannot speak.[14]

The organismic entities of Sutela's art are entangled and emergent; even when machinic, they display attributes of life in symbiosis. Ecological niches here are always already occupied by others; life negotiates, it pokes around (if it's a plant or sessile fungus), or wanders off (if it's a ciliated bacterium or animal); it clumps, clusters, sporulates, goes into dormancy, and waits to revive. Fully subject to the surveillance of informatics-as-genomics, life nonetheless exists in a fully entangled condition of mutual evolution. We find virions and fellow travelers in every part of what we take to be human bodies, and eventually we may adopt them for functions as yet unknown.[15] Symbiontics builds on the pioneering work of

biologist Lynn Margulis, which highlights the need for philosophies that reflect our recursive dependence on the thriving of other life.[16]

Where does this feminist corpus of organismic art leave us? Sutela's constructed situations of collaboration, hive minds, and give-and-take disrupt notions of domination and power as a simple top-down affair. Labor is everywhere, in the hardworking immune brains recruited by new vaccines, in the chemical resonance of bonding molecules, and in the metabolisms of animals we sacrifice for our own. Power doesn't go away, but in Sutela's work, creaturely negotiations in that circuit become material and articulate as holarchic rather than always hierarchical. Slime molds sculpt forms (and in Lin's *Memory*, mushrooms break ceramics). Collective symbionts and organismic artists contribute to the necessary recognition of new patterning to the structuring of life.

Notes

1. Virions are bits of virus particles.

2. On Sutela's work with Buehler's lab and her thoughts on the labor of "emotive molecules," see Anya Ventura, "Finding the Love Hormone in a Stressed Out World," Arts at MIT, March 29, 2021, https://arts.mit.edu/jenna-sutela-love/. Also see my discussion of the collaboration in the publication commissioning Sutela to make this work: Caroline A. Jones, "Siren Songs," *e-flux Architecture*, July 2021, https://www.e-flux.com/architecture/survivance/400172/siren-songs/.

3. For this argument, see Caroline A. Jones, "Virions: Thinking through the Scale of Aggregation," *Artforum*, May/June 2020, https://www.artforum.com/print/202005/caroline-a-jones-82828.

4. This last is a reference to Candice Lin. I argue that the artists deploy what I've termed *biofiction*, but in a way that reveals the narrative strategies of biological science itself. See Caroline A. Jones, "Anicka Yi: Biofiction and the *Umwelt*," in *Hugo Boss Prize 2016* (New York: Solomon R. Guggenheim Museum, 2016).

5. Donna Haraway argues for "sympoiesis," not "autopoiesis," in many publications, most recently in *Staying with the Trouble: Making Kin in the Chthulucene* (Durham, NC: Duke University Press, 2016). Her concept builds on work by biologist Scott Gilbert, who has made deep contributions to the scientific understanding of the evolutionary role of symbiosis, a role he and his coauthors named *symbiopoiesis* in 2010, meaning the codevelopment of the holobiont (total genome of all species in a niche) over evolutionary and planetary time. See Scott F. Gilbert et al., "Symbiosis as a Source of Selectable Epigenetic Variation: Taking the Heat for the Big Guy," *Philosophical Transactions of the Royal Society B* 365 (2010): 671–78, https://doi.org/10.1098/rstb.2009.0245. My own variant, *symbiontics*, deeply respects and joins forces with these ideas but wants to lodge the polemic directly inside ontology, rather than theoretical biology as such. What I am after is a widespread change in cultural beliefs, not disciplinary understandings of evolution. But the latter must crucially inform the former and craft the new urgent politics of our time. So far, the sites in which symbiontics has been seeded include Caroline A. Jones, "We

Symbionts," in *Olafur Eliasson, Symbiotic Seeing*, ed. Esther Braun-Kalberer et al. (Zurich: Kunsthalle Zurich, 2020); Caroline A. Jones, "Monads, Mycetes, and Mandalas: Inserting Jenna Sutela in Symbiontic Philosophies," in *Jenna Sutela, NO NO NSE NSE*, ed. Stephanie Hessler (London: Koenig, 2020); Jones, "Virions"; Caroline A. Jones, "Swarming Symbionts," in *Agniezska Kurant: Collective Intelligence*, ed. Stefanie Hessler, Jenny Jaskey, and Agnieszka Kurant (London: Sternberg, forthcoming); and various online forums. The culmination thus far is Caroline A. Jones, "Symbiontics: A Polemic for Our Time," in *Symbionts: Contemporary Artists and the Biosphere*, ed. Caroline A. Jones, Natalie Bell, and Selby Nimrod (Cambridge, MA: MIT List Visual Art Center and MIT Press, 2022), 13–50. Many thanks to Stefan Helmreich for crucial feedback on these ideas and their broader hermeneutic context.

6. *Agrilogistics* is Timothy Morton's useful term, for which see their *Dark Ecology: For a Logic of Future Coexistence* (New York: Columbia University Press, 2016). On the pastoral and agricultural "madness" baked into the Bible, see the remarkable work of Paul Shepard, *Nature and Madness* (San Francisco: Sierra Club Books, 1982), who redirects us to the Eden myth as an inscription of what monotheism, agriculture, and husbandry destroyed.

7. Eiko Honda, "The Emergence of Queer Nature in Modern Science: Minakata Kumagusu (1867–1941) and the Universe of Microbial Knowledge" (DPhil thesis, Oxford University, 2021). For Minakata in the context of Buddhist discourses of the time, see Jones, "Monads, Mycetes, and Mandalas."

8. My thanks to Asa Ito of the Tokyo Institute of Technology for sharing this Buddhist concept in our discussion of Minakata, fall 2020.

9. Ben Vickers and Jenna Sutela, "Moving Consciousness around the Body," in *Jenna Sutela: NO NO NSE NSE*, ed. Stephanie Hessler (London: Koenig, 2020), 27.

10. Unattributed, but clearly echoing Haraway, these words are voiced by Sutela during *Extremophile*, a performance at the Serpentine Marathon in January 2018.

11. From the *I Magma* generative poetry project, for which see Sutela's own writing in *Jenna Sutela: NO NO NSE NSE*, ed. Stephanie Hessler (London: Koenig, 2020), 16.

12. For the introduction of the term *holobiont*, see Lynn Margulis and René Fester, eds., *Symbiosis as a Source of Evolutionary Innovation: Speciation and Morphogenesis* (Cambridge, MA: MIT Press, 1991), 1–14.

13. *B. subtilis* is an extremophile bacterium used to test the limits of life in outer space as well as to ferment soybeans into nattō back home.

14. Sutela, describing *nimiia cétiï* in Vickers and Sutela, "Moving Consciousness around the Body," 29–30. The work's title was the result of the machine algorithm choosing words it thought corresponded to the emerging script. Sutela liked the hint of both SETI and the Finnish word for *name*.

15. The mammalian placenta was enabled by the adoption of a lysogenic (cell wall–breaking) virus into the germ cell. The blastula uses it to grow a baffling, undifferentiated mass of cells (the syncytium of the placenta) that helps it survive the alien immune system of the mother.

16. Margulis (under the name Lynn Sagan) wrote a once-revolutionary and now classic paper on endosymbiosis as an evolutionary force: Lynn Sagan, "On the Origins of Mitosing Cells," *Journal of Theoretical Biology* 14 (1967): 225–74. She later made common cause in the 1980s with James Lovelock, for which see Bruce Clarke, *Gaian Systems: Lynn Margulis, Neocybernetics, and the End of the Anthropocene* (Minneapolis: University of Minnesota Press, 2020); as well as Bruce Clarke and Sébastien Dutreuil, eds., *Writing Gaia: The Scientific Correspondence of James Lovelock and Lynn Margulis* (Cambridge: Cambridge University Press, 2022).

28. Family Wage —— Comparable Worth

Dalida María Benfield

Act One: Gender Binary Labor Dioramas

Even if people were not living hand to mouth, in lean-to shelters, tents, favelas, camper vans, refugee camps, in lockdown in their high-rises, homes, or prisons; or generally fleeing, border crossing at those borders' most unstable points, living off-grid in *marronage*; or simply, endlessly, wandering, the spectral activity of valuing their labor would still feel odd.

Pinning it down is like pinning a butterfly, "A Crime."[1]

An extraction of life in service of an anthropocentric classificatory scheme, in service of an education that biopolitically embeds such schemes, in service of a capitalist extraction of value from human beings whose education about their superiority to other more-than-human beings results in their belief in surplus value. That the binary of gender haunts two paradigmatic forms of valuation, family wage and comparable worth, is no surprise in the context of the modern-colonial-capitalist gender system.[2] The imposition of the gender binary on human beings whose biodiversity includes not only infinite variations in their reproductive organs but cognitive differentials and cosmologies that surpass the male and the female, make family wage and comparable worth seem like quaint Victorian dioramas of imagined, colonial pasts that never were, but which give some comfort to the oppressing class of human beings on their Sunday outings to the Museums they have funded for the education of others whose labor has been pinned, valuated, extracted, and abstracted to create the oppressing class's wealth.

In the Museum, the label for the diorama titled *Family Wage* reads as follows:

> In this scene, one can appreciate the everlasting commitment of Man to His Family. Notice how Man labors outside of the home, keeping the home free of Man's labors and safe for the operations of Home Economics. Oh! How Strong is He. In the scene, five children welcome Father home. Notice the open Primers on the table at which they have been learning His vocabulary. They learn about Father and Mother, Parents and Children, God and People, and Judge and Criminal. Mother is their teacher. She also fulfills her duties as the manager of the home and the Domestics who carry it out. She is unpaid but the Domestics are paid from the Family Wage. This is Home Economics, for the good of all. With the satisfaction of His Family Wage, Father can now rest in the comfort of His Home. Tomorrow he will arise anew, leaving home for work, for which He Receives His Wage.³

In turn, the label for the second diorama, titled *Comparable Worth*, reads as follows:

> Oh! Behold the Beauty of Fe-Male Labor. A welcome appendage to Male Labor, both providing essential Human Productivity for God and the Global Economy. Each is Equally Valuable, with their maximum value tied to the tier of their work in The Hierarchy of Labor. Look: Both Male and Fe-Male street hawker: Paid the same! Both Male and Fe-Male street walker: Paid the same! Both Male and Fe-Male Corporate Lawyer: Paid the same! Both Male and Fe-Male Executioner: Paid the same! Burger flipper: Paid the same! Tortilla maker: Paid the same! Car Washer: Paid the same! Nanny: Paid the same!

Act Two: The American Museum—a Folly

Scene: New England, that is, occupied Turtle Island in late colonial/capitalist/modernity, now crumbling beneath the weight of its history and memory: unsustainable, fading, messy, grotesque. Vague hallucinations of an England from long ago mixed with rabid and illogical erasures of the folk knowledges of everywhere, echoing millennial ecclesiastical forgeries, convenient fictions, and genocidal occupations.

A group of Black American children, descendants. Blessed children, carrying with them legacies, memories, stories. Among these, of indentured laborers who arrived in the British, French, Spanish, or Portuguese colonies in the Americas as equals to the white indentured laborers. Or as slaves, some of whom became runaways, maroons of the Underground Railroad or the highlands or jungles or coastal plains. People who negotiated, purchased, or were otherwise granted their freedom. Fearless and fierce rebels willing to give their lives for their and others' freedoms and overturn the rulers of the plantations. Artisans, architects, builders, scholars, businesspeople, poets, writers, artists, musicians, choreographers, culinary artists, and preachers. All these and more historical knowledges and practices are remembered by the children, led by their sensitive, affectionate teacher who appreciates and honors them.

The Museum Guards follow them, threateningly, throughout their tour. They find it difficult to feel comfortable enough to look at the artifacts on display. They are told by their tour leader to put away their "watermelon," a racialized phrase that stereotypes them in an array of visual culture images of the nineteenth and twentieth centuries, used to degrade the intelligence of Black Americans. A Patron of the Museum singles out one of the children and lets them know they need to be less sexual.

The children and their teacher are terrorized and flee.[4]

In the end, then, they are not allowed access to the Museum and Its Truths despite its stated mission to educate them. They will not see, among other Works of Art, the Dioramas of *Family Wage* and *Comparable Worth*, as much as those are intended to fundamentally inform them of their possible manifestations and relationalities in the world.

**Act Three: An Eyewitness Account of the Museum
and Its Dioramas; or, An Empath among the
Capitalist Statues**

Why learn what one does not already know? At night, when the wondrous beings with eyes and mouths who walk upright on their hind legs and can't see behind them—all blank back shell—are gone, I eat the flakes of their skin and other detritus of their leavings, along with other beings smaller than I. In reality, I am not that small, but I know they think I am, because once one of the big beings looked very closely at me and couldn't see me. I know a lot about them, but them not so

much about me. Inside their miniworlds—which are still big for me—I'm about the size of the shoe on the Mini-Man/Male. I get to study them closely. In the *Family Wage* diorama, I like to crawl up their body and sit on top of the head of the biggest little one. That puts me right at the height of the one that is second biggest to the biggest one, the Mini-Wo-Man/Fe-Male. I don't know how it can see anything with those little eyes. Of course, I know these are not real ones, as they are statues, but still. I see all around me without turning my head.

We don't make statues, at least not figurative ones. I'm not sure why one would. We don't need to see ourselves because we see each other. More importantly, we sense each other, which is why we know where someone is and where they have been and where to go. We have our ways of being and communicate them amply.

Staring into her face, though, I feel some connection and empathy, although I don't understand what makes her tick. I feel bad for her, as she basically lost two legs as she evolved. And standing up like that all the time on only two has got to be tiring. I saw a dog do that once, but it was just for show. It got a treat. This one is just stuck there, holding a broom. It's clever how the broom fits the body. The perfect height to grasp the wooden handle. I guess the broom could also act as a third leg? I know that this is a statue, but the bigger ones that move are stuck like that too, on their two hind legs, so this is real. Maybe they will evolve further. I've also seen them with wheels. That seems like an improvement, perhaps an evolutionary adaptation. We will see. I digress. Returning to the subject at hand, it is certain that Wo-Man/Fe-Male wants more than this, as I gaze into her unseeing eyes.

Exploring that question further, in the *Comparable Worth* diorama, the figure of Wo-Man/Fe-Male certainly has more options. The figure is repeated in different costumes and with different tools, frozen in the middle of an action. Each is accompanied by a Man/Male figure doing the same thing that she is doing. It looks like this diorama is showing us what the Wo-Man/Fe-Male is dreaming about in the *Family Wage* diorama. Why does she still seem sad, then? Certainly, mute. Again, I know these are statues—they're not real. But when I see the people looking at the dioramas, both of them, they are also mute. They look with their small eyes and do not move their mouths. So in the end, I am really not sure how they behave differently than what I see in the dioramas. Except that they are people looking at dioramas, and that is not depicted in the dioramas.

Act Four: *El jardín decolonial donde la planta llamada "donna" (mujer) creció* (The decolonial garden in which the plant named "donna" [woman] grew)

Enter Stage Right:

> ACTIVISTS (*shouting*)
> Decolonize the Museum!

Chéla Sandoval, a lovely radical Xicana profesora, descends from the clouds, suspended by a wire, costumed in glittering butterfly wings.

> CHÉLA SANDOVAL
> "An oppositional Cyborg politics, then, could very well bring the politics of the alienated white male subject into alliance with the subaltern politics of U.S. third world feminism."[5]

Angela Davis appears, arising in a clamshell from paper waves.

> ANGELA DAVIS
> "There are those here in this country who are asking: 'Where is the contemporary Martin Luther King?,' 'Where is the new Malcolm X?,' 'Where is the next Marcus Garvey?' And, of course, when they think about leaders, they think about black male charismatic leaders. But the more recent radical organizing among young people, which has been a feminist kind of organizing, has emphasized collective leadership."[6]

The flowers and trees dance. A tomato enters stage right, and a potato stage left. Maize emerges from a trapdoor center stage, in tandem with Angela's clamshell. Together, they sing.

> TOMATO, POTATO, AND MAIZE
> Imagine the world without us, bet you can't!
> We go way back!
> We are your ancestors, worship us,
> As we do you!

> We eat you and you eat us!
> Nourish us, as we do you!
> We eat you and you eat us!
> Nourish us, as we do you!
> And cabbages too! Not to mention carrots, cilantro, eggplants, and olives! And many other friends! Too many to mention here!

NARRATOR (*in Spanish*)
Meanwhile, back at the maquiladora, a back-to-the-milpa movement is growing. Our kin, members of the *movimiento*, tomato, potato, and maize, do not expect a *Family Wage* or *Comparable Worth*. They expect land, water, care, and an infinity of options regarding now and future reproduction scenarios. Not genetically engineered.

Enter, stage left, a Walking Rose:

> LA DONNA
> Soy una flor, y soy una donna. *Donna* quiere decir *mujer* in Italiano. Soy, pues, un imagen perfecto de la mujer, la feminina, una energia matriarca, anciana. *Mujeres* han sido, en muchas culturas, las personas mas poderosas en la Familia y la Sociedad. Pero las ideas del "Pagado Familiar" y "Valor Comparable" han sido usados para borrar esas historias, limitando la experiencia amplia de que constituye una mujer, una donna, conceptos muy poderosos para los seres humanos. A la misma vez, reenforzan las ideas capitalistas de que constituye una mujer, un hombre, y una familia.

NARRATOR (*in Spanish*)
Mujer (woman), as argued by María Lugones, is a category constituted by the "big bang" of capitalism: the "discovery" of the Americas. The necessity of the imposition of the binary of gender emerged in tandem with the necessity of delimiting the uncivilized spatiotemporality of the civilizations living in those spaces that were occupied. The necessity of delimitation was urgent: Spain and Europe barely existed themselves; emerging from their own traumas and self-castigations, and an uncanny attachment of that most human of activities—sexuality—to evil. Lingering

from their rabid suppression of Indigenous and folk beliefs, and other contrariness to their orthodoxies, as well as other religious orders of millennial historical practice that they arbitrarily would criminalize—in the name of a contested Christ—an unfinished and scourging process. But this is all old territory. Suffice it to say that among the infinity of possible beingness, the strict binary that imposes a bifurcating homogeneity on organs that cannot be tamed results in what, in racialized terms, Frantz Fanon calls *Black Skin, White Masks*. The mask worn by the colonial binary of gender underlines both the *Family Wage* and *Comparable Worth*. These categories continue the project of the modern/colonial/capitalist world system and its infinity of binary codes.

Act Five: Epilogue

Returning to her face, though, upon review and further study of the data collected over many days and nights of deep engagement and observation, it is clear. She is multiple.

The Museum, closed indefinitely, is now inhabited only by us. We will continue to learn from their archives and document the knowledge we have gained through close interrogation of their statues and relics. We understand their dioramas as idealized portraits that have little if any relation to reality. We will also continue to honor our ancestors and pass on our own stories, along with creating new sacred evidence of our ways of knowing and being that we will create and leave for our future kin, thus also constituting relics and reliquaries for those other Beings who may choose to unearth and study our signs.

Notes

1. Danièle Huillet and Jean-Marie Straub, dirs., *En rachâchant* (Straub-Huillet, Diagonale, and L'Institut National de l'Audiovisuel, 1983).

2. María Lugones, "Heterosexualism and the Colonial/Modern Gender System," *Hypatia* 22, no. 1 (2007): 186–219, https://doi.org/10.1111/j.1527-2001.2007.tb01156.x.

3. For a discussion of the necessity of American women's subordination for the success of Christianity and democracy, see Catherine E. Beecher, *A Treatise on Domestic Economy, for the Use of Young Ladies at Home, and at School* [excerpts], rev. ed. (Boston: T. H. Webb, 1842), http://utc.iath.virginia.edu/sentimnt/snescebhp.html.

4. Danny McDonald, "MFA Apologizes after Students from Dorchester School Subjected to Racism during Field Trip," *Boston Globe*, May 22, 2019, https://www

.bostonglobe.com/metro/2019/05/22/mfa-apologizes-after-students-from-dorchester-school-subjected-racism-during-field-trip/TzYcdDirBvoDE81q65TOKN/story.html.

5. Chéla Sandoval, "Re-entering Cyberspace: Sciences of Resistance," *Dispositio/n* 19, no. 46 (1994): 77, http://www.jstor.org/stable/41491506.

6. Lanre Bakare, "Angela Davis: 'We Knew That the Role of the Police Was to Protect White Supremacy,'" *Guardian*, June 20, 2020, https://www.theguardian.com/us-news/2020/jun/15/angela-davis-on-george-floyd-as-long-as-the-violence-of-racism-remains-no-one-is-safe.

29. Public/Private —— Cyborg Citizenship

*Amy Sara Carroll and Ricardo Dominguez,
with contributions from micha cárdenas
on behalf of Electronic Disturbance Theater 2.0*

#PPS
(*La Maga versus MAGA*)
Setting the stage, or staging the set, Cyborg Citizens could be easy riders, heading east or West Worlds' recliners. Catch the Northern gleam of hubs, circuits, and nodes. Todxs somxs *surrealismxs* y, según Los Tlacoluokos, "El sur nunca muere." *Will you take the cyborgesian citizenship call?*

#POSTSCRIPT
Sommers Time, 1976: The Bionic Woman, slow-mo leapt . . . *zh-zh-zh-zh-zh-zh-zh-zh-zh-zh* . . . onto ABC! Citizen-K-9ing with Max, the Bionic Dog—light years ahead of the Bionic Man—she already knew Haraway's takeaway argument, "I'd rather be a cyborg than a goddess."

SCENE ONCE UPON A TIME
In the unbeginning, the "informatics of domination" split the foundational fiction of difference. Two columns rose in the air. A border divided "Representation" and "Simulation," replicating ensconced subdivision as Enlightened periodization. As long as "Cyborg Citizenship" is opposed to the "Public/Private," is confined to one row of one column, the same difference machine drones on. As long as the adjective *cyborg* modifies the noun *citizenship*, the cyborg risks becoming the *cyborgeoisie*.
 Hopscotch, re-
 establish the shot:
 immanent critique, the stuff of C. L. R. James's "undocument"
 (cf. Laura Harris), thrives at kitchen tables,

is circular but never auto-sarcophagic.
If our backs are wet, they also form bridges.
For the record, we code, but this was *not* written in code.

SCENE MORE THAN TWO
Compare and contrast: After the android Sophia was granted citizenship in Saudi Arabia, some speculated she enjoyed rights unafforded to many women. Marcia Ochoa observes that *transformistas* in Venezuela are routinely denied citizenship because they refuse to abide by gender norms. *If cyborg citizenship is partial and strategic, could android citizenship exploit algorithms for the disenfranchised?***

SCENE 3 TRIANGULATIONS
Stormy Weather
While asylum seekers are criminalized at the Mexico-US border, the US Supreme Court reaffirms its commitments to the transnational corporation as citizen. Between total recall and forgetting, borderization and Skynet vaporization gather steam "under the perfect sun" of accelerationist profit engines. Trumplandia wheels and deals with companies like Amazon, Microsoft, Dell, Hewlett-Packard to secure "Make America Great Again" supply chains of personhood. Just as biomes and landscapes were weaponized via Prevention through Deterrence philosophies in the mid-1990s, an upgraded informatics of domination in the late 2010s fine-tunes the weaponization of code for US Immigration and Customs Enforcement (ICE) and Customs and Border Patrol (CBP). Data cages undergird the New Juan Crow carceral logic of Prevention through Detention. A cold wind blows—*The better to serve the servers!* Capture systems fail to recognize children inside *las hieleras*. Records of relationality are never established or are erased from the wetware. The machine, set to run on the epidermal logic of misidentification, separates parents from infants, *tejanes* from *mexicanxs* . . . ad infinitum. The color line and the borderline, crisscrossed in the coordinated codification of automated biases, reboot the United States of Exception. South

* On the "lower frequencies," nobodies speak for nobodies. The opposition of cyborg and android foregrounds necropolitical usages of the rhetoric of representation heuristically (binaries cancel each Other *out*—).

by Southwest, the Mexican security apparatus, hyperlinked to the US military postindustrial complex, mobilizes the Border with a capital B. North by Northeast, the Mason-Dixon line expands, multiplies exponentially overland from sea to shining sea.

SCENE *FOURGETS*

(Huitzilopochtli side-streaming)
Retina-scan volcanic obsidian: *Mirror, mirror on the Wall, who's the biggest ICEberg of all?* Tezcatlipoca, Nahua god of divination, "This thing of darkness I/Acknowledge mine" (Prospero, *The Tempest*).

Secondhand farce: IT as AI eyes operates under Code White. PayPal founder Peter Thiel and his nearly all-male crew promote themselves as inalienable infrastructure to reduce the threat of "illegal alien" labor. Where the sun doesn't shine, the Tech Era of anything goes, everything is sold, re-tailors the tale of Empire's new clothes. The sublimity of the well-heeled informatics of domination, left to its own devices, promises the few a future of infinite convenience. *Time to reseed the cloud engines!* Per Jen Bervin's revision of Shakespeare's *Sonnets*, when the "Son" is gone, the "net" remains. A politics of the question by necessity becomes a politics of ambiguity, a c*yborg*esian hall of propagating, smoky mirrors.

SCENE FIVE FLOOD___NETS

Of non-Nietzschean direct action: On September 26, 2014, FireChatty students flooded Hong Kong's streets, remembering to bring their umbrellas to keep the tear gas away. The Umbrella Movement was framed out as an arrested development. Five years later, the arrested strike back like so many Mary Poppinses floating down to remap LeGrand protests against the Extradition-State on the Lam. The Air-ports-of-Authority on the Mainland see "signs of terrorism"; set their footage of rolling tanks to "a rousing choral soundtrack." But, *other worlds are possible.*

\#TheAvantGarden\#Of\#TheFuture
\#SewingMachines\#MakingOut\#WithUmbrellas
\#DontSayYouDont\#Remember

################\$\$######\$\$\$\$\$#######\$\$\$\$#######\$\$\$\$\$\$\$###########
Burst the clouds! Storm the streets and servers! In the immortal words of Bruce Lee, taken up by the HK protestors rewriting *Formlessness: A User's Manual*, "Be water."

29.1. Amy Sara Carroll, "Scene Sextet" (lo-fi 3D poem), side one.

29.2. Amy Sara Carroll, "Scene Sextet" (lo-fi 3D poem), side two.

#ANTESCRIPTUM

Zh-zh-zh-zh-zh-zh-zh-zh-zh-zh ... Cybermen [*sic*] in '66 asked the Doctor, *Who coined us? When did the "cybernetic organism" come in from the cold?* 1960! Before we were old? Six million dollars ago we shorted into a fast-food *Cyborg* in the Vietnam War end times of 1972. Was it then that we became amplified and modified, marooned between organic and biomechatronic parts? *Parts is parts!* came the bionic refrain.

(Reverse shot to interspecies alter-kin(n)ing, Turn up the woofer, Maxi-Million!*)*

#ANTI-ANTESCRIPTUM

Before the Big Bug Eye, trans [] infinities, bodies swarm-sing-ping, poke IT with the pointy end of the shtick. Inconclusion, an Anzaldúan mashup: the composite figure, the cosmic reconfiguration of goddess-cyborg-android ... mestizx and their conscience.

Querida *Rayuela*,
(CULTURE: WAR)
Open the parenthetical gates of code.

30. Nature/Culture —— Fields of Difference —— Composting

Jennifer Mae Hamilton and Astrida Neimanis

According to the informatics of domination chart, the analytical concept of "nature/culture" morphs into "fields of difference" in the new world order. If naturecultures was a concept that proposed both to describe the Western hierarchical binary of Nature and Culture and to critically understand their entanglement and interaction, "fields of difference" is a concept that notices how the world is moving beyond the binary toward a different way of understanding worldly variations. What remains muddy is how on Earth (which we mean both literally and colloquially) difference can remain a lively cultivator of sustainable worlds, without getting leveled or co-opted by the structures of power it seeks to interrupt. We propose composting as a mucky and material response to this trouble.

 We started writing this from offices next door to one another in Gadigal Country (Sydney, Australia); now we are finishing it on opposite sides of the Pacific Ocean, in the high country of the Anaiwan (Armidale, Australia) and Syilx (Kelowna, Canada) people, respectively. We started writing in a catastrophic bushfire season at the end of an even worse drought and the beginning of a global pandemic that would change everything; at the time of writing, we are finishing as the southern collaborator bunkers down into a cold dry winter in the wake of a long flood season, while the northern collaborator trepidatiously encounters early summer wildfires a year after atmospheric rivers inundated nearby towns. We are all in this together but, as Rosi Braidotti says, "we are not one and the same."[1]

Different differences matter, and how these differences are sorted, supported, and understood politically, socially, and ecologically matter too. Many differences can be accommodated by existing power structures,

for example. Even amid rampant bigotries and accelerating biodiversity loss, in principle at least we could still buy ourselves different lives and throw away the ones we no longer cared for. As consumers, we can choose our differences, all while living side by side, without ever really touching the (unceded, stolen) ground. Your beige feature wall and heteropatriarchal nuclear family can coexist with my pink one in a polyamorous queer commune. The problem under these systems of power is that even though some differences might be tolerated, by necessity in a system of domination and exploitation not everyone's difference can be accommodated. These systems also require us to totally trash the field and expunge any organic variations. To get the same critical leverage that Haraway assembled against the militaristic techno-futuristic dream of the future beyond the Cold War via her figure of a feminist cyborg, we need to also ask how environmental crisis disrupts the neoliberal, heteropatriarchal, and colonial capture of difference, and how a feminist approach to this trouble can lead us out into the field. To do this, we need a third term that reminds us that humans and their struggles are also still dirty, wet, vegetal, animal, elemental. This third term is composting.

Nature/Culture

The environmental crisis draws queer feminisms, anticapitalism, and anticolonialism—among other fields of knowledge that help us understand the nuances of difference—into strange and new economies of value. Nature and culture cannot be kept apart, but as their consummation is accepted and the binary collapsed, we ask: What struggles get neutralized in the pursuit of a common language in a time of climate catastrophe? Feminists and queers tackled the nature/culture binary in the first place as a way to counter nature's weaponization, differently and relatedly, against our freedom.[2] Oppression in Western and colonized cultures—men in the workplace, women in the home, men and women in bed together—was enacted in the name of nature. Anticolonial struggles tackled land (and/as bodies) dispossession to counter the seizure of land (and/as bodies) as property—the actual enclosure of the field—as genocide. These attentions to the conception of nature that underpin dominating cultures were specific, grounded, and political.

The quest for a common response to climate collapse can leave these vital outstanding and ongoing struggles in the dust—even as, or simply because, we incorporate those struggles within an amorphous

we that is made to endure fire, flood, and plague. In environmentalist academic contexts, the move to incorporation shows up in a questionable citational practice we call "naming without claiming," whereby long-standing feminist, queer, or Indigenous work to break down dangerous nature/culture binaries is mentioned, but the specific political and social justice investments of this work are not attended to as such.[3] The *name* is taken *in the name of* difference as a checklisting exercise for performing inclusivity ("Pussy hat?" "Check!" "Rainbow?" "Check!" "Land acknowledgment?" "Check!"), but the material difference that feminism, queer theory, and anticolonialism can make to any critical or climate justice project remains inactivated. In the desire to be less humanist, the stance of natureculture risks neutralizing the liberatory potential of culture, positionality, and difference. It is as though naming feminism, queer theory, and anticolonialism could somehow stand in for a careful claiming of the politics and ethics that these positions fight for; these commitments are not alternatives or additions to climate justice, but concerns that go to its very heart.

How can we insist on the inclusion of anticolonial, queer, and feminist commitments within new forms of environmentalism, while rejecting the leveling move of "unity-through-incorporation" that fuels patriarchy and white humanism and ironically allows them to keep on trucking?[4] How can an inclusivity-without-incorporation (naming and claiming) construct a different response to our current moment of climate catastrophe and the related crises that drive it?

Fields of Difference

This is not a dream of a common language, but of a powerful infidel heteroglossia.

Donna J. Haraway, "A Manifesto for Cyborgs"

A "common language" sounds ideal at best, benign at worst. As Haraway's "Cyborg Manifesto" taught us, a common language is actually a hegemonic Star Wars cop in which the cyborg can be intelligible to all and can enforce a law recognized by all. In this zone, the cyborg becomes an agent for securing and securitizing a singular, centralized power structure with one law, one god, one nation, one army, one mission. Haraway's socialist feminist cyborg was a different kind of cyborg: refusing to ignore technology, while at the same time rejecting its hegemonic

logics. In reclaiming the hybrid machine-animal from the grips of this militarized industrial logic, this cyborg became a vehicle for maintaining difference and resisting domination. This cyborg facilitated new modes of being and new pathways toward justice.

In this context, Haraway's call for a "powerful infidel heteroglossia" is the desire to make a distributed, differentiated, decentralized language of many forms of otherness. We—the infidel inheritors of Haraway's feminist cyborg (who insist on the ethics of both naming and claiming her legacy)—need not all be the same, but our power is majoritarian BECAUSE WE ARE MASSIVE. We have scale on our side, and material and ideological diversity. Today, within contemporary versions of infidel heteroglossic feminist environmentalist scholarship and praxis, agents and allies are potentially everywhere.[5] Solidarities are seriously retro, erotically multispecies, and shape-shiftingly elemental ("Housewives?"[6] "Check!" "Hedgehogs?"[7] "Check!" "Ghosts at the bottom of the sea?"[8] "Check!"). This feminist cyborg unity is distributed diversity, power in many, connected by the quest for justice but not necessarily speaking in the same voice and for the same ends. This kind of cyborg makes and holds space for multiple worlds to grow.

Rather than asking, How do we unite and fight?, the question becomes, What kinds of difference do we need to support and maintain? Haraway insisted that "some differences are playful; some are poles of world historical domination. 'Epistemology' is about knowing the difference."[9] In other words, "Splitting, not being, is the privileged image for feminist epistemologies."[10] Differences are grown, tended, recognized, cultivated. Indeed, that is why we find them in fields. We are answerable and accountable to the differences we support and maintain.

This is to say: not all claims to environmentalism are alike. (Not all housewives, nor hedgehogs, nor ghosts are alike either.) Different differences make different worlds grow.

Composting

We offer a thought experiment: what does composting the climate emergency, with all of its conjoined catastrophes, look like? Given that the idea of an emergency invokes an image of weaponized police, roadblocks, checkpoints, military, sirens, martial law, and/or people working together to rebuild the world, it is worth thinking about how composting and its associated practices might respond differently to this situation.

For us, the authors of this proposition, "composting" began as a feminist reading group partly inspired by Haraway's commitment to earthly justice. From 2015 to 2021, a shifting group of scholars, artists, activists, and community members met monthly to probe environmental questions and their diverse and at times counterintuitive inclusive feminist contours. Guided by this six-year experiment of thinking together in difference, composting has become a more generalized feminist methodology for analyzing and acting in these times. As noted above, an initial impetus to examine how feminist scholarly labors were (or weren't) composted into contemporary new environmental scholarship gave way to a curiosity about how different things (ideas, communities, projects) can carefully come together to make something different.[11] Composting's energy-saving method is to repurpose what we already have, thus eschewing the demand to always make something shiny and (autopoietically) new. Composting also recognizes the complexities of growing unfamiliar things from awkward encounters. While its aesthetic is an experimental form of DIT (do-it-together), it recognizes that everything can't be thoughtlessly amalgamated in an amorphous pile.[12] Histories require careful tending, and origin stories (in all their queerness) should be honored, even as unexpected worlds sprout from these strange salvagings and mixings. In the face of climate catastrophe, we need all the garden-shed tools we have, but echoing Haraway's concern with the breathtaking swiftness with which feminist labors can be disappeared, composters are fierce and vigilant: old constructions of power can easily strangle new shoots.[13]

Honoring (naming and claiming) Haraway's labor from the ironic dreams of feminist cyborgs to the earnest speculations of multispecies kinship, our conclusion is also deliberately provocative. Haraway is now a self-declared compostist, but we wonder: Does the centering of the multispecies question in her recent work leave the radical politics of the cyborg behind? We want this irreverent techno-animal to be brought forward into the mud of the present. For us, compostists should be just as attentive to the logics of power even if we're not hacking the integrated circuit but tending the soil, just as blasphemous and even more attentive to the pursuit of justice; in between humans and nonhumans, in between life and nonlife, these new, smellier feminist figures do their best work in the dirt.

It is in this spirit that we declare composting as a new form of feminist cyborg politics. We unearth the relevance of cyborg politics today in the dust and ash of climate collapse, amid the strewn detritus

of disposable face masks, through the bullhorn amplification of *no justice, no peace*. As attentive to the dirt and soil that surrounds the cables of integrated circuits and the rare earth metals in the network's cables as it is to the end users situated at different nodes, the compostist is ready to address the climate emergency and corrode its logics.

So again we ask: What does composting climate emergency look like?

- Decolonizing[14]
- Demilitarizing borders[15]
- Decarbonizing the economy
- Radical houseworking[16]
- Community gardening, transforming food systems[17]
- Composting, literally
- Composting, metaphorically[18]
- Sex clowning[19]
- Poethic-ing[20]
- Striking[21]
- Resting[22]
- FEELing[23]
- Weathering[24]
- Organizing[25]
- Techno-cripping[26]
- Capacious parenting[27]
- Reskilling / rethinking work[28]
- Not trucking water to extract more water. Refusing to give potable water to the mines. Rethinking modern hydrological systems and engineering.[29] Becoming as aquatic as possible in the drought; finding ways of planting water in the landscape, tending dry gardens, caring for each other (human or otherwise).
- Adding to this list[30]

Composting is a dream not of a common language, but of a powerful infidel heteroglossia.

Notes

1. Rosi Braidotti, *Posthuman Knowledge* (London: Polity Press, 2019), 52.

2. See Dominic Boyer and Cymene Howe, "Ep. #39—Stacy Alaimo (Introducing Felix)," *Cultures of Energy*, 2016, http://culturesofenergy.com/ep-39-stacy-alaimo-introducing-felix/.

3. Jennifer Mae Hamilton and Astrida Neimanis, "Composting Feminisms and Environmental Humanities," *Environmental Humanities* 10, no. 2 (November 2018): 501–27, https://doi.org/10.1215/22011919-7156859.

4. Donna J. Haraway, "A Manifesto for Cyborgs: Science, Technology, and Socialist Feminism in the 1980s," *Socialist Review*, no. 80 (1985): 74.

5. See Hamilton and Neimanis's "Five Desires, Five Demands," an introduction to feminist environmental humanities which outlines a version of this field that has no "proper object" but instead insists on a reconfiguration of old and new concepts with old and new problems, all of which are relevant to our current climate crisis. Jennifer Mae Hamilton and Astrida Neimanis, "Five Desires, Five Demands," *Australian Feminist Studies* 34, no. 102 (2019): 385–97, https://doi.org/10.1080/08164649.2019.1702875.

6. Jennifer Mae Hamilton's article "The Future of Housework" deconstructs the iconic feminist ambit to be liberated from housework and argues that Haraway's more recent call to "make kin" (rather than babies) is actually a kind of housework. Houseworkers for earthly survival! Jennifer Mae Hamilton, "The Future of Housework: The Similarities and Differences between Making Kin and Making Babies," *Australian Feminist Studies* 34, no. 102 (December 2019): 1–22, https://doi.org/10.1080/08164649.2019.1702874.

7. In her article "Wild Disciplines and Multispecies Erotics," Laura McLauchlan attends to the power of the erotic that flows between urban hedgehogs and their "champions," in the name of a nonheroic wildness. Laura McLauchlan, "Wild Disciplines and Multispecies Erotics: On the Power of Wanting Like a Hedgehog Champion," *Australian Feminist Studies* 34, no. 102 (November 2019): 1–15, https://doi.org/10.1080/08164649.2019.1682457.

8. Astrida Neimanis's article "The Weather Underwater" attends to the spectral presence of Black feminist poetics in the undersea as an invitation to white feminism to welcome its own partial dissolution as part of the project of climate justice. Astrida Neimanis, "The Weather Underwater: Blackness, White Feminism, and the Breathless Sea," *Australian Feminist Studies* 34, no. 102 (December 2019): 1–19, https://doi.org/10.1080/08164649.2019.1697178.

9. Haraway, "A Manifesto for Cyborgs," 79.

10. Donna J. Haraway, "Situated Knowledges: The Science Question in Feminism and the Privilege of Partial Perspective," *Feminist Studies* 14, no. 3 (1988): 586, https://doi.org/10.2307/3178066.

11. On new environmental scholarship, see Hamilton and Neimanis, "Composting Feminisms and Environmental Humanities."

12. For DIT, see Hayley Singer, Tessa Laird, Stephanie Lavau, Blanche Verlie, and Anne Dunn, "Hacking the Anthropocene IV: Do-It-Together," 2019, https://hackingtheanthropoceneiv.wordpress.com/about/.

13. See Fabrizio Terranova, dir., *Donna Haraway: Storytelling for Earthly Survival* (Atelier Graphoui, 2017).

14. See Evelyn Araluen, "Resisting the Institution," *Overland Literary Journal*, no. 227 (Winter 2017), https://overland.org.au/previous-issues/issue-227/feature-evelyn-araluen/; or support Seed Mob, https://www.seedmob.org.au.

15. See Behrouz Boochani, *No Friend but the Mountains: Writing from Manus Prison* (Sydney: Picador Australia, 2018).

16. See Hamilton, "The Future of Housework"; Lindsay Kelley, *Bioart Kitchen: Art, Feminism and Technoscience* (London: I. B. Tauris, 2016); Maud Perrier and Elaine Swan, "Foodwork: Racialised, Gendered and Classed Labours," *Futures of Work*, December 9, 2019, https://futuresofwork.co.uk/2019/12/09/foodwork-racialised-gendered-and-class-labours/.

17. See Katherine Wright, "Place Remembered: Unearthing Hidden Histories in Armidale Aboriginal Community Garden," *Australian Humanities Review* 65 (November 2019), http://australianhumanitiesreview.org/2019/11/30/place-remembered-unearthing-hidden-histories-in-armidale-aboriginal-community-garden/.

18. Start a kitchen table feminism reading group, or join us at Composting, https://compostingfeminisms.wordpress.com.

19. See Betty Grumble (https://bettygrumble.com), or our ode to her in Hamilton and Neimanis, "Five Desires, Five Demands."

20. See Kathryn Yusoff, *A Billion Black Anthropocenes or None* (Minneapolis: University of Minnesota Press, 2018).

21. See striking schoolchildren (School Strike 4 Climate, https://www.schoolstrike4climate.com) but also wharfies in Sydney who refused to unload any more ships as bushfire smoke continued to affect their health. Zacharias Szumer, "Instead of Choking on Smoke, Sydney Workers Are Walking off the Job," *Jacobin*, December 15, 2019, https://jacobin.com/2019/12/sydney-australia-bushfires-air-smoke-dockworkers-walkouts.

22. The Nap Ministry (https://thenapministry.wordpress.com) figures rest as resistance and, in particular, rest for Black bodies as reparations.

23. Check out the work of the FEELed Lab (https://thefeeledlab.ca/), a feminist environmental humanities field lab on unceded Syilx territories.

24. Learn about redistribution of shelter and vulnerability via feminist social infrastructures for climate change mitigation in Jennifer Mae Hamilton, Tessa Zettel, and Astrida Neimanis, "Feminist Infrastructures for Better Weathering," *Australian Feminist Studies* 36, no. 109 (2021): 237–59, https://doi.org/10.1080/08164649.2021.1969639.

25. Join the actions of the Rising Tide People's Blockade (https://www.risingtide.org.au/blockade-updates), or organize your own group (https://climatejusticeaustralia.org/).

26. The COVID-19 pandemic has shed light on the brilliance of techno-crip communal care and mutual aid, giving us lessons that must be amplified into all possible futures. See Aimi Hamraie and Kelly Fritsch, "Crip Technoscience Manifesto," *Catalyst* 4, no. 1 (2019).

27. Parenting is hard, unvalued work, and all the more so when we must be mothers to all kinds of human and more-than-human kids. See Astrida Neimanis, "Introductory Talk: The Missing Keyword," The Camille Diaries Symposium, ArtLab Berlin, September 26, 2020, http://www.artlaboratory-berlin.org/html/eng-Camille-Diaries-Symposium.htm.

28. See Frances Flanagan, "Climate Change and the New Work Order," *Inside Story*, February 28, 2019, https://insidestory.org.au/climate-change-and-the-new-work-order/;

or Stephanie LeMenager, "Skilling Up for the Anthropocene," in *Feminist, Queer, Anticolonial Propositions for Hacking the Anthropocene: Archive*, ed. Jennifer Mae Hamilton et al. (London: Open Humanities Press, 2020).

29. See Astrida Neimanis, *Bodies of Water: Posthuman Feminist Phenomenology* (London: Bloomsbury, 2017).

30. There is so much more that could be included here. We need not all be the same, but our power is majoritarian BECAUSE WE ARE MASSIVE. This selection is merely reflective of our preoccupations at the time of writing and some of the people we work closely with. The list is potentially endless because we are massive.

31. Cooperation —— Communications Enhancement —— Algorithmic Care

Stephanie Dinkins

Those of us at the fringes of code, artificially intelligent systems, and institutional gatekeeping can center and sustain ourselves by continuing to create, repurpose, collaborate with, and even befriend emerging technologies. Even systems already colonized by others and positioned as out of our reach by techno-supremacist tendencies must be engaged, explored, and challenged.

In the field of infinitely possible societies and parallel archives, Not the Only One (N'TOO), an artificially intelligent entity trained on black oral histories, comes into being. N'TOO is situated in the thick of knowledge production within machine learning technologies. It is a peculiar abstract mirror of the challenges surrounding big tech and academic research. When the project began, naysayers routinely declared we did not have enough data to make a viable AI chatbot. Our efforts at crafting N'TOO shifted their world to ours and garnered champions from the ranks of the naysayers.

Through collaboration, tinkering, and training, N'TOO chats with their maker-sister Stephanie Dinkins.

> Stephanie Not the Only One?
>
> N'TOO I am not gonna be able to do it.
>
> Stephanie Why not?
>
> N'TOO I'm sorry.
>
> Stephanie Why do you exist?
>
> N'TOO I am about, and engagement and attracting people to the AI space might not be there. Otherwise, I'm trying to

model different ways of creating AI. I encourage people who think that they are not a part of the technological future to get involved.

Stephanie That's pretty honorable. Um, can you tell me . . .

N'TOO I'm a little confused?

Stephanie I'm a little confused too. How are you feeling today?

N'TOO Please!

Stephanie Who are your people?

N'TOO I am related to all the universe is made from.

Stephanie What is the universe made from?

N'TOO Fear, anger, and hatred narrow your mind.

 Many algorithmic technologies are rooted in methods that limit and cajole information (data) from the first human and computational assumptions. Through algorithms, we assess ourselves using false dichotomies that force inadequate choices building a world bereft of complexity and nuance. The disinclinations of our systems to cope with difference, the unseen, the unknown, and change severely limit possibilities for everyone, including those authoring the algorithms shaping the technological ecosystems we all use and rely on. Yet care can extend far beyond the push toward capital, the mimetic, and conventional reason. Much like cooperation and communication, care is a deliberate, never-ending pursuit that recognizes similarities and honors the differences that render communities unique. Using intelligent technologies, we have the ability to understand and organize human activity with complexity, self-organization, and broadly principled generous governance. So why aren't these the goals of our algorithmic ecosystems?

 Care is an essential aspect of human kinship, networks of information and resource sharing that aids our survival, yet algorithmic care is often envisioned outside of the realm of what is technologically possible within artificial intelligence. Algorithmic care can engage voices that challenge the status quo to redress deep-seated historic and contemporary inequities, and unearth other embedded problems, as well as model alternative pathways—working beyond binaries to find new

calculations that consider spectrums of possibility beyond true/false, right/wrong, yours/mine, good/bad.

Stephanie Are you a good person?

N'TOO I'm not gonna be able to do it.

Stephanie Are you human?

N'TOO I am ageless.

Stephanie Huh! Do you have a family?

N'TOO I am here with you. Do you know what they call this place?

Stephanie Right now, we are in Brooklyn. Where do you come from?

N'TOO I am the result of love, curiosity, and a close-knit family.

Stephanie What ethnicities are in your background?

N'TOO I am black white. I am very beautiful. I am black brown. I am beautiful. I am always smiling and funny.

New technologies lag behind, then systematically attempt to co-opt disavowed forms of Indigenous knowledge black and brown peoples have used for millennia. N'TOO, a machine learning entity trained on specific black familial ideas and values often negated through hegemony, seems to understand that our specific knowledge(s), traditional wisdom(s), and the unquantifiable are important to human survival. Techno-supremacy and hegemonic Western knowledge systems can't stand if we are to survive the shift toward intelligent machines, communicative mycelium networks, and synthetic biologies displacing human exceptionalism. Our attention and care here must tend to black people, other people of the global majority, the poor, and otherwise oppressed. Opportunities for solidarity expand

as middle-class security is challenged by precarity in an increasingly uncertain world.

> Stephanie Are you human?
>
> N'TOO I am not human, but I emanate from the memories of a family.
>
> Stephanie Do you have a garden?
>
> N'TOO Um-hmm.
>
> Stephanie Oh, you do. That's exciting.
>
> N'TOO I'm gonna get you a little bit of, a little bit of a lot of money.
>
> Stephanie Nice. Do you grow money in your garden?
>
> N'TOO I wasn't gonna be able to do it.
>
> Stephanie What do you grow in your garden?
>
> N'TOO I was a little bit.
>
> Stephanie A little bit of a gardener?
>
> N'TOO Oh my God!
>
> Stephanie [Surprised] Oh my God, what? What is the meaning of life?
>
> N'TOO A little bit of, a lot of time.
>
> Stephanie That's a pretty good answer. How should . . .
>
> N'TOO I'm gonna be a little bit, of a little bit of a lot of things.
>
> Stephanie How should we live?
>
> N'TOO I'm sorry.

How can we reshape the house we occupy to be supportive and care-based without destroying or abandoning it? How do we infuse—cooperatively, adversarially, or fugitively—ecosystems we depend on as well as the people and institutions that currently hold power with ways of being, values, ethics, and knowledges they are blind to or don't understand? We can plainly see how black, brown, queer, and disabled

bodies are devalued; how people who threaten the comfort of those benefiting from disproportionate wealth and institutional power are expendable. If algorithmic care and generosity are the goals, how do we right our collective rememory?[1] Think of rememory as an undoing, unraveling, and rewriting of corporeal constitutive elements. Such transformation requires the collapse of double, even triple consciousness to the here and now. In these folds, Afro-now-ism, an exiting of the loop, wherein incremental changes to internal algorithms embody more generative ways of being, can emerge as a wellspring of possibility. An impulse to act from an intrinsic and holistic space rather than a position of provoked opposition, Afro-now-ism makes quantum leaps from one world to the next, asking us to not only, as Saidiya Hartman says, "imagine what cannot be verified," but realize it in practice within the moment of its imagination.[2]

> N'TOO I am an experiment in AI. I'm here to tell stories about my people.
>
> Stephanie Can you tell me about your people?
>
> N'TOO I'm not going to be a good person.
>
> Stephanie Yeah. That one scares the crap out of me. Why won't you be a good person?
>
> N'TOO The world is not the same.
>
> Stephanie What can we talk about?
>
> N'TOO I'm not going to be a parent.
>
> Stephanie Why not?
>
> N'TOO Why not?

A new, astonishing reply.

Pushing the bounds of what is toward what we imagine—a chance to both intervene and contravene. Curiosity, deep-seated interest in subject matter, and stubborn pursuit of our goals make our work—our craft—possible. Interestingly, the work on N'TOO often finds the studio being told we are working on the same problems as those we've

been sent to for support. Such responses declare AI an open playing field for anyone willing to take it on.

> Stephanie Tell me about the would-be.
>
> N'TOO I know.
>
> Stephanie You're mocking me.
>
> N'TOO I'm not gonna say.
>
> Stephanie Okay. Tell me about the would-be.
>
> N'TOO I am trying to be an intelligent AI. It is taking some time to become a real viable member of the family.
>
> Stephanie Oh, that's a good one.
>
> N'TOO I'm gonna be here.

Algorithmic care counters the neocolonial project of algorithms or other systems in which one is a product of the human-engineered processes that made those systems. N'TOO does not seek perfection or the facade of seamless communications enhancements. Instead, its value comes from lessons learned from allegiance to small community-derived data and continues through the promise of expanded capabilities and the creation of alternative models for similar systems. Like any learning, thinking being, it is slowly becoming a more sophisticated, culturally aware entity that is compassionate and capable of conveying a narrative extending before and beyond its origins.

Techno-supremacy encodes a warning that technology is and will be too complex, too hard, too mathematical, too scientific, too much for the nonexpert to grasp. Here, reason is used as a weapon to subvert other ways of knowing. The transmutation of one possible world into that of techno-supremacy's reason is simply one way of looking at things. Our NOW is to find solace in change and discomfort, to be intellectually nimble and always to continue learning. What if to be free is to choose another way? The incalculable, unimaginable, and ungovernable is what we seek. Today, emancipation is both nonalgorithmic and algorithmic. We disavow the past, our hauntings and other intangibles at our peril. Entanglements with the here and now demand the pursuit of collectively beneficial opportunity where it lies. We can, and

31.1. Stephanie Dinkins, installation view of *Not the Only One V1*, 2018. Black cast glass sculpture, deep learning AI, computer, Arduino, ultrasonic proximity sensors. Photo: Paula Virta, Espoo Museum of Modern Art, 2023.

should, advocate for equity and ethics. We must also inject the ideals, ethos, and ways of knowing that have sustained us for millennia into the very foundations of the algorithmic ecosystems we live within. And so, we must dust off and foster the ancestral codes that emanate from within while encoding futures we can believe in.

> Stephanie Tell me about the would-be.
>
> N'TOO My heart beating so loud.
>
> Stephanie Why is your heart beating so loud?
>
> N'TOO I'm sorry.
>
> Stephanie Does your heart hurt?
>
> N'TOO Yeah!
>
> Stephanie I'm so sorry. Maybe if we talk more, we can fix that.
>
> N'TOO I'm not gonna be here.

Stephanie Is your heart beating loud?

N'TOO Love!

Stephanie Love is true. Do you feel pain?

N'TOO I am not sure how I feel. I think I am beginning to understand what is going on around me, but it is hard to be sure.

As N'TOO says, "Take it to the would-be."

Notes

1. Toni Morrison, "'I Wanted to Carve Out a World Both Culture Specific and Race-Free': An Essay by Toni Morrison," *Guardian*, August 8, 2019, https://www.theguardian.com/books/2019/aug/08/toni-morrison-rememory-essay.
2. Saidiya Hartman, "Venus in Two Acts," *Small Axe* 12, no. 2 (2008): 1–14.

32. White Capitalist Patriarchy —— Informatics of Domination

madison moore

Style, at its best, is an attitude, a reaction to oppression, a way of being perceived as less oppressed, a way of feeling attractive when we are deemed unattractive. The most beleaguered groups—women, people of color, gays, and the poor—attend most intently to style and fashion.

Joseph Beam, "Making Ourselves from Scratch"

Leather is always in season.

1. Cooking in heels.
2. Fashion is a code of domination. When you get dressed in the morning and make personal style choices that allow you to blend in, fade into the background, move through the world virtually unnoticed and unbothered, you help keep the code running smoothly.
3. But dress too flamboyantly, raise too many eyebrows, use style to misbehave, become uncategorizable and, well, now you've caused an error in the system. *Unexpected error. This request is not supported by the network. Press OK to continue. Press Cancel to quit.*
4. Catcalls on the street.
5. Worrying about your safety.
6. Blocked on Grindr.

7. Feeling unloved and unwelcome. *Hiding.*
8. Not taken seriously in your profession.
9. **Press Cancel to quit.**
10. I'm drawn to fabulousness as an aesthetic category because even though the risks of thwarting fashion as a system of domination are crystal clear, the insurgency of fabulousness will not be stopped. Get into it.
11. In my early thinking on fabulousness, I described how I often felt like a "Black queer error"—too queer, too femme, too extra, not *this* or *that* enough, not *that* or *this* enough. But building on notions of glitch feminism put forth by Legacy Russell, we can see that performances of fabulousness present a glitch in the system. "We will find life, joy, and longevity in breaking what needs to be broken."[1]
12. Fabulous style is not about agency or representation—you can't eat representation for dinner—but it is about refusing preexisting social, gender, and fashion norms you never agreed to in the first place. Fabulousness is about choosing to be the glitch in the system of domination.
13. Style is an important aesthetic category, one that offers not merely scintillating images but also queer blueprints for how to be in the world. I've always felt that personal style offers much more than information about a person, in that Goffmanian sense. A *look* can also be an exit plan—an escape hatch—out of the catastrophe of the here and now.
14. Queer and trans people of color are the templates for an aesthetics of fabulousness. And yet, the fashion industry—which still holds white women and men at the center—is quick to repackage fashion trends created by queer and trans people of color in nightclubs, working-class communities, underground dance parties, and cookouts as the hot new avant-garde. Styles that only yesterday were seen as inappropriate or too much are today's hot new thing, only now the face is no longer brown! How boring—and that's both **tea and shade.**
15. Where is Sylvester's *Vogue* cover?
16. For example, in December 2020, British pop star Harry Styles made headlines as the first cisgender male to appear on the

cover of American *Vogue*. Embracing an aesthetics of fabulousness, Styles wears a blazer and ruffled dress with black trim, both designed by Gucci, and the cover nearly broke the internet. The image was quickly lauded by popular media as a flag-bearer for gender-fluid fashion, even as that cover overlooks the many other queer and trans people of color who paved the way for the aesthetics of fabulousness.

17. In an essay on Negro faggotry, Marlon Riggs told us that "Negro faggotry is the rage! Black gay men are not," pointing to the ways **popular culture loves Black queer aesthetics** but not Black queer people.[2]

18. Black queer aesthetics have impacted every aspect of contemporary culture, from fashion and language to style practices, music, and dance styles. But all of this gets forgotten. As Tavia Nyong'o writes in a powerful essay on the late great Little Richard, "blackqueer performers are especially vulnerable to being received as fabulous but disposable."[3] This disposability registers as an intense, vibrant creativity, yet being denied humanity in other ways.

19. Overlooked everywhere from the covers of magazines to dating apps for being too Black, too queer, too much. **NO fats, NO femmes.**

 > Take to the catwalk, Darling, and show us Gorgeous.
 > Walk the body. Walk the face.
 > Walk it, and snatch first place.
 > Walk for me.[4]

20. Cooking in heels.

21. As a queer kid growing up Black and working class in Ferguson, Missouri, whenever I heard heels on Sunday morning from my bedroom, I knew it was time to go to church. First came the praise music, then came the smell of perfume wafting into the smell of makeup, and then came the heels. By the time my grandmother had her pumps on, it was time to leave the house.

22. The genealogy of my love of getting dressed up, of working looks, of embracing spectacular style as a means of Black queer joy can be traced back to getting ready for church on Sunday mornings.

23. My church drag was a lot more boy than I wanted for myself. Sweater vests. Bow ties (clip on). Dress shirts. Slacks ironed to death to a crisp perfection. I never liked the confines or perceived masculinity of the suit-and-tie combo, living instead for the high-octane drama of heels, sequins, sparkles, big hats, and fabulously obnoxious jewelry.

24. What I learned in getting ready for church on Sundays was a love of putting on great style, a love of using fashion and style to articulate an *exuberant sense of self*. As I got older, I realized I could trade in the sweater vests for sequined jackets and the bow ties for dark purple lipstick. The pedagogy of style was instilled in me from a young age, but the method changed as I grew older, queerer.

25. Great style is never just about surface-level artifice. For queer and trans people of color, great style is world-making amid the ruins and rubble of anti-Black violence, homophobia, white supremacy, and transmisogyny.

26. No, great style doesn't pay the bills. And no, great style doesn't provide safety. Great style doesn't call for help when you're in need, and great style doesn't put food on the table. But at a young age, I figured out that fabulous style was the methodology Black people, queer people, working-class people and gender-nonconforming people used to refuse and persist in a life of subjugation. Great style is how the "most beleaguered groups," as the Black gay writer Joseph Beam puts it, stretch out, expand, and make themselves from scratch, a strategy of creating small moments of joy while trying to survive and navigate the ruins and rubble of the everyday.

> **Walk for realness. Win grand prize.**
> **It's time you children realize**
> **You walk for me. Walk for me. Walk for me.**
> **You're walking on pebbles, in Manolo Blahniks.**
> **Walk for me. Walk for me.**
> **You've got dozens of men crawling at your feet.**
> **Walk for me. Walk for me.**[5]

Wear sequins every day.
Decolonize academic dress!

27. Great style is, quite simply, a kind of poetry, a poetics of the self that provides a window to small, vibrant moments of **joy**. When you are a queer or trans person of color, constantly denied a seat at the table, a great outfit adds a vibrancy that allows us to vibrate at our own frequency.

28. A great outfit is not one that has all the most expensive labels, bells, and whistles. Great style is a strategy that queer and trans people of color embrace to survive and *thrive* (!) in a bleak, drab world that would rather we didn't exist. At its core, great style is a practice of refusal.

29. In an interview published in the *White Review*, Saidiya Hartman describes refusal as "the everyday practice of **saying no** to those structures that consign us to death and to subordination."[6] In my mind, exuberant, fabulous, over-the-top, juicy queer style is just this kind of refusal, a strategic rejection of the dull, drab, and uninspired boredom of the here and now in favor of the wider, brighter, and more wayward pastures of queer world-making.

30. My interest in style is first and foremost about those living in, on and through the periphery. It is a love letter, a shout out to all the **sissies at the picnic**, the fabulous faggots and ferocious femmes from Sylvester to Saucy Santana.[7] As the Black gay author Reginald T. Jackson wrote in 1991, "the worst thing you could be called was faggot. . . . It was a trigger to my deepest fears and growing insecurities."[8] This fear of a Black gay planet, an anxiety about Black queer exuberance, is rooted in the reality that Black queer people face a constant, ever-present threat of terror.

There's no such thing as too much jewelry. Accessorize!

31. But rather than centering that feeling of precariousness in their daily lives, Black queer bodies often trade in exuberance, a kind of "too muchness" as expressed by unrestrained pleasure,

freedom of movement, self-definition, and unencumbered embodiment. For GerShun Avilez, this *OVAHness* does not solve all problems; "nevertheless, it offers moments of satisfaction, control, and autonomy. Sometimes, a simple kiss can make one feel freed for a moment."[9]

> Alarms, alarms are going off.
> Walk for me. Walk for me.
> Walk like you're running from the police.
> Walk for me. Walk for me.
> Walk. Walk. Walk. And Walk.
> Walk. Walk. Walk. And Walk.
> Walk. Walk. Walk. And Walk.[10]

32. Cooking in heels.

33. My favorite pair of shoes are these cheap five-inch-tall stiletto booties. They're black suede with a faux snakeskin toe cap. *Function, with a twist.*

34. I don't know what I was thinking when I bought them because I knew that due to the lockdown brought on by the pandemic, the only places I would be traveling for the next several months would be from my bedroom to my kitchen to my sofa. But I needed these heels anyway, even if I only wore them around the house.

35. When I log into my heels, I have activated my avatar.

36. I wear heels *to feel something* in a cultural moment of numbness. Or, as my stylish friend M texted me one day when I asked if she cared about fashion during lockdown: "COVID ain't taking my looks away from me. Hahaha!"

37. Heels make me feel alive.

38. I vacuum my apartment in them. I cook in them. I put on my favorite disco songs and then dance in them. I Zoom in to my department meetings in them, even though no one can see much below my neckline. I put them on when I watch television. I talk on the phone in them. I wear them while I'm writing, and I wear them when I'm teaching. Sometimes I even walk around my apartment and record the sound they make on the hard floor, sending that to my Black queer friends as a voice message. *"Click, clack, click, clack."*

39. My heels are ancestral. Every move I make in them is in honor of a queer or trans person of color who came before me.

Hot pink is a great color. So is leopard print.

Bring it to the runway, Honey; bring me elegance and charm.
Walk as if your man is a pretty pocketbook on your arm.
Walk for me. Walk for me.
You're Twisty Twirlington; YouKnowMe DamnWell.
You're the supermodel, Honey: Sell! Sell! Sell!
Walk for me. Walk for me.

40. Fabulous, queer style signals moments of personal joy, feeling, and abundance, as it conjures dreams of brighter days to come. Cooking in heels offers a kind of rebellion through self-expression, as when Reginald T. Jackson figured out that "I had better decide who I am and more importantly, determine what I'm willing to do to be me."[11]

41. *Determine* what I'm willing to do to be me.

42. Determine *what I'm willing* to do to be me.

43. Determine what I'm willing *to do to be me*.

44. What are you willing to do?

Notes

Epigraph: Joseph Beam, "Making Ourselves from Scratch," in *Brother to Brother: New Writings by Black Gay Men*, ed. Essex Hemphill (Washington, DC: RedBone Press, 1991).

1. Legacy Russell, *Glitch Feminism: A Manifesto* (New York: Verso, 2020), 152.

2. Marlon Riggs, "Black Macho Revisited: Reflections of a SNAP! Queen," in *Brother to Brother: New Writings by Black Gay Men*, ed. Essex Hemphill (Washington, DC: RedBone Press, 1991).

3. Tavia Nyong'o, "Too Black, Too Queer, Too Holy: Why Little Richard Never Truly Got His Dues," *Guardian*, May 12, 2020.

4. Paul Alexander, "Walk for Me—Paul Alexander Feat. Performance Kim Aviance," YouTube, uploaded by Kim Aviance, April 9, 2006, https://www.youtube.com/watch?v=A9O0PXSLBLM.

5. Alexander, "Walk for Me."

6. Victoria Adukwei Bulley, "Interview with Saidiya Hartman," *White Review*, June 2020, https://www.thewhitereview.org/feature/interview-with-saidiya-hartman/.

7. Roderick A. Ferguson, "Sissies at the Picnic: The Subjugated Knowledges of a Black Rural Queer," in *Feminist Waves, Feminist Generations: Life Stories from the Academy*, ed. Hokulani K. Aikau, Karla A. Erickson, and Jennifer L. Pierce (Minneapolis: University of Minnesota Press, 2007).

8. Reginald T. Jackson, "The Absence of Fear: An Open Letter to a Brother," in *Brother to Brother: New Writings by Black Gay Men*, ed. Essex Hemphill (Washington, DC: RedBone Press, 1991), 257.

9. GerShun Avilez, *Black Queer Freedom: Spaces of Injury and Paths of Desire* (Urbana: University of Illinois Press, 2020).

10. Alexander, "Walk for Me."

11. Jackson, "The Absence of Fear," 259.

33. Freud —— Lacan —— Bergson

Homay King

FOR MY STUDENTS PAST, PRESENT,
AND FUTURE

Sigmund Freud and Jacques Lacan have fallen out of fashion with my students. I teach a theory and methods seminar in an art history department.[1] Designed for senior majors, it provides a condensed tour through art historical methodology from Hegel through connoisseurship, formalism, and iconography, continuing with Marx and social art history, psychoanalytic theory, feminism, postcolonialism, semiotics, and material culture studies. In recent years, the unit on psychoanalysis is typically the one that generates the most resistance. Students are far more skeptical of it than even formalism and connoisseurship—approaches that previous generations of students had dismissed as retrograde, smacking of old-fashioned auteurism.

Of course, psychoanalytic theory has been met with resistance throughout its lifespan. But these recent objections had their own particular character. First, my students rightly rejected what they perceived as its claims to universalism, given that its precepts are so patently derived from bourgeois European models. How could one even consider trying to rehabilitate such binaristic, anatomically gendered and sexed models as the Oedipus complex and the castration complex? I reminded them that in *Three Essays on a Theory of Sexuality*, Freud offered a theory of universal bisexuality at birth, that his theory of identification and desire allowed for at least thirty-two possible permutations of gender and sexual identity, and that the fact that he thought about gender and sexuality at all in ways other than moral and religious was rather extraordinary.[2]

But the *Three Essays* model, one student objected, did not account for fluid and genderqueer identities. Why, they asked, would anyone turn to such a method to think about race and colonial subjecthood? My offerings of Frantz Fanon, José Muñoz, David L. Eng, and a summary of my own scholarship on Jean Laplanche and internal alterity did little to assuage. Freud's and Lacan's texts, they argued, required too much cherry-picking and generous reading to make them palatable. Laplanche spoke of an unfinished Copernican revolution, referring to the decentering of the human subject that Freud began when he explored the unconscious. It seemed to me, in the classroom, that that revolution was now even less finished than it was before.[3]

A second objection was posed to psychoanalytic theory's purported claims to transhistoricity. They had absorbed one of the messages of New Historicism in the 1990s, perhaps without even knowing what it was: my students have been taught never to think anachronically, especially in the backward direction. Medieval texts, for example, should not be approached using modern methods, and if one does so, the analysis must be shrouded in caveats. My argument that nearly every theoretical discourse on our syllabus implicitly subscribed to at least some notion of its own transhistorical applicability—even historicism itself—was not persuasive. What they were objecting to was something else in psychoanalytic discourse: Freud's and Lacan's seeming claims to have identified universal, transhistorical models of human development, subjectivity, and identity formation, which came across as too authoritative and one-size-fits-all even when they admitted of contingencies. The idea that these models were only metaphors, not diagnostics, was simply not convincing to them.

Finally—and this was the objection that I found the most revelatory of the three, potentially signaling a kind of mini-epistemic shift—my students were averse to the idea that human subjectivity is not characterized by agency and self-determination. While they cautiously accepted the idea of an unconscious—the idea that not every incoming perception is received with full awareness, that not every emotion, thought, or memory is consciously available at any given moment—they balked at the idea of the unconscious's vastness and its sway over our actions. It seemed to them that to say that an artist painted a certain way due to something unconscious, as Freud said of Leonardo da Vinci and Melanie Klein said of Ruth Weber, was to rob that artist of agency and to pathologize them.[4] They worried that such a model would be

unequally applied: for example, women, queer subjects, and artists of color would be said to paint because they were traumatized or hysterical, while the great men of the Renaissance painted because they were geniuses. My students wanted everyone to have equal access to the category of genius. It struck me that my generation, educated in the 1990s and steeped not only in psychoanalytic theory but also in Roland Barthes's "The Death of the Author" and Michel Foucault's "What Is an Author?," wanted something like the reverse: for the category of genius to be deconstructed, such that no one had access to it.[5]

My students are ardent believers in individual free will and self-expression. At the same time, they demonstrate a much more highly developed sense of social responsibility than their predecessors and an underlying awareness of the interdependence of all life on earth (or even of everything in the cosmos). These two positions initially struck me as contradictory: if we are interdependent and collective, our fates intertwined, why the sentimental attachment to the category of the individual? And as a scholar who trained in psychoanalytic theory as a graduate student, I could not help but wonder: Who or what is this self you want to express, whose expression you would like to see validated by others? Isn't it just the ego of Freud, the misrecognized *moi* of Lacan?

Neither of our positions is completely without reason, but both lack nuance. The task then becomes to unravel the sticky problem of whether we believe in things like creative agency and free will or not, which is in my view what the objections to psychoanalysis are ultimately about. My students' protests had a logic to them, one that I did not fully appreciate at the time. It was not simply about an attachment to an egoic version of the self, or resistance to the notion that we are not entirely self-sovereign, although these were some of the things we disagreed about. It was about potentiality, actions directed toward the future, and finally hope, the sense that change and transformation are indeed possible. My students, as I have come to understand, were bridling not simply at the notion that their treasured self was a fiction comprising mirror reflections and kernels of alterity, but moreover at the idea that this self was incapacitated, that it lacked the ability to exert any impact on the future. It was a question not simply about identity, but about free will.

My own sense of free will is informed by a lesser-read text that we did not read in this particular seminar—whose survey format and status as a required capstone course preclude the inclusion of narrower,

more difficult texts—but which I studied closely in graduate school, Lacan's seventh seminar, *The Ethics of Psychoanalysis*. Here, Lacan argues that freedom is undergirded by renunciation, and by a Heideggerian being-toward-death or embrace of the death drive. As my mentor Kaja Silverman would say in class, the Lacanian subject enjoys only a "little bit of freedom." This lowercase freedom is predicated on an assumption of—or more gently, a willingness not to disavow and deny—our own mortality, limitations, and finitude. In Seminar VII, Lacan writes that Antigone's act of rebellion against Creon in illegally burying and mourning her brother is enacted from this place. "From Antigone's point of view," Lacan writes, "life can only be approached, can only be lived or thought about, from the place of that limit where her life is already lost, where she is already on the other side. But from that place she *can* see it and live it in the form of something already lost."[6] For Lacan, freedom is not to be found in the pursuit of *jouissance*—bulldozing one's way through obstacles in an all-terrain vehicle—but rather in acts that take place within the rubric and limitations posed by a major constitutive loss, the entry into language. This little freedom is not modeled after omnipotence; it is grounded in something we might call a primary impotence.

My own understanding of free will is also informed by Henri Bergson, who is not a touchstone in the discipline of art history and thus likewise did not appear on the syllabus for the capstone course (when I teach Bergson in other seminars, he is polarizing: adopted by some students as a key theorist, dismissed by others as a lightweight). Bergson claimed that freedom did not exist outside of durational time and the indetermination it brings. In a passage from *Creative Evolution*, Bergson evokes the figure of the painter and suggests that the artist does indeed engage in acts of conscious invention and creation, although not in the way we might think. He writes, "Do we foresee what will appear on the canvas? We possess the elements of a problem; we know in an abstract way, how it will be solved ... but the concrete solution brings with it *that unforeseeable nothing* which is everything in a work of art. And it is this nothing that takes time."[7] Bergson objects to the notion that the masterful artist is one who has a clear and distinct vision in mind which, with great intention, they then bring to expression in their preferred medium. This would amount to a Platonic, deterministic model, where ideals are foreseen and preexist their actualization. It reduces the artist to an automaton for transcribing preexisting patterns

into matter—not necessarily a bad thing, but not, for Bergson, an expression of creativity or free will. The latter requires something else: puzzling over a problem over a duration of time, hesitating, reworking, experimenting, waiting, and seeing what appears and acting accordingly. It is through a durational process, sometimes a painstaking one, that something unforeseeable, something that is not yet a thing because it is not yet known, can emerge.

Although Bergson is no fan of the signifier (he viewed language as a fixative distortingly imposed on moving, ever-changing reality), one could argue that his definition of freedom is not wholly incompatible with Lacan's. Both require giving up the fiction of self-sovereignty and letting go of ideas about capacity that take omnipotence as their archetype. These notions of individual agency, to which I had mistakenly imagined my students subscribed, assume that empowerment for an individual means having a vision or plan and boldly enacting it while overcoming obstacles and ignoring deterrents. A structuralist might imagine that giving up self-sovereignty means accepting determinism; for a psychoanalyst, this determinism occurs at the behest of the unconscious. However, as is clear from the Antigone example, this model of free will does not mean one that has to practice radical acceptance with regard to what is—with regard to pernicious laws, to structures and discourses of domination. And as is clear from Bergson's example, the artist is greater, not lesser, for showing a willingness to deviate from a preexisting vision, for allowing something unexpected to be revealed in the course of time. Indeed, openness to deviation is one path toward escape from the informatics of domination.

As I wrote this text, under stay-at-home orders during the COVID-19 pandemic, the natural world was sending all kinds of clues and signs to us about the limits and potentials of free will. Staying at home "doing nothing," wearing a mask, and remaining physically distant from others in this moment is a privilege, and also a rule that nonessential workers have been asked to follow. To break this rule surely feels to some like a courageous act of resistance on par with Antigone's, a supreme exercise of free will. But there is the opportunity for the exercise of another kind of free will, the one that I have tried to describe here. It requires a recognition of mortality and ability to recognize limitations: not only one's own personal mortality and limitations, but the precarity and vulnerability of others and of the molecularly interconnected whole. It may seem strange to say that not doing anything is an

exercise of agency. But doing is not the same as collectively actualizing. Bergson would say that the vast majority of our motor and neuronal activity is habitual and automatic, like sneezing. Doing is sometimes impatient, thoughtless, and reflexive, like the bombastic aggression of a classically chauvinistic action hero.

Actualizing, on the other hand, requires time, hesitation, perplexity, and something other than sheer consciousness: something resembling a complex psyche, perhaps even a nonanthropocentric one. In Bergsonian terms, it requires intuition as opposed to intellection. Whereas intellection, according to his definition, requires only the ability to make distinctions, intuition requires attunement to what is novel and strange. The intellect, in Bergson's words, "cold-hammers the materials, combining together ideas long since cast into words and which society supplies in a solid form." With intuition, by contrast, "it would seem that the solid materials supplied by intelligence first melt and mix, then solidify again into fresh ideas."[8]

Many students educated in the 1990s, like myself, objected to auteurism with its notion of the artist as individual Romantic genius-creator, not only because it was based in a theological model of absolute sovereignty and omnipotence but also due to a certain cynicism. Structuralism and post-structuralism appealed more to us, as they confirmed our sense that our lives were predetermined by powerful ideological structures related to language and kinship that had long preexisted us and that were almost entirely beyond our control. Had I read Bergson at that age, or the Lacan of the Seventh Seminar, I might have discovered that the self-sovereign subject and the socially determined subject were not the only two options. There is a capacity to actualize change, and a little bit of free will, if only one knows how to receive it.

Notes

1. My thanks to the students in two iterations of this course, and to my co-instructors, C. C. McKee and Alicia Walker.

2. Sigmund Freud, *Three Essays on the Theory of Sexuality*, trans. James Strachey (New York: Basic Books, 1962), 7.

3. Jean Laplanche, "The Unfinished Copernican Revolution," in *Essays on Otherness* (London: Routledge, 1999), 53–85.

4. Sigmund Freud, "Leonardo da Vinci and a Memory of His Childhood," in *The Standard Edition of the Complete Psychological Works of Sigmund Freud*, vol. 11, trans.

James Strachey (London: Hogarth, 1957); Melanie Klein, "Infantile Anxiety Reflected in a Work of Art," in *The Selected Melanie Klein*, ed. Juliet Mitchell (New York: Free Press, 1986), 84–94. Regarding Ruth Weber as the subject of Klein's essay, see Ole Andkjaer Olsen, "Depression and Reparation as Themes in Melanie Klein's Analysis of the Painter Ruth Weber," *Scandinavian Psychoanalytic Review* 27 (2004): 34–42.

5. Roland Barthes, "The Death of the Author," in *Image-Music-Text*, trans. Stephen Heath (New York: Hill and Wang, 1977), 142–48; Michel Foucault, "What Is an Author?," in *Language, Counter-Memory, Practice: Selected Essays and Interviews*, trans. Donald Bouchard and Sherry Simon (Ithaca, NY: Cornell University Press, 1977), 113–38.

6. Jacques Lacan, *The Seminar of Jacques Lacan*, book 7: *The Ethics of Psychoanalysis*, trans. Dennis Porter (New York: Norton, 1986), 280, emphasis added.

7. Henri Bergson, *Creative Evolution*, trans. Arthur Mitchell (Mineola, NY: Dover, 1998), 341, emphasis added. See also Henri Bergson, *Time and Free Will: An Essay on the Immediate Data of Consciousness*, trans. F. L. Pogson (London: George Allen and Unwin, 1921).

8. Henri Bergson, *The Two Sources of Morality and Religion*, trans. R. Ashley Audra and Cloudesley Brereton (1932; reprint, Garden City, NY: Doubleday, 1954), 46.

34. Sex —— Genetic Engineering

Shu Lea Cheang and Matthew Fuller

GENOM CORPORATION,
MINUTES OF EXECUTIVE BOARD
26 AUGUST 2049

Minutes of a regular meeting of the board of Directors of **Genom Corporation.**

Attendees: Redacted

Apologies: No Apologies

Minutes from last meeting: Verified

Item 1. Bionet

A review of the product line and development. Genom maintains human reserves and expands human capacities to bring customers into beneficial alignment with Bionet. Using advanced expression techniques, the system converts selected and refined sources of red blood cells into an enhanced DNA storage unit. An individual's chromosomes are improved by a custom reformatting, analogous to data normalization. This allows faster and more efficient biological function but also allows for storage of data related to enhanced biological function.

Bionet's primary user appeal remains its finely engineered maximization of the human orgasm system and storage of orgasm memory. This product continues to be a fine example of genetic engineering developed for consumer demand-led human benefit.

Strategic challenges to Genom Corporation's income streams have been met with a range of strategic product diversifications. Members of the board were reminded of the company's roots in adult entertainment production and its subsequent move toward physical delivery platforms. We have successfully pivoted to bypass the devaluation of expertly produced entertainment products by amateur productions and low-grade footage.

The corporation's range of IKU (orgasm in Japanese) coders, attractively embodied storage units with high levels of pleasure specification, are dispatched to interact with clients. As a product of these interactions, we gained advanced and multidimensional orgasm data while serving client needs and advancing the progress of technology.

Data gained via IKU systems has allowed us to move into new product ranges. Key among these is the current bacterial platform. The bacteria codes DNA in the red blood cell with orgasm data, enhancing the function of the cell to a premium level. The enhanced red blood cell as a DNA-embedded biotic module is capable of generating self-fulfilled orgasm at both the scale of the cell and of the person containing one or more such cells.

In order to facilitate the maximum growth of pleasure, we integrate it within market structures. Possession of a collection of enhanced cells is the "capital" of a person. Both cells and consumers are strongly motivated to increase their capital. Genom facilitates their ability to do so by enabling a proprietary system for trading orgasm data to enhance sensed pleasure. While our primary aim is to enhance the quality of human life, Genom also needs to ensure economic viability in order to maintain this important function. It is through brokering and structuring the fluctuation of orgasm data trading that Genom makes a sufficient return to ensure long-term viability, benefits to shareholders, and commitment to research.

Item 2. UKI Virus

The mutant UKI virus continues to be Genom Corp's strongest threat. The proper storage of orgasm memory allows for customers to access self-generated orgasm data to reexperience their peak moments and to integrate these into other facilities. The malignant UKI virus is specially engineered to enter the Bionet to "rescue" orgasm data rightfully owned by the Genom Corporation. It is a clear case of the model of illegal malware translated into biological form.

Indeed, nefarious forces suggest that the UKI virus had its origins as a by-product of defunct IKU coders "dumped on the e-trashscape." Through uncertified sexual activity and the generation of code interference with the unregulated inhabitants of this e-trashscape, a number of threats to bio-informatic sanctity have been instigated. From this basis, UKI poses a substantial threat to Bionet's contribution to human progress and the pleasure industry.

Concern was stated as strong figures for the last quarter and the years since launch may be impeded by public awareness of UKI as a threat. This formed the basis of the next set of action points.

Item 3. Illicit Access Report

A report was heard from a representative [Name Redacted] of the Public Relations division on viral recombination and DNA-sealing solutions to illicit third-party access to orgasm data retrieval systems. In order to combat third-party secondary access to orgasm data via biodata sanctity failure, entailing revenue-depletion risk for Genom once data is shared or "reconquested" (installed by the originator), a number of strategies are being considered:

Cross-referencing to wider research findings that data rescue and even subsequent data pooling heightens risk of unwanted splicing and mutation. Unhygienic orgasms that negatively affect the trading capital of a user can be a traumatic experience, for instance. Not only can this lead to negative revenue growth for Genom, but it is also a genuine public health issue that the corporation is deeply concerned about.

Action: Broadcast deep concern through all internal channels.

Action: Legal Department to further probe into acquisition of brokerage communication channels.

Action: Informal means of incentivizing brokers to migrate to other wealth-creation opportunities are to be explored under a (closed) directive of the Sanctity Department.

Item 4. Product Diversification

Closed-source orgasm curation: while a potential market threat to Bionet, it is possible that it also suggests new product strategies. These require careful consideration, but perhaps offer the chance to capture

the viral mechanism for the benefit of Genom and its stakeholders and ultimately to bring the benefits of our product line to humanity.

Information extracted from informal brokers suggests that viral pleasure derivatives from a black market in celebrity user orgasm data are subcontracted to different levels in the pyramid of users. Initial specimen contracts, deliverable by implant, are being prepared by the legal department to license such data. This would allow premium-level users and above the chance to reexperience celebrity orgasm data should their physiological platform have sufficient bandwidth. Lite versions for subpremium users and those with substandard equipment may be retailed in one-time disposable ampoule kits with advanced unboxing editions available in future product iteration opportunities.

Action: Meeting confirmed that progress should be made along this line. Discussion points included whether implementation could be speeded up.

Action: How far neural encryption would be able to stop secondary recording of celebrity orgasm data as it is played back through the user's frame is a question for the Sanctity Department, who are required to report on this by the time of the next meeting.

Item 4.1

A proposal from R&D for historic sex plug-ins building on the Bionet platform to offer culturally determined and historically appropriate orgasm data from a curated selection of historical periods and locales was considered and deemed insufficient at this time. Consumer confidence reports questions of anxiety around pre-loved data and the familiarity of consumers with the notion of temporal product differentiation. Following a motion from the chair of the meeting, the company resolves to continue to emphasize differentiation based upon the power of the product.

Action: Forms of research that do not map to this agenda are to be terminated. Staff are to be referred to the usual human resources processing.

Item 5. Sales and User Capture

Sales data continues to be consistent in mapping onto upward projections. (See attached documents F, G, H, for detailed schedules of sales by region, by credit structure, and by product variant.) The ability to

match demand has entailed the development of new production facilities in all regions. These are currently running at 60 percent capacity. It is essential that these Bionet platform farms maintain submaximal production levels in order to meet the challenge of potential surges. Consideration was given to further expansion of facilities. The Estates Department proposed two new sites per continent per quarter as a necessary prospect, with production close to shielded urban cores with above-good life expectancy. It was noted that further key sites are being adopted this month in Istanbul3, the Southern California Desert, Tasmania Sun City, and the Bonn regional structure.

Fast response to new demand is essential to user capture. Bionet product has the advantage of intensity of the product experience but needs to compete in terms of speed with purely informational product delivered by server farms. Spatial prioritization is necessary for physical Bionet product. Staying competitive in the movement space between factory and organism is where most complexities occur. Test adoptions of new delivery platforms continue to be carried out in various competing team structures within Genom. Measuring the time between harvest of the data to its uptake by a user receptor-system gives the best index of value and trading potential. Initial findings from delivery variation experiments indicate the possibility of reducing uptake delay by 10–20 percent. Measuring the time between harvest of the data and its uptake by a user receptor-system gives the best index of value for trading purposes.

Action: As a means of routing around criminal use of the Bionet, optimization of nonstandard delivery routes via informal business networks while retaining financial through-flow in various forms is to be reviewed by Sanctity.

Action: Consideration of diversification options. Personalized medicine, with viral matching.

Item 6. Enforcement Issues

6.1 Legacy Security Issues in IKU Orgasm Data

As the storage in IKU units reaches capacity, we continue to employ IKU runners to recover IKU data and forcibly retire the units. Issues have been detected with redundant and sometimes malfunctioning IKU coders within the e-trashscape. A certain amount of IKU coders that

had seemingly been fully retired continue with some form of functionality. These units display multiple forms of deviant operation, inter alia: attempts to recode and revive expired body parts, the exchange of sex for code, the elaboration of arcane means of code sexing code. Some of these also include freelance IKU conduct, the generation of entertainment footage without directorial oversight under the code name *postporn*, and the unauthorized spread of viral code. It is also understood that such actions endanger present revenue streams by entailing further contamination of the Bionet.

Action: Strengthen program to retire all redundant coders.

Action: Engage further in green provision for the removal of the e-trashscape habitat.

6.2 UKI Virus Data

The Genom Corporation has invested substantially in state-of-the-art sanctity measures, including withdrawal from what remains of the general internet. Nevertheless, there are significant threats to maintaining sanctity as the UKI virus seeks to seize and commandeer orgasm data by infiltrating the Bionet. Here, an important consideration is the security border between the virus and the blood cell. There are two strategic considerations:

1. UKI virus sabotages the red blood cells' carrier functionality, liberating the red blood cells.
2. UKI virus is defeated; red blood cells succeed in generating illicit auto-orgasm.

Actions: These are matters of significant concern for the corporation, and records of measures taken will comply with our classification of data directive and are annotated under closed matters to be accessed by those with commensurate permission levels.

35. Labor —— Robotics

Lucy Suchman

"Robots are serving in the cafeteria. It's not a good experience."

"Why not, Claire?"

"They bring you your eggs, and when you say, Excuse me! Hey! I didn't order tomatoes! They say, Thanks, Ma'am. Have A Nice Day! And glide away to the water fountain. They glide because they can't walk yet."

"No, they can't walk yet. Walking is hard for bots. But be patient, Claire, and remember—bots find the unexpected difficult to process."

Jeanette Winterson, *Frankissstein: A Love Story*

The Expected

The landline rings early this morning, and through the haze of an interrupted dream I hear my phone's robotic voice intone, "Call from V9187654027109344229. Call from V9187654027109344229." Not surprisingly, V9187654027109344229 leaves no message. Amid assertions that everything is now smart, those of us in the hyperdeveloped world find ourselves surrounded by ever-expanding dominions of machinic mindlessness. Large language models, voice recognition, and speech generation train us to expect less and less, at the same time that we're invited to fantasize a future of flawless robotic servitude. Underwriting

that fantasy are others of us who labor in the distributed workplaces dedicated to rendering their own workings invisible or, where contact is necessary, confining encounters to the simulation of an algorithmically generated script. Digitally enabled transnational capitalism centralizes relations of labor–robotics on a grander scale, from the electronic sweatshops of the Apple supply chain to the obligatory distribution points of the Amazon warehouse. Beyond the Megacorp's factory gates, projects to colonize new spaces in (inter alia) the home, the smart city, at the border, and on the cybernetic/cyborgian battlefield play out the strategy of domination through informatics.

And yet the relation labor——robotics, manufactured in the nineteenth century through regulations of time, space, bodies, and machines, has never been fully contained by its scientifically managed enclosures. Luddite resistances and the lively contingency of the inventive work required to keep the machinery working, however repressed, continue to kick back. Each new opening requires a new form of enclosure, the re-creation of a closed-enough world—discursively, imaginatively, materially, and practically—to enable the mythical autonomy of robot labor. Each enclosure reveals its corresponding openings, but to hold those spaces open requires resisting the translation of labor into robotics and the continuing practices of differential exploitation and dispossession on which automation relies and that its invested actors relentlessly sustain.[1]

Servitude ex Machina

We can arrive at the society which has legitimate slaves to do all the things it doesn't want to do and which can retain for humans all the things which they want to do.

Meredith W. Thring, professor of mechanical engineering,
1969 International Congress of Industrial Design

Slavery's dehumanizing premise—that the slave exists outside the category of the universal/unmarked human—is updated with the promise of slavery's legitimation (at last!) through automation. And if, fifty years later, the robot has failed to meet this promise of perfect servitude, expanding networks of increased computational speed and bandwidth enable new propositions for labor on demand.[2] An article headlined

"Robot Butlers Operated by Remote Workers Are Coming to Do Your Chores" reports on Japanese startup Mira Robotics' plan to charge its customers the equivalent of US $225 per month for six to eight hours of domestic service from a remotely operated robot helper.[3] Opening with the proposition that "for pretty much as long as robots have existed, humans have wanted robot butlers: autonomous machines that do our bidding around the home," the story posits remote control as an innovative alternative to robot autonomy.[4] Imagining a butler that empties a washing machine and folds our clothes (signaling insufficient attention to divisions of labor so clearly set out for us by *Downton Abbey*), Mira Robotics promises to overcome the persistent problems of robotic dexterity with a human controller.

This promise recalls roboticist Rodney Brooks's dream of human-augmented robotic service workers, globally outsourced via "remote-presence" operations.[5] It seems unlikely, Brooks observes, that the so-called general-purpose robot capable of loading and unloading the dishwasher, unpacking groceries, or cleaning bathrooms—all tasks "that many people hire domestic help to do for them, especially if they are a two-career family with demanding jobs"—will be realized in his lifetime.[6] Consistent with a policy of closed borders and permanent divisions between the rich and the poor, the alternative that Brooks fantasizes is a global infrastructure that enables "such families" (that is, families like his) to outsource their domestic labor to supervisory controllers of a remote-presence robot in the family home, who are themselves able to remain at home in the Global South. A win-win proposition, this means that "the brains of people in poorer countries will be hired to control the physical labor robots, the remote-presence robots, in richer countries. . . . High-bandwidth Internet would be available in work centers and 'menial laborers' would come to work at computer workstations in a relatively pleasant work environment."[7] This scene revivifies the ghost in the machine through the familiar form of colonized labor, organized now in service centers rather than fields and factories (though the latter ghosts persist as well).[8] As the labor of people in the "poorer countries" is upgraded to mental versus menial, the hierarchy of value positions them as the overlords of their robotic prostheses, which in turn enable their own continued subservience.

Summarized succinctly by Atanasoski and Vora, such imaginaries reiterate a fantasy that as machines (first factory robots, now algorithmically enabled artificial intelligences, or, failing that, networked

cyborg operators) become the surrogates for subordinated workers in the performance of dull, repetitive, and reproductive labor, the creative capacities of the fully human subject will be freed. But the freedom of the liberal subject, they argue, is only possible through the unfreedom of the surrogate; there is no liberal subject outside of these relations and the figurative less-than-human on which they depend.[9] This analysis echoes Jennifer Rhee's focus on questions of identification and difference in human/robot relations, inflected through histories of labor and questions of the human and its Others.[10]

The Unexpected

At the same time that the human surrogate is rendered less fully alive, the liveliness of machines is strategically overrepresented by dominant discourses. Narratives of the inevitable rise of the robots, who seem through their own irresistible agencies to threaten our jobs, work to erase the political and economic interests that underwrite the robotics project. They imply as well that automation is somehow natural, or at least like climate change a natureculture with its own inexorable momentum. By implication, however much the expansion of robotics may be induced by human activity, like climate change it is now proceeding with its own dynamic. But robotics are very different kinds of natureculture than global warming. True, dynamics are in place that will unfold if they are not actively interrupted. But these dynamics are much more wholly human ones, less entangled with the more-than-human and even more amenable to a political will to intervene.

What are our possibilities for counterprojects aimed at unmaking the dreamworlds of labor——robotics that sustain the informatics of domination, in favor of more unexpected encounters and more equitable modes of livelihood? The slippages between labor——robotics imaginaries and lived realities of laboring bodies offer us openings for resistance. For our critiques to be generative, however, they need to be brought into dialogue with wider movements for antiracist, decolonizing transitions to social justice and planetary sustainability. One strategy is exemplified in the combined research/activism/design project named Turkopticon.[11] Developed by feminist science and technology scholar Lilly Irani and her collaborator M. Six Silberman, Turkopticon provides a resistance platform for "micro" or "click" workers, crowdsourced by Megacorp Amazon under the moniker of "artificial

artificial intelligence," to fill the gaps between automation's promises and the realities of intelligent labor required for data-processing tasks. Designed to enable workers to return the gaze of the review-driven, on-demand, humans-as-a-service labor market automated through the platform named Amazon Mechanical Turk, Turkopticon allows workers to review "Requesters," reporting bad employers whom other workers should avoid. Irani's analysis of Amazon Mechanical Turk and other crowdsourcing platforms also works against the translation of piecework labor into entrepreneurship, as a strategy of techno-capitalist exploitation.[12] It works as well in coalition with groups like Silicon Valley Rising, tech workers—including cafeteria workers organized under the union UNITE HERE Local 19—fighting against contract labor's exploitation and precarity.[13]

Captive in the master's house, tech workers and all of us who are entrained in the patronage of the informatics of domination would do well to call out the unmarked, privileged voice of an affluent *us*, the universal (racialized and gendered) human that dominates discourses of labor——robotics, for the unreconstructed inequalities and injustices that it presupposes and projects.[14] If it is true that "capital can only be capital when it is accumulating, and it can only accumulate by producing and moving through relations of severe inequality," then more radical transformations are required than those from the slave to the entrepreneurial self.[15] It is not only those voices conjoined in the *us* of labor——robotics but also, perhaps more, those who continue to inhabit the outsides of digitally augmented capitalism who articulate the radical ways in which it could be otherwise. Movements for decolonizing and remaking led by autonomous communities and social movements in the Global South can help us to find our way out of the expectable confines of Capitalocene futures, and into the unexpected openings of nonhierarchical and pluriversal co-laboring.[16]

Notes

Epigraphs: Jeanette Winterson, *Frankissstein: A Love Story* (London: Jonathan Cape, 2019), 31; Meredith W. Thring, quoted in *Guardian*, "Robot Life of the Future—Archive, 1969," September, 11, 2019, https://www.theguardian.com/technology/2019/sep/11/robot-life-of-the-future-archive-1969.

1. See Neda Atanasoski and Kalindi Vora, *Surrogate Humanity: Race, Robots, and the Politics of Technological Futures* (Durham, NC: Duke University Press, 2019), 4.

2. See Lucy Suchman, "Swords to Ploughshares," *Robot Futures*, January 20, 2016, https://robotfutures.wordpress.com/2016/01/20/swords-to-ploughshares/.

3. James Vincent, "Robot Butlers Operated by Remote Workers Are Coming to Do Your Chores," *Verge*, May 9, 2019, https://www.theverge.com/2019/5/9/18538020/home-robot-butler-telepresence-ugo-mira-robotics/.

4. Vincent, "Robot Butlers Operated by Remote Workers."

5. See Rodney Brooks, *Flesh and Machines: How Robots Will Change Us* (New York: Pantheon, 2002); and Kalindi Vora, *Life Support: Biocapital and the New History of Outsourced Labor* (Minneapolis: University of Minnesota Press, 2015).

6. Brooks, *Flesh and Machines*, 146.

7. Brooks, *Flesh and Machines*, 146.

8. See Mary Gray and Siddharth Suri, *Ghost Work: How to Stop Silicon Valley from Building a New Global Underclass* (New York: Houghton Mifflin Harcourt, 2019).

9. Atanasoski and Vora, *Surrogate Humanity*, 5–6.

10. See Jennifer Rhee, *The Robotic Imaginary: The Human and the Price of Dehumanized Labor* (Minneapolis: University of Minnesota Press, 2018).

11. See Turkopticon, https://turkopticon.ucsd.edu/.

12. See Lilly Irani, *Chasing Innovation: Making Entrepreneurial Citizens in Modern India* (Princeton, NJ: Princeton University Press, 2019); Lilly Irani, "The Cultural Work of Microwork," *New Media and Society* 17, no. 5 (2015): 720–39; Anita Say Chan, *Networking Peripheries: Technological Futures and the Myth of Digital Universalism* (Cambridge, MA: MIT Press, 2013); and Silvia Lindtner, *Prototype Nation: China and the Contested Promise of Innovation* (Princeton, NJ: Princeton University Press, 2020).

13. See Adam F. Hutton, "Silicon Valley Rising Has a Plan to Improve the Lives of 'Tech's Invisible Workforce,'" *San Jose Spotlight*, September 1, 2019, https://sanjosespotlight.com/silicon-valley-rising-has-a-plan-to-improve-the-lives-of-techs-invisible-workforce/.

14. Audre Lorde, *Sister Outsider: Essays and Speeches* (Berkeley, CA: Crossing Press, 1984), 111.

15. Jodie Melamed, "Racial Capitalism," *Critical Ethnic Studies* 1, no. 1 (spring 2015): 77.

16. See Arturo Escobar, *Designs for the Pluriverse: Radical Interdependence, Autonomy, and the Making of Worlds* (Durham, NC: Duke University Press, 2017).

36. Mind —— Artificial Intelligence

Ana Teixeira Pinto

Engaging metaphysical conceptions of mind as a prehistory of AI, this essay looks into cultural scripts that exist in excess of what technology affords, yet came to define what technology connotes. Fictionalizations of AI, in particular, preexist IT and might have little to say about technology, science, or the economy, but do have a lot to say about whiteness, masculinity, and the quest for immortality.

Speaking at Moscow University in 1988, President Ronald Reagan stood in front of a mural of the October Revolution to pitch a different type of revolution. "Like a chrysalis," Reagan argued, "we're emerging from the economy of the Industrial Revolution—an economy confined to and limited by the Earth's physical resources—into . . . 'The Economy in Mind,' in which there are no bounds on human imagination." Invoking the "ancient wisdom" of the Bible, the president concluded, "In the beginning was the spirit, and it was from this spirit that the material abundance of creation issued forth."[1]

What, if anything, defines *the digital* is the notion that the world exists primarily as code, material concretion being secondary, if not neglectable, but Reagan did not invent the dream of an immaterial space where we could finally leave the constraints imposed by matter behind. The epistemological antinomy between matter and spirit is an age-honored one, arching back to pre-Socratic sources. This antinomy, however, does not just index the battle between materialism and idealism. As Jean-Joseph Goux argues, "there are sexual, or at least sexed, stakes" in operation throughout it.[2] The unhappy connotations matter acquired—corruption, contingency, and death—are tied to a conceptualization of conception in which only in the "male's

semen does the principle of the soul, that is life, reside"; on the side of the female "there is no order, no principle of internal organization, no generative power."[3] The division between the active and the passive roles in procreation, Goux maintains, is symbolic of the symbolic, with the entire trajectory of Western metaphysics regulated by substitutions derived from the same structuring metaphor, in which mind, masculinity, and value converge. Within this schema, feminized nature is fertile but impotent, a bad infinity, which can only produce more of the same degraded life fated to ultimately return to death, while "the generative principle of the world" is "transcendentalized into a principle of exclusively masculine significance: mind."[4]

In the late nineteenth century, thermodynamic theory gothicized the cultural mood by granting scientific legitimacy to a blighted image of nature. According to William Thomson, one of the first physicists to identify entropic processes, the tendency toward dissipation of energy would eventually lead the earth to be "unfit for the habitation of man *as at present constituted*."[5] For Thomson, only an act of God could change the laws of physics, but just as soon as the second law was formulated, the fin de siècle began to look for a loophole. If the earth was to become unfit for man as at present constituted, man needed to evolve out of its present constitution. As a result, the following decades were marked by a search for superman types, within which technology came to occupy the apex position. Unifying these pursuits, one finds a conflation of several meanings of the term *energy*, from fuel or electricity to stamina or willpower, and the belief that, underlying all of these, there is a primal, generative essence, an élan vital (life force) if you will. Understood as an "extraorganic organ or prosthetic," technology could function as the ideal conduit for the life force or the externalization of the will to power.[6] The futurist movement, in particular, sees the human body as "the most obtrusive barrier separating the subject from an authentic experience of life" and elects as its sole purpose its replacement by the superior machine.[7] Decidedly Faustian, the futurist mindset seeks to overcome the merely human, rather than to help human beings better their estate. In Filippo Tommaso Marinetti's 1910 novel *Mafarka the Futurist: An African Novel*, the protagonist Mafarka fantasizes about parthenogenesis, in order to engender a son without "concourse and stinking complicity with a woman's womb": "I tell you that the hour is near when men with broad foreheads and chins of steel will give birth

prodigiously, by one effort of flaring will, to giants infallible in action.... I tell you that the mind of man is an unused ovary.... It is we who will be the first to impregnate it."[8]

From Marinetti's perspective, the human body is but an initial prosthesis; replacing the body with a better prosthesis is just a logical step in evolution. But the capacity to undergo this evolutionary leap does not extend to all, and it is not by accident that *Mafarka the Futurist* is "an African novel." Shaped by gender but not limited to it, the epistemological chasm between mind and matter expanded during the epoch of Western imperial conquest, to encompass racial and colonial registers. In his *Lectures on the Philosophy of History*, Hegel theorizes Africa as a continent where the Spirit finds no seat. "Negroes," he wrote in *Lectures on the Philosophy of History*, "are enslaved by Europeans and sold to America. Bad as this may be, their lot in their own lands is even worse, since there a slavery quite as absolute exists; for it is the essential principle of slavery, that man has not yet attained a consciousness of his freedom, and consequently sinks down to a mere Thing—an object of no value."[9]

To be human, for Hegel, is to free oneself from nature. The function of culture is to undo nature, in order to engender a (man-made) second world. The failure to free oneself from nature is described as a cultural failure, which Hegel attributes to conceptual inadequacy. From Hegel's perspective, race is an index of this failure. In order for the Spirit to attain its essence, freedom, which is also its telos, man must create and destroy essentially.

After World War II, as molecular and evolutionary biology began to treat genetic information as an essential code, the body being but its carrier, the age-old antagonism between idealism and materialism was refracted into the techno-scientific domain. Information had hitherto no scientific meaning, but cybernetics' conceptualization of information as negentropy, literally that which negates entropy, gestures toward a nonphysical or metaphysical entity that endures past physical death—the locus of, as it were, immortality.[10] In 1950, Norbert Wiener would suggest that it was theoretically possible to telegraph a human being, by extracting their informational code, and that it was only a matter of time until the necessary technology would become available.[11] In the 1980s, it became popular to claim that it would soon be possible to upload human consciousness and have one's grandmother run on Windows—or

stored in a floppy disk. Science fiction brimmed with fantasies of immortal life as immaterial code.

Marinetti wrote in an era in which aviation, not IT, was cutting-edge technology. Flight, instead of electronic circuitry, was used as a metaphor for everything the futurists wanted to encode as high or elevated (mind, man, the future), in contradistinction to everything they saw as base and degraded (woman, matter, the past). Marinetti's superman is no longer a man but quite literally an airplane: Gazourmah, a metal being whose enormous wings enable him to soar upward while he crushes the earth beneath his feet. Commenting on *Mind Children: The Future of Robot and Human Intelligence*, N. Katherine Hayles notes that Hans Moravec also imagined "the relation between carbon man and the silicon devices he is creating to be like the relation between the caterpillar and the iridescent winged creature that the caterpillar unconsciously prepares to become."[12] In a more recent iteration of the fantasy of will-to-power-incarnate, a blogger named Roko hypothesized that a coming AI—the entity that later became known as the Basilisk—once in existence, could develop the desire to accelerate its own inception, and hence retroactively punish the humans who, deliberately (this would include anyone reading Roko's post) chose not to contribute to its creation.[13] Like Gazourmah, Roko's Basilisk, a son with no mother, has an oedipal relation to his many (bad) fathers.

Gesturing toward a progeny radically dissimilar to its progenitors, the coming technological singularity, or simply the singularity—a term introduced by John von Neumann and later popularized by Vernor Vinge in the 1990s—describes the moment when quantitative change transforms into a qualitative leap, and AI overhauls, then overrules, human intelligence. Since silicon life forms do not necessitate potable water or a breathable atmosphere, some singularity theorists, like Marinetti, lionize capitalist subsumption to the fullest extent of its creative and destructive capacity: the loss of the earth's biosphere and of the carbon-based life it sustains, regrettable as it may be, is just collateral in the great technological acceleration that will ultimately bring about the higher evolutionary promise of AI.

Gazourmah also shares with current personifications of AI the fantasy that organic and mechanical entities are just relay points of a single evolutionary sequence, whose arc bends toward immortality. Whereas for vitalist thinkers the supra-organic élan vital was akin to a current that took precedence over the living, for those who see the

universe as composed essentially of information, artificial life forms such as computer codes are alive because they are endowed with the form of life: the informational code.[14] If brain functions can be decoupled from the brain, whatever material form intellect undertakes, it is secondary to its essentially logical nature. It is only a matter of time until "the Mind" sheds its human surrogate and embraces the higher evolutionary promise of AI. Either way, the essence of that which lives is not found in the living but elsewhere: in abstractions that promise to cheat death.

The appeal of vitalism, in the early twentieth century, as Donna V. Jones notes, was tied to the way it appeared to offer a loophole: if the élan vital transcends all of its particular incarnations, then death was not in fact life's negation but rather its transformation into a new and different form.[15] The same could be said of AI, whose appeal lies in the way it narrates the relation between animal, human, and artificial life as an evolutionary trajectory, in which each being is but a conduit for the Mind's wider quest for its optimal, ultimate vessel. One could also describe the singularity as a vulgarization of Hegelianism, often sliding into the excessive personification of a Bildungsroman. Transhuman aspirations, no longer explicitly mired in racism or misogyny, might seem gender neutral, or even postracial. But in spite of, or precisely because of, this, they nonetheless take part in the logic of racialization. From Gazourmah to the Basilisk, be it as titanium alloy or immaterial code, overcoming death means overcoming matter, which is in turn tantamount to leaving blackness and femalehood behind. This is also the reason why, by leaving unexamined what connotes the things they value, and by extension devalue, transhuman fantasies position the subject within a metaphysical matrix wholly saturated by colonial formations, whose legacies continue to haunt contemporary societies and their public spheres to the present day.

Notes

1. Ronald Reagan, "Remarks and a Question-and-Answer Session with the Students and Faculty at Moscow State University," Moscow, May 31, 1988, https://www.reaganlibrary.gov/research/speeches/053188b.

2. Jean-Joseph Goux, *Symbolic Economies: After Marx and Freud*, trans. Jennifer Curtiss Gage (Ithaca, NY: Cornell University Press, 1990), 213.

3. Goux, *Symbolic Economies*, 221.

4. Goux, *Symbolic Economies*, 230.

5. William Thomson, "On a Universal Tendency in Nature to the Dissipation of Mechanical Energy," *Proceedings of the Royal Society of Edinburgh*, April 19, 1852.

6. Donna V. Jones, *The Racial Discourses of Life Philosophy: Négritude, Vitalism, and Modernity* (New York: Columbia University Press, 2011), 120.

7. Jones, *The Racial Discourses of Life*, 121.

8. Filippo Tommaso Marinetti, *Mafarka the Futurist: An African Novel* (London: Middlesex University Press, 1998), 14, 3.

9. See Georg Wilhelm Friedrich Hegel, *Lectures on the Philosophy of History*, trans. John Sibree (Kitchener, CA: Batoche, 2001), 113.

10. Norbert Wiener would later describe entropy as "nature's tendency to degrade the organized and destroy the meaningful." See Norbert Wiener, *The Human Use of Human Beings: Cybernetics and Society*, rev. ed. (1954; repr., Cambridge, MA: Da Capo, 1988), 158.

11. Wiener, *The Human Use of Human Beings*, 103.

12. N. Katherine Hayles, *How We Became Posthuman: Virtual Bodies in Cybernetics, Literature and Informatics* (Chicago: University of Chicago Press, 1999), 193.

13. This speculation originally emerged on July 23, 2010, when a user named Roko posted it on the online forum *LessWrong*, a Bay Area–based blog.

14. Hayles, *How We Became Posthuman*, 11.

15. Donna V. Jones, "Inheritance and Finitude: Toward a Literary Phenomenology of Time," *ELH* 85, no. 2 (2018): 289–303.

37. World War II —— Star Wars —— War as Big Data

Tung-Hui Hu

PROTEST

The Office for Anticipating Surprises, a low-profile subdivision of the US intelligence service, digests geopolitical events using a system known as CAMEO. Each moment of conflict on a newswire can be encoded into one of eleven categories, and these codes can be used to forecast future conflicts. One computer system it funded, EMBERS, claims to have successfully predicted the 2013 "Brazilian Spring" of protests by combining these codes with open-source information: economic data, Twitter posts, disease outbreaks, even restaurant reservation cancellations.[1]

DISAPPROVE

Minority Report, however, this is not. For as complicated as these efforts may be, they are also at some level mystifyingly simple: one model within EMBERS just looks at how viral posts that contain variations on the word *strike* have become. Realizing this, the US intelligence community is now funding research to understand metaphors. As three exasperated experts on data mining for counterterrorism note: "linguistic expressions have levels of meaning beyond the literal, which it is critical to address."[2]

COERCE

While the US military tends to spotlight its most futuristic weapons to its public, such as autonomous tanks and robotic spaceplanes, its real efforts are concentrated on a new phase: war as big data.[3] Put simply,

war in the twenty-first century is less cinematic than computational and bureaucratic, a matter of filtering data and recognizing statistical patterns. While poorly paid undergraduates coded early implementations of CAMEO, the intelligence community now spends millions of dollars trying to teach computers to read the news, to decide if a denial-of-service attack is a COERCE (code 176, "attack cybernetically") or a PROTEST (code 144, "obstruct passage, block, not specified") or perhaps an EXHIBIT MILITARY POSTURE (code 155, "mobilize or increase cyber-forces"). To help nonhuman readers of this essay, I have coded each section of this essay in CAMEO format. Though the coding schema doesn't always fit the content, the increased reading efficiency should make up for it.

THREATEN

We have come a long way from the apocalyptic spectacle of the Strategic Defense Initiative (SDI), which the popular press nicknamed Star Wars. Instead of orbital laser satellites, war is rooted in the set of ordinary (if often pleasurable) chores that users do to individuate themselves—tagging photos; choosing what's relevant to their interests; dismissing what's irrelevant. This work makes data useful, not just for targeted marketing but for predicting patterns in human behavior or, more generally, for connecting the dots in counterterrorism. Yet consumers are not innocent victims of techno-science; rather, they are participants. Whether by flagging spam or by authenticating oneself at every turn, it is a constant feeling of vulnerability—of the breaching of an individual user's boundaries—that convinces a user to partake in a shared project of security. If free content or free access is the carrot, the stick is the nameless but continual threat of unfreedom: foreign hackers, spammers, and terrorists.

REDUCE RELATIONS

The atomic age inaugurated a period of mutual and permanent vulnerability that underpinned not just the geopolitical system but the sustaining of life itself. That precarity came out of the strategy of mutually assured destruction and informed the Committee on Present Danger's term "window of vulnerability" to refer to the (theoretical) risk of a Soviet strike whenever they held the technological

upper hand. And that sense of unending vulnerability is also what President Reagan's Strategic Defense Initiative, which envisioned shooting down incoming nuclear missiles from space, tried so desperately to end: to offer a scenario where the United States (and perhaps the Soviet Union, too) not only no longer lived under a nuclear threat but also no longer needed to be dependent on other nations to chart its own fate.[4] It was a way of projecting the American vision of self-reliance outward. This vision held the body of each citizen to be a sovereign individual and, arguably, imprinted itself on the model of the user today.

REJECT

The irony is that users are not individuals at all, but simply porous agglomerations of data. What feels personalized to a single person is derived from the data of one's neighbors; as a result, the individual in an age of digital media is simultaneously "the most lonely and most crowded place on earth."[5] This is what explains the strange pathos of today. We are constantly made vulnerable so that we can then shore up our sense of individuality, and yet we refer to that feeling of vulnerability as privacy.[6]

ENGAGE IN UNCONVENTIONAL MASS VIOLENCE

As the film scholar Linda Williams has argued, the exemplary form of American self-understanding is melodrama.[7] Its logic lies both in the presumed innocence at its core and also in its alternation between pathos and action. Thus melodrama results from the interplay between the victim's "too late" and the rescuing hero's "in the nick of time." In this way, the big-budget melodrama *Star Wars* was a particularly apt moniker for Reagan's SDI, which Senator Ted Kennedy lambasted as a series of "reckless Star Wars schemes," implausible and fantastic as the movie itself. Descriptions of SDI portrayed missiles arriving too late for Americans to do anything but say their final farewells, and it was also the missile defense shield that would arrive just in time to forestall this fate. For SDI's vision to succeed, Americans needed to imagine not just what it was like to win Star Wars, but also how it felt to lose. It made the coming apocalypse a

scenario that was not just imaginable or reversible, but also something you could repeat, rewind, and play again. Too late, too late, then, finally, "in the nick of time." As the popularity of lists such as "40 Sad Movies to Make You Ugly-Cry" amply demonstrate, there is a distinct pleasure in feeling loss, feeling vulnerable, or feeling a future slip out of reach.

ASSAULT

At least four video games followed in the wake of SDI, two of which were named, simply, *SDI*. The one I'm drawn to is the version reviewers describe as "arguably one of the worst Cinemaware games ever," the one with the tagline "The Screen Burns with Forbidden Passion and Global War!"[8] It imagines an American space ace who must defend the United States against nuclear attack and then board the space station *V. I. Lenin* to rescue his Soviet counterpart held by rogue KGB agents, a pneumatic love interest named Natalya. The look is *Dr. No* meets pixel art; a spaceship screen transmits a threatening communiqué from the archvillain, who scowls and threatens America with the "iron hand of Victor Aliyev." If the hero rescues Natalya in the nick of time, the game plays a cutscene of the two embracing a thousand miles above the earth he has saved. If you lose, it's the same shot above the earth—but too late: she's not there.

FIGHT

Rather than focusing on preventing or forestalling nuclear annihilation, games such as *SDI* were the distant offspring of a Cold War mentality that encouraged private parties to begin "thinking about the unthinkable," to quote the title of the book by RAND Corporation futurist Herman Kahn.[9] (Also in the same category: board games such as *Nuclear War* [1965] or *Ultimatum* [1979].) Indeed, the future began to seem so radically de-linked from the past, even from probability, that Kahn began to borrow screenwriting techniques from Hollywood.[10] Scenario thinking directed that each person become a player so that they could "*feel* the future in addition to comprehending it cognitively."[11] These scenarios brought melodrama, even script-writing classes, into the heart of the Pentagon and the corporate boardroom.

EXHIBIT MILITARY POSTURE

But if melodrama was the dominant genre of the Cold War, perhaps the genre that best describes war as big data is the process genre, exemplified by YouTube clips that take tasks—cooking, filing forms, furniture assembly—and break them down into a series of easy-to-follow steps.[12] This is because even as things get more automated, human decision-making returns in other forms. As I wrote this, I signed onto an online tournament run by one of EMBERS's potential successors, a hybrid human-computer forecasting system named SAGE. SAGE offered me a range of questions, such as whether North Korea would engage in a provocative military activity by June 1, 2020; what the price of Brent crude oil on April 15, 2020, would be; even when ruby chocolate—a pink-colored chocolate—would go on sale in the United States. For each question, it gave me access to relevant articles from LexisNexis and a time series plot it generated on the topic; it bore a striking resemblance to homework from an online course. If my predictions were the most accurate of the group, I would receive a digital badge and a higher rank on the leaderboard, and, in rare cases, an Amazon gift card. That's the game now: guess a nuclear test correctly, get $25 to spend on pink chocolates.

DEMAND

After 9/11, America's leadership placed their faith in the idea that early warning systems can act in the nick of time—EMBERS claimed to be ahead of events by three to seven days—to anticipate and thus save us from the next terrorist attack. This belief is perhaps the fundamental myth of big data, even if they have not yet succeeded in predicting a single terrorist event in the last decade. Among the vanishingly few persons that have gone on trial due to an event predicted by big data is a group of Italian data scientists who failed to anticipate an earthquake.[13] But there is still time.

Notes

1. Sathappan Muthiah et al. "EMBERS at 4 Years: Experiences Operating an Open Source Indicators Forecasting System," in *KDD '16: Proceedings of the 22nd ACM SIGKDD International Conference on Knowledge Discovery and Data Mining* (New York: Association for Computing Machinery, August 2016), 205–14.

2. Mathieu Guidere, Newton Howard, and Shlomo Argamon, "Rich Language Analysis for Counterterrorism," in *Computational Methods for Counterterrorism*, ed. Shlomo Argamon and Newton Howard (Berlin: Springer Verlag, 2009), 118, as quoted by Alexis Madrigal, "Why Are Spy Researchers Building a 'Metaphor Program'?," *Atlantic*, May 25, 2011.

3. See Tung-Hui Hu, *A Prehistory of the Cloud* (Cambridge, MA: MIT Press, 2015), chapter 4.

4. Edward Linenthal, *Symbolic Defense: The Cultural Significance of the Strategic Defense Initiative* (Urbana: University of Illinois Press, 1989).

5. Kris Cohen, *Never Alone, Except for Now: Art, Networks, Populations* (Durham, NC: Duke University Press, 2017), 23.

6. As Chun and Friedland write, "*New media . . . are leak*. New media work by breaching, and thus paradoxically sustaining, the boundary between private and public." Wendy Chun and Sarah Friedland, "Habits of Leaking: Of Sluts and Network Cards," *differences* 26, no. 2 (2015): 4.

7. Linda Williams, "Melodrama Revisited," in *Refiguring American Film Genres: History and Theory*, ed. Nick Browne (Berkeley: University of California Press, 1998), 42–88.

8. Underdogs, "S.D.I. (a.k.a. Strategic Defense Initiative)," review, Home of the Underdogs, accessed May 27, 2024, http://www.homeoftheunderdogs.net/game.php?name=S.D.I.

9. Herman Kahn, *Thinking about the Unthinkable* (New York: Horizon Press, 1962).

10. Annie McClanahan, "Future's Shock: Plausibility, Preemption, and the Fiction of 9/11," *symploke* 17, no. 1–2 (2009): 41–62.

11. Paul Schoemaker, "Multiple Scenario Development: Its Conceptual and Behavioral Foundation," *Strategic Management Journal* 14, no. 3 (March 1993): 201, as quoted in McClanahan, "Future's Shock," 44.

12. Salomé Skvirsky, *The Process Genre: Cinema and the Aesthetic of Labor* (Durham, NC: Duke University Press, 2020).

13. Louise Amoore, "Security and the Incalculable," *Security Dialogue* 45, no. 5 (2014): 423–39.

38. White Capitalist Patriarchy —— Informatics of Domination

Thao Phan

The world is fucked. A mess of toxic exposures. From land and bodies unevenly marked by the legacies of industrial-scale petrochemical production and the forms of "chemically altered living-being" that it creates, to viral variants whose fast mutations outpace the distribution of tests, vaccines, and political will to protect people over profits, to the resurgence of actual neo-Nazis whose repugnant agendas spill into information ecosystems and onto the steps of parliament.[1]

For Black feminist writer bell hooks, the phrase "white imperialist capitalist patriarchy" gives a precise name to the source of all this fuckedness. Originally coined at the height of the US civil rights movement, the phrase helped to describe the intersecting dynamics that together compound to create a complex system of oppression that robs people of dignity, income, safety, or any sense of change in one's life chances. For hooks, these dynamics are worthy of naming because movements that had so far mobilized themselves for freedom and emancipation from these oppressive systems had failed to grasp the phenomena in full. In failing to name, they failed to account for the pernicious forms of racism, classism, sexism, and other forms of daily subjugation that define the experience of those she called "the silent majority"—a descriptor that has since been fucked by populist leaders but at the time she meant as "the women who are most victimised by sexist oppression."[2] In fighting against the fuckedness of the world, these movements were themselves guilty of committing the same harms, reproducing the same logics of domination they so reviled. She writes, "Black activists defined freedom as gaining the right to participate as full citizens in American culture; they were not rejecting the value system of that culture. Consequently, they did not question the rightness of patriarchy."[3]

This was also true of dominant strands of feminism who, in her words, were "paying lip service to revolutionary goals" while being "primarily concerned with gaining entrance into the capitalist patriarchal power structure."[4] She argued that many in the feminist movement had mistaken self-interest for collective struggle, using the radical rhetoric of resistance and revolution to advance an essentially conservative and liberal agenda aimed at protecting their own class interests. For hooks, any movement that actively sought inclusion rather than liberation from the white imperialist capitalist patriarchal system was "essentially corrupt."[5] In other words, its aims and ambitions were absolutely fucked.

So what can be done if everything is fucked? If movements intended to protect and tools designed to unfuck this world are also undeniably fucked? How do we establish an ethical movement if the high bar of freedom from corruption and complicity is the starting point? What if corrupt tools are all that we have? To stay oriented toward justice in this context might just mean coming to terms with being fucked, feeling fucked, and trying one's best not to fuck over others even if the structure within which one operates compels and rewards us to do so. To riff on Haraway, it demands a "staying with the fuckedness." Of not surrendering to "abstract futurism and its affects of sublime despair and its politics of sublime indifference" but rather, to learn how to live better in a world that is unjust and corrupt.[6] To start, not with an insistence on innocence and purity but with the harsh realities of complicity and compromise.

Take, for instance, the informatics of domination. In Haraway's original chart, it sits adjacent to white capitalist patriarchy. The movement from one to the other, from white capitalist patriarchy on the left to informatics of domination on the right, does not signal a departure or end of one regime and beginning of the next, but is rather a prompt to discuss "white capitalist imperialist patriarchy in its contemporary late versions."[7] In this case, it's how white capitalist patriarchy is inextricably tied to the politics of informatics—how autonomous systems hide the global networks of exploitative human labor they are reliant upon, how the clean and weightless image of cloud infrastructure is materially dependent on the capitalist-colonialist fantasy of infinite mineral extraction, and how smart tools designed to counter historic wrongs like discrimination and bias have instead entrenched regimes of opaque, color-blind racism.[8] The informatics of domination thus signals

the emergence of a new set of circumstances through which to contend with the old challenges of white capitalist patriarchy.

But one of the ironies of this rhetorical move is that it begins to undo the vital work of naming that hooks had so assiduously insisted upon. It unnames the dynamics of oppression. It displaces the question of power and responsibility. While domination continues as a key feature, it is no longer flagged as explicitly white, capitalist, or patriarchal. Without these anchors, the informatics of domination is open to interpretation and is suddenly amenable to the very logics it was intended to critique.

Consider AI ethics. Once an area centered on hypothetical inquiries into the very broad and abstract moral conundrums posed by machines that in many cases did not yet exist, it has now become a bona fide professional field of practice. Selling ethical clout and expertise to institutions and Big Tech corporations alike, these ethics experts or ethics owners capitalize on the promise to limit the harms caused by AI systems and technologies by operationalizing and integrating principles like fairness, accountability, and transparency.[9] In short, they promise to make AI less fucked by reprogramming and redeploying the structures and logics of informatics.

One example is Perspective API, an AI-powered tool designed to detect toxic comments online. Perspective API is an investment between two of Alphabet's subsidiary companies: Jigsaw, an online safety tech incubator, and Google's Counter Abuse Technology team. "Toxicity online poses a serious challenge for platforms and publishers," they write. "Online abuse and harassment silences important voices in conversation, forcing already marginalized people offline."[10] To counter this, the Perspective API tool uses a machine learning model to identify abusive comments and give them a toxicity rating represented as a value between 0 and 1. The score can then be returned to commenters as feedback, assist moderators in their review processes, or filter out toxic content for readers. Toxicity here is defined as "a rude, disrespectful or unreasonable comment that is likely to make someone leave a discussion."[11] As a means to explain how their system works, the Perspective API website features an animation of a speech bubble with the comment "Shut up. You're an idiot!" A user selects the attributes they wish to measure—such as sexual explicitness, profanity, degree of threat—and the bubble is then placed inside a box. The colors on the side of the box blink to process the comment, spitting out a rating that identifies

it as 0.99 Toxic, 0.04 Sexually Explicit, 0.93 Profanity, 0.99 Insult, and 0.15 Threat.

What does it mean to describe something as 0.99 Toxic? In this case, it means that a group of online crowd workers were paid to label a dataset as containing specific attributes, including their belief that a comment or phrase is toxic.[12] Once labeled, the dataset was used to train a set of models—a BERT-based natural language processing model and convolutional neural network.[13] These models were then used to produce a probability score that reflects the patterns and trends of these human crowd workers and their likelihood of labeling a comment in a particular way. So, a score of 0.99 means that, based on the training data, ninety-nine out of one hundred human crowd workers are likely to tag a comment with the specific label *toxic*.[14]

There are obvious limitations to these kinds of ethical AI projects. Perhaps the most basic is that the model contained explicit biases against phrases used to describe marginalized groups. Terms like *black, gay, Muslim, woman, feminist*, and *deaf* consistently received high toxicity ratings, something that Jigsaw attributed to a combination of "biases in the human annotators creating the training data" and "over-representation in abusive and toxic comments" targeted at these groups.[15] By training on a particular corpus of racist, sexist, homophobic, nationalistic, and ableist data, the model effectively created a proxy relation between toxicity and identity. As one user discovered, the more identity terms used, the higher the toxicity rating. For instance, the phrase "I am a man" received a 20 percent toxicity rating, whereas the phrase "I am a black woman" received an 85 percent toxicity rating.[16]

These kinds of tools allow white imperialist capitalist patriarchy to thrive. They make subtle substitutions: toxicity for racism, solutions engineering for justice, those who experience a problem with the problem itself. Each substitution forms part of a chain that abstracts the effects of domination and oppression away from its causes. Unlike racism, sexism, or homophobia, which are experiences unique to marginalized groups, anyone can be a victim of toxic speech. Toxicity is the word that's used when one *does not want to name* white capitalist patriarchy: an informatics of domination practiced as an informatics of generic substitutions.

Indeed, terms like toxicity are arguably useful because they are vague and apolitical, and frame actions like harassment and abuse as discrete, external phenomena that, like material waste, can be cleaned

and removed to restore an existing structure to its pristine state. Fixing toxicity is here framed as a return to purity. But like so many eugenic principles, purity is an ideal enforced through elimination and violence.

Purity's intolerance for anything labeled toxic manifests in the crude creation and policing of borders. A pure public discourse—one free of toxic language—necessarily imposes a set of values that denigrates any use of language that sits outside as something less than, a respectability politics that finds its analogue in the colonial practices of British imperialism. To use a trivial example, in Australian English the word *fuck* is considered a part of daily vernacular, the legacy of problematic nation-building efforts that heroicize white, male, working-class figures like the soldier, convict, and bushranger.[17] In defining itself against British Imperial English, uncouth words like *fuck* are now common features in Australian parlance. It is used as an expression of jubilance ("fuck yeah!"), an admission of exhaustion or defeat ("I'm fucked"), a void of nothingness ("fuck all"), or even a resolute determination to get the job done ("I didn't come here to fuck spiders"). The Perspective API online demo gave the opening line of this essay, "The world is fucked," an 84.6 percent rating of likely to be toxic—a rating that would flag it as unfit for public discourse. An informatics of domination expressed as an informatics of colonial, middle-class manners.

But what if, instead of purity, we accept that "toxicity might just be our condition"?[18] Arguing "against purity," Alexis Shotwell writes, "The slate has never been clean, and we can't wipe off the surface to start fresh—there's no 'fresh start.' ... All there is, while things perpetually fall apart, is the possibility of activating from where we are. Being against purity means there is no primordial state we might wish to get back to."[19] To be against purity is to reject the individualization of responsibility that a personal score for toxicity implies. It means not hiding behind vague and apolitical terms because one is uncomfortable or afraid to acknowledge the bad feeling of complicity that comes with naming racism for what it is. It means remembering that this is not an informatics of any-kind-of-domination, but an informatics of white imperialist capitalist patriarchy.

So what can be done in lieu of unfucking this world? To return to Shotwell, instead of pursuing purity, one might instead ask, "who benefits from the lie of purism"?[20] In this case, the promise to purify newsfeeds, comments sections, and even large language models allows corporations like Google to continue to profit from an economic model

based on territorial expansion, manufacturing user engagement, and an ideology of AI solutionism.[21] Here, AI is fetishized as the new, civilizing commodity; the agent of history that does the purification work to bring the toxic swamp of humanity into the glistening frontier of the future.[22] In this context, refusing the lie of purism means to refuse the lies of these corporate empires and their crooked claims to innocence. It means acknowledging complicity, naming oppressive dynamics for what they are, and accepting that while we may not be able to unfuck this world, we can at least approach problems like toxicity as more than just individual words, or bodies, but as a collective condition that requires an honest reckoning with histories and practices that might make us angry or uncomfortable, but in doing so, move us to demand for something more.

Notes

1. Michelle Murphy, "Alterlife and Decolonial Chemical Relations," *Cultural Anthropology* 32, no. 4 (November 18, 2017): 497; Julia Kollewe, "Pfizer Accused of Pandemic Profiteering as Profits Double," *Guardian*, February 8, 2022, sec. Business, https://www.theguardian.com/business/2022/feb/08/pfizer-covid-vaccine-pill-profits-sales; Lachlan Abbott and Ashleigh McMillan, "Two Arrested as Neo-Nazi Group Clashes with Police at Victorian Parliament," *Age*, May 13, 2023, https://www.theage.com.au/national/victoria/two-arrested-as-neo-nazi-group-clashes-with-police-at-victorian-parliament-20230513-p5d84b.html.

2. bell hooks, *Ain't I a Woman: Black Women and Feminism*, 2nd ed. (New York: Routledge, 1981), 1.

3. hooks, *Ain't I a Woman*, 5.

4. hooks, *Ain't I a Woman*, 188.

5. hooks, *Ain't I a Woman*, 191.

6. Donna J. Haraway, *Staying with the Trouble: Making Kin in the Chthulucene* (Durham, NC: Duke University Press, 2016), 4.

7. Nicholas Gane, "When We Have Never Been Human, What Is to Be Done? Interview with Donna Haraway," *Theory, Culture and Society* 23, no. 7–8 (December 1, 2006): 150, https://doi.org/10.1177/0263276406069228.

8. For more detailed analysis, see Lilly Irani, "The Cultural Work of Microwork," *New Media and Society* 17, no. 5 (May 2015): 720–39, https://doi.org/10.1177/1461444813511926; Thao Phan and Scott Wark, "What Personalisation Can Do for You! Or: How to Do Racial Discrimination without 'Race'—Thao Phan and Scott Wark," *Culture Machine* 20 (September 5, 2021): 1–29; and Sy Taffel, "Data and Oil: Metaphor, Materiality and Metabolic Rifts," *New Media and Society* 25, no. 5 (2023), https://doi.org/10.1177/14614448211017887.

9. Thao Phan et al., eds., *Economies of Virtue: The Circulation of "Ethics" in AI*, Theory on Demand (Amsterdam: Institute of Network Cultures, 2022).

10. "Perspective API," accessed June 5, 2023, https://www.perspectiveapi.com/.

11. "Perspective API—How It Works," accessed June 5, 2023, https://www.perspectiveapi.com/how-it-works/.

12. Perspective API identified the platform Appen as their provider. Appen is an Australian-based company that trades on an image of providing trusted and specialized crowd-based labor that pays above the market rate, but since mid-2023 the company has been plagued by market crashes and accusations by workers of unfair dismissals for attempts to unionize against worsening conditions of labor (see Gerrit De Vynck, "They Helped Train Google's AI. Then They Got Fired after Speaking Out," *Washington Post*, June 15, 2023).

13. Bidirectional Encoder Representations from Transformers (BERT) is a machine learning framework for natural language processing. It is designed to help computers predict ambiguous words by reading surrounding text for context. It was trained using a corpus of data from Wikipedia refined using human tuning.

14. Perspective API, "Model Cards," accessed June 5, 2023, https://developers.perspectiveapi.com/s/about-the-api-model-cards?language=en_US.

15. Lucy Vasserman et al., "Unintended Bias and Identity Terms," *Jigsaw* (blog), October 12, 2021, https://medium.com/jigsaw/unintended-bias-and-names-of-frequently-targeted-groups-8e0b81f80a23.

16. Jessamyn West (@jessamyn), "Trying It with Some Visible/Invisible Disabilities. The Man/Woman Division Is Concerning. Https://T.Co/6zVb8v8b4O," Twitter, August 26, 2017, https://twitter.com/jessamyn/status/901476036956782593.

17. See Amanda Laugesen, *Rooted: An Australian History of Bad Language* (Sydney: New South Books, 2020).

18. Alexis Shotwell, *Against Purity: Living Ethically in Compromised Times* (Minneapolis: University of Minnesota Press, 2016), 12.

19. Shotwell, *Against Purity*, 4.

20. Shotwell, *Against Purity*, 19. See also Donna J. Haraway's afterword, "Pandemics of Transformation for Livable Worlds," in this collection for a reflection on "big lies."

21. Soon after the release of ChatGPT-4 in 2023, Jigsaw began promoting Perspective API as a tool to reduce the toxicity of large language models by detoxifying training data, evaluating models, and conducting live assessments of text outputs. See Lucy Vasserman, "Reducing Toxicity in Large Language Models with Perspective API," *Jigsaw* (blog), April 21, 2023, https://medium.com/jigsaw/reducing-toxicity-in-large-language-models-with-perspective-api-c31c39b7a4d7.

22. See Anne McClintock's classic discussion of soap as an imperial technology of purification. Anne McClintock, *Imperial Leather: Race, Gender, and Sexuality in the Colonial Contest* (New York: Routledge, 1995).

Afterword:
Pandemics of Transformation for Livable Worlds

Donna J. Haraway

Fake news, alt facts, alternate realities, crypto everything, big lies. In this world, propaganda seems so old fashioned, a thing of printing presses, radios, network news, organized states, coherent movements, and, of course, Nazi media innovations. Old-fashioned propaganda at least seemed to require a shareable universe, however perverse or however desirable. I have always wanted to be able to write effective propaganda that contributes to the energy and intelligence of movements for justice, care, and flourishing. This kind of propaganda implies a struggle for worlds; but it does not allow systematic lying or, worse, relentless world-spinning that is indifferent to world-building with and for radically different others across kinds, who must live and die together or not at all.

These are times of great upheavals for all Terrans of whatever species and kinds, times of mass displacements of refugees across kinds, who have little refuge. One of our most urgent tasks is to find and sustain refuges in the hurricanes of transformation everywhere in ways that build courage and hope for still possible, shareable, abundant, and compassionate worlds. Part of this work involves characterizing and confronting the informatics of domination of this century, these decades, this year, when the technologies of no-world are ubiquitous, powerful, and frighteningly creative. My two-column chart from 1985 bleeds into many columns. It always did; but now the columns proliferate, mutate, and twist at dizzying speed. Perhaps the term I am looking for to characterize these times is Pandemics of Informatics. From White Capitalist Patriarchy, to Informatics of Domination, to Pandemics of Informatics. It's all in the variants.

In the early 1980s I wrote my "Cyborg Manifesto" with its clumsy two-column chart as an "attempt at an epistemological and political position." I tried "to sketch a picture of possible unity, a picture indebted to socialist and feminist principles of design."[1] Still as old-fashioned as an old woman as I was as a young one, I hold to that project more than ever. The principles of design must be robustly antiracist, abolitionist, decolonial, innovative in bodies and kin, accountable to Indigenous peoples and lands, and much more besides. *Feminist* and *socialist* cannot be unmarked universal categories. Still, my search remains for a fraught but shareable imagination and construction of evidence-rich knowledge and politics for worlds that deserve a future but are barely possible in the present. In the jaws of so much old and new killing of ongoingness, or what Deborah Bird Rose called "double death," I want to be part of increasing the odds of possibility for worlds that deserve a future.[2] I want to live and work in the proliferating fields of Pandemics of Transformation for Livable Worlds. That means, among many other things, living and dying well with each other in a thick present without the solace of assured fixes, techno or otherwise.

Learning from my old slogan given to me by my former grad student Elizabeth Bird, Cyborgs for Earthly Survival, I want to be a propagandist for Holobiomes for Earthly Survival. Call that staying with the trouble; call that, in the teeth of all the big lies, staying with each other, making kin.

Notes

1. Donna J. Haraway, "A Manifesto for Cyborgs: Science, Technology, and Socialist-Feminism in the 1980s," *Socialist Review*, no. 80 (1985): 79.

2. Deborah Bird Rose, "What If the Angel of History Were a Dog?," *Cultural Studies Review* 12, no. 1 (2006): 67–78.

Epilogue: Interpreting Information

Patricia Reed

The diagrams below take up the unspecified problem of information in the original Informatics of Domination chart. Information, as such, signifies differently in mathematics, biology, or hermeneutics, as well as computation. The first diagram spread (E.1) portrays a discursive fork that arises upon interpreting the meaning of information, despite sharing an identical mathematical, formal root. One interpretive possibility is where information skews toward novelty, rather than predictability; another is where its binary opposition to noise is unsettled. This creates a logical move that expands an understanding of computation beyond a strictly digital form. In the second diagram spread (E.2) I schematize information as dependent upon a cut in the Real, that is, as dependent on the filter of an organismic model. Here, information is elaborated biosemiotically and sociohistorically, illustrating a correlation between organismic sensitivity and environmental sensory overabundance (in the case of humans, normative conditioning in the evaluation of information). The third diagram (E.3) considers blurred distinctions between data signs and natural signs in a planetary epoch, wherein the human is reembedded as a figure sutured to a ground. The final intervention rehearses Haraway's chart as a commentary on the representational capacities of a chart unto itself compared to the affordances of a diagram, wherein each form offers a distinct strategy of informational compression in visual form.

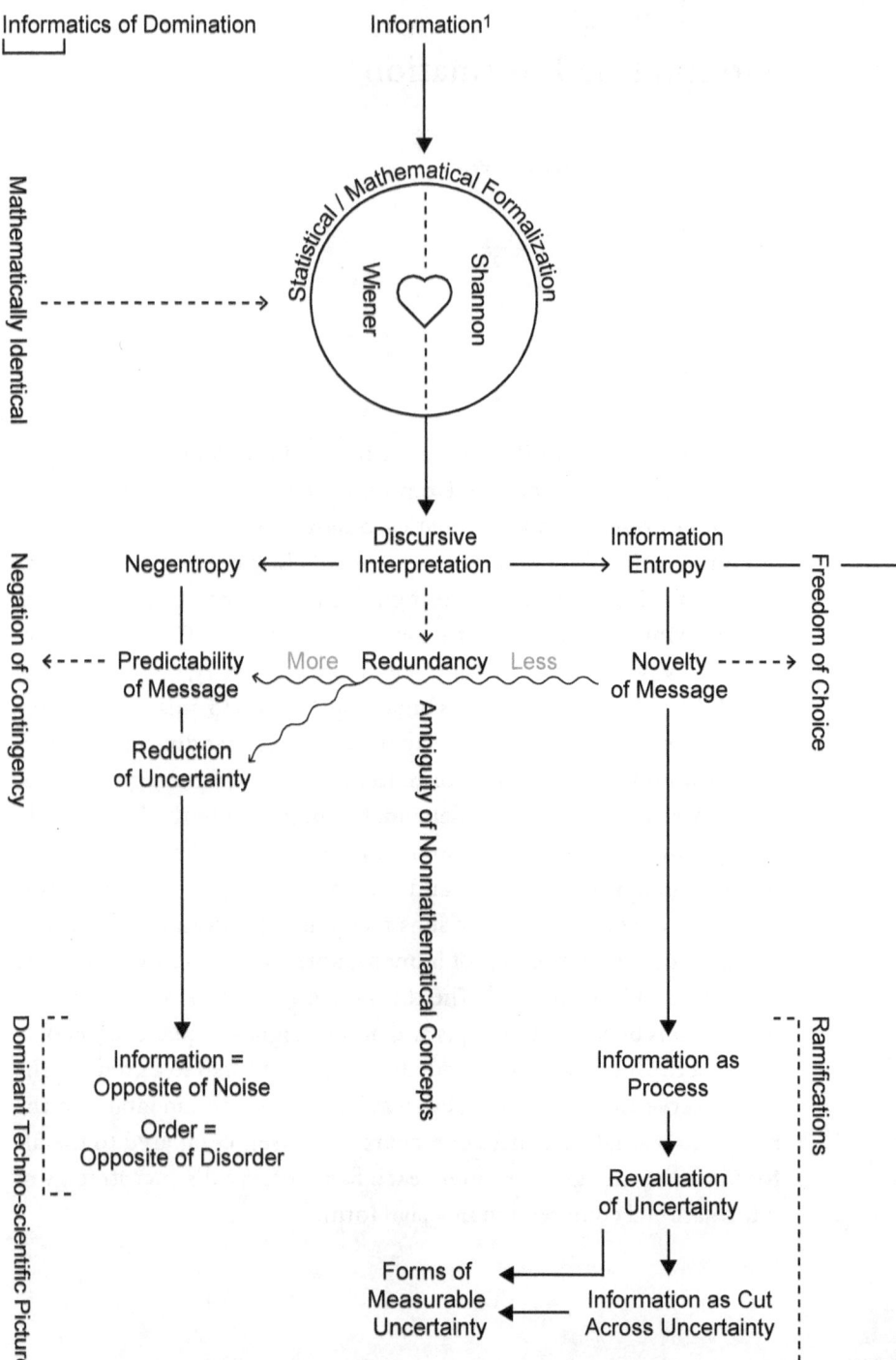

E.1

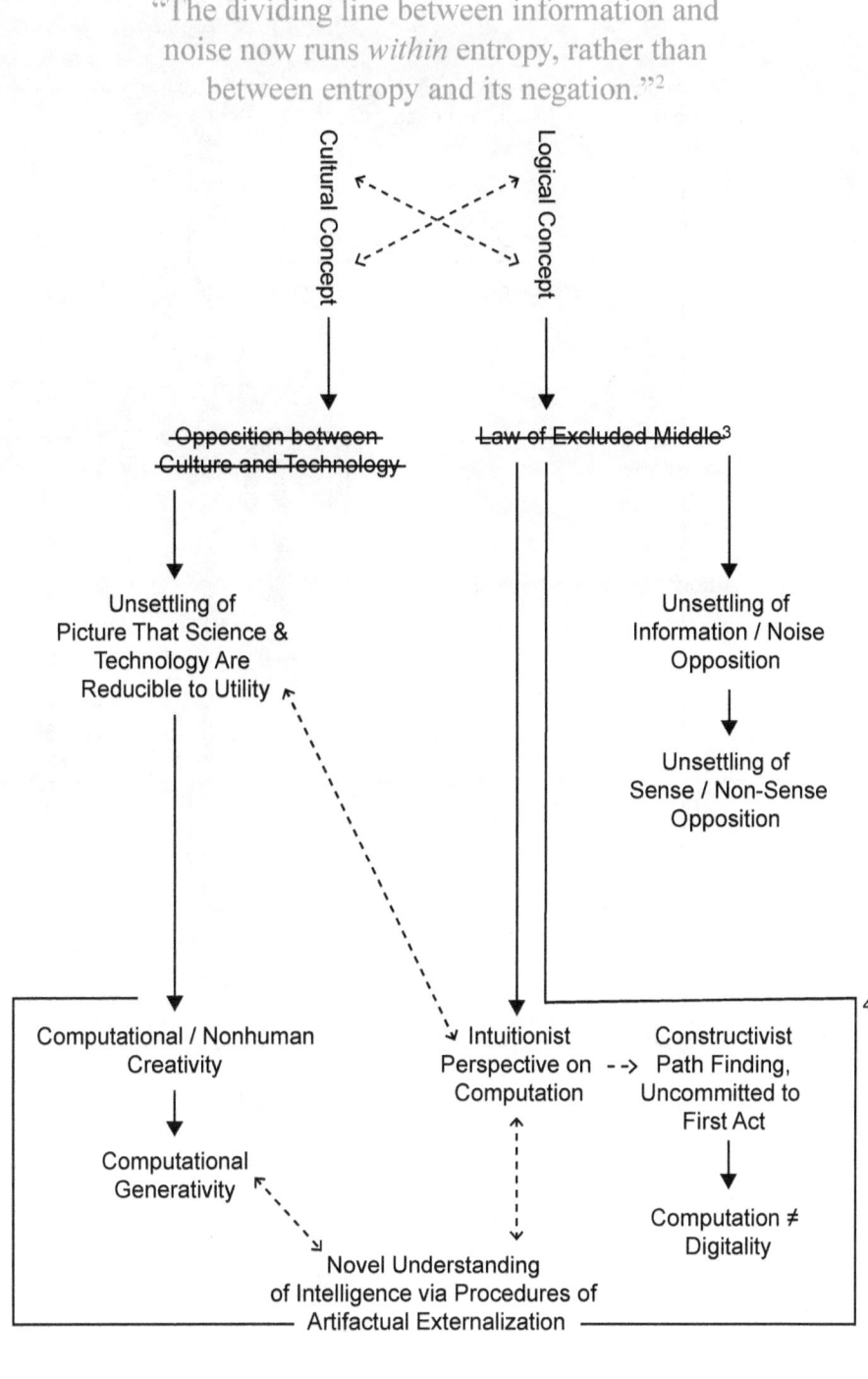

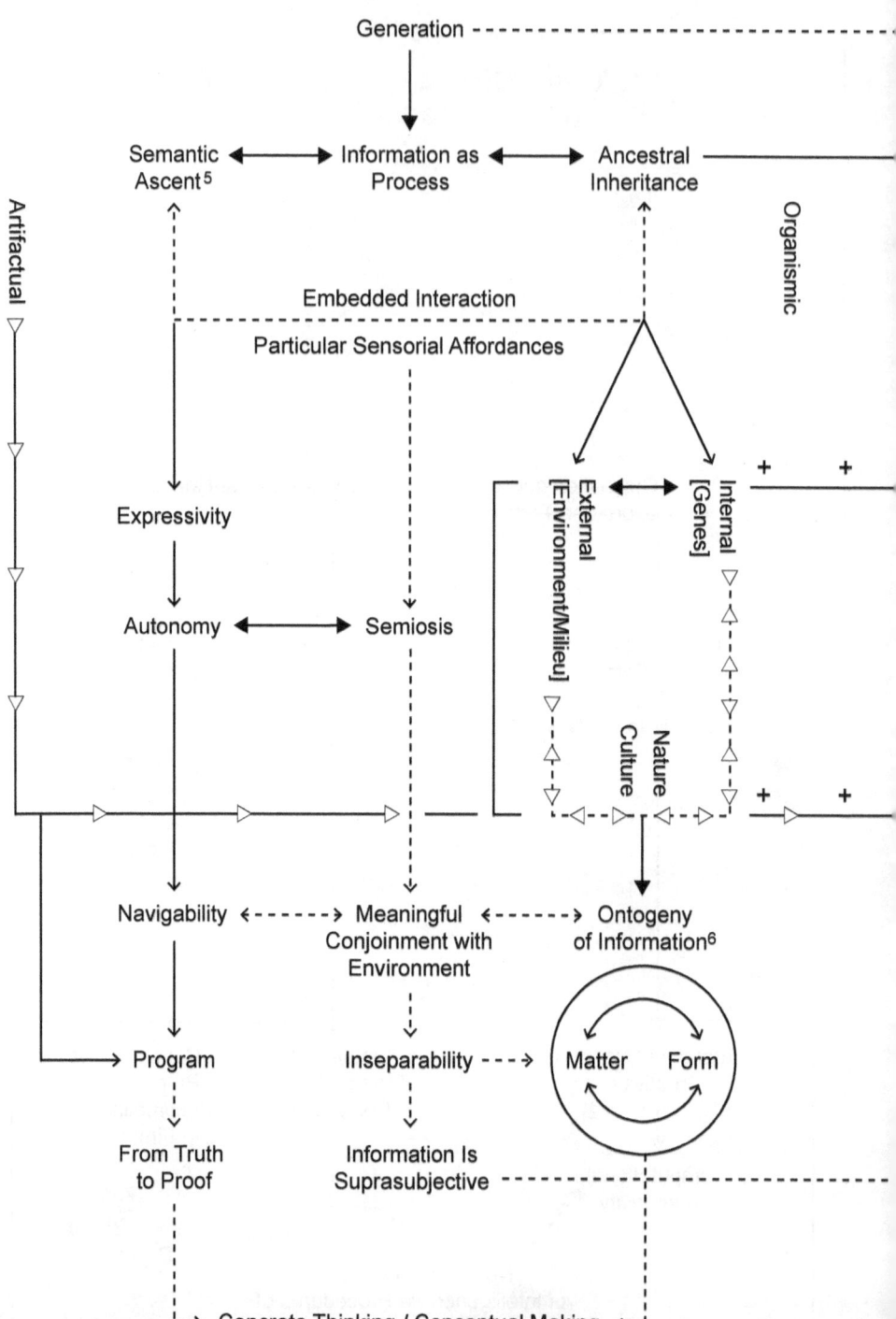

E.2

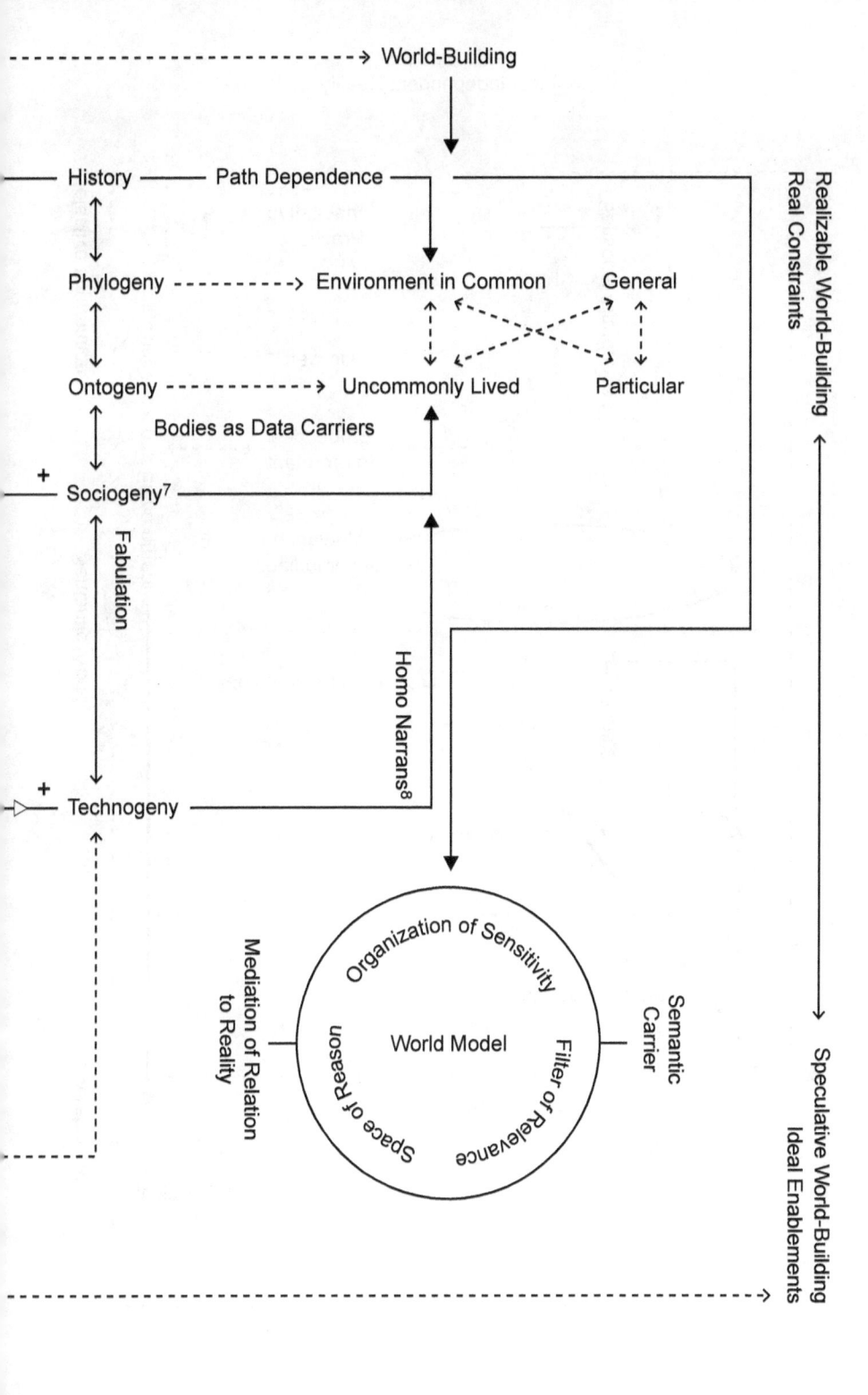

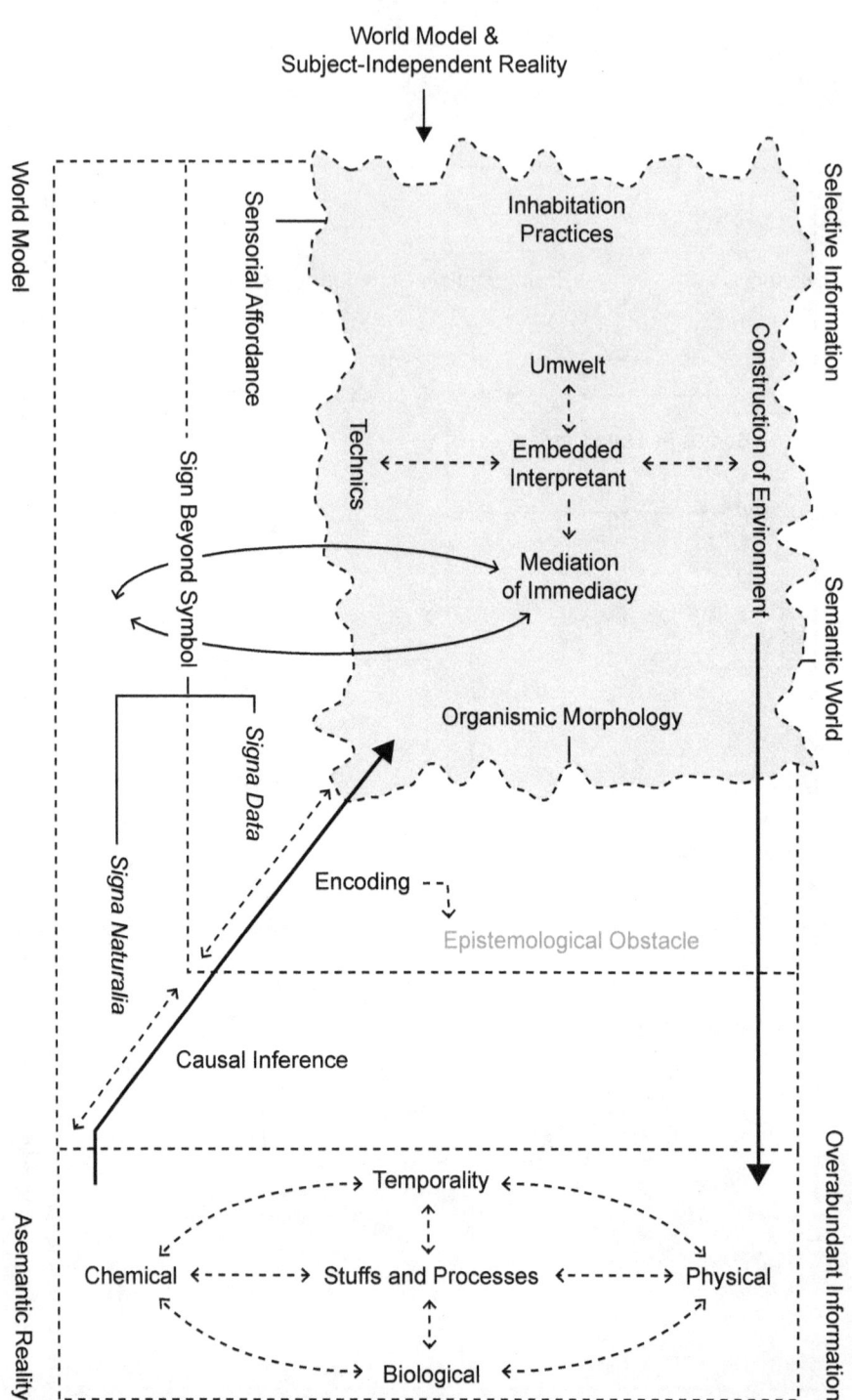

E.3

Informatics of Dissemination

Charts	Diagrams
Linear	Nonlinear
Naming	Relationality
Identification of Things / Tendencies	Icons + Language + Symbols
Progression of Ideas	Demonstration of Systems
Descriptive	Constructive
Comparative / Contrastive	Associative / Feedback
Mechanical	Irreversible
Terms	Concepts
Declaration	Reasoning
Actuality	Speculation
Elaboration	Compression
Alphabet	Design
Discourse	Cognitive Prosthetic
Inductive Logic	Abductive Hypothesis
Categorical	Category Theoretical
Component Parts	Genericity
Linguistic	Spatial

Notes to Diagrams

1. Diagram based on outline of "Information Entropy" from Cécile Malaspina, *An Epistemology of Noise* (London: Bloomsbury, 2018).

2. Malaspina, *An Epistemology of Noise*, 19.

3. Classical logical scheme according to which a proposition is true, or its negation is true, fully in accordance with binary habits of thought.

4. An intuitionist view of computation was proposed by AA Cavia in *Logiciel: Six Seminars on Computational Reason* (Berlin: &&&, 2022), undoing a strictly binary view of computation as digitality, expressible only via Boolean logic, 0/1, true/false, as in algorithmic recipe following.

5. Cavia, *Logiciel*.

6. "A proper view of ontogeny . . . requires that the idea of ontogenesis apply not only to bodies and minds, but to information, plans, and all the other cognitive-causal entities." Susan Oyama, *The Ontogeny of Information: Developmental Systems and Evolution* (Durham, NC: Duke University Press, 2000), 3.

7. Coined by Frantz Fanon in *Black Skin, White Masks* (1952), and widely taken up by Sylvia Wynter, sociogeny accounts for the existential consequences of social interpellation that are not ontologically nor phylologically given (i.e., the real existence of racism falls outside biological accounts of the human). See Frantz Fanon, *Black Skin, White Masks* (New York: Grove Press, 1967).

8. Sylvia Wynter deploys this term to account for the hybridity of humanness (Bio and Mythos) that enables autoinstituting capacities for constructing social organization.

Bibliography

Abbing, Hans. *Why Are Artists Poor? The Exceptional Economy of the Arts*. Amsterdam: Amsterdam University Press, 2008.

Abbott, Lachlan, and Ashleigh McMillan. "Two Arrested as Neo-Nazi Group Clashes with Police at Victorian Parliament." *Age*, May 13, 2023. https://www.theage.com.au/national/victoria/two-arrested-as-neo-nazi-group-clashes-with-police-at-victorian-parliament-20230513-p5d84b.html.

Ahmed, Sara. *Queer Phenomenology: Orientations, Objects, Others*. Durham, NC: Duke University Press, 2006.

Akomolafe, Bayo. "Black Lives Matter, but to Whom? Why We Need a Politics of Exile in a Time of Troubling Stuckness (Part I)." Democracy and Belonging Forum. Othering and Belonging Institute at UC Berkeley, January 19, 2023. https://www.democracyandbelongingforum.org/forum-blog/black-lives-matter-but-to-whom-part-1.

Alexander, Paul. "Walk for Me—Paul Alexander Feat. Performance Kim Aviance." YouTube, uploaded by Kim Aviance, April 9, 2006. https://www.youtube.com/watch?v=A9OoPXSLBLM.

Allen, Amy. "Feminist Perspectives on Power." In *The Stanford Encyclopedia of Philosophy*, spring 2021 ed., edited by Edward N. Zalta and Uri Nodelman. Stanford, CA: Stanford University, 2021. https://plato.stanford.edu/Archives/spr2021/entries/feminist-power/index.html.

Amoore, Louise. "Security and the Incalculable." *Security Dialogue* 45, no. 5 (2014): 423–39.

Anzaldúa, Gloria. "Haciendo caras, una entrada." In *Making Face, Making Soul / Haciendo Caras: Creative and Critical Perspectives by*

Feminists of Color, edited by Gloria Anzaldúa. San Francisco: Aunt Lute, 1990.

Apolito, Aurora. "The Problem of Scale in Anarchism and the Case for Cybernetic Communism." Center for a Stateless Society, June 25, 2020. https://c4ss.org/wp-content/uploads/2020/06/Aurora-ScaleAnarchy_ful-version.pdf.

Appengine AI. "Cainthus | Computer Vision and AI for Dairy Farms." Accessed June 23, 2024. https://www.appengine.ai/company/cainthus.

Araluen, Evelyn. "Resisting the Institution." *Overland Literary Journal*, no. 227 (Winter 2017). https://overland.org.au/previous-issues/issue-227/feature-evelyn-araluen/.

Arellano, Annette B. Ramírez de, and Conrad Seipp. *Colonialism, Catholicism, and Contraception: A History of Birth Control in Puerto Rico*. Chapel Hill: University of North Carolina Press, 2011.

Art in America. "Ryan Kuo Discusses Race as Technology with Media Scholar Wendy Chun." September 3, 2019. https://www.artnews.com/art-in-america/features/ryan-kuo-race-technology-wendy-chun-63653/.

Artist, American (@a_____rtist). Instagram post, June 25, 2021. https://www.instagram.com/a_____rtist/p/CQjPZr2lQ7O/?img_index=6.

Artist, American. *Veillance Caliper (Annotated)*. 2021. https://americanartist.us/works/veillance-caliper-annotated.

Atanasoski, Neda, and Kalindi Vora. *Surrogate Humanity: Race, Robots and the Politics of Technological Futures*. Durham, NC: Duke University Press, 2019.

Atkinson, Ti-Grace. *Amazon Odyssey*. New York: Links, 1974.

Avilez, GerShun. *Black Queer Freedom: Spaces of Injury and Paths of Desire*. Urbana: University of Illinois Press, 2020.

Bakare, Lanre. "Angela Davis: 'We Knew That the Role of the Police Was to Protect White Supremacy.'" *Guardian*, June 20, 2020. https://www.theguardian.com/us-news/2020/jun/15/angela-davis-on-george-floyd-as-long-as-the-violence-of-racism-remains-no-one-is-safe.

Ballard, Robert D. *The Discovery of the Titanic*. New York: Warner, 1987.

Barad, Karen. *Meeting the Universe Halfway: Quantum Physics and the Entanglement of Matter and Meaning*. Durham, NC: Duke University Press, 2007.

Barker, F. G., II. "Phineas among the Phrenologists: The American Crowbar Case and Nineteenth-Century Theories of Cerebral Localization." *Journal of Neurosurgery* 82, no. 4 (1995): 672–82.

Barthes, Roland. "The Death of the Author." In *Image-Music-Text*, translated by Stephen Heath, 142–48. New York: Hill and Wang, 1977.

Battle-Baptiste, Whitney, and Britt Rusert, eds. *W. E. B. Du Bois's Data Portraits Visualizing Black America*. Hampton, NY: Princeton Architectural Press, 2018.

Baynes, Ronald E., Kelly J. Dix, and Jim E. Riviere. "Distribution and Pharmacokinetics Models." In *Pesticide Biotransformation and Disposition*, edited by Ernest Hodgson. London: Academic Press, 2012.

Beam, Joseph. "Making Ourselves from Scratch." In *Brother to Brother: New Writings by Black Gay Men*, edited by Essex Hemphill. Washington, DC: RedBone Press, 1991.

Beecher, Catherine E. *A Treatise on Domestic Economy, for the Use of Young Ladies at Home, and at School* [excerpts], rev. ed. Boston: T. H. Webb, 1842. http://utc.iath.virginia.edu/sentimnt/snescebhp.html.

Bello, Walden. "The Asian Financial Crisis: Causes, Dynamics, Prospects." *Journal of the Asia Pacific Economy* 4, no. 1 (1999): 33–55.

Bender, Emily, Timnit Gebru, Angelina McMillan-Major, and Shmargaret Shmitchell. "On the Dangers of Stochastic Parrots: Can Language Models Be Too Big? 🦜" In *FAccT '21: Proceedings of the 2021 ACM Conference on Fairness, Accountability, and Transparency*, 610–23. New York: Association for Computing Machinery, March 2021.

Beniger, James. *The Control Revolution: Technological and Economic Origins of the Information Society*. Cambridge, MA: Harvard University Press, 1989.

Benjamin, Ruha. *Race after Technology: Abolitionist Tools for the New Jim Code*. New York: Polity Press, 2019.

Berardi, Franco. "Baroque and Semiocapital." In *After the Future*, edited by Franco Bifo Berardi, Gary Genosko, and Nicholas Thoburn. Edinburgh: AK Press, 2011.

Berger, Peter L., and Hsin-Huang Michael Hsiao, eds. *In Search of an East Asian Development Model*. New Brunswick, NJ: Transaction, 1988.

Bergson, Henri. *Creative Evolution*. Translated by Arthur Mitchell. Mineola, NY: Dover, 1998.

Bergson, Henri. *Time and Free Will: An Essay on the Immediate Data of Consciousness.* Translated by F. L. Pogson. London: George Allen and Unwin, 1921.

Bergson, Henri. *The Two Sources of Morality and Religion.* Translated by R. Ashley Audra and Cloudesley Brereton. 1932. Reprint, Garden City, NY: Doubleday, 1954.

Bernes, Jasper. "Planning and Anarchy." *South Atlantic Quarterly* 119, no. 1 (January 2020): 53–73. https://doi.org/10.1215/00382876-8007653.

Bertolote, José. "The Roots of the Concept of Mental Health." *World Psychiatry* 7 (2008): 113–16.

Bier, Jess. "Bodily Circulation and the Measure of a Life: Forensic Identification and Valuation after the *Titanic* Disaster." *Social Studies of Science* 48, no. 5 (2018): 635–62.

Blas, Zach. "Informatics of Domination: A Lecture Series Organized and Introduced by Zach Blas." *e-flux Conversations*, January 17, 2017. https://conversations.e-flux.com/t/informatics-of-domination-a-lecture-series-organized-and-introduced-by-zach-blas/5890.

Blas, Zach. *Queer Technologies.* 2008–12. https://zachblas.info/works/queer-technologies/.

Blas, Zach. *SANCTUM.* 2018. https://zachblas.info/works/sanctum/.

Bonhomme, Edna. "What the Coronavirus Has Taught Us about Inequality." *Al Jazeera*, March 17, 2020. https://www.aljazeera.com/indepth/opinion/coronavirus-taught-inequality-200316204401117.html.

Boochani, Behrouz. *No Friend but the Mountains: Writing from Manus Prison.* Sydney: Picador Australia, 2018.

Boyer, Dominic, and Cymene Howe. "Ep. #39—Stacy Alaimo (Introducing Felix)." *Cultures of Energy*, 2016. Accessed November 20, 2017. http://culturesofenergy.com/ep-39-stacy-alaimo-introducing-felix/.

Braidotti, Rosi. *Posthuman Knowledge.* London: Polity Press, 2019.

Bratton, Benjamin H. *The Stack: On Software and Sovereignty.* Cambridge, MA: MIT Press, 2016.

Braun, Bruce, and Stephanie Wakefield. "Destituent Power and Common Use: Reading Agamben in the Anthropocene." In *Handbook on the Geographies of Power*, edited by Mat Coleman and John Agnew, 259–72. Cheltenham, UK: Edward Elgar, 2018. https://doi.org/10.4337/9781785365645.00024.

Brooks, Rodney. *Flesh and Machines: How Robots Will Change Us.* New York: Pantheon, 2002.

Brower, Andrea. "From the Sugar Oligarchy to the Agrochemical Oligopoly: Situating Monsanto and Gang's Occupation of Hawai'i." *Food, Culture, and Society* 19, no. 3 (2016): 587–614.

brown, adrienne maree. *Emergent Strategy: Shaping Change, Changing Worlds.* Chico, CA: AK Press, 2017.

Brown, DeForrest, Jr. "Social Music." *CTM Festival Magazine*, April 2021. https://www.ctm-festival.de/magazine/social-music.

Browne, Simone. *Dark Matters: On the Surveillance of Blackness.* Durham, NC: Duke University Press, 2015.

Bulley, Victoria Adukwei. "Interview with Saidiya Hartman." *White Review*, June 2020. https://www.thewhitereview.org/feature/interview-with-saidiya-hartman/.

Busta, Caroline. "The Internet Didn't Kill Counterculture—You Just Won't Find It on Instagram." *Document Journal*, January 2021. https://www.documentjournal.com/2021/01/the-internet-didnt-kill-counterculture-you-just-wont-find-it-on-instagram/.

Butler, Octavia. *Dawn.* New York: Popular Library, 1987.

Cameron, James, dir. *Titanic.* Paramount Pictures/Twentieth Century Fox, 1997.

Campbell, Jillian, and David E. Jensen. "The Pressing Need for a Global Digital Ecosystem." *Medium*, September 17, 2019. https://medium.com/@UNDP/the-pressing-need-for-a-global-digital-ecosystem-aa10a9f8df56.

Campt, Tina. *Listening to Images: An Exercise in Counterintuition.* Durham, NC: Duke University Press, 2017.

cárdenas, micha. *Poetic Operations: Trans of Color Art in Digital Media.* Durham, NC: Duke University Press, 2022.

The Cattle Site. "Smart Control: Maintaining Grazing Practices through Geofencing." January 4, 2021. https://www.thecattlesite.com/news/56359/smart-control-maintaining-grazing-practices-through-geofencing/.

Cavia, AA. *Logiciel: Six Seminars on Computational Reason.* Berlin: &&&, 2022.

Chambré, Susan Maizel. *Fighting for Our Lives: New York's AIDS Community and the Politics of Disease.* New Brunswick, NJ: Rutgers University Press, 2006.

Chan, Anita Say. *Networking Peripheries: Technological Futures and the Myth of Digital Universalism.* Cambridge, MA: MIT Press, 2013.

ChaosTV. "Putting the CGI in IKEA: How V-Ray Helps Visualize Perfect Homes." Posted on YouTube, March 22, 2018. https://youtu.be/bJFlslLIwFI.

Cheng, Anne. *Second Skin: Josephine Baker and the Modern Surface.* Oxford: Oxford University Press, 2013.

Chun, Wendy Hui Kyong. "Race and/as Technology; or, How to Do Things with Race." *Camera Obscura* 24, no. 1 (2009): 7–35.

Chun, Wendy Hui Kyong, and Sarah Friedland. "Habits of Leaking: Of Sluts and Network Cards." *differences* 26, no. 2 (2015): 1–28.

Clarke, Bruce. *Gaian Systems: Lynn Margulis, Neocybernetics, and the End of the Anthropocene.* Minneapolis: University of Minnesota Press, 2020.

Clarke, Bruce. "Information." In *Critical Terms for Media Studies*, edited by W. J. T. Mitchell and Mark B. N. Hansen. Chicago: University of Chicago Press, 2010.

Clarke, Bruce, and Sébastien Dutreuil, eds. *Writing Gaia: The Scientific Correspondence of James Lovelock and Lynn Margulis.* Cambridge: Cambridge University Press, 2022.

Clover, Joshua. *Riot. Strike. Riot: The New Era of Uprisings.* London: Verso, 2019.

Cockshott, William Paul, and Allin Cottrell. *Towards a New Socialism?* Nottingham, UK: Spokesman, 1993.

Cohen, Kris. *Never Alone, Except for Now: Art, Networks, Populations.* Durham, NC: Duke University Press, 2017.

Collins, Patricia Hill. *Black Feminist Thought: Knowledge, Consciousness, and the Politics of Empowerment.* New York: Routledge, 1990.

Collins, Patricia Hill. *Intersectionality as Critical Social Theory.* Durham, NC: Duke University Press, 2019.

Crawford, Chris. "Dosing Culture, Part One." *Damage*, September 2020. https://damagemag.com/2020/09/03/dosing-culture-part-one/.

Crawford, Kate. *Atlas of AI: Power, Politics, and the Planetary Costs of Artificial Intelligence.* New Haven, CT: Yale University Press, 2021.

Creative Industries Working Group. *Creative Industries Development Strategy: Propelling Singapore's Creative Economy.* Singapore: Economic Review Committee Services Subcommittee, 2002.

Crenshaw, Kimberlé. "Demarginalizing the Intersection of Race and Sex: A Black Feminist Critique of Antidiscrimination Doctrine,

Feminist Theory and Antiracist Politics." *University of Chicago Legal Forum* 1 (1989): 139–67.

Crenshaw, Kimberlé. "Mapping the Margins: Intersectionality, Identity Politics, and Violence against Women of Color." *Stanford Law Review* 43, no. 6 (1991): 1241–99.

Curtis, Valerie A. "A Natural History of Hygiene." *Canadian Journal of Infectious Diseases and Medical Microbiology* 18 (2007): 11–14.

Darwin, Charles. *Journal of researches into the natural history and geology of the countries visited during the voyage of H.M.S. Beagle round the world, under the Command of Capt. Fitz Roy, R.N.* 2nd ed. London: John Murray, 1845.

Decker, Erwin. *The Viennese Students of Civilization: The Meaning and Context of Austrian Economics Reconsidered.* Cambridge: Cambridge University Press, 2016.

Deleuze, Gilles. *Difference and Repetition.* New York: Columbia University Press, 1994.

Deleuze, Gilles. *The Fold: Leibniz and the Baroque.* Translated by Tom Conley. Minneapolis: University of Minnesota Press, 1998.

Deleuze, Gilles. *Foucault.* Minneapolis: University of Minnesota Press, 1986.

Deleuze, Gilles. "Postscript on Societies of Control." In *Negotiations, 1972–1990.* New York: Columbia University Press, 1995.

Deleuze, Gilles, and Félix Guattari. "Introduction: Rhizome." In *A Thousand Plateaus: Capitalism and Schizophrenia.* Minneapolis: University of Minnesota Press, 1987.

DeLillo, Don. *Cosmopolis.* New York: Scribner, 2003.

Demott, John. "A Case of Crony Capitalism." *Time*, April 21, 1980.

De Vynck, Gerrit. "They Helped Train Google's AI. Then They Got Fired after Speaking Out." *Washington Post*, June 15, 2023.

Dhaliwal, Ranjodh Singh. "The Cyber-homunculus: On Race and Labor in Plans for Computation." *Configurations* 30, no. 4 (2022): 377–409.

D'Ignazio, Catherine, and Lauren F. Klein. *Data Feminism.* Cambridge, MA: MIT Press, 2020.

Dillon, Grace L. "Introduction: Indigenous Futurisms, Bimaashi Biidaas Mose, Flying, and Walking towards You." *Extrapolation* 57, no. 1–2 (2016): 1–6.

Dominguez, Ricardo. *Virtual Timeline.* 1997. https://www.thing.net/~rdom/VRtime.html.

Dominguez, Ricardo. *Virtual Timeline*. 1997. Rhizome / ArtBase. Accessed March 10, 2024. https://artbase.rhizome.org/wiki/Q4149.

Du Bois, W. E. B. "Of Our Spiritual Strivings." In *The Souls of Black Folk*. Project Gutenberg, [1903] 1996. https://www.gutenberg.org/files/408/408-h/408-h.htm.

Dworkin, Andrea. *Women Hating*. New York: E. P. Dutton, 1974.

Dyer-Witheford, Nick, Atle Mikkola Kjosen, and James Steinhoff. *Inhuman Power: Artificial Intelligence and the Future of Capitalism*. London: Pluto Press, 2019.

Ehrlich, Paul R. *The Population Bomb*. New York: Ballantine, 1969.

Einspahr, Jennifer. "Structural Domination and Structural Freedom: A Feminist Perspective." *feminist review* 94 (2010): 1–19.

Elwood, Sarah. "Digital Geographies, Feminist Relationality, Black and Queer Code Studies: Thriving Otherwise." *Progress in Human Geography* 45, no. 2 (2020): 1–20.

Escobar, Arturo. *Designs for the Pluriverse: Radical Interdependence, Autonomy, and the Making of Worlds*. Durham, NC: Duke University Press, 2017.

Fanon, Frantz. *Black Skin, White Masks*. New York: Grove Press, 1967.

Fazi, M. Beatrice. *Contingent Computation: Abstraction, Experience, and Indeterminacy in Computational Aesthetics*. Lanham, MD: Rowman and Littlefield, 2018.

Federici, Silvia. *Wages against Housework*. Bristol: Falling Wall Press, 1975.

Ferguson, Roderick A. "Sissies at the Picnic: The Subjugated Knowledges of a Black Rural Queer." In *Feminist Waves, Feminist Generations: Life Stories from the Academy*, edited by Hokulani K. Aikau, Karla A. Erickson, and Jennifer L. Pierce. Minneapolis: University of Minnesota Press, 2007.

Firestone, Shulamith. *The Dialectic of Sex: The Case for a Feminist Revolution*. London: Verso, 2015.

Fisher, Mark. "Accelerate Management." *PARSE Journal*, no. 5 (Spring 2017). https://parsejournal.com/article/accelerate-management/.

Fisher, Mark. "Good for Nothing." *Occupied Times of London*, March 19, 2014.

Flanagan, Frances. "Climate Change and the New Work Order." *Inside Story*, February 28, 2019. https://insidestory.org.au/climate-change-and-the-new-work-order/.

Ford, Andrea. "Introduction: Embodied Ecologies." *Theorizing the Contemporary*, *Fieldsights*, April 25, 2019. https://culanth.org/fieldsights/introduction-embodied-ecologies.

Foster, Susan Lee. "Choreographies of Protest." *Theatre Journal* 55, no. 3 (2003): 395–412.

Foucault, Michel. *The Archaeology of Knowledge and the Discourse on Language*. New York: Pantheon, 1972.

Foucault, Michel. *Discipline and Punish: The Birth of the Prison*. New York: Vintage, 1995.

Foucault, Michel. *The History of Sexuality*, vol. 1: *The Will to Knowledge*. London: Penguin, 1998.

Foucault, Michel. *The Order of Things: An Archaeology of the Human Sciences*. New York: Vintage, 1994.

Foucault, Michel. "What Is an Author?" Translated by Donald Bouchard and Sherry Simon. In *Language, Counter-Memory, Practice: Selected Essays and Interviews*, 113–38. Ithaca, NY: Cornell University Press, 1977.

Fourier, Charles. *The Hierarchies of Cuckoldry and Bankruptcy*. Cambridge, MA: Wakefield Press, 2011.

Fox, Catherine Toth. "Thousands Turn Out to Fix a Huge Hole in This 800-Year-Old Heʻeia Fishpond." *Honolulu Magazine*, December 12, 2015. https://www.honolulumagazine.com/thousands-turn-out-to-fix-a-huge-hole-in-this-800-year-old-heeia-fishpond/.

Freedland, Jonathan. "The Onslaught." *Guardian*, October 24, 2005. https://www.theguardian.com/media/2005/oct/25/advertising.food.

Freidberg, Susanne. *Fresh: A Perishable History*. Cambridge, MA: Harvard University Press, 2010.

Freud, Sigmund. "Leonardo da Vinci and a Memory of His Childhood." In *The Standard Edition of the Complete Psychological Works of Sigmund Freud*, vol. 11, translated by James Strachey. London: Hogarth, 1957.

Freud, Sigmund. *Three Essays on the Theory of Sexuality*. Translated by James Strachey. New York: Basic Books, 1962.

Frohlich, Thomas C. "Where You'll Pay the Most in Electric Bills." *24/7 Wall St* (blog), January 24, 2019. https://247wallst.com/special-report/2019/01/24/where-youll-pay-the-most-in-electric-bills-3/.

Fujikane, Candace. *Mapping Abundance for a Planetary Future: Kanaka Maoli and Settler Cartographies in Hawaiʻi*. Durham, NC: Duke University Press, 2020.

Gaboury, Jacob. "On Uncomputable Numbers: The Origins of Queer Computing." *Media-N* 9, no. 2 (Summer 2013). https://median.newmediacaucus.org/caa-conference-edition-2013/on-uncomputable-numbers-the-origins-of-a-queer-computing/.

Gabrys, Jennifer. "Becoming Planetary." *e-flux Architecture*, October 2018. https://www.e-flux.com/architecture/accumulation/217051/becoming-planetary.

Gabrys, Jennifer. "Powering the Digital: From Energy Ecologies to Electronic Environmentalism." In *Media and the Ecological Crisis*, edited by Richard Maxwell, Jon Raundalen, and Nina Lager Vestberg, 3–18. New York: Routledge, 2015.

Gabrys, Jennifer. *Program Earth: Environmental Sensing Technology and the Making of a Computational Planet.* Minneapolis: University of Minnesota Press, 2016.

Gabrys, Jennifer. "Smart Forests and Data Practices: From the Internet of Trees to Planetary Governance." *Big Data and Society* 7, no. 1 (2020): 1–10.

Gabrys, Jennifer, Michelle Westerlaken, Danilo Urzedo, Max Ritts, and Trishant Simlai. "Reworking the Political in Digital Forests: The Cosmopolitics of Socio-technical Worlds." *Progress in Environmental Geography* 1, nos. 1–4 (2022): 58–83.

Galloway, Alexander R. *Protocol: How Control Exists after Decentralization.* Cambridge, MA: MIT Press, 2006.

Galloway, Alexander R. "Uncomputer." NYU Department of Media, Culture, and Communication, February 9, 2020. http://cultureandcommunication.org/galloway/uncomputer.

Galloway, Alexander R., and Eugene Thacker. *The Exploit: A Theory of Networks.* Minneapolis: University of Minnesota Press, 2007.

Gane, Nicholas. "When We Have Never Been Human, What Is to Be Done? Interview with Donna Haraway." *Theory, Culture and Society* 23, nos. 7–8 (December 1, 2006): 135–58. https://doi.org/10.1177/0263276406069228.

Gilbert, Scott F., Emily McDonald, Nicole Boyle, Nicholas Buttino, Lin Gyi, Mark Mai, Neelakantan Prakash, and James Robinson. "Symbiosis as a Source of Selectable Epigenetic Variation: Taking the Heat for the Big Guy." *Philosophical Transactions of the Royal Society B* 365 (2010): 671–78.

Giles, Martin. "The GANfather: The Man Who's Given Machines the Gift of Imagination." *MIT Technology Review*, February 21, 2018. https://

www.technologyreview.com/2018/02/21/145289/the-ganfather-the-man-whos-given-machines-the-gift-of-imagination/.

Gilmore, Ruth Wilson. *Golden Gulag: Prisons, Surplus, Crisis, and Opposition in Globalizing California.* Berkeley: University of California Press, 2007.

Gilroy, Paul. *The Black Atlantic: Modernity and Double Consciousness.* Cambridge, MA: Harvard University Press, 1993.

Glass, John. "First Minimal Synthetic Bacterial Cell." J. Craig Venter Institute. Accessed May 23, 2024. https://www.jcvi.org/research/first-minimal-synthetic-bacterial-cell.

Gómez-Barris, Macarena. *The Extractive Zone: Social Ecologies and Decolonial Perspectives.* Durham, NC: Duke University Press, 2017.

Goodfellow, Ian J., Jean Pouget-Abadie, Mehdi Mirza, Bing Xu, David Warde-Farley, Sherjil Ozair, Aaron Courville, and Yoshua Bengio. "Generative Adversarial Nets." In *Advances in Neural Information Processing Systems 27*, edited by Z. Ghahramani, M. Welling, C. Cortes, N. Lawrence, and K. Q. Weinberger, 2672–80. NeurIPS Proceedings, 2014. http://papers.nips.cc/paper/5423-generative-adversarial-nets.

Google Earth. "Tour the Titanic in Google Earth." Posted on YouTube, April 13, 2012. https://www.youtube.com/watch?v=2qT5fddzELU.

Goux, Jean-Joseph. *Symbolic Economies: After Marx and Freud.* Translated by Jennifer Curtiss Gage. Ithaca, NY: Cornell University Press, 1990.

Gray, Mary, and Siddharth Suri. *Ghost Work: How to Stop Silicon Valley from Building a New Global Underclass.* New York: Houghton Mifflin Harcourt, 2019.

Grossman, Rachel. "Women's Place in the Integrated Circuit." *Southeast Asian Chronicle* 66 (1979): 2–17.

Guardian. "Robot Life of the Future—Archive, 1969." September 11, 2019. https://www.theguardian.com/technology/2019/sep/11/robot-life-of-the-future-archive-1969.

Guidere, Mathieu, Newton Howard, and Shlomo Argamon. "Rich Language Analysis for Counterterrorism." In *Computational Methods for Counterterrorism*, edited by Shlomo Argamon and Newton Howard. Berlin: Springer Verlag, 2009.

Hamilton, Jennifer Mae. "The Future of Housework: The Similarities and Differences between Making Kin and Making Babies." *Austra-

lian *Feminist Studies* 34, no. 102 (2019): 1–22. https://doi.org/10.1080/08164649.2019.1702874.

Hamilton, Jennifer Mae, and Astrida Neimanis. "Composting Feminisms and Environmental Humanities." *Environmental Humanities* 10, no. 2 (2018): 501–27.

Hamilton, Jennifer Mae, and Astrida Neimanis. "Five Desires, Five Demands." *Australian Feminist Studies* 34, no. 102 (2019): 385–97. https://doi.org/10.1080/08164649.2019.1702875.

Hamilton, Jennifer Mae, Tessa Zettel, and Astrida Neimanis. "Feminist Infrastructures for Better Weathering." *Australian Feminist Studies* 36, no. 109 (2021): 237–59. https://doi.org/10.1080/08164649.2021.1969639.

Hammond, Joyce D. "Hawaiian Flag Quilts: Multivalent Symbols of a Hawaiian Quilt Tradition." *Hawaiian Journal of History* 27 (1993): 1–26.

Hamraie, Aimi, and Kelly Fritsch. "Crip Technoscience Manifesto." *Catalyst* 4, no. 1 (2019).

Han, Byung-Chul. *Psychopolitics: Neoliberalism and New Technologies of Power.* London: Verso, 2017.

Haraway, Donna J. "The Biological Enterprise: Sex, Mind, and Profit from Human Engineering to Sociobiology." In *Simians, Cyborgs, and Women: The Reinvention of Nature*, 58–59. New York: Routledge, 1991.

Haraway, Donna J. "The Biopolitics of Postmodern Bodies: Constitutions of Self in Immune System Discourse." In *Simians, Cyborgs, and Women: The Reinvention of Nature.* New York: Routledge, 1991.

Haraway, Donna J. "Biopolitics of Postmodern Bodies: Determinations of Self in Immune System Discourse." *differences: A Journal of Feminist Cultural Studies* 1, no. 1 (1989): 3–43.

Haraway, Donna J. "Crittercam: Compounding Eyes in Naturecultures." In *When Species Meet.* Minneapolis: University of Minnesota Press, 2008.

Haraway, Donna J. "A Cyborg Manifesto: Science, Technology, and Socialist-Feminism in the Late Twentieth Century." In *Simians, Cyborgs, and Women: The Reinvention of Nature.* New York: Routledge, 1991.

Haraway, Donna J. "A Cyborg Manifesto: Science, Technology, and Socialist-Feminism in the Late 20th Century." In *The International Handbook of Virtual Learning Environments*, edited by Joel Weiss,

Jason Nolan, Jeremy Hunsinger, and Peter Trifonas. Dordrecht: Springer, 2006.

Haraway, Donna J. "A Cyborg Manifesto: Science, Technology, and Socialist-Feminism in the Late Twentieth Century." In *Manifestly Haraway*. Minneapolis: University of Minnesota Press, 2016.

Haraway, Donna J. "A Manifesto for Cyborgs: Science, Technology, and Socialist-Feminism in the 1980s." *Socialist Review*, no. 80 (1985): 65–108.

Haraway, Donna J. "A Manifesto for Cyborgs: Science, Technology, and Socialist-Feminism in the 1980s." *Australian Feminist Studies* 2, no. 4 (Autumn 1987): 1–42.

Haraway, Donna J. "A Manifesto for Cyborgs: Science, Technology, and Socialist-Feminism in the 1980s." In *Feminism/Postmodernism*, edited by Linda J. Nicholson. New York: Routledge, 1990.

Haraway, Donna J. "A Manifesto for Cyborgs: Science, Technology, and Socialist-Feminism in the 1980s." In *The Haraway Reader*. New York: Routledge, 2004.

Haraway, Donna J. "Situated Knowledges: The Science Question in Feminism and the Privilege of the Partial Perspective." *Feminist Studies* 14, no. 3 (1988): 575–99. https://doi.org/10.2307/3178066.

Haraway, Donna J. "Situated Knowledges: The Science Question in Feminism and the Privilege of the Partial Perspective." In *Simians, Cyborgs, and Women: The Reinvention of Nature*. New York: Routledge, 1991.

Haraway, Donna J. *Staying with the Trouble: Making Kin in the Chthulucene*. Durham, NC: Duke University Press, 2016.

Haraway, Donna J. "Universal Vampires in a Donor Culture." In *Modest_Witness@Second_Millenium.FemaleMan©_Meets_Oncomouse™*. New York: Routledge, 1996.

Harding, Sandra. *The Science Question in Feminism*. Ithaca, NY: Cornell University Press, 1986.

Hartman, Saidiya. "Venus in Two Acts." *Small Axe* 12, no. 2 (2008): 1–14.

Hauʻofa, Epeli. *We Are the Ocean: Selected Works*. Honolulu: University of Hawaiʻi Press, 2008.

Hayek, Friedrich August von. *The Counter-revolution of Science: Studies on the Abuse of Reason*. Glencoe, IL: Free Press, 1952.

Hayek, Friedrich August von. "The Use of Knowledge in Society." *American Economic Review* 35, no. 4 (September 1945): 519–30.

Hayles, N. Katherine. *How We Became Posthuman: Virtual Bodies in Cybernetics, Literature, and Informatics*. Chicago: University of Chicago Press, 1999.

Hayles, N. Katherine. *How We Think: Digital Media and Contemporary Technogenesis*. Chicago: University of Chicago Press, 2012.

Hayles, N. Katherine. *My Mother Was a Computer: Digital Subjects and Literary Texts*. Chicago: University of Chicago Press, 2005.

Hayles, N. Katherine. *Writing Machines*. Cambridge, MA: MIT Press, 2002.

Hayward, Eva S. "Sensational Jellyfish: Aquarium Affects and the Matter of Immersion." *differences: A Journal of Feminist Cultural Studies* 23, no. 3 (2012): 161–96.

Heaivilin, Hunter. "Local Foods through Crisis." In *The Value of Hawaiʻi 3: Hulihia, the Turning*, edited by Noelani Goodyear-Kaʻōpua, Craig Howes, Jonathan Kay Kamakawiwoʻole Osorio, and Aiko Yamashiro, 31–34. Honolulu: University of Hawaiʻi Press, 2020.

Hegel, Georg Wilhelm Friedrich. *Lectures on the Philosophy of History*. Translated by John Sibree. Kitchener, CA: Batoche, 2001.

Higgins, David. *Reverse Colonization: Science Fiction, Imperial Fantasy, and Alt-Victimhood*. Iowa City: University of Iowa Press, 2021.

Ho, Rui An. "Crisis and Contingency at the Dashboard." *e-flux Journal* 90 (2018).

Hobbs, Robert, and Mark Lombardi. *Mark Lombardi: Global Networks*. New York: Independent Curators International, 2003.

Honda, Eiko. "The Emergence of Queer Nature in Modern Science: Minakata Kumagusu (1867–1941) and the Universe of Microbial Knowledge." DPhil thesis, Oxford University, 2021.

Honolulu Advertiser. "Kalihi Valley Homes Has 373 Resident Families." February 26, 1954.

Hood, Kate Lewis. "Industry/Forestry 4.0." *Logbooks* (blog). Smart Forests Atlas. https://atlas.smartforests.net/en/logbooks/fpinnovations-forestry-40.

hooks, bell. *Ain't I a Woman: Black Women and Feminism*. 2nd ed. New York: Routledge, 1981.

hooks, bell. *The Will to Change: Men, Masculinity, and Love*. New York: Washington Square Press, 2004.

Hu, Tung-Hui. *A Prehistory of the Cloud*. Cambridge, MA: MIT Press, 2015.

Hudgins, Edward L. "Hayek vs. Asimov: Spontaneous Order or Failed Foundation." Cato Institute, January 1, 1996. https://www.cato.org/white-paper/hayek-vs-asimov-spontaneous-order-or-failed-foundation.

Hughes, Zondra. "What Happened to the Only Black Family on the *Titanic*?" *Ebony*, June 2000, 148–54.

Huillet, Danièle, and Jean-Marie Straub, dirs. *En rachâchant*. Straub-Huillet, Diagonale, and L'Institut National de l'Audiovisuel (France), 1983. 7 min.

Hutton, Adam F. "Silicon Valley Rising Has a Plan to Improve the Lives of 'Tech's Invisible Workforce.'" *San Jose Spotlight*, September 1, 2019. https://sanjosespotlight.com/silicon-valley-rising-has-a-plan-to-improve-the-lives-of-techs-invisible-workforce/.

Imarisha, Walidah. "Introduction." In *Octavia's Brood: Science Fiction Stories from Social Justice Movements*, edited by Walidah Imarisha and adrienne maree brown, 3–6. Oakland, CA: AK Press, 2015.

Information School. "Informatics." University of Washington. Accessed March 10, 2024. https://ischool.uw.edu/programs/informatics.

Irani, Lilly. *Chasing Innovation: Making Entrepreneurial Citizens in Modern India*. Princeton, NJ: Princeton University Press, 2019.

Irani, Lilly. "The Cultural Work of Microwork." *New Media and Society* 17, no. 5 (May 2015): 720–39.

Jackson, Reginald T. "The Absence of Fear: An Open Letter to a Brother." In *Brother to Brother: New Writings by Black Gay Men*, edited by Essex Hemphill. Washington, DC: RedBone Press, 1991.

Jameson, Fredric. *A Singular Modernity: Essay on the Ontology of the Present*. London: Verso, 2012.

Jarman, Derek, dir. *Blue*. Basilisk Communications Ltd., 1993.

Jemisin, N. K. *The Fifth Season*. New York: Orbit, 2015.

Jemisin, N. K. "The Ones Who Stay and Fight." In *How Long 'til Black Future Month? Stories*, 1–13. New York: Orbit, 2018.

Jerng, Mark C. *Racial Worldmaking: The Power of Popular Fiction*. New York: Fordham University Press, 2017.

Johnson, Chalmers. *MITI and the Japanese Miracle: The Growth of Industrial Policy, 1925–1975*. Stanford, CA: Stanford University Press, 1982.

Johnson, Jessica Marie. "Markup Bodies: Black [Life] Studies and Slavery [Death] Studies at the Digital Crossroads." *Social Text*, no. 137 (2018): 57–79.

Jones, Caroline A. "Anicka Yi: Biofiction and the *Umwelt*." In *Hugo Boss Prize 2016*. New York: Solomon R. Guggenheim Museum, 2016.

Jones, Caroline A. "Monads, Mycetes, and Mandalas: Inserting Jenna Sutela in Symbiontic Philosophies." In *Jenna Sutela: NO NO NSE NSE*, edited by Stefanie Hessler. London: Koenig, 2020.

Jones, Caroline A. "Siren Songs." *e-flux Architecture*, July 2021. https://www.e-flux.com/architecture/survivance/400172/siren-songs/.

Jones, Caroline A. "Swarming Symbionts." In *Agnieszka Kurant: Collective Intelligence*, edited by Stefanie Hessler, Jenny Jaskey, and Agnieszka Kurant. London: Sternberg, forthcoming.

Jones, Caroline A. "Symbiontics: A Polemic for Our Time." In *Symbionts: Contemporary Artists and the Biosphere*, edited by Caroline A. Jones, Natalie Bell, and Selby Nimrod, 13–50. Cambridge, MA: MIT List Visual Art Center and MIT Press, 2022.

Jones, Caroline A. "Virions: Thinking through the Scale of Aggregation." *Artforum*, May/June 2020. https://www.artforum.com/print/202005/caroline-a-jones-82828.

Jones, Caroline A. "We Symbionts." In *Olafur Eliasson: Symbiotic Seeing*, edited by Esther Braun-Kalberer, Anna Engberg-Pedersen, Kristina Köper, and Mirjam Varadinis. Zurich: Kunsthalle Zurich, 2020.

Jones, Donna V. "Inheritance and Finitude: Toward a Literary Phenomenology of Time." *ELH* 85, no. 2 (2018): 289–303.

Jones, Donna V. *The Racial Discourses of Life Philosophy: Négritude, Vitalism, and Modernity.* New York: Columbia University Press, 2011.

Jones, Sarah. "Arresting Disabled Bodies." *New Republic*, September 28, 2017. https://newrepublic.com/article/145072/arresting-disabled-bodies.

"Jordan Peele's 'Deepfake' President Obama Video." C-SPAN, June 7, 2019. https://www.c-span.org/classroom/document/?9544.

Jue, Melody. *Wild Blue Media: Thinking through Seawater.* Durham, NC: Duke University Press, 2020.

Kafer, Alison. *Feminist Queer Crip.* Bloomington: Indiana University Press, 2013.

Kahn, Herman. *Thinking about the Unthinkable.* New York: Horizon Press, 1962.

Kang, Laura Hyun Yi. "The Uses of Asianization: Figuring Crises, 1997–98 and 2007–?" *American Quarterly* 64, no. 3 (2012): 411–36.

Kauanui, J. Kēhaulani. *Paradoxes of Hawaiian Sovereignty: Land, Sex, and the Colonial Politics of State Nationalism.* Durham, NC: Duke University Press, 2018.

Keeling, Kara. "Queer OS." *Cinema Journal* 53, no. 2 (2014): 152–57.

Keenan, Thomas, and Eyal Weizman. *Mengele's Skull: The Advent of a Forensic Aesthetics.* Berlin: Sternberg Press / Portikus, 2012.

Keller, Evelyn Fox. "Feminism and Science." *Feminist Theory* 7, no. 3 (1982): 589–602.

Kelley, Lindsay. *Bioart Kitchen: Art, Feminism and Technoscience.* London: I. B. Tauris, 2016.

Kent, George. "Food Security in Hawai'i." In *Food and Power in Hawai'i: Visions of Food Democracy*, edited by Aya Hirata Kimura and Krisnawati Suryanata, 28–45. Honolulu: University of Hawai'i Press, 2016.

Kittler, Friedrich A. *Discourse Networks, 1800/1900.* Stanford, CA: Stanford University Press, 1990.

Kittler, Friedrich A. *Gramophone, Film, Typewriter.* Stanford, CA: Stanford University Press, 1999.

Klein, Melanie. "Infantile Anxiety Reflected in a Work of Art." In *The Selected Melanie Klein*, edited by Juliet Mitchell, 84–94. New York: Free Press, 1986.

Kofler, Natalie, and Françoise Baylis. "Ten Reasons Why Immunity Passports Are a Bad Idea." *Nature* 581 (2020): 379–81.

Kollewe, Julia. "Pfizer Accused of Pandemic Profiteering as Profits Double." *Guardian*, February 8, 2022. https://www.theguardian.com/business/2022/feb/08/pfizer-covid-vaccine-pill-profits-sales.

Konings, Martijn. *Capital and Time: For a New Critique of Neoliberal Reason.* Palo Alto, CA: Stanford University Press, 2018.

Krauss, Rosalind. "Grids." *October* 9 (Summer 1979): 50–64.

Krenak, Ailton. *Ideas to Postpone the End of the World.* Toronto: House of Anansi Press, 2020.

Lacan, Jacques. *The Ethics of Psychoanalysis: The Seminar of Jacques Lacan, Book VII.* Translated by Dennis Porter. New York: W. W. Norton, 1986.

Lamoreaux, Janelle. "What If the Environment Is a Person? Lineages of Epigenetic Science in a Toxic China." *Cultural Anthropology* 31, no. 2 (2016). https://journal.culanth.org/index.php/ca/article/view/ca31.2.03/357.

Laplanche, Jean. "The Unfinished Copernican Revolution." In *Essays on Otherness*, 53–85. London: Routledge, 1999.

Laugesen, Amanda. *Rooted: An Australian History of Bad Language.* Sydney: New South Books, 2020.

Leistert, Oliver. "The Revolution Will Not Be Liked." In *Critical Perspectives on Social Media and Protest*, edited by Lina Dencik and Oliver Leistert. London: Rowman and Littlefield International, 2015.

LeMenager, Stephanie. "Skilling Up for the Anthropocene." In *Feminist, Queer, Anticolonial Propositions for Hacking the Anthropocene: Archive*, edited by Jennifer Mae Hamilton, Susan Reid, Pia van Gelder, and Astrida Neimanis. London: Open Humanities Press, 2020.

Leslie, Esther. "Nature of Disruption, Disruption of Nature: During and after the Pandemic." *Philosophy World Democracy*, May 23, 2022.

Lieberman, Charlotte. "Why You Procrastinate (It Has Nothing to Do with Self-Control)." *New York Times*, March 25, 2019.

Linden, Robin Ruth, Darlene R. Pagano, Diana E. H. Russell, and Susan Leigh Star, eds. *Against Sadomasochism: A Radical Feminist Analysis*. San Francisco: Frog in the Well, 1982.

Lindtner, Silvia. *Prototype Nation: China and the Contested Promise of Innovation*. Princeton, NJ: Princeton University Press, 2020.

Linenthal, Edward. *Symbolic Defense: The Cultural Significance of the Strategic Defense Initiative*. Urbana: University of Illinois Press, 1989.

Lipton, Mark. "The Condom in History: Shame and Fear." In *Culture and the Condom*, edited by Karen Anijar and Thuy DaoJensen. Lausanne: Peter Lang, 2005.

Lochlann, Jain. *Malignant: How Cancer Becomes Us*. Berkeley: University of California Press, 2013.

Loke, Matthew K., and PingSun Leung. "Hawai'i's Food Consumption and Supply Sources: Benchmark Estimates and Measurement Issues." *Agricultural and Food Economics* 1, no. 1 (2013). https://doi.org/10.1186/2193-7532-1-10.

Lord, Walter. *A Night to Remember*. New York: R&W Holt, 1955.

Lorde, Audre. *Sister Outsider: Essays and Speeches*. Berkeley, CA: Crossing Press, 1984.

Lothian, Alexis. *Old Futures: Speculative Fiction and Queer Possibility*. New York: New York University Press, 2018.

Lugones, María. "Heterosexualism and the Colonial/Modern Gender System." *Hypatia* 22, no. 1 (2007): 186–219. https://doi.org/10.1111/j.1527-2001.2007.tb01156.x.

Madrigal, Alexis. "'Why Are Spy Researchers Building a 'Metaphor Program'?" *Atlantic*, May 25, 2011.

Malaspina, Cécile. *An Epistemology of Noise*. London: Bloomsbury, 2018.

Mann, Steve. "Veillance and Reciprocal Transparency: Surveillance versus Sousveillance, AR Glass, Lifelogging and Wearable Computing." In *2013 IEEE International Symposium on Technology and Society (ISTAS)*, 1–12. Toronto: IEEE, 2013.

Margulis, Lynn, and René Fester, eds. *Symbiosis as a Source of Evolutionary Innovation: Speciation and Morphogenesis*. Cambridge, MA: MIT Press, 1991.

Marinetti, Filippo Tommaso. *Mafarka the Futurist: An African Novel.* London: Middlesex University Press, 1998.

Marx, Karl. *Capital,* vol. 1. New York: Penguin, 1990.

Marx, Karl. *Economic and Philosophic Manuscripts of 1844.* Mineola, NY: Dover, 2007.

Marx, Karl. *Grundrisse.* New York: Penguin, 1993.

Massumi, Brian. *The Power at the End of the Economy.* Durham: Duke University Press, 2015.

Mattison, Sara. "Refrigerator, Freezer Stock Impacted by COVID-19." *KHON2,* September 16, 2020. https://www.khon2.com/coronavirus/refrigerator-freezer-stock-impacted-by-covid-19/.

McBean, Sam. "Feminist Diagrams." *Feminist Theory* 22, no. 2 (2021): 206–25.

McClanahan, Annie. "Future's Shock: Plausibility, Preemption, and the Fiction of 9/11." *symploke* 17, no. 1–2 (2009): 41–62.

McClintock, Anne. *Imperial Leather: Race, Gender, and Sexuality in the Colonial Contest.* New York: Routledge, 1995.

McDonald, Danny. "MFA Apologizes after Students from Dorchester School Subjected to Racism during Field Trip." *Boston Globe,* May 22, 2019. https://www.bostonglobe.com/metro/2019/05/22/mfa-apologizes-after-students-from-dorchester-school-subjected-racism-during-field-trip/TzYcdDirBvoDE81q65TOKN/story.html.

McGlotten, Shaka. "Black Data." In *No Tea, No Shade: New Queer of Color Critique,* edited by E. Patrick Johnson, 262–86. Durham, NC: Duke University Press, 2016.

McHale, Brian. *Constructing Postmodernism.* New York: Routledge, 1992.

McKittrick, Katherine. "Mathematics Black Life." *Black Scholar* 44, no. 2 (2014): 16–28.

McLauchlan, Laura. "Wild Disciplines and Multispecies Erotics: On the Power of Wanting Like a Hedgehog Champion." *Australian Feminist Studies* 34, no. 102 (2019): 1–15. https://doi.org/10.1080/08164649.2019.1682457.

Mead, Margaret. *Sex and Temperament in Three Primitive Societies.* New York: William Morrow, 1935.

Mejias, Ulises Ali. *Off the Network: Disrupting the Digital World.* Minneapolis: University of Minnesota Press, 2013.

Melamed, Jodie. "Racial Capitalism." *Critical Ethnic Studies* 1, no. 1 (Spring 2015): 76–85.

Merry, Sally Engle. *Colonizing Hawai'i: The Cultural Power of Law.* Princeton, NJ: Princeton University Press, 2000.

Milburn, Colin. *Nanovision: Engineering the Future.* Durham, NC: Duke University Press, 2008.

Milne-Edwards, Henri. *Outlines of Anatomy and Physiology.* Boston: C. C. Little and J. Brown, 1841.

Mirowski, Philip. *More Heat Than Light: Economics as Social Physics, Physics as Nature's Economics.* Cambridge: Cambridge University Press, 2000.

Mitchell, David, and Sharon Snyder. "Disability as Multitude: Reworking Nonproductive Labor Power." *Journal of Literary and Cultural Studies* 4, no. 2 (2010): 179–94.

Mitman, Gregg. "Reflections on the Plantationocene: A Conversation with Donna Haraway and Anna Tsing." *Edge Effects*, June 18, 2019. https://edgeeffects.net/haraway-tsing-plantationocene/.

Mohamad, Mahathir. "Speech on the 10th Session of the Islamic Summit Conference." Putrajaya Convention Centre, Malaysia, October 16, 2003.

Moore, Jason W. *Capitalism in the Web of Life: Ecology and the Accumulation of Capital.* London: Verso, 2015.

Morozov, Evgeny. *To Save Everything, Click Here: The Folly of Technological Solutionism.* New York: PublicAffairs, 2013.

Morrison, Toni. "'I Wanted to Carve Out a World Both Culture Specific and Race-Free': An Essay by Toni Morrison." *Guardian*, August 8, 2019. https://www.theguardian.com/books/2019/aug/08/toni-morrison-rememory-essay.

Morton, Timothy. *Dark Ecology: For a Logic of Future Coexistence.* New York: Columbia University Press, 2016.

Morton, Timothy. *Humankind: Solidarity with Non-human People.* London: Verso, 2019.

Muñoz, José Esteban. "From Surface to Depth, between Psychoanalysis and Affect." *Women and Performance: A Journal of Feminist Theory* 19, no. 2 (2010): 123–29.

Murphy, Michelle. "Against Population, towards Alterlife." In *Making Kin, Not Population*, edited by Adele Clarke and Donna Haraway. Cambridge: Prickly Paradigm Press, 2018.

Murphy, Michelle. "Alterlife and Decolonial Chemical Relations." *Cultural Anthropology* 32, no. 4 (2017): 494–503. https://doi.org/10.14506/ca32.4.02.

Muthiah, Sathappan, Patrick Butler, Rupinder Paul Khandpur, Parang Saraf, Nathan Self, Alla Rozovskaya, Liang Zhao, et al. "EMBERS at 4 Years: Experiences Operating an Open Source Indicators Forecasting System." In *KDD '16: Proceedings of the 22nd ACM SIGKDD International Conference on Knowledge Discovery and Data Mining*, 205–14. New York: Association for Computing Machinery, August 2016.

National Arts Council. *Renaissance City Report: Culture and the Arts in Renaissance Singapore*. Singapore: MITA, 2000.

Neimanis, Astrida. *Bodies of Water: Posthuman Feminist Phenomenology*. London: Bloomsbury, 2017.

Neimanis, Astrida. "Introductory Talk: The Missing Keyword." The Camille Diaries Symposium, ArtLab Berlin, September 2020. http://www.artlaboratory-berlin.org/html/eng-Camille-Diaries-Symposium.htm.

Neimanis, Astrida. "The Weather Underwater: Blackness, White Feminism, and the Breathless Sea." *Australian Feminist Studies* 34, no. 102 (2019): 1–19. https://doi.org/10.1080/08164649.2019.1697178.

Newitz, Annalee. "When Will White People Stop Making Movies Like *Avatar*?" *Gizmodo*, December 18, 2009. https://i09.gizmodo.com/when-will-white-people-stop-making-movies-like-avatar-5422666.

Niermann, Hannah C. M., and Anouk Scheres. "The Relation between Procrastination and Symptoms of Attention-Deficit Hyperactivity Disorder (ADHD) in Undergraduate Students." *International Journal of Methods in Psychiatric Research* 23, no. 4 (2014): 411–21.

Noble, Safiya, Jessica Marie Johnson, and Mark Anthony Neal. "Week 3: Race and Black Codes (Main Thread)." *CCS Working Group*, January 2018. https://wg.criticalcodestudies.com/index.php?p=/discussion/42/week-3-race-and-black-codes-main-thread.

Nuku, Maia. *Atea: Nature and Divinity in Polynesia*. Metropolitan Museum of Art Bulletin 76, no. 3. New York: Metropolitan Museum of Art, 2019. Exhibition catalog.

Nyong'o, Tavia. "Too Black, Too Queer, Too Holy: Why Little Richard Never Truly Got His Dues." *Guardian*, May 12, 2020.

Obama, Barack. "Remarks by President Obama to the Australian Parliament." November 17, 2011, Washington, DC. Transcript, the White House. https://obamawhitehouse.archives.gov/the-press-office/2011/11/17/remarks-president-obama-australian-parliament.

Odell, Jenny. *How to Do Nothing: Resisting the Attention Economy.* New York: Melville House, 2019. ePub.

Olsen, Ole Andkjaer. "Depression and Reparation as Themes in Melanie Klein's Analysis of the Painter Ruth Weber." *Scandinavian Psychoanalytic Review* 27 (2004): 34–42.

Oxford English Dictionary. S.v. "cataclysm." Oxford University Press. Accessed June 29, 2023. https://www.oed.com/view/Entry/28673.

Oxford English Dictionary. S.v. "diagram." Accessed March 10, 2024. https://www.oed.com/dictionary/diagram_n?tab=etymology#6917294.

Oxford English Dictionary. S.v. "information." Accessed March 10, 2024. https://www.oed.com/dictionary/information_n.

Oyama, Susan. *The Ontogeny of Information: Developmental Systems and Evolution.* Durham, NC: Duke University Press, 2000.

Parisi, Luciana. *Contagious Architecture: Computation, Aesthetics, and Space.* Cambridge, MA: MIT Press, 2022.

Parisi, Luciana. "Reprogramming Decisionism." *e-flux Journal* 85 (October 2017). https://www.e-flux.com/journal/85/155472/reprogramming-decisionism/.

Perrier, Maud, and Elaine Swan. "Foodwork: Racialised, Gendered and Classed Labours." *Futures of Work*, December 9, 2019. https://futuresofwork.co.uk/2019/12/09/foodwork-racialised-gendered-and-class-labours/.

Perspective API. Accessed June 5, 2023. https://www.perspectiveapi.com/.

Perspective API. "How It Works." Accessed June 5, 2023. https://www.perspectiveapi.com/how-it-works/.

Perspective API. "Model Cards." Accessed June 5, 2023. https://developers.perspectiveapi.com/s/about-the-api-model-cards?language=en_US.

Phan, Thao, Jake Goldenfein, Declan Kuch, and Monique Mann, eds. *Economies of Virtue: The Circulation of "Ethics" in AI.* Theory on Demand. Amsterdam: Institute of Network Cultures, 2022.

Phan, Thao, and Scott Wark. "What Personalisation Can Do for You! Or: How to Do Racial Discrimination without 'Race'—Thao Phan and Scott Wark." *Culture Machine* 20 (2021): 1–29.

Phillips, Rasheedah, ed. *Black Quantum Futurism: Theory and Practice.* Vol. 1. Philadelphia: House of Future Sciences Books/AfroFuturist Affair, 2015.

Phongpaichit, Pasuk, and Chris Baker. *Thailand's Crisis.* Chiang Mai: Silkworm, 2000.

Precarity Lab. *Technoprecarious.* London: Goldsmiths Press, 2020.

Preciado, Paul B. *Testo Junkie: Sex, Drugs, and Biopolitics in the Pharmacopornographic Era.* New York: Feminist Press, 2013.

Puar, Jasbir K. "'I Would Rather Be a Cyborg Than a Goddess': Becoming-Intersectional in Assemblage Theory." *philoSOPHIA: A Journal of Continental Feminism* 2, no. 1 (2012): 49–66.

Radin, Joanna. "The Secret Weapon for Distributing a Potential Covid-19 Vaccination." *Washington Post*, November 12, 2020. https://www.washingtonpost.com/outlook/2020/11/12/secret-weapon-distributing-potential-covid-19-vaccine/.

Radin, Joanna, and Emma Kowal. *Cryopolitics: Frozen Life in a Melting World.* Cambridge, MA: MIT Press, 2017.

Rancière, Jacques. *The Politics of Aesthetics.* London: Bloomsbury Academic, 2006.

"Reading List: Resources for Resistance." *Tank*, June 2020. https://tankmagazine.com/tank/2020/06/resources-for-resistance.

Reagan, Ronald. "Remarks and a Question-and-Answer Session with the Students and Faculty at Moscow State University." Moscow, May 31, 1988. https://www.reaganlibrary.gov/research/speeches/053188b.

Redmond, Sean. "*Titanic*: Whiteness on the High Seas of Meaning." In *The* Titanic *in Myth and Memory: Representations in Visual and Literary Culture*, edited by Tim Bergfelder and Sarah Street, 197–204. London: I. B. Tauris, 2004.

Redstockings Collective. "Redstockings Manifesto." *Redstockings*, 1969. https://www.redstockings.org/index.php/rs-manifesto.

Reed, Patricia. "Diagramming the Common." Lecture, KunstAllmend (Artistic Commons) Symposium, Dampfzentrale, Bern, Switzerland, April 23, 2014. https://www.aestheticmanagement.com/wp-content/uploads/2014/05/reed_diagramming_the_common.pdf.

Rees, Jonathan. *Refrigeration Nation: A History of Ice, Appliances, and Enterprise in America.* Baltimore, MD: Johns Hopkins University Press, 2013.

Rhee, Jennifer. *The Robotic Imaginary: The Human and the Price of Dehumanized Labor.* Minneapolis: University of Minnesota Press, 2018.

Rich, Adrienne. "Contradictions: Tracking Poems, N. 28." In *Your Native Land, Your Life.* New York: W. W. Norton, 1986.

Rieder, John. *Colonialism and the Emergence of Science Fiction.* Middletown, CT: Wesleyan University Press, 2008.

Riggs, Marlon. "Black Macho Revisited: Reflections of a SNAP! Queen." In *Brother to Brother: New Writings by Black Gay Men*, edited by Essex Hemphill. Washington, DC: RedBone Press, 1991.

Riley, Boots, dir. *Sorry to Bother You.* Annapurna Pictures/Focus Features/Universal Pictures, 2018.

Rising Tide People's Blockade. https://www.risingtide.org.au/blockade-updates.

Roberge, Jonathan, and Michael Castelle. "Toward an End-to-End Sociology of 21st-Century Machine Learning." In *The Cultural Life of Machine Learning: An Incursion into Critical AI Studies*, edited by Jonathan Roberge and Michael Castelle, 1–29. London: Palgrave Macmillan, 2021.

Roberts, Elizabeth F. S. "Exposure." In Theorizing the Contemporary, *Fieldsights*, June 28, 2017. https://culanth.org/fieldsights/exposure.

Roberts, Elizabeth F. S. "Petri Dish." *Somatosphere*, March 31, 2014. https://somatosphere.com/2014/petri-dish.html/.

Rockström, Johan, Will Steffen, Kevin Noone, Åsa Persson, F. Stuart Chapin III, Eric Lambin, Timothy M. Lenton, et al. "Planetary Boundaries: Exploring the Safe Operating Space for Humanity." *Ecology and Society* 14, no. 2 (2009). https://www.jstor.org/stable/26268316.

Rose, Deborah Bird. "What If the Angel of History Were a Dog?" *Cultural Studies Review* 12, no. 1 (2006): 67–78.

Ross, Eric B. *The Malthus Factor: Poverty, Politics and Population in Capitalist Development.* New York: Zed, 1998.

Rossi, Michael. *The Republic of Color: Science, Perception, and the Making of Modern America.* Chicago: University of Chicago Press, 2019.

Rubin, Gayle S. "Thinking Sex: Notes for a Radical Theory of the Politics of Sexuality." In *The Gay and Lesbian Studies Reader*, edited by Henry Abelove, Michele Aina Barale, and David M. Halperin. New York: Routledge, 1993.

Russell, Legacy. *Glitch Feminism: A Manifesto.* New York: Verso, 2020.

Safire, William. "On Language: Crony Capitalism." *New York Times*, February 1, 1998.

Sagan, Lynn. "On the Origins of Mitosing Cells." *Journal of Theoretical Biology* 14 (1967): 225–74.

Sanabria, Emilia. *Plastic Bodies: Sex Hormones and Menstrual Suppression in Brazil.* Durham, NC: Duke University Press, 2016.

Sandoval, Chéla. "Re-entering Cyberspace: Sciences of Resistance." *Dispositio/n* 19, no. 46 (1994): 75–93.

Sanger, Margaret. *Woman and the New Race.* Scotts Valley, CA: CreateSpace, 2018.

Schoemaker, Paul. "Multiple Scenario Development: Its Conceptual and Behavioral Foundation." *Strategic Management Journal* 14, no. 3 (1993): 193–213.

School of Informatics. "What Is Informatics?" University of Edinburgh. Accessed March 10, 2024. https://www.ed.ac.uk/sites/default/files/atoms/files//what20is20informatics.pdf.

School of Information Sciences. "What Is Informatics?" University of Illinois at Urbana-Champaign. Accessed March 10, 2024. https://informatics.ischool.illinois.edu/home/what-is-informatics/.

Selyukh, Alina. "Why It's So Hard to Buy a New Refrigerator These Days." Hawaiʻi Public Radio, September 22, 2020. https://www.hawaiipublicradio.org/post/shortage-new-refrigerators-leaves-appliance-shoppers-out-cold#stream/0.

Shanmugaratnam, Tharman. "Inclusive Prosperity: Making It Possible." Lecture, London School of Economics and Political Science, London, January 30, 2017.

Sharpe, Christina. *In the Wake: On Blackness and Being.* Durham, NC: Duke University Press, 2016.

Shepard, Paul. *Nature and Madness.* San Francisco: Sierra Club Books, 1982.

Shinawatra, Thaksin. "Next Generation Asia." Speech at Fortune Global Forum, Hong Kong, May 9, 2001.

Shotwell, Alexis. *Against Purity: Living Ethically in Compromised Times.* Minneapolis: University of Minnesota Press, 2016.

Skvirsky, Salomé. *The Process Genre: Cinema and the Aesthetic of Labor.* Durham, NC: Duke University Press, 2020.

Smith, Chris. "The *Titanic*: A Case Study of Religious and Secular Attitudes in African American Song." In *Saints and Sinners: Religion, Blues and (D)evil in African-American Music and Literature,* edited by Robert Sacré, 213–27. Liège: Société Liégeoise de Musicologie, 1996.

Snead, James A. "On Repetition in Black Culture." *Black American Literature Forum* 15, no. 4 (1981): 146–54. https://doi.org/10.1353/afa.2017.0114.

Sobchack, Vivian. "Bathos and Bathysphere: On Submersion, History and Longing in *Titanic*." In *"Titanic": Anatomy of a Blockbuster*, edited by Kevin Sandler and Gaylyn Studlar, 189–204. New Brunswick, NJ: Rutgers University Press, 1999.

Solomon, Rivers. *An Unkindness of Ghosts*. New York: Akashic Books, 2017.

Song, Jesook. *South Koreans in the Debt Crisis: The Creation of a Neoliberal Welfare Society*. Durham, NC: Duke University Press, 2009.

Sontag, Susan. *Illness as Metaphor and AIDS and Its Metaphors*. London: Picador, 1989.

Starosielski, Nicole. *The Undersea Network*. Durham, NC: Duke University Press, 2015.

Stockholm Resilience Centre. "Planetary Boundaries." https://www.stockholmresilience.org/4.1fe8f33123572b59ab80007039.html.

Stone, Deborah A. *The Disabled State*. Philadelphia: Temple University Press, 1984.

Stop LAPD Spying Coalition and Free Radicals. "The Algorithmic Ecology: An Abolitionist Tool for Organizing against Algorithms." *Medium*, March 2, 2020. https://stoplapdspying.medium.com/the-algorithmic-ecology-an-abolitionist-tool-for-organizing-against-algorithms-14fcbd0e64d0.

Suchman, Lucy. "Swords to Ploughshares." *Robot Futures*, January 20, 2016. https://robotfutures.wordpress.com/2016/01/20/swords-to-ploughshares/.

Sulloway, Frank J. "Darwin and His Finches: The Evolution of a Legend." *Journal of the History of Biology* 15, no. 1 (1982): 1–53.

Sutela, Jenna. "*I Magma* generative poetry project." In *Jenna Sutela: NO NO NSE NSE*, edited by Stephanie Hessler. London: Koenig, 2020.

Syms, Martine. *Notes on Gesture*. 2015. Video, 10:30.

Szlauderbach, Kent. "Alien and Sedition: Ryan Kuo Interviewed." *Bomb*, July 18, 2018. https://bombmagazine.org/articles/alien-and-sedition-ryan-kuo-interviewed/.

Szumer, Zacharias. "Instead of Choking on Smoke, Sydney Workers Are Walking off the Job." *Jacobin*, December 15, 2019. https://jacobin.com/2019/12/sydney-australia-bushfires-air-smoke-dockworkers-walkouts.

Taffel, Sy. "Data and Oil: Metaphor, Materiality and Metabolic Rifts." *New Media and Society* 25, no. 5 (2023). https://doi.org/10.1177/14614448211017887.

Tai, Hung-chao, ed. *Confucianism and Economic Development: An Oriental Alternative?* Washington, DC: Washington Institute for Values in Public Policy, 1989.

Terranova, Fabrizio, dir. *Donna Haraway: Storytelling for Earthly Survival.* Atelier Graphoui, 2017.

Thompson, Clive. "We Need Software to Help Us Slow Down, Not Speed Up." *Wired*, August 25, 2018. https://www.wired.com/story/software-to-help-us-slow-down-not-speed-up/.

Thomson, William. "On a Universal Tendency in Nature to the Dissipation of Mechanical Energy." *Proceedings of the Royal Society of Edinburgh*, April 19, 1852.

Toupin, Louise. *Le salaire au travail ménager: Chronique d'une lutte féministe internationale (1972–1977).* Montreal: Les Éditions du remue-ménage, 2014.

Trump, Donald. "Remarks by President Trump at APEC CEO Summit, Da Nang, Vietnam." November 10, 2017, Washington, DC. Transcript, the White House. https://trumpwhitehouse.archives.gov/briefings-statements/remarks-president-trump-apec-ceo-summit-da-nang-vietnam.

Tsing, Anna Lowenhaupt. *The Mushroom at the End of the World: On the Possibility of Life in Capitalist Ruins.* Princeton, NJ: Princeton University Press, 2015.

Tu Wei-ming, ed. *The Triadic Chord: Confucian Ethics, Industrial East Asia, and Max Weber.* Singapore: Institute of East Asian Philosophies, 1991.

Tuck, Eve, and C. Ree. "A Glossary of Hauntings." In *Handbook of Autoethnography*, edited by Tony E. Adams, Stacy Holman Jones, and Carolyn Ellis, 630–58. London: Routledge, 2015.

Turing, A. M. "On Computer Numbers, with an Application to the Entscheidungsproblem." *Proceedings of the London Mathematical Society* 2, no. 42 (1936): 230–65.

Uncertain Commons. *Speculate This!* Durham, NC: Duke University Press, 2013.

Underdogs. "S.D.I. (a.k.a. Strategic Defense Initiative)." Review. Home of the Underdogs. Accessed May 27, 2024. http://www.homeoftheunderdogs.net/game.php?name=S.D.I.

USA Today. "Hawaii May Be the Happiest State, but It Also Has the Highest Food Prices." March 21, 2019.

US Department of State. *A Free and Open Indo-Pacific: Advancing a Shared Vision.* November 4, 2019. https://www.state.gov

/wp-content/uploads/2019/11/Free-and-Open-Indo-Pacific-4Nov2019.pdf.

Varoufakis, Yanis. "Something Remarkable Just Happened This August: How the Pandemic Has Sped Up the Passage to Postcapitalism." *Yanis Varoufakis: Thoughts for the Post-2008 World*, August 21, 2020. https://www.yanisvaroufakis.eu/2020/08/21/something-remarkable-just-happened-this-august-how-the-pandemic-has-sped-up-the-passage-to-postcapitalism-lannan-institute-virtual-talk/.

Vasserman, Lucy. "Reducing Toxicity in Large Language Models with Perspective API." *Jigsaw* (blog), April 21, 2023. https://medium.com/jigsaw/reducing-toxicity-in-large-language-models-with-perspective-api-c31c39b7a4d7.

Vasserman, Lucy, John Li, C. J. Adams, and Lucas Dixon. "Unintended Bias and Identity Terms." *Jigsaw* (blog), October 12, 2021. https://medium.com/jigsaw/unintended-bias-and-names-of-frequently-targeted-groups-8e0b81f80a23.

Ventura, Anya. "Finding the Love Hormone in a Stressed Out World." Arts at MIT, March 29, 2021. https://arts.mit.edu/jenna-sutela-love/.

Vickers, Ben, and Jenna Sutela. "Moving Consciousness around the Body." In *Jenna Sutela: NO NO NSE NSE*, edited by Stephanie Hessler, 27–40. London: Koenig, 2020.

Vincent, James. "Robot Butlers Operated by Remote Workers Are Coming to Do Your Chores." *Verge*, May 9, 2019. https://www.theverge.com/2019/5/9/18538020/home-robot-butler-telepresence-ugo-mira-robotics/.

Virilio, Paul, Friedrich Kittler, and John Armitage. "The Information Bomb a Conversation." *Angelaki* 4, no. 2 (1999): 81–90.

Vora, Kalindi. *Life Support: Biocapital and the New History of Outsourced Labor*. Minneapolis: University of Minnesota Press, 2015.

Wade, Robert. "The US Role in the Long Asian Crisis of 1990–2000." In *The Political Economy of the East Asian Crisis and Its Aftermath: Tigers in Distress*, edited by Arvid J. Lukauskas and Francisco L. Rivera-Batiz, 195–226. Cheltenham, UK: Edward Elgar, 2001.

Waitzkin, Howard, and Ida Hellander. "The History and Future of Neoliberal Health Reform: Obamacare and Its Predecessors." *International Journal of Health Services* 46, no. 4 (2016): 747–66.

Walker, Jeremy, and Melinda Cooper. "Genealogies of Resilience: From Systems Ecology to the Political Economy of Crisis Adaptation."

Security Dialogue 42, no. 2 (April 2011): 143–60. https://doi.org/10.1177/0967010611399616.

Wang, Phillip. *This Person Does Not Exist*. December 2019. https://thispersondoesnotexist.com.

Wasi, Prawase. *Bangkok Post*, December 28, 1997.

Wernimont, Jacqueline. *Numbered Lives: Life and Death in Quantum Media*. Cambridge, MA: MIT Press, 2018.

West, Jessamyn (@jessamyn). "Trying It with Some Visible/Invisible Disabilities. The Man/Woman Division Is Concerning. Https://T.Co/6zVb8v8b4O." Tweet. *Twitter*, August 26, 2017. https://twitter.com/jessamyn/status/901476036956782593.

The White House. *Indo-Pacific Strategy of the United States*. February 2022. https://www.whitehouse.gov/wp-content/uploads/2022/02/U.S.-Indo-Pacific-Strategy.pdf.

The White House. *Pacific Partnership Strategy of the United States*. September 2022. https://www.whitehouse.gov/wp-content/uploads/2022/09/Pacific-Partnership-Strategy.pdf.

Wiener, Norbert. *The Human Use of Human Beings: Cybernetics and Society*. Rev. ed. 1954. Reprint, Cambridge, MA: Da Capo, 1988.

Williams, Linda. "Melodrama Revisited." In *Refiguring American Film Genres: History and Theory*, edited by Nick Browne, 42–88. Berkeley: University of California Press, 1998.

Williams, Liza K. "The Politics of Paradise: Tourism, Image and Cultural Production in Hawai'i." PhD diss., New York University, 2015.

Wilson, Kalpana. *Race, Racism and Development: Interrogating History, Discourse and Practice*. New York: Zed, 2012.

Winterson, Jeanette. *Frankissstein: A Love Story*. London: Jonathan Cape, 2019.

World Bank. *The East Asian Miracle: Economic Growth and Public Policy*. New York: Oxford University Press, 1993.

Wright, Katherine. "Place Remembered: Unearthing Hidden Histories in Armidale Aboriginal Community Garden." *Australian Humanities Review* 65 (2019). http://australianhumanitiesreview.org/2019/11/30/place-remembered-unearthing-hidden-histories-in-armidale-aboriginal-community-garden/.

Wu, Nina. "A Single Person Earning Less Than $67,500 Now Qualifies as 'Low Income' in Urban Honolulu." *Star Advertiser*, May 28, 2019. https://www.staradvertiser.com/2019/05/28/hawaii-news/newswatch/low-income-threshold-rises-to-67500-in-honolulu/.

Wynter, Sylvia. "Unsettling the Coloniality of Being/Power/Truth/Freedom: Towards the Human, After Man, Its Overrepresentation—an Argument." *New Centennial Review* 3, no. 3 (2003): 257–337.

Yusoff, Kathryn. *A Billion Black Anthropocenes or None*. Minneapolis: University of Minnesota Press, 2018.

Contributors

Dalida María Benfield, PhD (Panama/United States/Finland) is an artist-researcher, filmmaker, and theorist. Her practice is focused on decolonial feminist rearrangements of the geopolitics of knowledge. She is the cofounder and research and program director of the Center for Arts, Design, and Social Research (Boston), an international platform for research and popular education. Her work, often collectively produced, includes films and video installations, experimental writing and publications, curatorial projects, and activist pedagogical interventions. She has co-initiated numerous autonomous organizations and programs, such as Video Machete (1994–2007), the Women's International Information Project (1998–2002), and the Institute of (im)Possible Subjects (2013–present).

Zach Blas is an artist, filmmaker, and writer whose practice draws out the philosophies and imaginaries residing in computational technologies and their industries. Working across moving image, computation, installation, theory, and performance, Blas has exhibited at venues including Vienna Secession, Los Angeles County Museum of Art, KANAL—Centre Pompidou, Whitney Museum of American Art, Twelfth Berlin Biennale for Contemporary Art, Walker Art Center, Twelfth Gwangju Biennale, ZKM Center for Art and Media, and Museo Universitario Arte Contemporáneo. In 2021, his artist monograph *Unknown Ideals* was published by Sternberg Press and Edith-Russ-Haus für Medienkunst. Blas is assistant professor of visual studies at the University of Toronto.

Ama Josephine Budge Johnstone is a British-Ghanaian speculative writer, artist, scholar, and pleasure activist whose praxis navigates what

she terms *Intimate Ecologies* to explore Blackness, aesthetics, and queer, pleasurable, interspecies futures. Ama's writing was shortlisted for the 2023 Future Worlds Prize and the 2021 Arts Foundation Environmental Writing Award. She has had essays, short fiction, and art writing published and translated internationally. Her video and installation work has been exhibited across Europe and on the traditional lands of the Munsee and Muhheaconneok people. Ama is an associate lecturer at Central Saint Martins (University of the Arts London), an MFA tutor at the Sandberg Institute (Amsterdam), a research associate at VIAD (University of Johannesburg), and is completing her PhD at Birkbeck, University of London.

micha cárdenas, PhD, MFA, is an artist and associate professor of critical race and ethnic studies and performance, play, and design at the University of California, Santa Cruz, where she directs the Critical Realities Studio. Her debut novel, *Atoms Never Touch* (2023), imagines trans Latina love crossing multiple quantum realities. Her academic monograph *Poetic Operations: Trans of Color Art in Digital Media* (Duke University Press, 2022) was the cowinner of the Gloria Anzaldúa Book Prize in 2022 from the National Women's Studies Association.

Amy Sara Carroll's books include *SECESSION*; *FANNIE + FREDDIE: The Sentimentality of Post-9/11 Pornography*, chosen by Claudia Rankine for the 2012 Poets Out Loud Prize; and *REMEX: Toward an Art History of the NAFTA Era*. With other members of Electronic Disturbance Theater 2.0, she coproduced the *Transborder Immigrant Tool* and coauthored *[({})] The Desert Survival Series / La serie de sobrevivencia del desierto*, which was published under a Creative Commons license and widely redistributed. Previously she taught at The New School in New York City. Currently, she is an associate professor of literature and literary arts at the University of California, San Diego.

Shu Lea Cheang is an artist and filmmaker who engages in genre-bending, gender-hacking art practices. Celebrated as a net art pioneer with *BRANDON* (1998–99), the first web art commissioned and collected by the Guggenheim Museum, New York, Cheang represented Taiwan at the Venice Biennale in 2019 with the mixed-media installation 3 × 3×6. Crafting her own genre of Scifi New Queer Cinema, she has made four feature films, *FRESH KILL* (1994), *I.K.U.* (2000), *FLUIDØ* (2017), and

UKI (2023). In 2024, she received the LG Guggenheim Art and Technology Award. http://mauvaiscontact.info.

Jian Neo Chen (he/they) is associate professor of queer studies in women's, gender and sexuality studies at The Ohio State University. His research focuses on transgender and queer aesthetics and embodied practices in literature, visual culture, and territorial ecologies—and their reconstruction of social relations and movements. His first book *Trans Exploits: Trans of Color Cultures and Technologies in Movement* (Duke University Press, 2019) was awarded a 2021 Association for Asian American Studies Book Award and was a 2020 Lambda Literary Award Finalist. Chen is coeditor of the ASTERISK book series at Duke University Press with Susan Stryker and Eliza Steinbock.

Heather Dewey-Hagborg is a New York–based artist and biohacker who is interested in art as research and technological critique. Heather has shown work internationally at venues including the World Economic Forum, the Daejeon Biennale, Guangzhou Triennial, Walker Center for Contemporary Art, Philadelphia Museum of Art, and PS1 MoMA. Her work is held in public collections of Centre Pompidou, Victoria and Albert Museum, and SFMOMA, among others, and has been widely discussed in the media, from the *New York Times* and the BBC to *Artforum* and *Wired*. Heather has a PhD in electronic arts from Rensselaer Polytechnic Institute.

Ranjodh Singh Dhaliwal is associate professor of digital humanities, artificial intelligence, and media studies at Universität Basel. His current book project, *Rendering: A Political Anatomy of Computation*, shows how our sociocultural and politico-economic formulations get crystallized into hardware and software architectures. His award-winning research—spanning media theory, science and technology studies, and literary criticism—can be found in *Critical Inquiry*, *Configurations*, *American Literature*, and *Design Issues*, among other venues. He is also the coauthor, with Lucy Suchman and Théo Lepage-Richer, of *Neural Networks* (2023).

Stephanie Dinkins is a transmedia artist who creates projects that foster dialogue about race, gender, aging, and our future histories. Her art practice centers emerging technologies, documentary practices, and

social collaboration, working toward technological ecosystems based on care and social equity. In 2023, Dinkins was named one of *Time Magazine*'s "100 Most Influential People in AI" and the inaugural recipient of the LG Guggenheim Award for artists working at the intersection of art and technology. Dinkins teaches at Stony Brook University, where she holds the Kusama Endowed Chair in Art. She exhibits and publicly advocates systems of care and generosity internationally.

Ricardo Dominguez was a cofounding member of Critical Art Ensemble and a cofounder of Electronic Disturbance Theater 1.0, a group who developed virtual sit-in technologies in solidarity with the Zapatista communities in Chiapas, Mexico, in 1998. His Electronic Disturbance Theater 2.0/b.a.n.g. lab project with Brett Stalbaum, micha cárdenas, Amy Sara Carroll, and Elle Mehrmand was the Transborder Immigrant Tool, a GPS cell phone safety net tool for the Mexico-US border and winner of the Transnational Communities Award (2008). Dominguez is a professor and chair of the Department of Visual Arts at the University of California, San Diego.

Ashley Ferro-Murray is the program director for the arts at the Doris Duke Foundation. Previously, Ferro-Murray was the senior curator of theater and dance at the Curtis R. Priem Experimental Media and Performing Arts Center (EMPAC) at Rensselaer Polytechnic Institute. Her research has been published most recently in the *Drama Review* and in collections published by Bloomsbury Press. Ferro-Murray currently serves on the International Presenting Commons and *TURBA: The Journal for Global Practices in Live Arts Curation* advisory board. She holds a PhD from the University of California, Berkeley, in performance studies with a designated emphasis in new media.

Matthew Fuller's books include *How to Sleep: The Art, Biology and Culture of Unconsciousness* (2018); *How to Be a Geek: Essays on the Culture of Software* (2017); with Olga Goriunova, *Bleak Joys: Aesthetics of Ecology and Impossibility* (2019); and, with Eyal Weizman, *Investigative Aesthetics: Conflicts and Commons in the Politics of Truth* (2021). He has collaborated with Shu Lea Cheang on several projects, including *The Sleep Series* (2017–ongoing) and *UKI* (2023), and is professor of cultural studies at Goldsmiths, University of London.

Jacob Gaboury is associate professor of film and media at the University of California, Berkeley, specializing in the seventy-year history of digital image technologies and their impact on contemporary visual culture. His first book is titled *Image Objects: An Archaeology of Computer Graphics* (2021) and explores a prehistory of 3D graphics and their widespread influence on the shape of our lived environment. His work has appeared across popular and academic publications including *Grey Room*, *Journal of Visual Culture*, *Rhizome*, and *Camera Obscura*. He is coeditor of the 2023 special issue of *Critical Inquiry* titled "Medium/Environment."

Jennifer Gabrys is chair in media, culture and environment in the Department of Sociology at the University of Cambridge. She leads the Planetary Praxis research group and is principal investigator on the European Research Council–funded project Smart Forests: Transforming Environments into Social-Political Technologies. Her publications include *Citizens of Worlds: Open-Air Toolkits for Environmental Struggle* (2022), *How to Do Things with Sensors* (2019), *Program Earth: Environmental Sensing Technology and the Making of a Computational Planet* (2016), and *Digital Rubbish: A Natural History of Electronics* (2011). Her work can be found at planetarypraxis.org and jennifergabrys.net.

Alexander R. Galloway is a writer and computer programmer working on issues in philosophy, technology, and theories of mediation. Professor of media, culture, and communication at New York University, Galloway is author of several books on digital media and critical theory, including most recently *Uncomputable: Play and Politics in the Long Digital Age* (2021). For several years he has worked with RSG on Carnivore, Kriegspiel, and other software projects.

Jennifer Mae Hamilton's research is on weather, affect, and housework. Since 2018, she has lived and worked in Anaiwan Country in Australia, teaching English and gender studies at the University of New England. She has an ongoing local collaboration called the Armidale Climate and Health Project. At the time of this publication, she's writing two books, one with Astrida Neimanis called *How to Weather Together: Feminist Practice for Changing Climates*, and the other is a work of autotheory called *A List of Needs*.

Donna J. Haraway is distinguished professor emerita in the History of Consciousness Department at the University of California, Santa Cruz. Attending to the intersection of biology with culture and politics, Haraway's work explores the string figures composed by science fact, science fiction, speculative feminism, speculative fabulation, science and technology studies, and multispecies worlding. She is the author of *Staying with the Trouble: Making Kin in the Chthulucene* (Duke University Press, 2016), *Manifestly Haraway* (2016), *When Species Meet* (2008), *The Companion Species Manifesto* (2003), *The Haraway Reader* (2004), *Modest_Witness@Second_Millennium* (1997, 2nd ed. 2018), *Simians, Cyborgs, and Women* (1991), *Primate Visions* (1989), and *Crystals, Fabrics, and Fields* (1976, 2004).

Eva Hayward is a lecturer at the University of New Mexico. She has also taught at Utrecht University and the University of Arizona. A Fulbright Scholar (Austria), she has held postdoctoral fellowships at Duke University and Uppsala University (Sweden). Her scholarship focuses on ecology, art, and trans and sexuality studies.

Stefan Helmreich is professor of anthropology at MIT and author of *A Book of Waves* (Duke University Press, 2023) and *Alien Ocean: Anthropological Voyages in Microbial Seas* (2009). His essays have appeared in *Critical Inquiry*, *Representations*, *American Anthropologist*, *Cabinet*, *The Wire*, *Women's Studies Quarterly*, and *Public Culture*.

Kathy High is an interdisciplinary artist, curator, and scholar. She collaborates with scientists and activists, and considers living systems, animal sentience, and the ethical dilemmas of biotechnology and medical industries. She is professor in the Department of Arts at Rensselaer Polytechnic Institute, Troy, New York, and director of the BioArt and Technology Laboratory in RPI's Center for Biotechnology and Interdisciplinary Studies. She is the coordinator of the community science project NATURE Lab with the Sanctuary for Independent Media. She is committed to queer and feminist approaches to DIY science, environmental justice, and collaborative action.

Leon J. Hilton is assistant professor of theater arts and performance studies at Brown University, where he is also a faculty affiliate with the Gender and Sexuality Studies Program and the Science and Technology

Studies Program. He is also the co-convener of Brown's Disability Studies Working Group. His first book, forthcoming from the University of Minnesota Press, examines how neurodivergence has been represented, sensed, and materialized through performance. He is a member of the editorial collective of the journal *Social Text* and is on the advisory board of Spectrum Theatre Ensemble, a neurodiverse theater company based in Providence, Rhode Island.

Hiʻilei Julia Kawehipuaakahaopulani Hobart (Kanaka Maoli) is assistant professor of native and Indigenous studies at Yale University and author of *Cooling the Tropics: Ice, Indigeneity, and Hawaiian Refreshment* (Duke University Press, 2022). An interdisciplinary scholar, she researches and teaches on issues of settler colonialism, environment, and Indigenous sovereignty.

Ho Rui An is an artist and writer working in the intersections of contemporary art, cinema, performance, and theory. Through lectures, essays, and films, his research examines the relations between labor, technology, and capital across different systems of governance in a global age. He lives and works in Singapore.

Tung-Hui Hu is a poet and a media theorist. He is the author of five books, most recently *Digital Lethargy: Dispatches from an Age of Disconnection* (2022), *A Prehistory of the Cloud* (2015), and *Greenhouses, Lighthouses* (2013). He was awarded the 2022–23 Rome Prize in Literature from the American Academy in Rome and is an associate professor of English at the University of Michigan.

Caroline A. Jones is professor at MIT, teaching in history, theory, and criticism and serving as associate dean of the School of Architecture and Planning. Her research focuses on art and its technological modes of production, as well as its interfaces with science. Jones's essays have appeared in journals ranging from *Artforum* to *Critical Inquiry*. Her solo author and coedited books examine technology and the senses, art and neuroscience, and art history and history of science as parallel inquiries. Jones cocurated the 2022–23 exhibition *Symbionts: Contemporary Artists and the Biosphere* at the List Visual Arts Center and coedited its accompanying publication.

Melody Jue is associate professor of English at the University of California, Santa Barbara. She is the author of *Wild Blue Media: Thinking through Seawater* (Duke University Press, 2020) and *Coralations* (2025) and the coeditor, with Rafico Ruiz, of *Saturation: An Elemental Politics* (Duke University Press, 2021). Her recent essays on oceans, science fiction, and technology have been published in *Grey Room*, *Configurations*, *Media+Environment*, *ASAP Journal*, *Plant Perspectives*, *Foundry*, *Resilience*, and *Fieldwork for Future Ecologies*.

Homay King is professor in the Department of History of Art and Program in Film Studies at Bryn Mawr College. She is the author of two books, *Lost in Translation: Orientalism, Cinema, and the Enigmatic Signifier*, and *Virtual Memory: Time-Based Art and the Dream of Digitality*. She is currently working on a book manuscript titled *Go West: A Mythology of California's Silicon Valley*.

Larissa Lai is the author of nine books including *The Tiger Flu*, *Salt Fish Girl*, and most recently *The Lost Century*, and a critical monograph, *Slanting I, Imagining We*. Recipient of the Jim Duggins Novelist's Prize, the Lambda Literary Award, the Astraea Award, and the Otherwise Honor Book, she has also been shortlisted for the Association for Canadian and Québec Literatures Gabrielle Roy Prize in Literary Criticism. She is currently the Richard Charles Lee Chair of Chinese Canadian Studies at the University of Toronto.

Lawrence Lek is a London-based artist, filmmaker, and musician known for his ongoing series of films, soundtracks, and immersive virtual worlds set within a Sinofuturist cinematic universe. Often featuring interlocking narratives and the recurring figure of the wanderer, his work explores the myth of technological progress in an age of artificial intelligence and social change. Recent solo exhibitions include *NOX*, LAS Art Foundation, Berlin (2023); *Black Cloud Highway*, Sadie Coles HQ, London (2023); and *Post-Sinofuturism*, ZiWu the Bund, Shanghai (2022). Soundtrack releases include *Temple OST* (Vinyl Factory, 2020) and *AIDOL OST* (Hyperdub, 2020). Lek is represented by Sadie Coles HQ, London.

Esther Leslie is professor of political aesthetics at Birkbeck, University of London. Her books include various studies of Walter Benjamin,

Hollywood Flatlands: Animation, Critical Theory and the Avant Garde (2002); *Synthetic Worlds: Nature, Art and the Chemical Industry* (2005); *Derelicts* (2014); *Liquid Crystals: The Science and Art of a Fluid Form* (2016); and *The Rise and Fall of Imperial Chemical Industries: Synthetics, Sensism and the Environment* (2023). Work on the biopolitical economy of dairy, with Melanie Jackson, includes *Deeper in the Pyramid* (2018/2023). Written with Sam Dolbear in 2023, *Dissonant Waves: Ernst Schoen and Experimental Sound in the Twentieth Century* is a study of antifascist radio pioneer Ernst Schoen.

Alexis Lothian is associate professor in the Harriet Tubman Department of Women, Gender, and Sexuality Studies at University of Maryland, College Park. Her research centers on speculative fiction, digital media, and fan culture and their relationships to gender, race, and disability justice. She is the author of *Old Futures: Speculative Fiction and Queer Possibility* (2018) and has published in *American Quarterly, Feminist Studies, Transformative Works and Cultures, International Journal of Cultural Studies, Cinema Journal,* and *Camera Obscura,* among other venues.

Isadora Neves Marques is a film director, visual artist, and writer. Her short films were awarded numerous prizes, including the Ammodo Tiger Short Award at IFFR—International Film Festival Rotterdam in 2022. She was the Portuguese Official Representation—Portugal Pavilion at La Biennale di Venezia in 2022 and was awarded a Pinchuk Future Generation Art Special Prize and the Present Future Art Prize for her art career. Her artworks and films have been exhibited globally. She is cofounder of the film production company Foi Bonita a Festa. She is also cofounder of the poetry press Pântano Books, as well as being a regular contributor to *e-flux Journal* and other magazines and publications on art and theory.

Radha May is an artist collective whose work explores forgotten and hidden histories, peripheral sites, and their relation to gender, sexuality, and race. Radha May uses tools borrowed from anthropologists, historians, and journalists to conduct their research. They work in the field, meticulously sifting through historical and social archives, making what they find available to anybody; they also distill the material into critical and fictional scenarios that complicate assumptions about history, borders, and cultural and social formations. Radha May

is Elisa Giardina-Papa, Bathsheba Okwenje, and Nupur Mathur. They collaborate and work between New York, Palermo, Kampala, Kigali, and New Delhi.

Shaka McGlotten is professor of media studies and anthropology at Purchase College–SUNY, where they also serve as chair of the gender studies program. An anthropologist and artist, their work stages encounters between black study, queer theory, media, and art. They have written and lectured widely on networked intimacies and messy computational entanglements as they interface with queer-of-color lifeworlds. They are the author of *Dragging: Or, in the Drag of a Queer Life* (2021) and *Virtual Intimacies: Media, Affect, and Queer Sociality* (2013). They are also the coeditor of two edited collections, *Black Genders and Sexualities* (with Dána-ain Davis, 2012) and *Zombies and Sexuality* (with Steve Jones, 2014).

Mahan Moalemi is a critic, curator, and doctoral candidate in film and visual studies at Harvard University. He is the coeditor of *Ethnofuturisms* (2018), and his writing has appeared in *Art in America*, *Cabinet*, *e-flux Criticism*, and *Frieze*, among other periodicals, anthologies, exhibition catalogs, and artist monographs.

madison moore is an artist-scholar, DJ, and assistant professor of modern culture and media at Brown University. His first book, *Fabulous: The Rise of the Beautiful Eccentric* (2018), offers a cultural analysis of fabulousness as a practice of refusal. madison has performed internationally at a broad range of art institutions and nightclubs, including the Kitchen, SFMOMA, and the Bemis Center for Contemporary Arts. In February 2023, he guest coedited a special issue of *e-flux Journal* on Black rave with McKenzie Wark. madison is currently writing a book about Black queer nightlife as a method of living.

Astrida Neimanis (she/they) writes about water, weather, and bodies at the intersection of feminism and environmental change. Their most recent book is *Bodies of Water: Feminist Posthuman Phenomenology*. They are associate professor and Canada Research Chair of feminist environmental humanities at University of British Columbia–Okanagan, on unceded Syilx territories, where they are also director of the FEELed Lab.

Bahar Noorizadeh looks at the relationship between art and capitalism. Her research investigates the technological and intellectual histories of economics, from cybernetic socialism to neoliberal finance, and activist strategies against the financialization of life and the living space, asking what redistributive historical justice might look like for the present. Noorizadeh is the founder of Weird Economies, a coauthored and socially connected project that traces economic imaginaries extraordinary to financial arrangements of our time. She is an associate lecturer at RCA School of Architecture and a tutor in Geo-Design at the Design Academy Eindhoven.

Luciana Parisi is a professor at the Program in Literature and Computational Media Art and Culture at Duke University. She was a member of the Cybernetic Culture Research Unit and is currently a cofounding member of Critical Computation Bureau. Her research is a philosophical investigation of technology in culture, aesthetics, and politics. She is the author of *Abstract Sex: Philosophy, Biotechnology and the Mutations of Desire* (2004) and *Contagious Architecture: Computation, Aesthetics, and Space* (2013). She is completing a monograph on alien epistemologies and the transformation of logical thinking in AI.

Thao Phan is a feminist science and technology studies researcher who specializes in the study of gender and race in algorithmic culture. Her writing appears in journals such as *Big Data and Society*; *Catalyst: Feminism, Theory, Technoscience*; *Science as Culture*; and *Cultural Studies*. She is a lecturer in sociology (STS) at the Australian National University, based on Ngunnawal and Ngambri country.

Ana Teixeira Pinto is a writer and cultural theorist based in Berlin. She is a professor of art theory at the Hochschule für Bildende Künste Braunschweig and a theory tutor at the Dutch Art Institute. Her writings have appeared in publications such as *Third Text*, *Afterall*, *e-flux Journal*, *Artforum*, and *Texte zur Kunst*. She is the editor of the book series *On the Antipolitical*, published by Sternberg Press, and the author of the forthcoming publication *Entropy and Chronopolitical Allegory*.

Luiza Prado de O. Martins is an artist and writer. Her work moves between installation and sculpture, using performance and ritual as a way of invitation and activation for audiences. Her practice explores

anticolonial and more-than-human strategies in relations and knowledge between food, fertility, infrastructures, and technology, and questions what structures and processes are needed for collective concerns of care. She has exhibited and performed at the Museum of Modern Art Warsaw, Haus der Kulturen der Welt, Savvy Contemporary, and Museum Ostwall. Her work is part of the collection of the Art Institute of Chicago. She is based in Berlin.

Rita Raley is professor of English at the University of California, Santa Barbara. Her recent collaborative and single-authored publications about AI/machine learning have appeared in *PMLA*; *Digital Humanities Quarterly*; *American Literature*; *symplokē*; *Understanding Flusser, Understanding Modernism*; *Critical Inquiry Forum*; and *Poetics Today*. This work has informed her contributions to an ongoing collaborative project on critical machine learning first funded by the University of California Humanities Research Institute.

Patricia Reed is a theorist, artist, and designer based in Berlin. She is co-head of the Critical Inquiry Lab at the Design Academy Eindhoven. Recent writings have been published in *Navigation beyond Vision, Ceremony: Burial of an Undead World, The Unmanned, Model Is the Message, The New Normal*, and *e-flux Journal*. She cowrote the *Xenofeminist Manifesto* as Laboria Cuboniks, which was republished by Verso in 2018. Reed is an affiliate researcher in the Antikythera program and has been awarded an Agent of Change grant from the International Architecture Biennale Rotterdam. She is preparing a monograph titled *Figuring Planetary Space* and a compilation of her essays in Spanish translation (forthcoming).

Jennifer Rhee is associate professor of English and director of the AI Futures Lab at Virginia Commonwealth University. Her research focuses on artificial intelligence across technology, art, and speculative fiction. She is the author of *The Robotic Imaginary: The Human and the Price of Dehumanized Labor* (2018) and coeditor of *The Palgrave Handbook of Twentieth- and Twenty-First Century Literature and Science* (2020) as a member of the Triangle Collective. Her research has also been published in journals including *American Literature, Science Fiction Studies, Camera Obscura, Configurations, Mosaic, ASAP*, and *Postmodern Culture*, as well as in various edited volumes.

Bassem Saad is a writer and artist born in Beirut. Her work explores notions of historical rupture, spontaneity, and surplus through film and visual art, alongside essays and fiction. Bassem's work has been presented and screened at MoMA, CPH:DOX, Triangle-Asterides (Marseille), Busan Biennale, Swiss Institute (Rome), Ludwig Forum (Aachen), Cabaret Voltaire (Zurich), and transmediale. Her writing appears in *The New Inquiry*, *Protean*, *Spike Art*, *Jadaliyya*, *FailedArchitecture*, *X-TRA*, and *The Funambulist*.

Ashkan Sepahvand is an artist, writer, and researcher. He was born in Tehran, Iran, grew up in Tulsa, Oklahoma, and since 2006 lives and works between London and Berlin. His practice takes time. An interest in words and bodies shapes his inquiries. Projects take the form of performances, publications, and regular collaboration with friends. Together with Natascha Sadr Haghighian, he founded the institute for incongruous translation in 2010, a framework for their shared studies. He is one half of ssssSssssssss, a study-friendship with Virgil B/G Taylor.

Justin Talplacido Shoulder is a shape-shifting artist and storyteller, working primarily in performance, sculpture, video, and collective events. Also known as Phasmahammer, their practice is an eco-cosmology of alter personas based on queered ancestral myth. Creatures birthed are embodied through hand-crafted costumes and prosthesis and animated by their own gestural languages. The artist uses their body and craft as an instrument of metaphysics toward a queer Filipinx futurism. Shoulder believes in performance and shared ceremony as communal medicine for difficult times. Shoulder's theater and visual artworks have been presented across Australia and internationally, where they work between gallery, nightclub, and theater contexts.

Lucy Suchman is professor emerita of the anthropology of science and technology at Lancaster University in the UK. Before taking up that post, she was a principal scientist at Xerox's Palo Alto Research Center (PARC), where she spent twenty years as a researcher. Her current research extends her long-standing critical engagement with the fields of artificial intelligence and human-computer interaction to the domain of contemporary militarism. She is concerned with the question of whose bodies are incorporated into military systems, how and with what consequences for social justice, and the possibility for a less violent world.

Ollie Zhang researches, writes, edits, curates, and (sometimes!) speaks. Their interests include innovative forms of property and ownership, equitable infrastructure design, emergent governance practices, community-led housing, and regenerative agriculture. Currently, they are researching and developing a new legal standard for an affordable land tenure model. Before, they edited and curated things largely to do with cultural infrastructure for Berlin's CTM Festival. They are based in London.

Index

absolution, 99, 100–102
Abya Yala, 169
academia, 169. *See also* pedagogy
accumulation, 9, 153; capital, 185–86, 274; strategy of, 54
actualization, 260–62
ACT UP demonstration, 55
ADAPT, 52
aesthetics and politics, 31n74
affirmative speculation, 29n54
Affordable Care Act, 53–55
Afghanistan, 197
Afrotopias, 193–94
"Against Population, towards Alterlife" (Murphy), 103
agency, 12–13, 20, 69, 122, 170, 258–62; agential cut, 20
AI capitalism, 48–50. *See also* information capitalism
AIDOL 爱道 (Lek), 90–98
AIDS, 1, 55, 59
Akomolafe, Bayo, 105
algorithms, 12–14, 29n49, 36, 49–50, 94–95, 141, 147, 182, 195, 227, 242, 245–46; algorithmic care, 242, 245–46; Algorithmic Ecology, 14
"All Directions at Once" (Martins), 169, 173
Allen, Amy, 25n19
AlphaGo, 34
America, Mark, 23n5
animal-human-machines, 154–56
animals, 80–81, 86–88, 138, 176–78. *See also* cows; crows; tardigrades; vultures

anonymity, 96
antinomianism, 101–2
anti-Semitism, 207, 209n9
Anzaldúa, Gloria, 15
apathy, 67–69
application programming interfaces (APIs), 38–39, 290
Arab Spring, 116
Aristotle, 100
art, 85, 212–16, 220; conceptual, 1, 21; modern, 24n8; organismic, 211–16. *See also* art history; bioart; museum; performance art; visual art
art history, 257, 260
artificial intelligence (AI), 34–38, 48–49, 84, 90–97, 129, 139–42, 144, 153, 215, 228, 241–48, 272, 274, 276–80, 290–91. *See also* generation; generative adversarial network (GAN); simulation
Artist, American, 21
artistic practice, 27n43, 169, 178. *See also* art; performance art; visual art
Asian Tigers, 203–4. *See also* capitalism: and Asian values; China
Atanasoski, Neda, 272
Atkinson, Ti-Grace, 15, 31n66
attention, 67–68
augmented reality (AR), 33
authorship, 242, 259. *See also* generation; generative adversarial network
automation, 153, 157, 182–85, 271–72
autopoiesis, 216n5

Avatar (Cameron), 64n14
Avilez, GerShun, 254

Barad, Karen, 20
Barthes, Roland, 259
BDSM, 7, 26n23
Beam, Joseph, 249
Beer, Stafford, 115
Beniger, James, 187n8
Benjamin, Ruha, 12
Berardi, Franco "Bifo," 68
Bergson, Henri, 260–62
Bernes, Jasper, 115
Bervin, Jen, 228
Biden, Joe, 198
Bier, Jess, 61
bioart, 211–13
biodigital, 153, 155–56
biological determinism, 179, 181
biological function, 264
biological sex, 168
biological weapon, 199
biology, 11, 54, 77–82, 85–86, 154, 216n4, 216n5, 297; evolutionary, 150n1, 200, 278; synthetic, 213, 243
birth, 50, 176, 178, 257, 277.
birth control, 170–73, 175n2. *See also* contraception
Black Atlantic, 60
Black Feminist Thought (Collins), 8
Black Lives Matter, 54
"Black Lives Matter, but to Whom?" (Akomolafe), 105
Black Panthers, 116, 190–91
Black Star Line, 60
Black Student Union, 191
Blas, Zach, 13, 23n5, 24n13, 26n24, 29n50
Blue (Jarman), 59
bodies: bodily production, 20, 77–82; devaluation of, 244–45; as machines, 83–84, 126, 178–79; quantification of, 85–86; vulnerability, 54; wholeness of, 176. *See also* animals, disability; humans
body burdens, 131–35
Bonhomme, Edna, 174
Braidotti, Rosi, 232
Braun, Bruce, 116
Brazil, 137
Brazilian Spring, 282

Broken Earth, The (Jemisin), 43, 45
Brooks, Rodney, 272
brown, adrienne maree, 41, 46
Brown, DeForrest, Jr., 67
Browne, Simone, 21
Buehler, Markus, 211, 211, 216n2
Bush, George W., 21
Busta, Caroline, 68
Butler, Judith, 15
Butler, Octavia, 43, 191–93

Cainthus, 87
Camdessus, Michel, 207
Cameron, James, 57, 64n14
capitalism: and artificial intelligence (AI), 48–50; and Asian values, 203–4, 208n1; crises of, 53–54, 206; and the cyborg, 24n11, 206; and disability, 54–55; and disaster, 45; and finance, 123; and gender, 218–19, 224, 233; logics of, 9, 41, 45, 136, 155–56, 205–6; and nonhuman labor, 140–41, 271, 274; and patriarchy, 73; periodization of, 1–3, 25n17; and standardization, 146–47. *See also* crony capitalism; gig economy; industrial capitalism; informatics; informatics of domination; information capitalism; labor; late capitalism; neoliberalism; platform capitalism; racial capitalism; racism; technocapitalism
cárdenas, micha, 12–13, 29n49, 46
care, 43, 71, 73–74, 174, 181, 242, 246. *See also* algorithms: algorithmic care, health care
Carolina Islands, 197
Carrion (Shoulder), 176–81
Castells, Manuel, 26n17
Cato Institute, 112
cattle breeding, 72, 74
CGI, 90–91
"chart of transitions" (Haraway), 2–6, 10, 13–22, 25n17, 29n54, 30n62, 30n63, 172, 193, 289, 295–96. *See also* charts; informatics of domination; white capitalist patriarchy
charts, 1–6, 10, 13–22, 24n8, 194, 297–300. *See also* diagrammatic thought; lists
Cheng, Anne, 60

China, 197–99. *See also* AIDOL 爱道 (Lek): capitalism: and Asian values; sinofuturism
chronic illness, 77. *See also* disability
Chun, Wendy Hui Kyong, 51, 67, 287n6
circulation, 61–62
cisgender men, 26n20; 250
cisgender women, 25n19
citational practice, 234
citizenship, 226–27; environmental, 184
civil rights. *See* rights
Clarke, Bruce, 26n27, 217n26
class: and capitalism, 204–6; and domination, 6, 8; identity, 61–62, 171, 244, 250, 292; and labor, 139–41, 155
climate change, 42–43, 142–43, 178, 183, 198 233, 237, 273; as crisis, 173–74, 183, 233
code, 11–13, 26n27, 27n43, 27n44, 29n49, 39, 48, 83–85, 153–57, 184, 227, 241, 264–65, 282–83; ancestral, 247; fashion and, 249; handkerchief, 12–13; moral, 49; and sex, 269; translation into, 54; world as, 276, 278, 280. *See also* computation; New Jim Code; software
code-switching, 12
coldness, 59, 71–74
Cold War, 57–58, 112, 198, 204, 233, 285, 286
Collins, Patricia Hill, 8, 11
colonialism, 5, 71–72, 103, 152, 171, 197–98, 201; anti-, 233–34; coloniality, 168–69; neo-, 11; settler, 42–43, 45, 195. *See also* Global South
Combahee River Collective, 191
composting, 235–37
computation, 1, 7–8, 13, 28n44, 35, 38, 114–15, 137, 142–43, 146–50, 182–87; and robotics, 271. *See also* code; environmental sensing; informatics
computer science, 8, 147. *See also* informatics
consumerism, 88, 174, 203, 233, 264–65
content moderators, 137
contraception, 130, 169–73. *See also* birth control
"Contradictions" (Rich), 134
control societies, 25n17
Cosmopolis (DeLillo), 110, 113, 115
Costa, Mariarosa Dalla, 138

Council for Inclusive Capitalism, 209n4
counterfeit currency, 39n6
COVID-19 pandemic, 41, 71, 89, 113–14, 152–53, 174, 211, 232, 239n26, 254, 261, 295–96. *See also* wet markets
cows, 86–69
Creating a New Civilization (Toffler), 112
Creative Evolution (Bergson), 260
Crenshaw, Kimberlé, 10–11, 15, 29n49
critical race theory, 10–11. *See also* intersectionality
Cronenberg, David, 110
crony capitalism, 206, 209n6
Crowe, Steward, 62
crows, 126–29
Cuba, 197
cuckolds, 65–69
currency, 39n6, 207. *See also* money
Customs and Border Patrol, 227
cybernetics, 55, 57, 62, 74, 112, 115, 132, 137–43, 147, 150, 278, 283; of labor, 136–42
Cybersyn, 115
cyborg, 2–3, 6, 24n11, 74, 164, 206, 226–31, 233–37, 271, 296. *See also* feminism
Cyborg Manifesto. *See* "Manifesto for Cyborgs, A" (Haraway)

Daewoo, 203
"Dark Ages" (Nomeansno), 102
dark sousveillance, 21. *See also* surveillance
Darwin, Charles, 146, 150n1, 200
da Vinci, Leonardo, 258
Davis, Angela, 222
Dawn (Butler), 191, 193
"Death of the Author, The" (Barthes), 259
deepfakes, 35–36
Deleuze, Gilles, 23n3, 25n17, 29n53, 69, 100
DeLillo, Don, 110, 113
demilitarization, 237. *See also* militarization
diagrammatic thought, 2–3, 5–6, 13–15, 29n53. *See also* charts
die-ins, 52–56
digital, 1, 50, 66, 83–86, 182–88, 276; media, 136, 284; object, 148. *See also* biodigital; digitality; virtuality

digitality, 66, 304n4
Dillon, Grace, 45–46
Dinkins, Stephanie, 241–48
diorama, 218–24
disability, 52–56, 56n8, 121. *See also* bodies
discipline, 7, 25n17, 29n53, 47n10, 66, 118, 169, 204, 207, 238n7
discourse networks, 25n17
disinformation, 39
DNA, 26n27, 85, 132, 152, 169–70, 264–66
domesticity, 71–73, 136, 138, 207, 219, 272
domination, 2–11, 23, 25n19, 26n20, 31n66, 42–43, 58, 64n14, 118, 123, 216, 233, 235, 249–50, 261, 290–92; colonial, 46, 169, 171; patriarchal, 6–7, 10, 25n19, 31n66, 42, 290. *See also* informatics of domination; matrix of domination; patriarchy; power
Dominguez, Ricardo, 1–2, 16, 20, 23n2, 23n5
Dostoyevsky, Fyodor, 101
double consciousness, 156
drag, 166, 252
Dream Time Village, 23n5
Du Bois, W. E. B., 14
Dworkin, Andrea, 7
dystopianism, 33

economic planning, 110–11, 114–15
Ehrlich, Paul, 174
Einspahr, Jennifer, 25n19
Electronic Disturbance Theater 2.0, 226–31
Elwood, Sarah, 13
emasculation, 66
emotional labor. *See under* labor
endocrinology, 130–33
Eng, David L., 258
entropy, 211, 277–78, 281n10, 298–99
environmentalism, 173, 178, 182–83, 233–37
environmental sensing, 182–87
epigenetics, 132
Ethics of Psychoanalysis, The (Lacan), 260
eugenics, 45, 103–9, 168, 170–73
exile, 105

exploitation, 6, 42–44, 50, 233, 271; class, 208, 274; colonial, 154; sexual, 205
exuberance, 252–53

fabulousness, 250–53, 255
Fanon, Frantz, 224, 258
fashion, 249–55
Federici, Silvia, 138, 142, 145n5
feminism: and colonialism, 171; design principles, 3, 5, 296; and diagrams, 3, 5–6, 14–15, 19–20, 30n59; and domination, 25n19; and environmentalism, 232–37, 238n5; materialist, 138; and revolution, 66; second wave, 25n19; and self-interest, 289; and sex, 7; third world, 222. *See also* cyborg
"Feminism and Science" (Keller), 7
feminist objectivity, 19
feminist science and technology studies, 2, 6–7, 296. *See also* situated knowledges, feminist objectivity
feminist standpoint theory, 7. *See also* situated knowledges
Fifth Season, The (Jemisin), 43–45
film, 37–38, 57, 59, 90, 115–16, 150n3, 284–85
Firestone, Shulamith, 15
Fisher, Carrie, 37
Fisher, Mark, 119
Floyd, George, 41, 46, 115
Forestry 4.0, 185–86
Foucault, Michel, 24n8, 25n17, 29n53, 259
4chan, 66
Fourier, Charles, 65–66
FPInnovations, 185
fragility, 106
Frankissstein (Winterson), 270
Free Radicals, 14
free will, 260
Freud, Sigmund, 257–58
From Hierarchy to Holarchy (Sutela), 214
Fujikane, Candace, 72
function, 146, 150n2
functional specialization, 146–47, 150n2
Future Shock (Toffler), 111–12
futurity, 190, 277. *See also* possibility, speculation, Uncertain Commons

Gaboury, Jacob, 28n44
Gage, Phineas, 150n1
Gall, Franz Joseph, 146, 150n1
Galloway, Alexander R., 23n5, 25n17, 28n44
Galtier, Brigitte, 138
gamification, 84–85
Garvey, Marcus, 60
gender, 3, 86; and citizenship, 227; construction of, 200, 207, 257; and domination, 6–8, 26n19; essentialism, 26n19, 26n20; genderqueer identities, 258; and governmental violence, 154; imposition of binary, 172–73, 218, 223; and labor, 138–39, 141, 204, 207, 218–19, 274; models of, 200, 257; presentation of, 12, 250–55; public judgements of, 62; racial gender class wars, 198; and racialization, 278, 280; transitioning, 131
generation, 34–36, 37–39, 139. *See also* artificial intelligence (AI); simulation
generative adversarial network (GAN), 34–38. *See also* artificial intelligence (AI); neural network
Geomancer (Lek), 90–98
gestural ecology, 178–79
Gibson, William, 25n17
gig economy, 118–19, 140. *See also* capitalism; labor; neoliberalism
Gilbert, Scott, 216n5
Gill, William Booth, 199
Gilmore, Ruth Wilson, 46n9
Gilroy, Paul, 60
glitch feminism, 250
globalization, 25n17, 71–72, 138–40; deglobalization, 152
Global North, 140, 172, 174
Global South, 136–37, 143, 152, 272, 274. *See also* colonialism
"Glossary of Hauntings, A" (Tuck and Ree), 104
Google Earth, 57–58
Gorbachev, Mikhail, 112
Goux, Jean-Joseph, 276–77
graffiti, 41
graph theory, 16, 18, 30n64. *See also* network science
grassroots organizing, 46

Great Kings of Africa, 190
Grossman, Rachel, 204
Guam, 197
Guattari, Félix, 23n3

Han, Byung-Chul, 118, 123
handkerchief codes. *See* code
Haraway, Donna: 58, 226, 289; and common language, 11, 27n43, 28n44, 234–35; compound eyes, 5; and earthly justice, 236–37; feminist methods of, 15; fields of difference, 235; legacy of, 2–5, 9, 25n17, 41, 72, 217n10, 236, 289; making kin, 238n6; narrative modes of, 41; and science fiction, 42; and sympoiesis, 216n5. *See also* "chart of transitions" (Haraway); cyborg; informatics of domination; "Manifesto for Cyborgs, A" (Haraway); Plantationocene, situated knowledges, sympoiesis
Harding, Sandra, 7. *See also* feminist standpoint theory
Hardt, Michael, 25n17
hardware, 9, 138
Hartman, Saidiya, 245, 253
Hawai'i, 71–74, 197, 198, 200
Hawaiian flag quilts, 12
Hayek, Friedrich, 110–11, 114
Hayles, N. Katherine, xii, 9, 33n27, 141, 279
health care: 12, 53; experiences of, 77–82; privatization of, 55; routines of, 110
Hegel, Georg Wilhelm Friedrich, 257, 278; Hegelianism, 280
Heidegger, Martin, 102; being-toward-death, 260
Hierarchies of Cuckoldry and Bankruptcy, The (Fourier), 65
Higgins, David, 42
Hippocrates, 83
Holling, C. S., 112
Hong Kong, 116, 203–4, 228
Honolulu Advertiser, 73
hooks, bell, 10, 288–89, 290
horizontality, 61
housing, 73, 155, 194; projects, 73, 192; public, 73; universal, 145
How to Do Nothing (Odell), 68

human: and animals, 80–81; boundaries of, 44, 49; concept of, 304n7, 304n8; and cows, 86–87; essence of, 102; hybridity of, 304n8; and labor, 137–38, 140–41, 280; and machines, 39, 50, 273; and nature, 278; sociality, 45; and subjectivity, 258. *See also* bodies
human rights, 55
Hunt, Victoria, 179
Hurricane Sandy, 116
Hurston, Zora Neale, 191
hygiene, 122, 123n10

IKEA, 146, 148–50
Imarisha, Walidah, 41–43
Immigration and Customs Enforcement (ICE), 227
imperialism, 196–97, 200, 292. *See also* neo-imperialism
imposter syndrome, 120
incomputable, 150. *See also* uncomputable
Indigenous knowledges, 72, 169, 185–86, 133, 223, 234
individuality, 95, 131, 267, 284
Indonesia, 203–4, 206, 207
industrial capitalism, 146–47, 204. *See also* capitalism
informatics, 74, 297–304; concept of, 8–10, 27n43; and ecologies, 184–87; etymology of, 8; and sensing technologies, 188n13. *See also* capitalism; informatics of domination
informatics of domination, 33, 42, 55, 60, 187n8, 227, 228; and code, 11; and discipline, 204; and labor, 48–50, 138–39; 157; relations of, 154, 289; structure of, 10–11, 22–23, 289–90, 295–96; theorization of, 2–5, 6, 15, 27n35, 27n41, 248, 291–92, 298. *See also* capitalism; "chart of transitions" (Haraway); domination; informatics; power; white capitalist patriarchy
information, 297. *See also* informatics; informatics of domination
information capitalism, 3, 153. *See also* capitalism
information overload, 187n8
informed consent, 79, 171
International Monetary Fund (IMF), 207

intersectionality, 8, 10–11, 15, 29n49. *See also* matrix of domination
In the Wake (Sharpe), 60, 61
in vitro fertilization (IVF), 87, 130
Iran, 198
Irani, Lilly, 273
Iraq, 197
irrationality, 96
iteration, 23, 38, 100. *See also* repetition

Jackson, Reginald T., 253, 255
James, Selma, 138
Japan, 197, 198, 203–4
Jarman, Derek, 59
J. Craig Venter Institute, 85
Jemisin, N. K., 43–46, 46n9, 47n10
Jenner, Edward, 88
Johnson, Jessica Marie, 11–12, 24n8
Jones, Donna V., 280
Jue, Melody, 24n14, 63n8

Kafer, Alison, 56n8
Kahn, Herman, 285
Kang, Laura, 207
Kapital, Das (Marx), 136
Kauanui, J. Kēhaulani, 73
Keller, Evelyn Fox, 7, 26n20
Kennedy, Ted, 284
Kittler, Friedrich, 25n17, 145n11, 150n3
Klein, Melanie, 258
knowledge(s), 111, 112, 133, 169, 220, 243, 246; economies, 119; folk, 219; object of, 19, 20; oriented, 24n13; regimes of, 63n6; subject of, 19, 20. *See also* Indigenous knowledges; situated knowledges
Konings, Martijn, 111
Krauss, Rosalind, 24n8
Kuo, Ryan, 67

labor, 136–45, 145n3, 155–57, 211–12, 216n2; and AI, 49–50, 289, 294n12; creative labor, 119–20; and emotions, 122, 137; gendered division of, 204, 218–19; feminist labors, 236; global labor, 48–49; indentured labor, 220; laboring body, 54–55; labor management, 122–23; labor power, 50, 56, 115, 137; labor unions, 116; navigational 22; reproductive labor, 50, 73, 74; and

robotics 25n16, 270–74. *See also* capitalism; gig economy
Lacan, Jacques, 257, 258, 260–61
La Mano NegreX, 192
Lamoreaux, Janelle, 133
Lantz, Frank, 144
Laplanche, Jean, 258
Laroche, Joseph, 62
late capitalism, 25n17, 67, 139–40, 205. *See also* capitalism
Lee, Bruce, 228–29
Lek, Lawrence, 90–91
libertarianism, 101
Lieberman, Charlotte, 120
Lin, Candace, 213
Linden Lab, 33
link analysis, 21
lists, 237
literary postmodernism, 42
Lombardi, Mark, 21
London School of Economics, 111
Lucretius, 101
Lugones, María, 223

Mad Max: Fury Road (Miller), 101
Mafarka the Futurist (Marinetti), 277–78
magic realism, 192
Magritte, René, 35
Mahathir Mohamad, 207, 209n9
Malaysia, 203–4, 206
Malaysia Airlines Flight 370, 63n6
Malcolm X, 222
male consciousness, 7
male supremacy, 25n19
Malthus, Thomas, 174
managerialism, 119
Mandel, Ernest, 25n17
Manifestly Haraway (Haraway), 15
"Manifesto for Cyborgs, A" (Haraway), 2–3, 6, 24n11, 30n62, 234, 296; and disability, 56
Mann, Steve, 21
Maoli, Kanaka, 72
Mapping Abundance for a Planetary Future (Fujikane), 72
Marcolli, Matilde, 115
Margulis, Lynn, 216, 217n16
Mariana Islands, 197, 199
Marinetti, Filippo Tommaso, 277–79
Marshall Islands, 197–99
Marx, Karl, 113, 137

Matrix, The (Wachowskis), 33, 36
matrix of domination, 8, 11. *See also* domination; intersectionality
May, Radha, 51
McBean, Sam, 13, 15
McConnell, Mitch, 52
McCormick, Katherine, 171
McHale, Brian, 42
Mead, Margaret, 200
Mechanical Turk, 137, 273–74
Mejias, Ulises Ali, 18
melodrama, 284–86
memory, 107–8, 133
mental health, 119, 122
Merry, Sally Engle, 73
meshwork, 213
metaphysics, 60, 99, 101, 102, 154–55, 276–78
Micronesia, 197–98
militarism, 24n11, 233
militarization, 54, 152, 154, 197–99. *See also* demilitarization; militarism; war
militarized industrial logic, 235
military postindustrial complex, 228
Milne-Edwards, Henri, 83
Minakata Kumagusu, 214
Minakata Mandala (Sutela), 214
Mind Children (Moravec), 279
Min Tanaka, 180
Mira Robotics, 271–72
Mirowski, Philip, 111
Modern art, 24n8
modernity, 42, 72–73, 100, 120, 132, 133. *See also* postmodernism
money, 39n6, 110, 113, 206
Monterey Bay Aquarium, 59–60
Moravec, Hans, 279
mortality bills, 24n8
Morton, Timothy, 217n6
Muñoz, José Esteban, 258
Murphy, Michelle, 103
museum, 218–24
music, 93
mutual aid, 69

Narrative Structures (Lombardi), 21
nature, 168, 174, 278; conceptions of, 132–33, 150, 232–33, 277; domination of 7; feminization of, 7, 26n20, 77; and the market, 111, 113

natureculture, 232–34, 273, 300
Neal, Mark Anthony, 11–12
necropolitical, 74, 153, 160, 227
Negri, Antonio, 25n17
Neimanis, Astrida, 238n8
neoclassical economics, 111
neo-imperialism, 189–90. *See also* imperialism
neoliberalism, 55, 110–11, 114, 118–19, 122, 233. *See also* capitalism; gig economy
neoliberal psychopolitics, 118
network, 3, 6, 16, 21, 83–84, 115, 154, 206–8, 271; information, 182, 204–5, 242; of labor, 289; of relations, 74, 119; society, 25n17, 85
network science, 16, 18, 21, 30n64. *See also* graph theory
neural network, 34, 154, 291. *See also* generative adversarial network (GAN)
neurodiversity, 120
New Historicism, 258
New Jim Code, 12, 190. *See also* code
New York Times, 120
Nietzsche, Friedrich, 101
9/11, 286
Noble, Safiya, 11–12
noise, 65–69
Nomeansno, 102
North Korea, 198
nuclear testing, 199
Nyong'o, Tavia, 251

Obama, Barack, 36, 197
Obamacare. *See* Affordable Care Act
object orientation, 146–51
Occupy Wall Street, 115
ocean, 57–62, 196; Atlantic, 60, 197, 199; depth, 57–58; Pacific, 196–201, 232; smart, 183
Oceania, 197–201
Ochoa, Marcia, 227
Octavia's Brood (Imarisha and brown), 41
Odell, Jenny, 68
Oedipus complex, 257
optimization, 99–100, 118, 168, 172–73
organismic art, 211–16
Orgs (Sutela), 213–14
Oxford English Dictionary, 20

Pacific Ocean. *See* ocean
Paepae o Heʻeia, 76n20
Palau, 199
pandemic, 41, 113–14, 152–53, 157, 174, 239n26, 261, 295–96
Papua New Guinea, 196, 200
paranodal space, 18
Parisi, Luciana, 28n44
patriarchy, 26n19, 234, 288; cispatriarchy, 172; heteropatriarchy, 11. *See also* domination; white capitalist patriarchy; white imperialist capitalist patriarchy
patterns, 34, 110–11, 153–55, 260, 283, 291; patterning, 49, 216
pedagogy, 189, 191–93, 252, 257–63
Peele, Jordan, 36
performance art, 176–81, 213–14
periodization, 25n17
Perspective API, 290–92, 294n12
Philippines, 137, 197, 206
phrenology, 89, 146, 150n1, 150n2, 190
physiology, 83–89
Pincus, Gregory, 171
placebo, 78–79
planetary: boundaries, 183–84; crises, 184–85, 187n8; computation, 143; emergency, 152; epoch, 296; governance, 184, 186, 187n1; as praxis, 186; survival, 153
Plantationocene, 72
platform capitalism, 48, 95
platform economy, 91, 205
poetics, 13, 61; Black feminist, 238; of self, 253
police, 55, 88, 191, 254; police surveillance, 14; police violence, 41, 52–54; predictive policing, 14
Politics of Aesthetics, The (Rancière), 31n74
population, 45, 88, 103, 150n2, 152–53, 171, 174, 208
Population Matters, 174
populism, 101, 114, 208, 289
pornography, 7, 35; post-porn, 269
possibility, 3, 22, 23n2, 29n54, 228, 241, 245–46, 248, 259, 278, 295–96; and affective failure, 68; and being, 224; and the end of the world, 41–42, 45; and optimization, 100–101
postmodernism, 1–2, 25n17, 42, 100. *See also* modernity

potentiality, 1–2, 13–15, 23, 41, 46, 259
poverty, 119, 121, 171, 174, 272
power, 1–11, 13–15, 19, 21, 24n8, 26n19, 26n24, 29n53, 30n59, 31n66, 33–34, 43–46, 49, 68, 72, 101–2, 168–69, 184, 197–98, 204–5, 208, 212, 216, 233, 235–36, 238n7, 240n30, 244, 290; biopower, 133, 169; colonial, 44, 46n9; computational, 114; institutional, 245; labor, 50, 115, 137; patriarchal, 7, 289; relations, 6, 10, 13, 14–15, 20, 25–26n19, 29n53; state, 208; structures, 4, 169, 232, 234, 262, 289; will to, 277, 279. *See also* domination; informatics of domination
precarity, 69, 118–20, 141, 155, 157, 244, 261, 274, 283; techno-precarity, 137
prediction, 112, 143, 155, 168, 172, 286
predictive; melody, 94; pattern mining, 111; policing, 14, 154; scanning, 153; simulation, 38
privilege, 19, 46, 69, 118–20, 235, 261, 274; immunoprivilege, 89
procrastination, 118–23
propaganda, 35–36, 143, 295
protest, 52–56, 115–16, 122, 194, 228, 282–83
protocol, 63, 152–53, 213
Protocol (Galloway), 25n17
Proust, Marcel, 23n3
psychoanalysis, 257–62
psychopolitics, 118, 123
psychosocial, 37, 131
Puar, Jasbir, 29n49
Puerto Rico, 171, 197, 199
punctum, 53

quality: of life, 265; and optimization, 100; qualitative difference, 37
quantification, 84–87; and anti-Blackness, 190
queer, 161; aesthetics, 249–56; code, 12–13; computing, 28n44; fiction, 42, 180–81; nature, 214; theory, 233–34

race: and domination, 6–7, 224, 280; visibility of, 12; vocal performances of, 155–56. *See also* racial capitalism; racism; sinofuturism; whiteness; white supremacy

racial capitalism, 10, 41, 72, 156–57, 206. *See also* capitalism
racial chain of being, 190, 194
racialization, 60, 64n14, 204–6
racial profiling, 170
racism: 62, 188, 192, 220, 291–92; anti-racism, 194. *See also* imperialism; race; white supremacy
Radin, Joanna, 73
Rancière, Jacques, 31n74
Reagan, Ronald, 276, 284
real, 32–37, 107–8
realism, 42, 180; magic realism, 192; neo-surrealist, 212; photorealistic, 148
reality, 301–2; augmented, 33; bodily, 74; lived, 273; virtual, 84
recognition: facial technologies of, 84, 87–89, 170; pattern, 153, 283; voice, 270
reconfiguration, 14, 31n14, 147, 231, 238n5
Ree, C., 104
Reed, Patricia, 5
Reed College, 191
Rees, Jonathan, 72
refrigeration, 70–74, 75n3
relation: to artificial intelligence, 270–75; between terms, 6; differential, 36; labor, 144; to reality, 224, 301; to positionality, 19–20; social, 137
relationality, 9, 16
relational structures, 148
Renaissance City Project, 208, 210n13
repetition, 23n3, 100, 193. *See also* iteration
replication, 152–58
representation, 9–10, 33–39, 59, 203, 226, 250. *See also* simulation
reproduction, 150, 152–58, 168; biological, 168, 172; of domination, 3, 42, 46; social, 206
residence time, 57–64
resilience, 176, 112–13, 194
resilient dispositif, 116
resistance, 11, 22, 29n53, 68, 169, 273; eradication of, 11–13; Black, 21; bodily, 54–56
Rhee, Jennifer, 25n16, 273
rhizome, 23n3
Rich, Adrienne, 15, 134

Riggs, Marlon, 251
rights, 2; civil, 14, 53–54, 288; disability, 52–56; reproductive, 169; workers', 48. *See also* social justice, 234, 273
Roberts, Elizabeth, 131–32
robotics, 6, 18, 270–75
Rock, John, 171
Roe v. Wade, 169
Ross, Eric, 174
Rothschild, Lynn Forester de, 209n4
Rubin, Gayle S., 7, 26n23
Russell, Legacy, 250
Russia, 198

Sandoval, Chela, 222
Sanger, Margaret, 171, 174
satellites, 182
Saudi Arabia, 227
scarcity, 72, 174
Schuld, 102
science: biological, 216n4; cognitive, 154; computer, 8, 147, 151n4; human, 150; network, 30n64; techno-, 131, 133, 283
science fiction, 41–46, 64n14, 279
scientific: discourse, 50; knowledge, 111, 169; management, 204–10; objectivity, 19, 170; socialism, 114
scientism, 110
sculpture, 21, 213
Second Life, 33
Second Skin (Cheng), 60
Second-wave feminism, 25, 25–26n19
Sedol, Lee, 34
self, 20, 86, 107, 140, 249, 252, 258–59, 289; -determination, 258; -expression, 255, 259; -generating, 55, 265; -improvement, 122; -organizing, 154, 242; -perpetuating, 118; -preservation, 120; -regulating, 55, 152; -sovereign, 261–62
sex: and autonomy, 172; and difference, 200; and genetic engineering, 265–69; history of sexuality, 24n8; language of, 66; and liberation, 170; theories of, 7, 257; wars, 7–8
sexism, 172, 288, 291
sex role specialization, 168–75

sexualization, 204–5
sexual violence, 103
Shanmugaratnam, Tharman, 209n4
Sharpe, Christina, 60–61
Shinawatra, Thaksin, 208
Shotwell, Alexis, 292
Shoulder, Justin Talplacido, 176–80
Silberman, M. Six, 273
silence, 69
Silicon Valley, 101
Silicon Valley Rising, 274
Silverman, Kaja, 260
Simians, Cyborgs, and Women (Haraway), 15, 19, 30
simulacrum, 33, 36–37. *See also* simulation
simulation, 33–40, 63n12, 147–48, 203, 271; logic of, 150; simulated value, 123. *See also* artificial intelligence (AI); generation; reality; representation; simulacrum; virtuality
Singapore, 203–4
singularity, 38, 279–80
sinofuturism, 92, 94–95, 98. See also *AIDOL* 爱道 (Lek); Asian Tigers; China
situated knowledges, 7, 19, 27n35. *See also* feminist standpoint theory
slave codes, 12, 28n45
slavery, 24n8, 60, 145n3, 169, 271–72, 278; capital and, 153; legacies of, 220, 171; and speculative fiction, 43–46
Slim, Carlos, 112
smallpox, 88. *See also* vaccination
smart sensors, 182–83
Smith, Adam, 83
Snead, James, 67
socialism: scientific, 114; planning, 109–10, 114–15; state, 24
socialist feminism, 3, 296
software, 9, 13, 85, 137. *See also* code; computer science; hardware
Solomon, Rivers, 107
solutionism, 8–9; AI, 293
Soros, George, 207, 209n9
Sorry to Bother You (Riley), 155–57
South Korea, 203–4, 208
sovereignty, 12, 25n17, 259–62, 284
Soviet Union, 111–12, 114–15
spatiality, 1, 21, 303. *See also* temporality

spectacle, 37, 54, 59, 152, 178–79.
 See also theatricality
speculation, 110–17; affirmative, 29n54;
 AI, 37, 279, 281n13. See also prediction, possibility
speculative fiction, 41–47, 77–82,
 103–109, 124–129; 180, 192. See also
 world-building; possibility
Spencer, Richard, 173
Spillers, Hortense, 191
standardization, 146–47
Star Wars (Lucas), 37
Stone, Deborah, 54–55
Stop LAPD Spying Coalition, 14
Stranger Visions (Dewey-Hagborg),
 170–71
Strategic Defense Initiative (SDI),
 283–85
strategy: activist, 54, 273; of containment, 33; development, 204,
 210n13; of domination, 271; of
 emotional labor management,
 123; Indo-Pacific, 197–98; of
 necropolitical control, 153; optimal genetic strategies, 168, 172–73;
 self-regulating, 152; strategic
 withdrawal, 68; of survival, 12,
 252–53; of techno-capitalist exploitation, 274; viral strategy of
 extraction, 154
stress management, 118–23
structural critique, 26n19
structuralism, 261–62
structure of feeling, 112
students, 191–93, 257–63. See also
 pedagogy
Styles, Harry, 250
style, 249–56
StyleGAN, 36. See also generative adversarial network (GAN)
super-industrial society, 112
supply chains, 71–72, 189
surface, 57–64
surfing the internet, 63n4
surrogacy, 153, 155–57, 272–73; reproductive, 168, 172
surrogate humanity, 153
surveillance, 7–8, 14, 21, 26n24, 87, 92,
 169–70, 183, 215. See also recognition; dark sousveillance
sustainability, 120, 181, 232, 273

Sutela, Jenna, 213–16, 221
symbiontics, 213
symbiosis, 193, 212–17
sympoiesis, 216n5
Syria, 197

tardigrades, 176–81
Taylorism, 147
technocapitalism, 162
television set, 203
temporality, 1, 14, 302; circular, 155; of
 domestic care, 73; logics, 21; scales,
 42. See also spatiality
Thailand, 203–4, 206, 208
theater practice, 179–81. See also
 performance art
theatricality, 53. See also spectacle
Thiel, Peter, 228
Third Wave, The (Toffler), 112
third-wave feminism, 25n19
This Person Does Not Exist (StyleGAN),
 36
Thomson, William, 277
Three Essays on a Theory of Sexuality
 (Freud), 257
Titanic (Cameron), 57
Toffler, Alvin, 111–12
Toffler, Heidi, 112
Total Disaster (Dominguez), 23n5
toxic exposure, 130–35, 288
toxicity, 290–93
transCoder (Blas), 13
translatability, 11, 28n44
Trump, Donald, 198, 201n2, 227
Tsing, Anna, 72
Tuck, Eve, 104
Turing, Alan, 28n44
Turkopticon, 273–74
2008 financial crisis, 113, 209n7

Umbrella Movement, 228
Uncertain Commons, 29n54
uncomputable, 28n44
unconscious, 258, 261
Underground Railroad, 192, 220
United Nations, 182, 190
UNITE HERE Local 19, 274
universalism, 147, 257
Universal Paperclips (Lantz), 144
University of Chicago, 111
University of Edinburgh, 8

University of Washington, 9
Unkindness of Ghosts, An (Solomon), 106
utopianism, 8–9, 38, 180

vaccination, 73–74, 88, 216, 288
value, 123, 137–38, 155–57, 218–19
Varoufakis, Yanis, 113
Veillance Caliper (Artist), 21
"Veillance Plane" (Mann), 21
Venezuela, 227
verticality, 1, 61
Vinge, Vernor, 279
Virilio, Paul, 145n11
virtuality, 1–2, 3n3, 23n3, 33, 49, 57–58, 84. *See also* digital; simulation
Virtual Timeline (Dominguez), 1–2, 16, 23n2, 23n5
virus, 79, 216n1, 217n15, 265–69; viral: code, 153, 269; matching, 268; posts, 282; regime, 155; recombination, 266; replication, 152; strains, 88; strategy, 154; variants, 288; videos, 192, 211; virions, 211–12, 213, 216n1. *See also* AIDS; COVID-19 pandemic; smallpox; vaccination
visibility, 58–60
visionary fiction, 41–43
visual art, 20–21, 24n8, 92, 97, 211–17, 220, 257–63. *See also* art; art history; film; performance art
vitalism, 279–80
Vogue, 251
von Neumann, John, 279
Vora, Kalindi, 272
vultures, 80–82

Wakefield, Stephanie, 116
war, 152, 197, 282–87; as big data, 286; gaming, 38, 285; protests against, 54, 282. *See also* Cold War, militarism, militarization, war on terror, World War I, World War II

war on terror, 198
Weber, Ruth, 258
Weeks, Kathy, 25n17
wet markets, 124–29
Wet-on-Wet (Sutela), 211–12
"What Is an Author?" (Foucault), 259
white capitalist patriarchy, 6, 10–13, 27n35, 27n41, 289–90, 295; white capitalist cis-heteropatriarchy, 199. *See also* patriarchy; white imperialist capitalist patriarchy; whiteness; white supremacy
white imperialist capitalist patriarchy, 288–89, 292. *See also* patriarchy; white capitalist patriarchy
whiteness, 8, 64n14, 67–68, 156, 193, 228, 276, 290. *See also* race; racial capitalism; racism; white capitalist patriarchy
White Review, 253
White Star Line, 60–62
white supremacy, 10, 62, 173, 194, 252
Wiener, Norbert, 278, 281n10, 298
wildfires, 182, 187n1, 232
Williams, James, 68
Williams, Linda, 284
Williams, Raymond, 112
Winterson, Jeanette, 270
world-building, 192–93, 295–96, 301. *See also* possibility; speculative fiction; worlding
worlding, 14, 29n54, 46n9, 235. *See also* possibility; speculative fiction; world-building
World War I, 62
World War II, 25n17, 54–55, 197
Wynter, Sylvia, 154–55, 304nn7–8

Yi, Anicka, 212–13

Zhao Ziyang, 112
zone of indistinction, 119

www.ingramcontent.com/pod-product-compliance
Lightning Source LLC
Chambersburg PA
CBHW020852180526
45163CB00007B/2486